EUPHORIA FASHION

Heidi Bivens

A24

Contents

Foreword by Jeremy Scott 4

Introduction by Heidi Bivens 8

RUE 16

In Conversation with *Euphoria*'s Creator Sam Levinson 48

JULES 56

In Conversation with Costume Designer Arianne Phillips 96

MADDY 110

Q&A with Fashion Design House Coperni 138

NATE 148

Essay: Bound—Normcore as Fashion Bondage 158 KAT 172 In Conversation with Makeup Artist Doniella Davy 188 CASSIE 196 Essay: It's My *Euphoria* Party, and I'll Cry if I Want To 218 FEZCO 224 LEXI 238 Essay: High Camp at "Euphoria High" 250 Essay: Memes, Moods, and Miu Miu Eras 262

FOREWORD

JEREMY
SCOTT

What is the look of *Euphoria*? You can't put it into words, actually. *Euphoria*'s style is more of a feeling. It's a mood. I feel very passionate about fashion in that way. Fashion—true fashion—is not about trends and labels and all the rest. Rather, it's about the clothes and how we wear them—and how wearing clothes makes us feel. We all have to get dressed in the morning. Clothing is how we tell people what tribe we're with. What are the bands we like? What are the websites we like to visit? What are the restaurants we like to go to? What are our political beliefs? Even people who think that they don't care about clothes are signaling exactly that by the choices they're making. We reveal everything through our clothes, even if we're not conscious of it—that's the magic in dressing ourselves. Style is the ultimate form of personal expression.

No one understands this better than Heidi Bivens. I like to joke that Heidi has dual citizenship. That is, she's a citizen in the world of fashion, but she's also a citizen in the world of costume design. (Usually, people are in one camp or the other—rarely are they in both.) Heidi got her start in the '90s working as an intern at *W Magazine* and *Paper*. She has worked as a fashion stylist at places such as *Vogue, Interview, i-D,* and elsewhere. Later, she made the transition to costume design, working on incredible films, including Michel Gondry's *Eternal Sunshine of the Spotless Mind* and David Lynch's *INLAND EMPIRE*. She got her big break, of course, working with Harmony Korine on the costumes for *Spring Breakers* and, more recently, on his latest film, *The Beach Bum*.

Heidi has the discerning eye of an editor. She knows exactly what length a crop top should be—how high a tube sock should run up someone's ankle. But she also knows how to create a character. She knows how style can tell a story. We really believe Maddy Perez (played by Alexa Demie) is that girl—smart enough to know what's not good for her—when she wears a custom-designed

body-con cut-out dress. We feel the restlessness of Rue Bennett (played by Zendaya) with her tie-dye shirts and vintage pants. We worship the sexuality of Kat Hernandez (played by Barbie Ferreira) with her latex tops and body harnesses (and her whip!). The fact that these characters feel so real to us is not solely because of the acting (though it is excellent). It's also about Heidi making very exacting choices in how these characters adorn themselves. That's a skill very few people have. I mean, the fact that glitter is now synonymous with *Euphoria*—well, that's exactly what I'm describing.

Euphoria captures what it feels like to be a teenager. Over the course of these two seasons, we've fallen in love with these characters. We have discovered who they really are. We have felt all that good energy and all that self-destruction. We understand their fragility and vulnerability. The show makes me remember what it was like to search for happiness, love, companionship—but also for myself. It's genius in that way.

When it comes to translating the world around us into something that makes sense visually, I like to think that we're all crazy zombies walking around. What I mean is, it can be challenging for us to process what's happening to us in the moment, precisely because it's occurring in real time. With a show like *Euphoria*, Heidi's mastery is demonstrated in her ability to create something that reflects this understanding, and it gives the show an edge it might not otherwise have. It feels self-aware, but not cliché. I suspect a lot of people could be great costume designers for period films set in the 1800s, but very few people could do contemporary costumes and make looks as iconic as the ones Heidi has created.

Heidi has used pieces that I've designed in her work on the show. In the first season, Jules Vaughn (played by Hunter Schafer) wears a Fall/Winter 2018 Jeremy Scott printed organza crop jean jacket and a Spring/Summer 2019 Jeremy Scott cropped graphic crewneck top. In the second season, Cassie Howard

(played by Sydney Sweeney) wears a Spring/Summer 2021 Moschino gingham bustier dress with nursery rhyme appliqués. I couldn't be more honored. But I'm also good friends with Heidi outside of work. We met in 2011 at the wedding of our mutual friend Sarah Andelman, who founded the Parisian concept store Colette. I had designed one of Sarah's wedding dresses. It was a gorgeous summer evening. There was this beautiful dinner out in the middle of a field. There were fireflies. Everyone was so happy. Heidi and I hit it off instantly. She's an incredible person, just so charming and sweet. That's why I want to champion her. I want to shout her name from the rooftops. I believe that what she's done has become part of the cultural zeitgeist in a major way. So many of us strive for that—and so few of us ever achieve it. And she's done it all with talent, yes, but also with such grace. And she's just getting started. I'm in awe. We have yet to see all the incredible things she will do.

INTRO-
DUCTION

HEIDI BIVENS

What makes someone follow a path toward a chosen profession? Often it's an instinct, a calling, a voice from within that speaks to a passion, igniting a spirit of discovery. Sometimes the path is clear. Other times you stumble upon it, feeling your way through. All paths are the right ones. There are no mistakes, only lessons to learn. Costume design is the kind of endeavor through which, over time, with each story, script, and character, one learns to hone their own visual language.

There are many ways to approach the discipline of costume design. My earliest memories of knowing I wanted to design costumes are tied to a love for personal expression through fashion and the desire to tell stories. Storytelling is part of being human. We're drawn to stories because we see ourselves reflected in them. We experience our lives through the stories we tell, which inform us of who we are, how we relate to others, and how we view our own personal history. Stories can be windows into other lives lived, teach us about empathy and compassion, and help us develop new ways of seeing.

Story-building is second nature for me, so much so that there's a running joke with close friends about a habit I have of making up backstories for people I meet for the first time, without knowing anything about them. Often without being conscious of it, I have an urge to decide where they're from, where they went to school, how many siblings they have, and what kind of relationship they have (or had) with their parents—all because my brain has an impulse to write the story before it's told to me.

As early as I can remember, I have understood the concept that clothing can be a conduit for communicating one's personality and tastes. Growing up in Northern Virginia, each school year on picture day I would contemplate what my outfit choice would say about me. I understood the school portrait would be part of my life's visual history. I think this early, innate understanding

had everything to do with my mother's love of fashion, history, and clothing. She loved to dress up my sister and me in vintage clothes and take photos of us in elaborate tableaux she would art direct. I humored her at the time without realizing that she was inspiring me to follow a career path toward costume design.

To be a well-versed costume designer, you must be a keen observer. People-watching is a large part of my research, especially with contemporary stories. Like social anthropologists, costume designers are constantly making mental notes of how people are dressed walking down the street; we notice what kind of shoes or wristwatch they're wearing, how they may have mis-buttoned their shirt, or the colors and textures they've chosen. All these details are clues to a person's background, personal tastes, and idiosyncrasies—they are the fibers of their personality.

I've always had a knack for recognizing the silhouette of a person, sometimes more than their face. I see a person only from behind, a city block or more away, guess who it is, and then come to learn I'm correct. Film and television audiences may not always register it, but the silhouette of a character on screen is a substantial part of how they're recognized, perceived, and remembered. The way my brain processes outlines of people is a big part of how I created the look of the ensemble of characters in *Euphoria*, giving each their own defined silhouette.

Finding inspiration through character research is my favorite part of the process. I glean as much information as possible from the scripts and let it pass through a metaphorical sieve to create style rules for each character based on their socio-economic background, family dynamics, religious or spiritual leanings, and what they consciously try to communicate to others with the way they dress. Creating a type of costume "bible" that provides guidelines for each character's likes and dislikes, their favorite colors and brands, helps my costume

crew and me stay true to each character while still providing room for their story arcs to be fully realized. It's been fascinating to see how the fans and audience of *Euphoria* have come to embrace and even emulate the look of the characters on the show.

In all works of narrative fiction, my goal is to keep the audience emotionally engaged and maintain their suspension of disbelief. I grew up understanding what it meant to get lost in movies and that a great film or show has the possibility to transport the viewer into the world of the story. I grew up inspired by some of the best teen/youth culture films ever made: *Ferris Bueller's Day Off*, *Edward Scissorhands*, *Heathers*, *Clueless*, *Do the Right Thing*, *Twin Peaks: Fire Walk with Me*, *Just Another Girl on the IRT*, *River's Edge*, and *Election*, to name a few. These films made an indelible impression on me and undoubtedly inspired the work I do with teen characters today.

In *Euphoria*, I had the great pleasure of collaborating with writer/director Sam Levinson to translate what was in his head onto the screen. Because his vision was free of any strict norms, I was able to redefine what "reality" was within the world of the show. This is a true gift from a director to a costume designer, and one that made me feel valued. In an age where costume designers are striving to be considered equal creative partners on par with production designers and directors of photography, the producers of *Euphoria* are trailblazing.

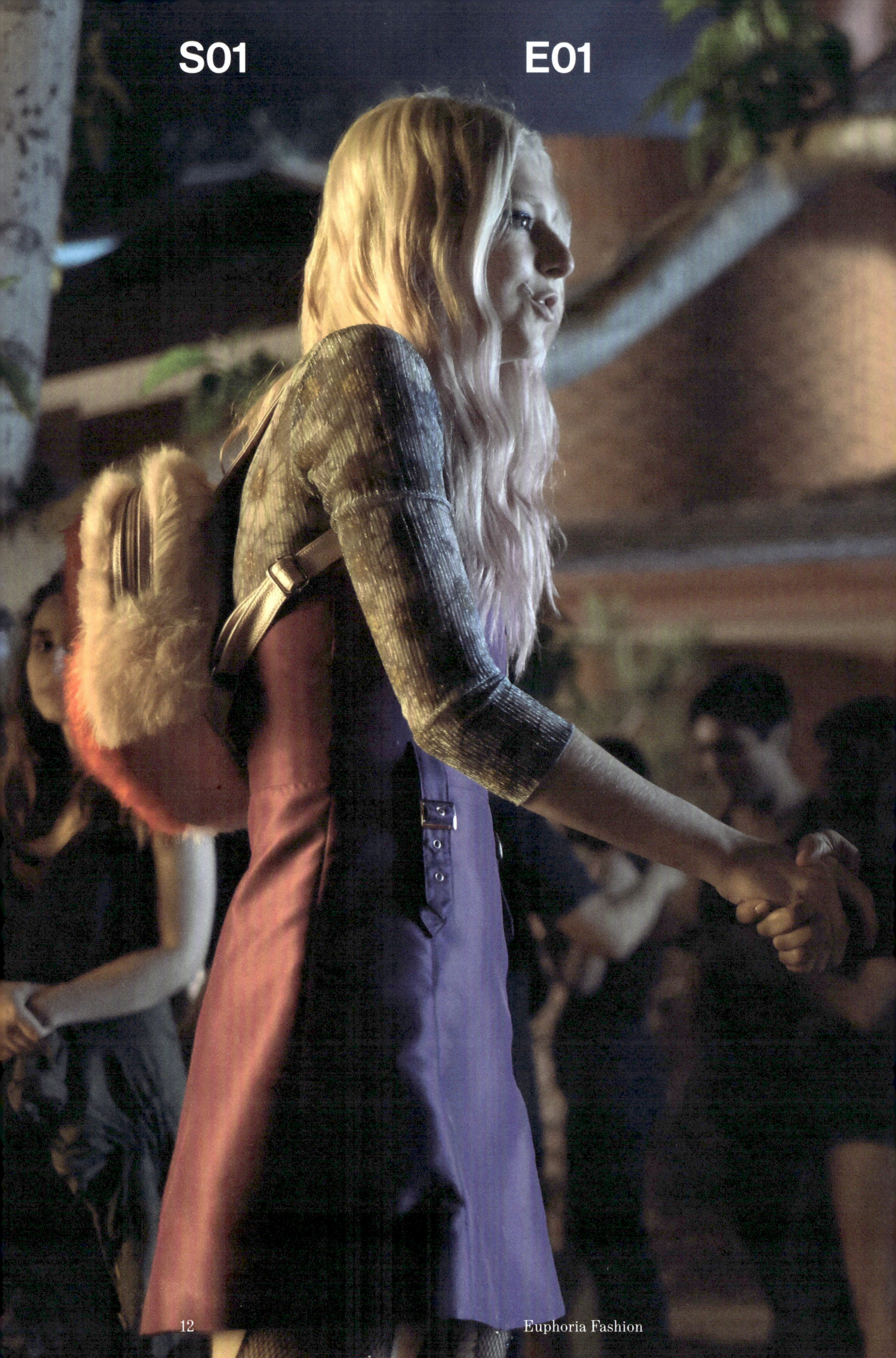

"Pilot"

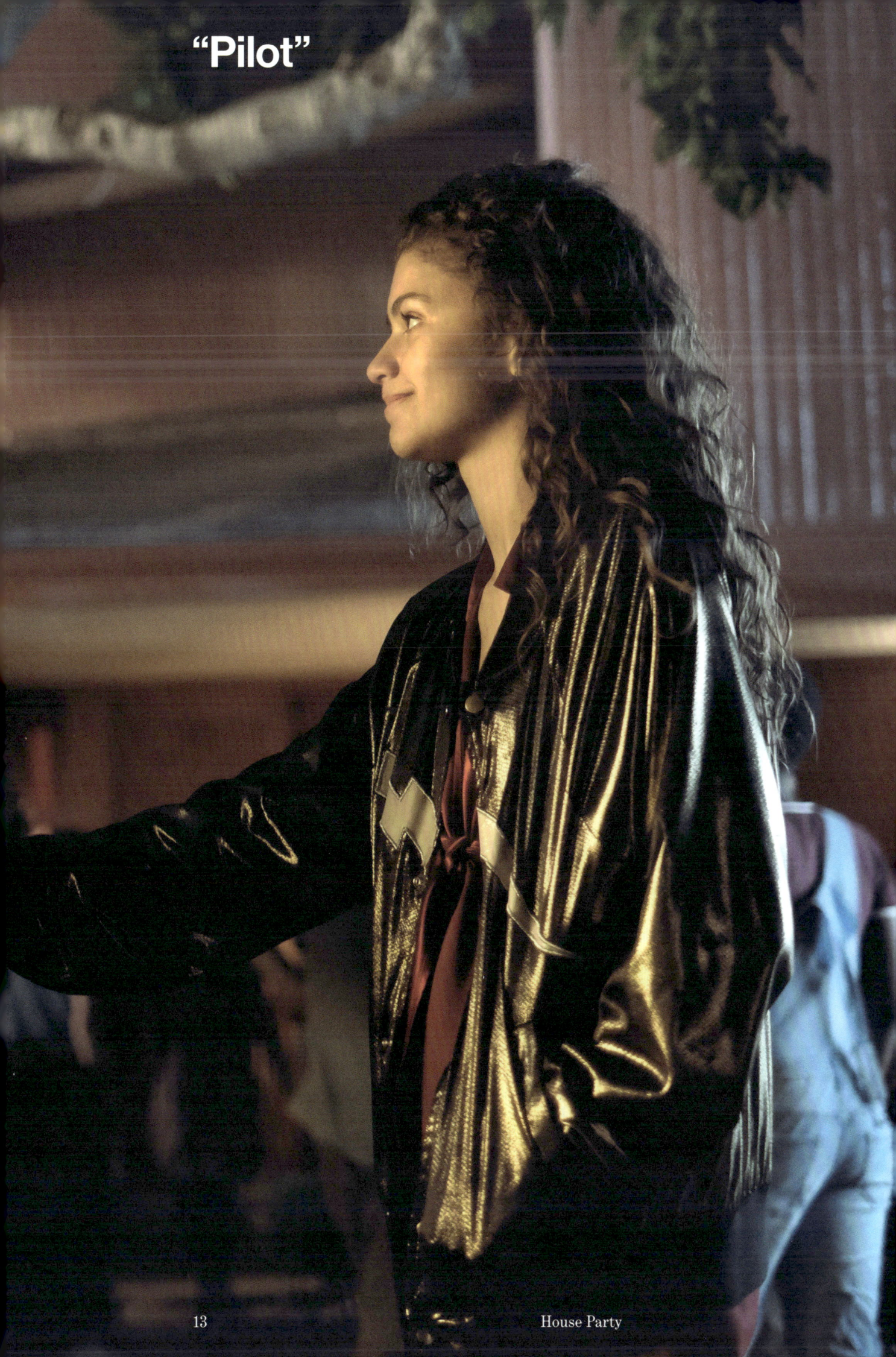

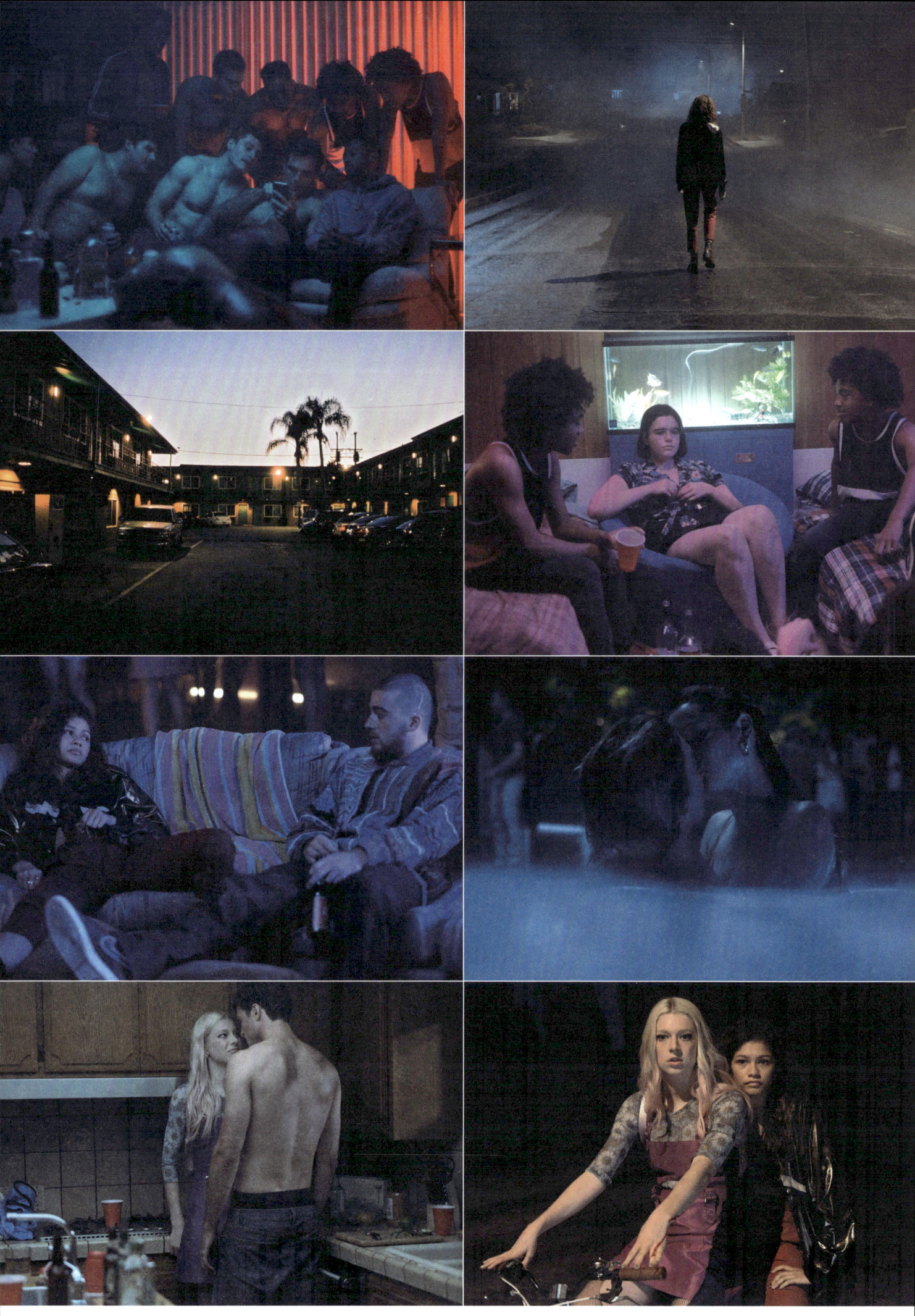

Euphoria Fashion

It's a Friday night, and McKay, a football player at East Highland High, hosts a house party to mark the end of the summer. His best friend, Nate, and other teammates arrive early to the party and find themselves discussing Cassie, his new love interest. Nate shows him a stash of nudes of Cassie and a sex tape from a password-protected online directory. Nate's advice: "You fuck her like the whore she is, you kick her ass to the curb."

Cassie also arrives early. A previously hesitant McKay takes her to his room where the two hook up.

While driving to the party with her girls, Maddy spots Rue, who recently returned home from rehab, walking along the side of the road toward the party. Maddy exclaims, "Didn't Rue die?" to which BB, sitting in the back seat, responds, "I hate ghosts." Kat, in the passenger seat, rolls her window down and yells, "Yo, Casper, you want a ride?"

Jules, the new girl in town, is at a motel hooking up with an older man she met on a queer dating app. She ghosts him to meet up with Kat at McKay's party. Meanwhile, at the party, Kat finds herself smoking weed in a room with McKay's younger twin brothers and Wes, a guy from a neighboring school. After a few rounds of sexual boasting, the guys challenge Kat, a virgin, to prove that she's a "slut" by taking off her shirt.

Fezco, Rue's dealer and friend, arrives at the party and tells Rue how much he missed her and was worried about her when she was in rehab. Kat emerges from a room and shares that she lost her virginity.

Maddy causes a scene in the pool when she hooks up with Tyler, a guy she met at the party. She tells him that she's using him "to get back at [her] really shitty ex-boyfriend," Nate. Nate is enraged and humiliated when he confronts her in the pool before going back inside to take a shot. His reaction turns violent, and he directs his anger at the recently arrived Jules, questioning who she is and why she's at the party. When he threatens to hurt her, she grabs a knife and screams at him to "back the fuck up." Rue watches the interaction and immediately falls in love. She follows Jules outside, introduces herself, and asks where Jules is off to. When Jules tells her that she's going home, Rue replies, "Can I come home with you?" and the two set off on Jules' bike.

I. RUE

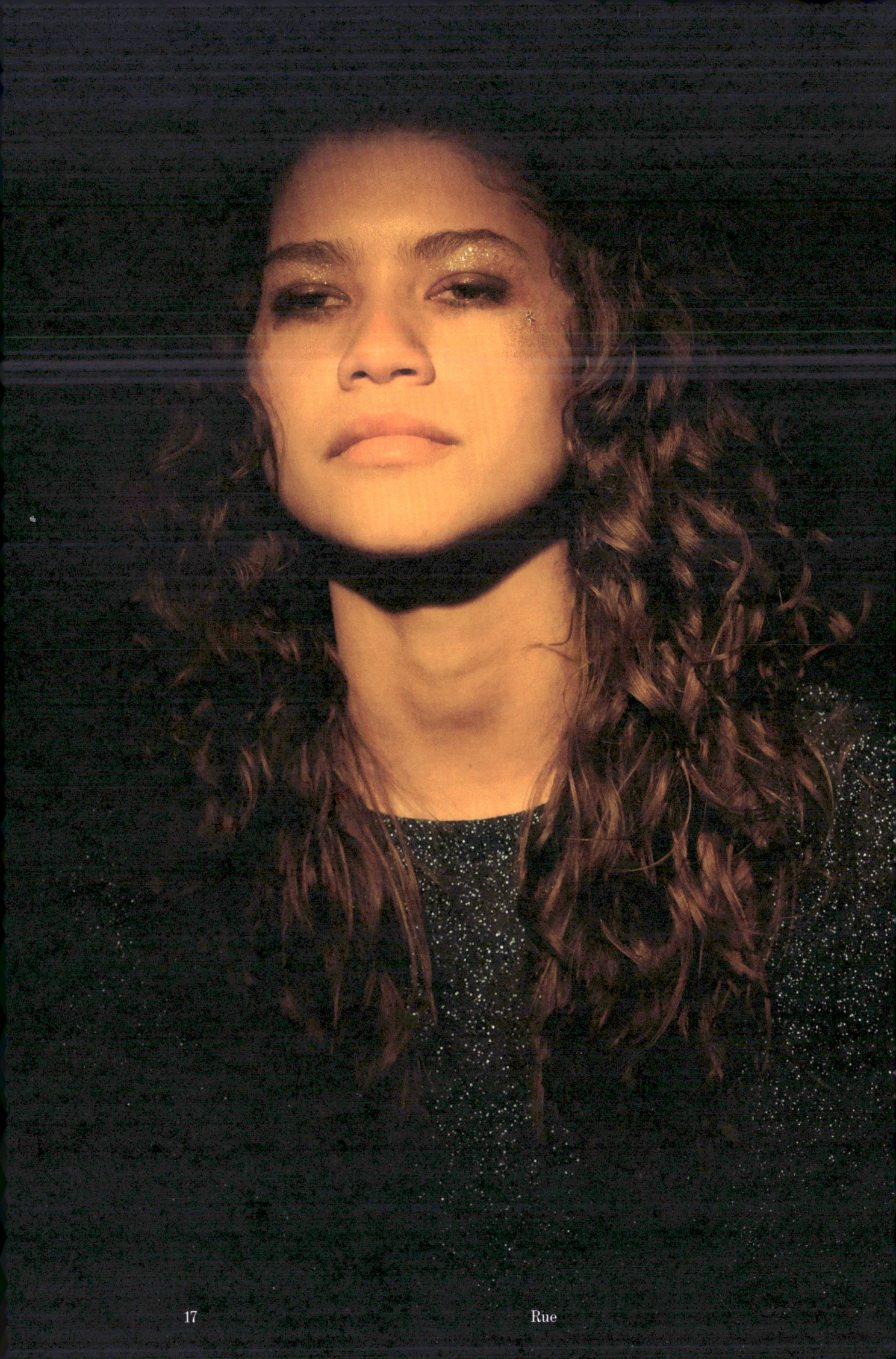

"If I could be a different person, I promise you, I would. Not because I want it, but because they do. And therein lies the catch." —Rue Bennett

Rue has been trying to outrun her anxiety and depression from a very young age. Her emotionally dependent relationship with her addictions often leaves her feeling apathetic and uninterested in her personal appearance. Her mood and stability can often be tracked by her clothing choices—a bright-printed shirt when she's feeling upbeat and positive about the possibility of sobriety in Season One versus the darker, more somber tones of Season Two. As she navigates the extreme highs and lows of her emotions, her look is made up of things she's picked up off her bedroom floor. Still, she has an innate sense of style. She knows who she is but struggles with loving herself unconditionally. She tells Lexi in Episode 208 that she thinks the school play (**p.254**) was the first time she's been able to look at her life and not hate herself. The way her peers interpret Rue's style choices is exemplified by Lexi's costumes for "Jade," Rue's avatar in the play—overalls, baggy T-shirts, workwear pants, and her signature Converse high tops (**p.42**).

The beloved burgundy hoodie that belonged to Rue's deceased father, Robert, becomes a security blanket for her. She wraps herself in it in honor of his memory, longing to be close to him again. She forgoes the hoodie for most of the second season as she descends to her rock bottom—it recalls too much for her own conscience to bear. But there is hope and light and support from her friends and family to get clean, and by the final episode of Season Two we see a fresher looking Rue, who we can hope is on the path to better things.

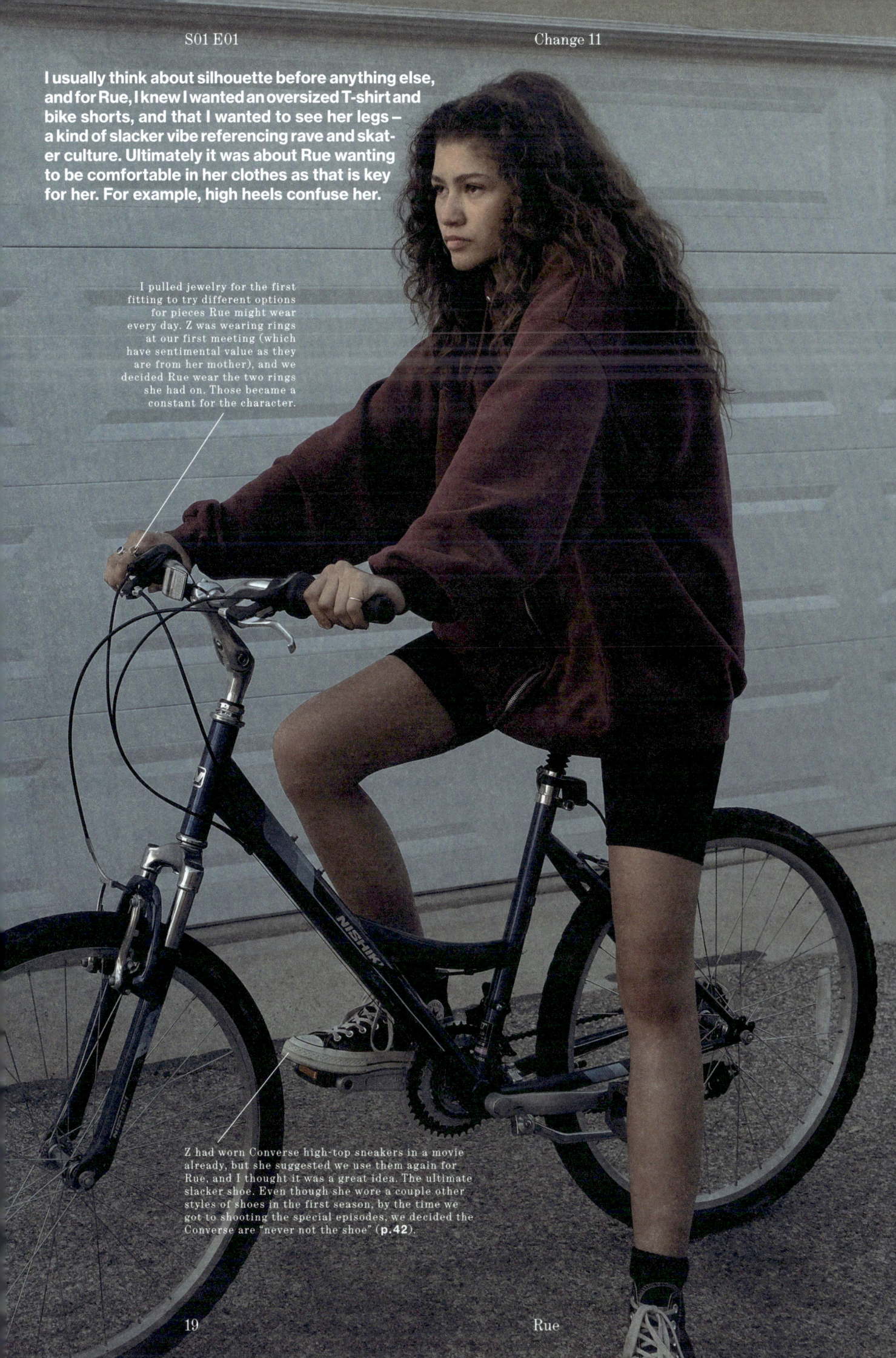

I usually think about silhouette before anything else, and for Rue, I knew I wanted an oversized T-shirt and bike shorts, and that I wanted to see her legs — a kind of slacker vibe referencing rave and skater culture. Ultimately it was about Rue wanting to be comfortable in her clothes as that is key for her. For example, high heels confuse her.

I pulled jewelry for the first fitting to try different options for pieces Rue might wear every day. Z was wearing rings at our first meeting (which have sentimental value as they are from her mother), and we decided Rue wear the two rings she had on. Those became a constant for the character.

Z had worn Converse high-top sneakers in a movie already, but she suggested we use them again for Rue, and I thought it was a great idea. The ultimate slacker shoe. Even though she wore a couple other styles of shoes in the first season, by the time we got to shooting the special episodes, we decided the Converse are "never not the shoe" (**p.42**).

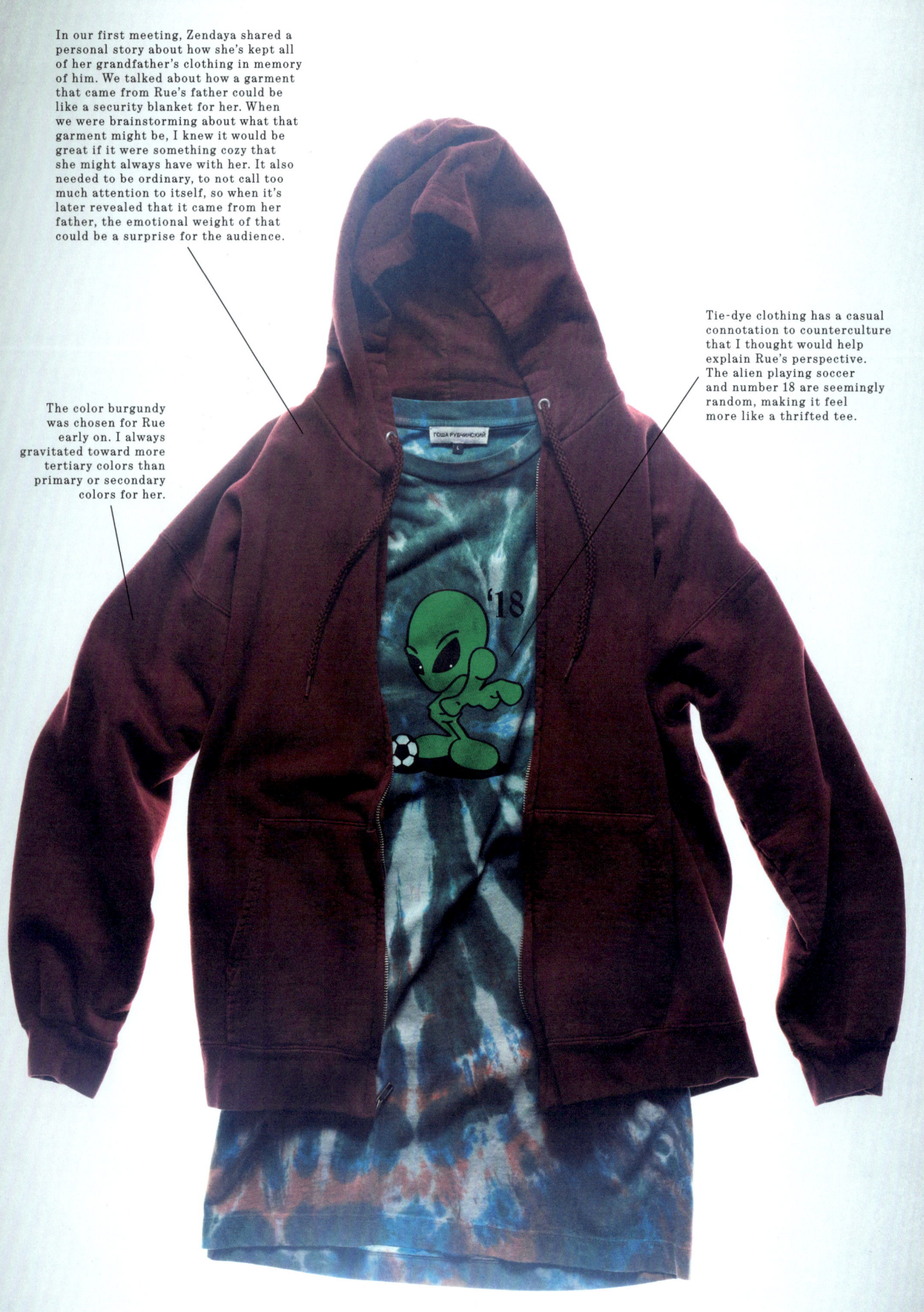

In our first meeting, Zendaya shared a personal story about how she's kept all of her grandfather's clothing in memory of him. We talked about how a garment that came from Rue's father could be like a security blanket for her. When we were brainstorming about what that garment might be, I knew it would be great if it were something cozy that she might always have with her. It also needed to be ordinary, to not call too much attention to itself, so when it's later revealed that it came from her father, the emotional weight of that could be a surprise for the audience.

The color burgundy was chosen for Rue early on. I always gravitated toward more tertiary colors than primary or secondary colors for her.

Tie-dye clothing has a casual connotation to counterculture that I thought would help explain Rue's perspective. The alien playing soccer and number 18 are seemingly random, making it feel more like a thrifted tee.

S01 E01 Change 17

For this look, I wanted to do something tonal with her hero color. I was very into the idea of color-drenching at the time. As it relates to Rue, it is relatively easy to do, and coordinating is a way she's unconsciously signaling to others she's on the proverbial wagon.

What Rue wears to the party in the first episode of the first season (p.12) is especially important because we're just learning about her, and every detail can communicate something. She's just out of rehab and making an effort to look put together.

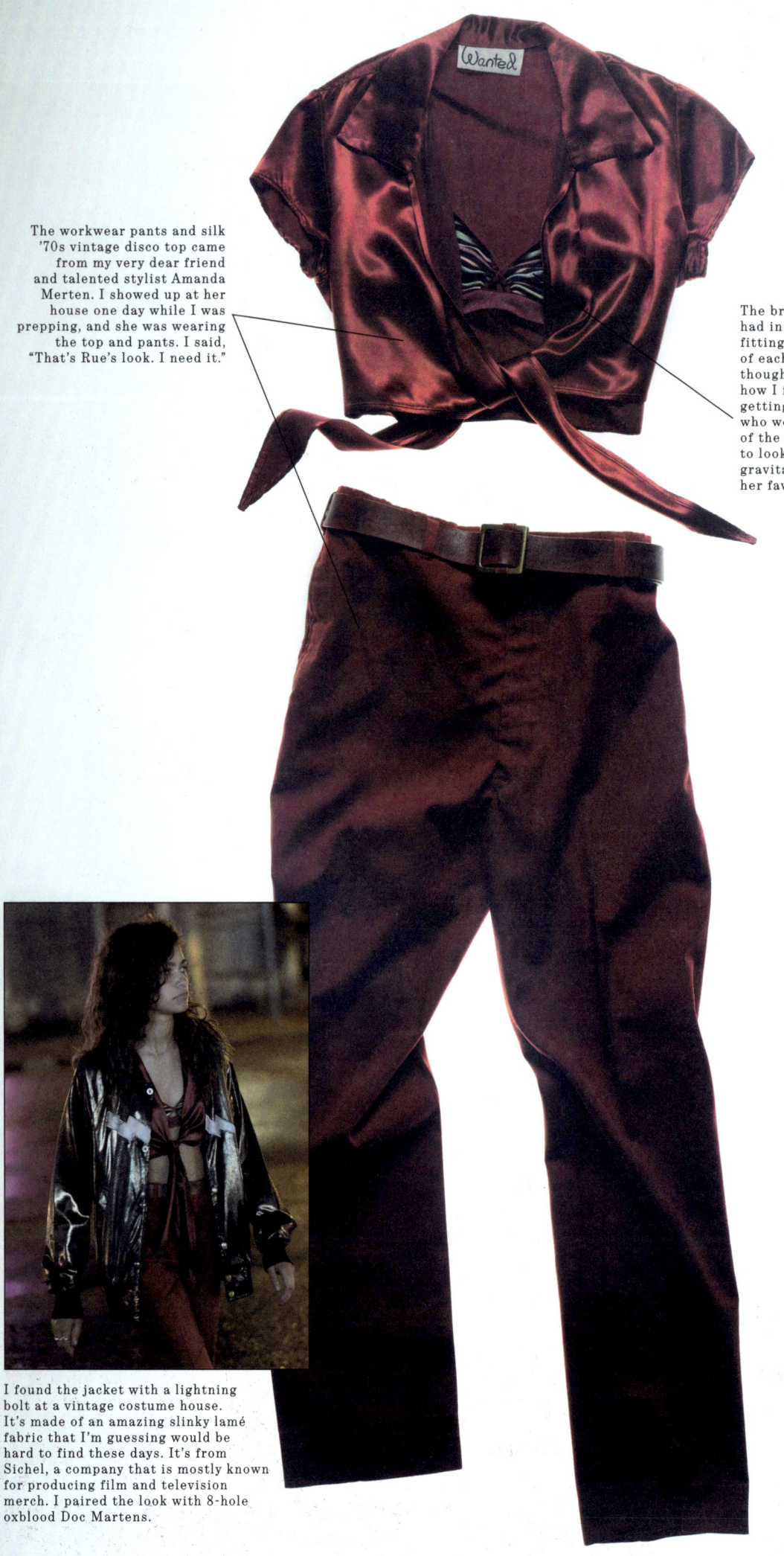

The workwear pants and silk '70s vintage disco top came from my very dear friend and talented stylist Amanda Merten. I showed up at her house one day while I was prepping, and she was wearing the top and pants. I said, "That's Rue's look. I need it."

The bra was a random piece we had in stock pulled for our first fittings. The idea that all the details of each costume aren't overly thought out and planned represents how I imagined Rue would approach getting dressed. She is someone who would just grab something out of the drawer to wear. It happens to look coordinated because she gravitates toward certain colors— her favorite being burgundy/maroon.

I found the jacket with a lightning bolt at a vintage costume house. It's made of an amazing slinky lamé fabric that I'm guessing would be hard to find these days. It's from Sichel, a company that is mostly known for producing film and television merch. I paired the look with 8-hole oxblood Doc Martens.

Euphoria Fashion

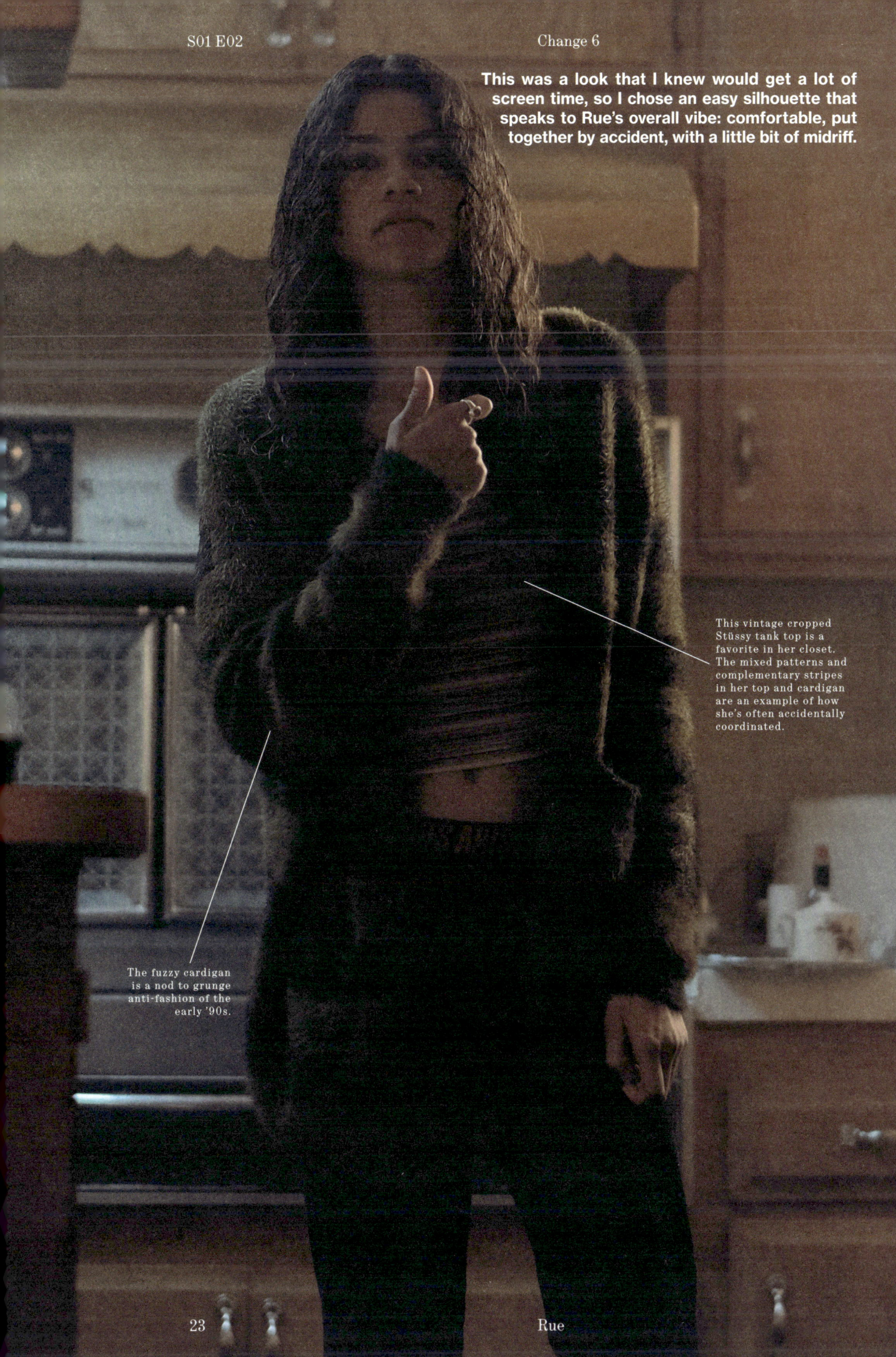

S01 E02 — Change 6

This was a look that I knew would get a lot of screen time, so I chose an easy silhouette that speaks to Rue's overall vibe: comfortable, put together by accident, with a little bit of midriff.

This vintage cropped Stüssy tank top is a favorite in her closet. The mixed patterns and complementary stripes in her top and cardigan are an example of how she's often accidentally coordinated.

The fuzzy cardigan is a nod to grunge anti-fashion of the early '90s.

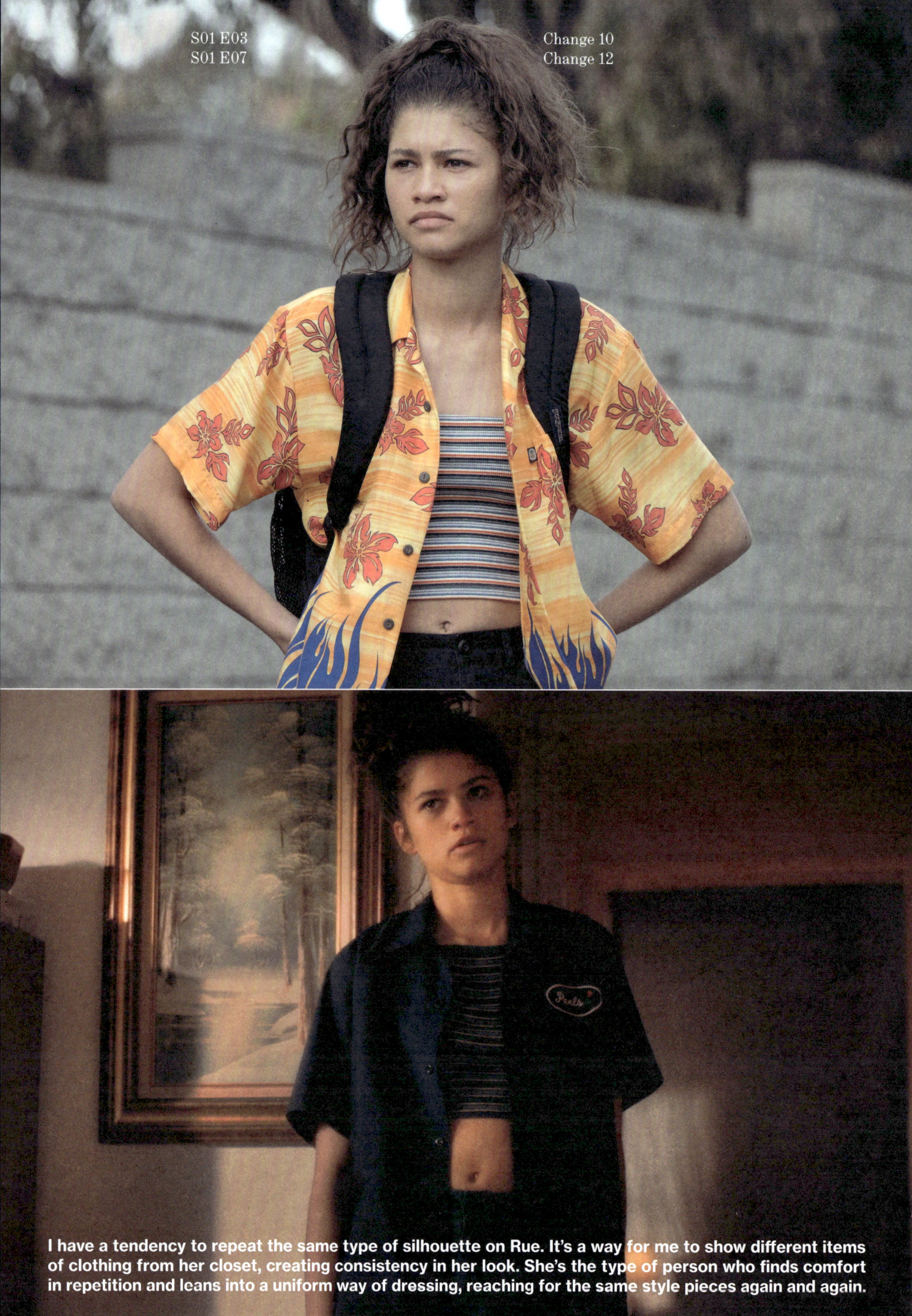

I have a tendency to repeat the same type of silhouette on Rue. It's a way for me to show different items of clothing from her closet, creating consistency in her look. She's the type of person who finds comfort in repetition and leans into a uniform way of dressing, reaching for the same style pieces again and again.

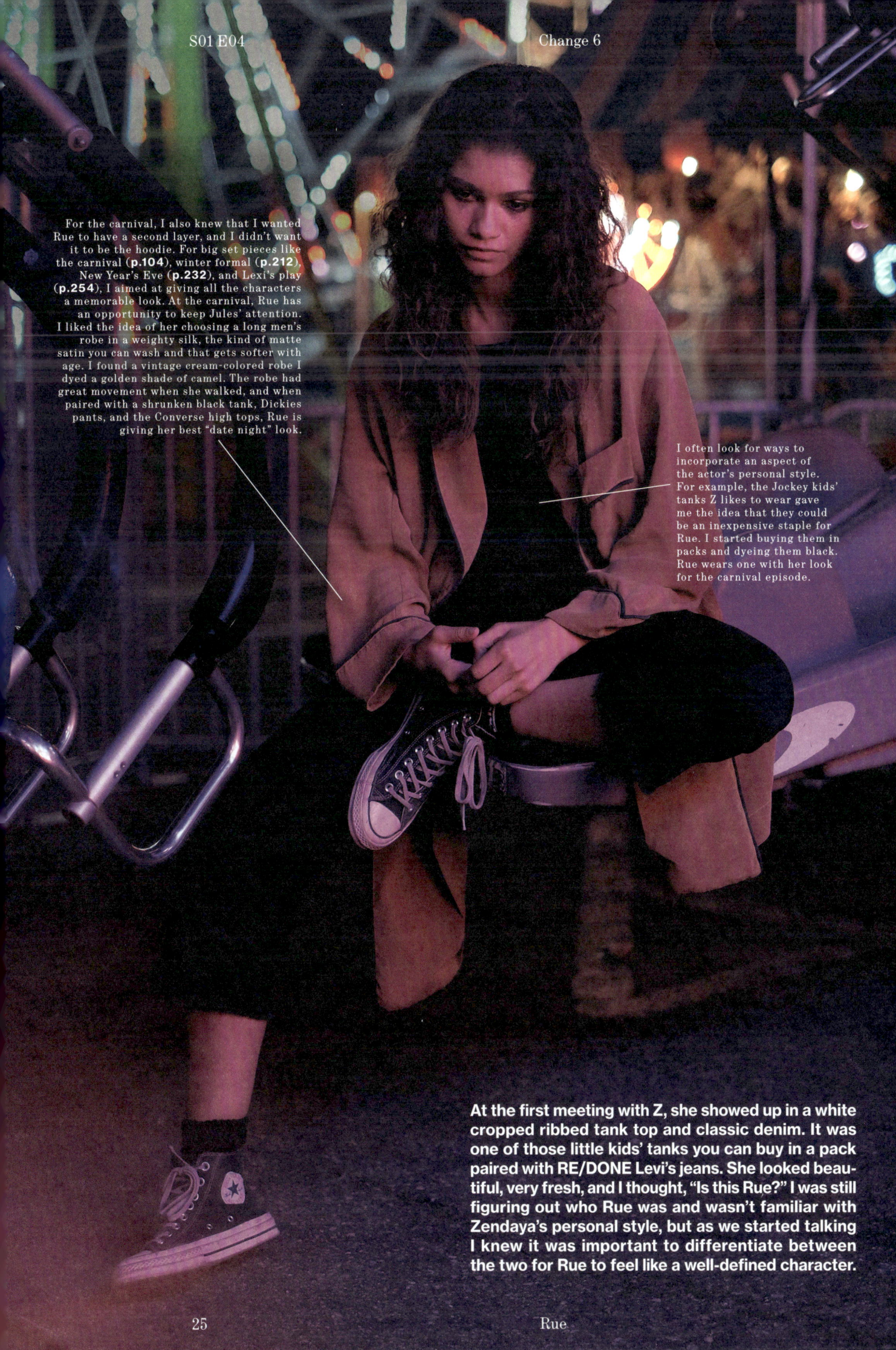

For the carnival, I also knew that I wanted Rue to have a second layer, and I didn't want it to be the hoodie. For big set pieces like the carnival (**p.104**), winter formal (**p.212**), New Year's Eve (**p.232**), and Lexi's play (**p.254**), I aimed at giving all the characters a memorable look. At the carnival, Rue has an opportunity to keep Jules' attention. I liked the idea of her choosing a long men's robe in a weighty silk, the kind of matte satin you can wash and that gets softer with age. I found a vintage cream-colored robe I dyed a golden shade of camel. The robe had great movement when she walked, and when paired with a shrunken black tank, Dickies pants, and the Converse high tops, Rue is giving her best "date night" look.

I often look for ways to incorporate an aspect of the actor's personal style. For example, the Jockey kids' tanks Z likes to wear gave me the idea that they could be an inexpensive staple for Rue. I started buying them in packs and dyeing them black. Rue wears one with her look for the carnival episode.

At the first meeting with Z, she showed up in a white cropped ribbed tank top and classic denim. It was one of those little kids' tanks you can buy in a pack paired with RE/DONE Levi's jeans. She looked beautiful, very fresh, and I thought, "Is this Rue?" I was still figuring out who Rue was and wasn't familiar with Zendaya's personal style, but as we started talking I knew it was important to differentiate between the two for Rue to feel like a well-defined character.

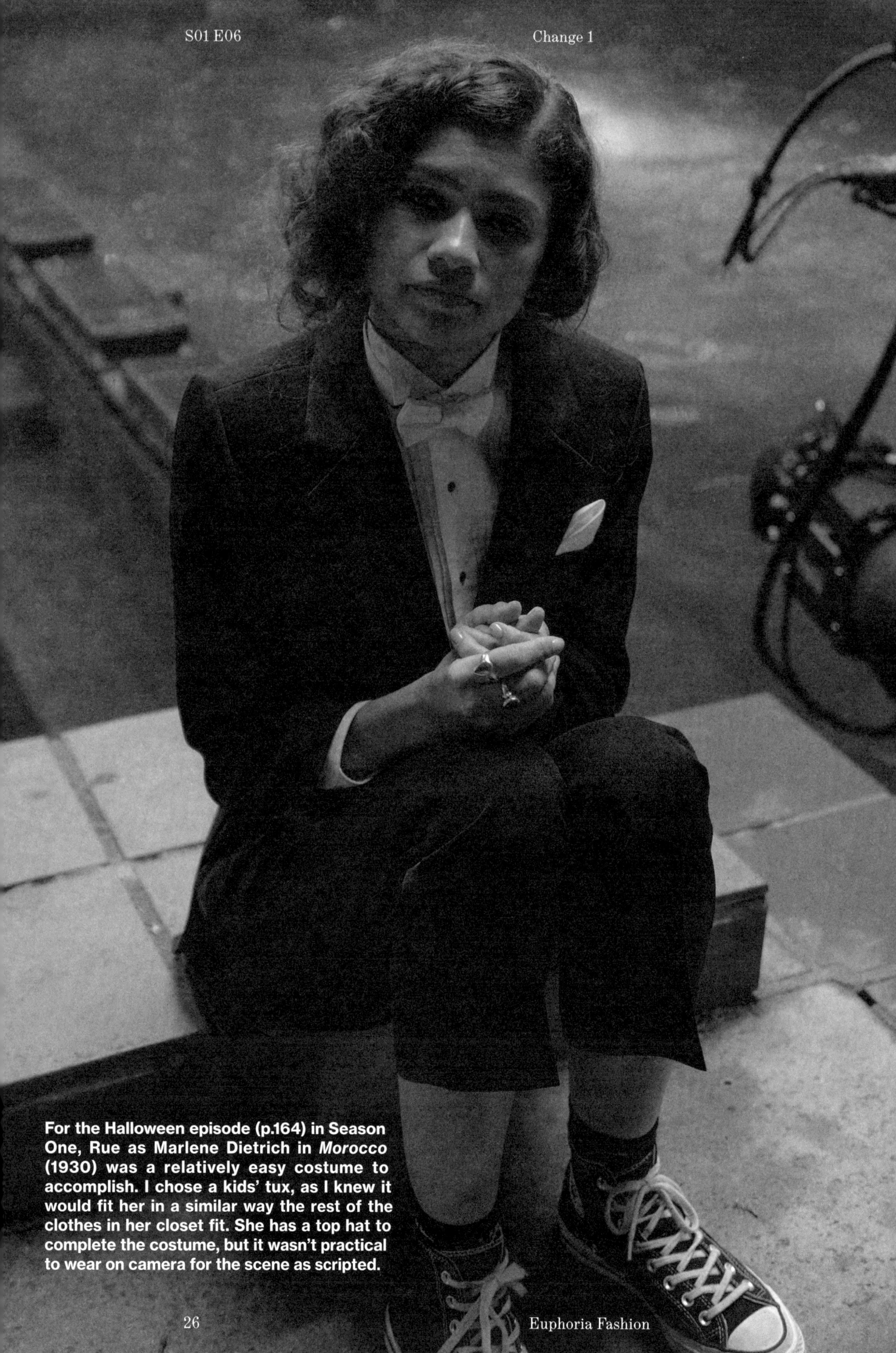

For the Halloween episode (p.164) in Season One, Rue as Marlene Dietrich in *Morocco* (1930) was a relatively easy costume to accomplish. I chose a kids' tux, as I knew it would fit her in a similar way the rest of the clothes in her closet fit. She has a top hat to complete the costume, but it wasn't practical to wear on camera for the scene as scripted.

S01 E07 — Change 1

Rue's detective look is made up of a combination of vintage pieces, including a trench coat and a hat that ultimately didn't make it on screen. I often design multiple layers for costumes and then give the actors the freedom to decide which to include for each scene.

Rue's signature kids' tank top in white seemed like a natural choice to pair with vintage suspenders while she's spiraling in her bedroom and calls Lexi in the middle of the night.

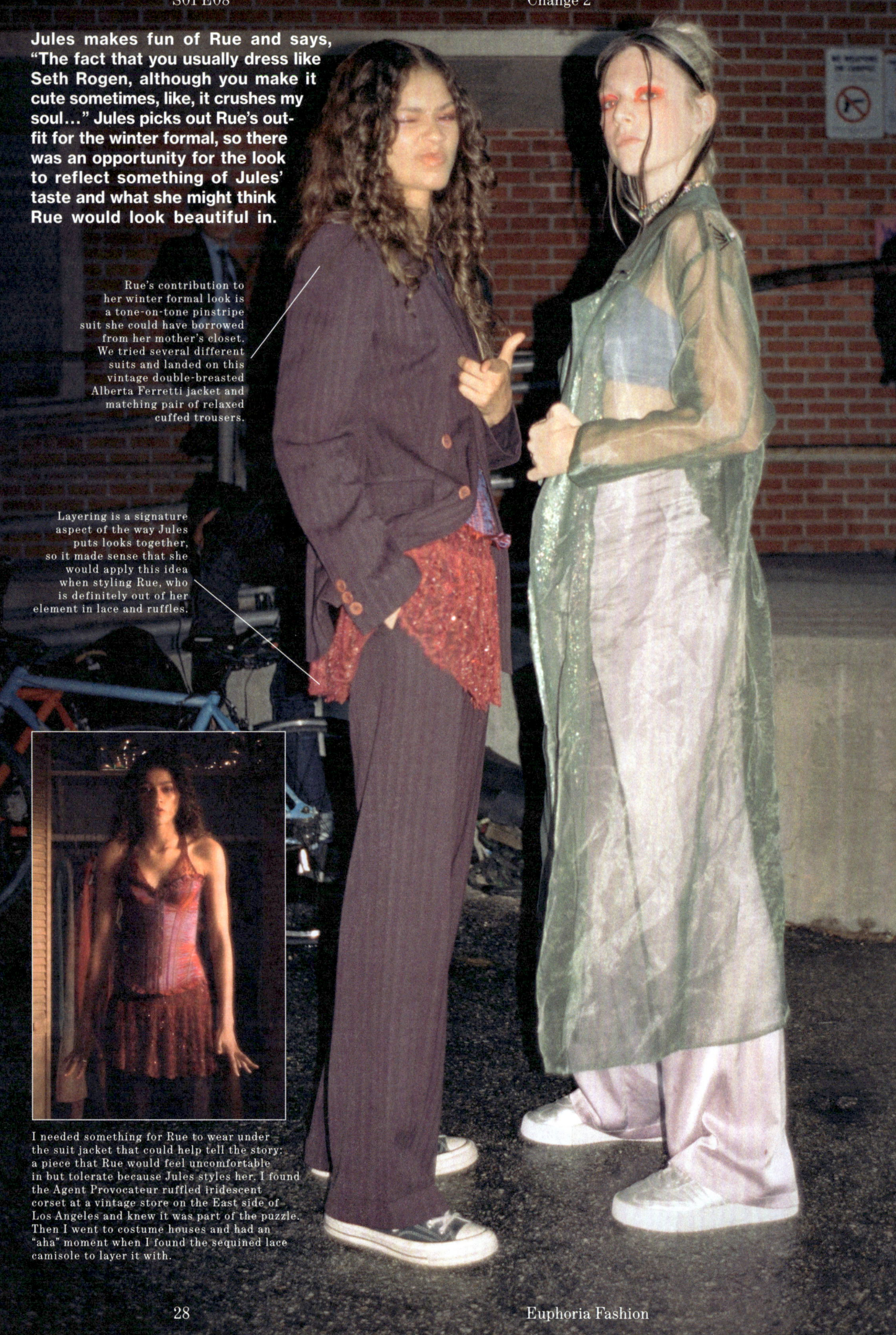

Jules makes fun of Rue and says, "The fact that you usually dress like Seth Rogen, although you make it cute sometimes, like, it crushes my soul…" Jules picks out Rue's outfit for the winter formal, so there was an opportunity for the look to reflect something of Jules' taste and what she might think Rue would look beautiful in.

Rue's contribution to her winter formal look is a tone-on-tone pinstripe suit she could have borrowed from her mother's closet. We tried several different suits and landed on this vintage double-breasted Alberta Ferretti jacket and matching pair of relaxed cuffed trousers.

Layering is a signature aspect of the way Jules puts looks together, so it made sense that she would apply this idea when styling Rue, who is definitely out of her element in lace and ruffles.

I needed something for Rue to wear under the suit jacket that could help tell the story: a piece that Rue would feel uncomfortable in but tolerate because Jules styles her. I found the Agent Provocateur ruffled iridescent corset at a vintage store on the East side of Los Angeles and knew it was part of the puzzle. Then I went to costume houses and had an "aha" moment when I found the sequined lace camisole to layer it with.

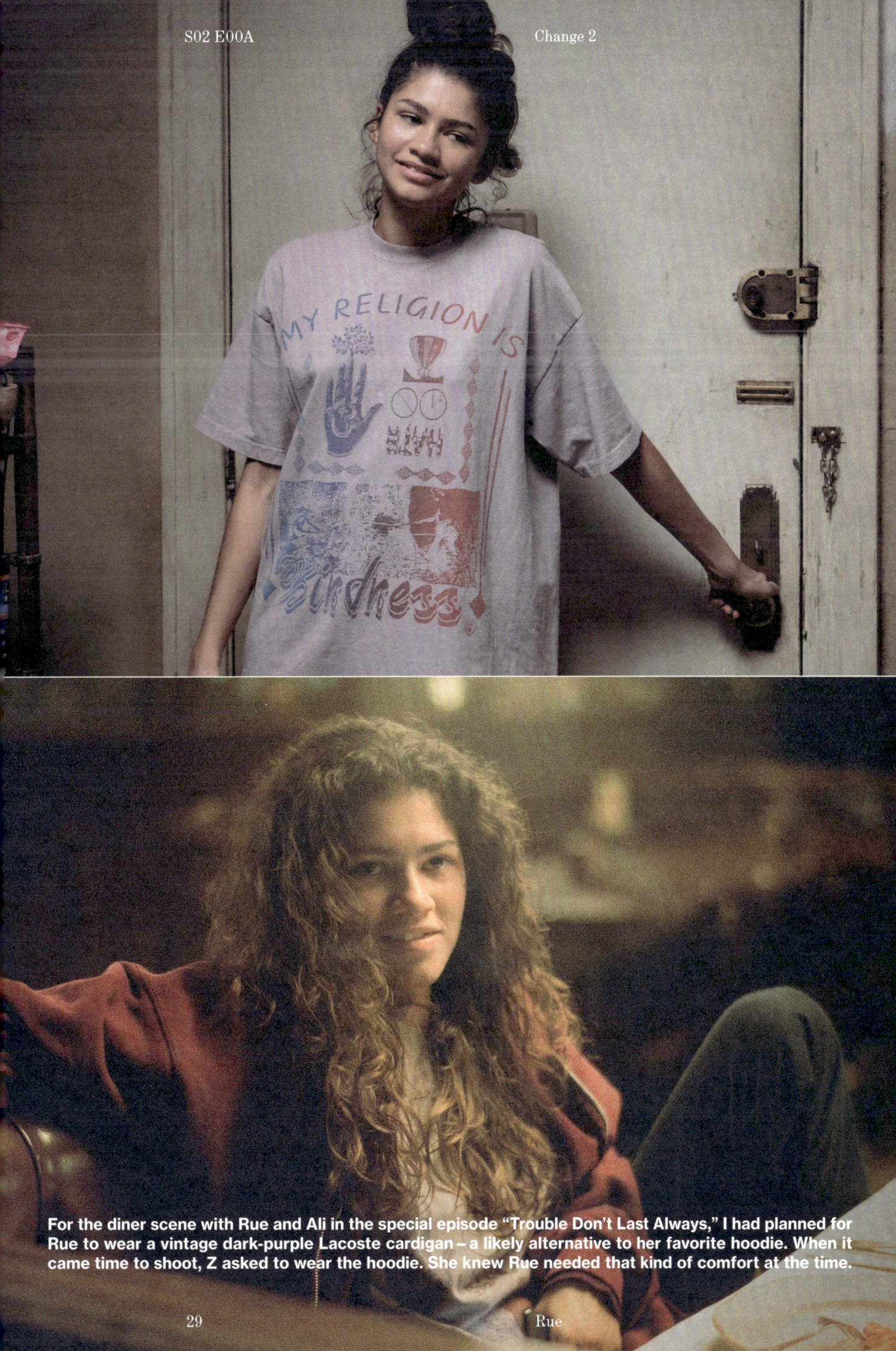

S02 E00A Change 2

For the diner scene with Rue and Ali in the special episode "Trouble Don't Last Always," I had planned for Rue to wear a vintage dark-purple Lacoste cardigan—a likely alternative to her favorite hoodie. When it came time to shoot, Z asked to wear the hoodie. She knew Rue needed that kind of comfort at the time.

I found the Jean Paul Gaultier vest at Procell, a vintage shop in New York City. I knew there was a New Year's Eve party (p.232) coming up in Season Two and was convinced this could be a stand-out piece for Rue.

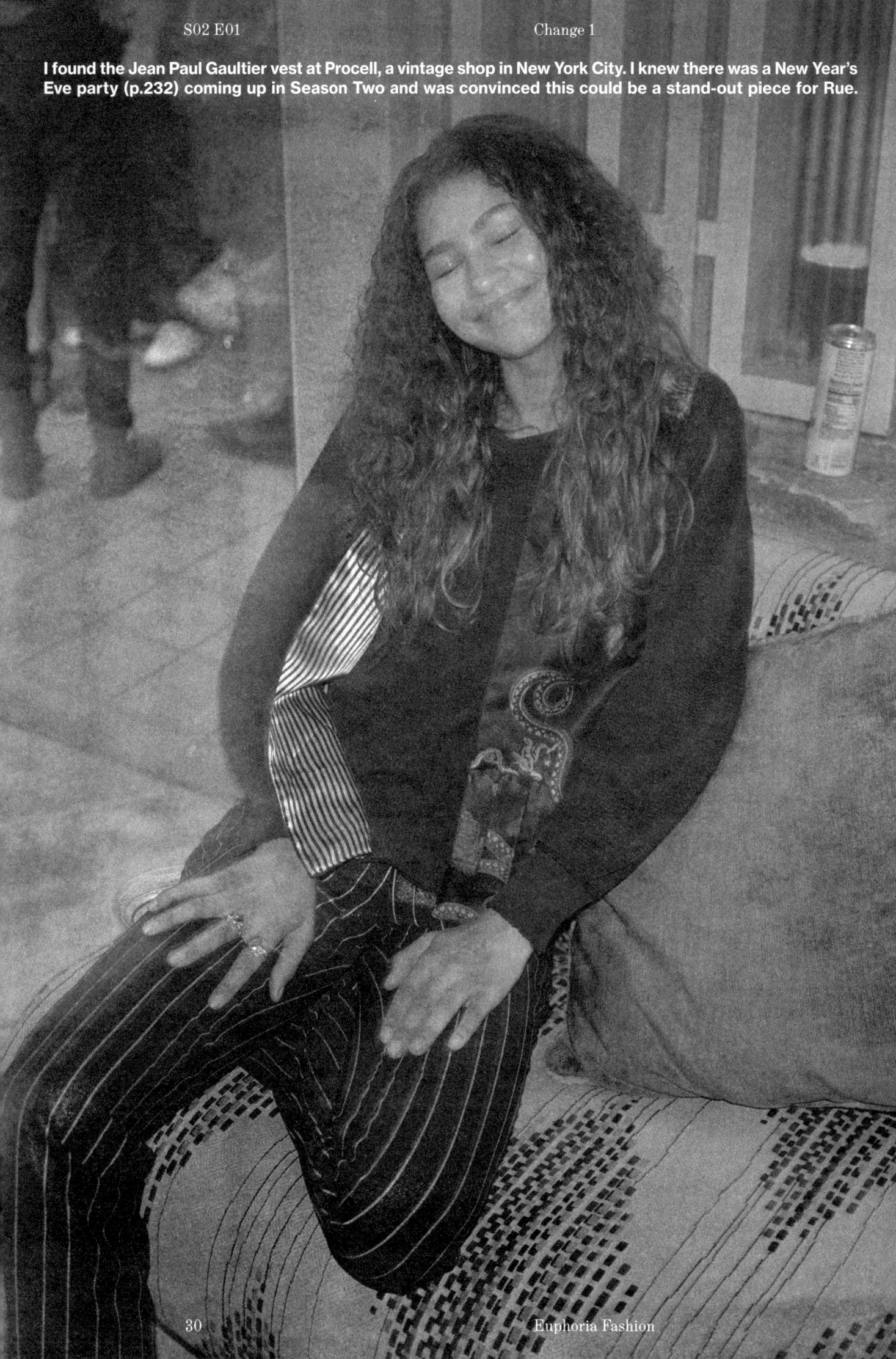

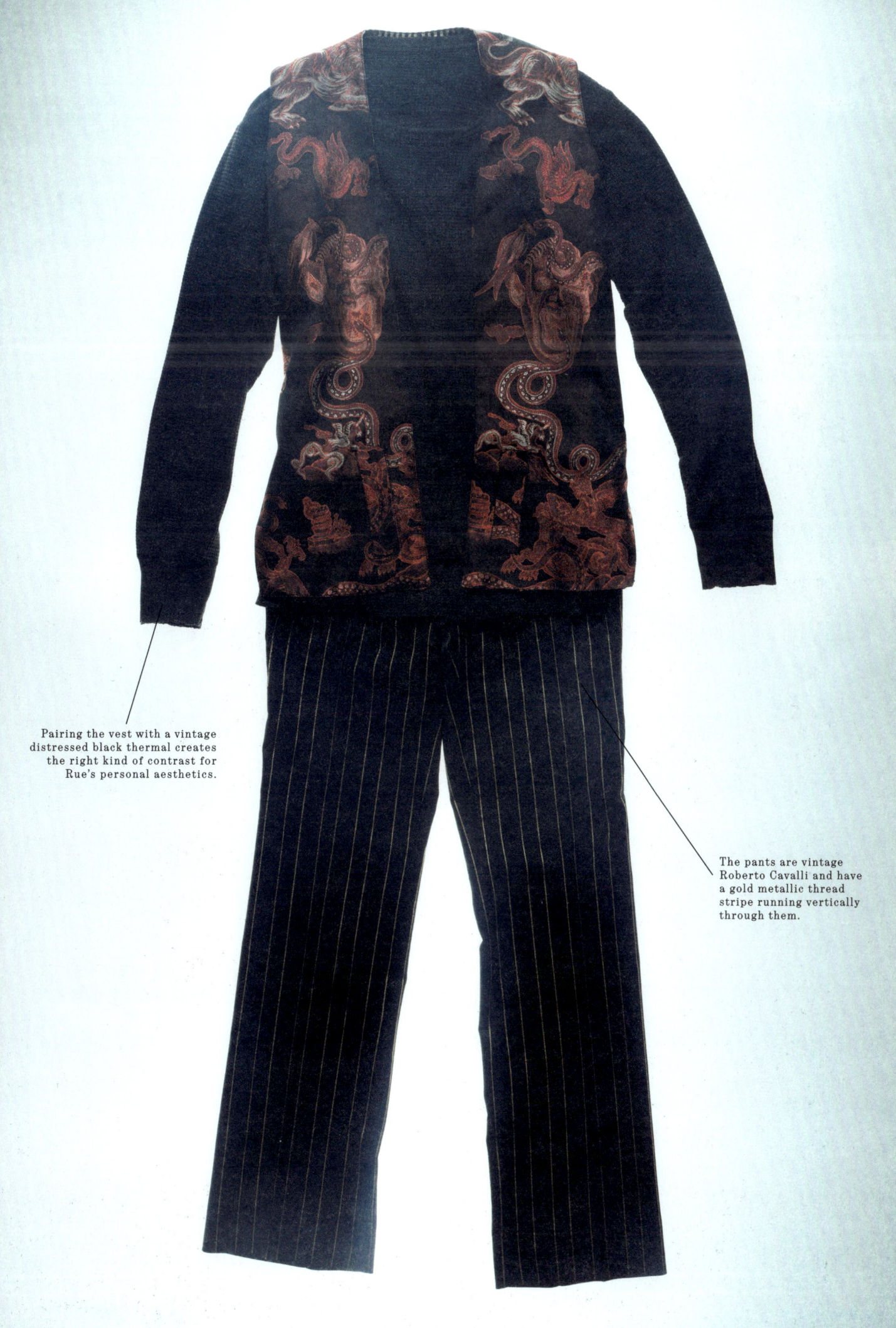

Pairing the vest with a vintage distressed black thermal creates the right kind of contrast for Rue's personal aesthetics.

The pants are vintage Roberto Cavalli and have a gold metallic thread stripe running vertically through them.

Rue

S02 E02 — Change 1

This gas station-style jacket from the brand Peels became a new second layer for Season Two that we see in several scenes. The vintage intarsia knit vest she wears underneath the jacket felt good for a first day of school look. At this point, Rue is still trying to appear in control and have some semblance of sobriety.

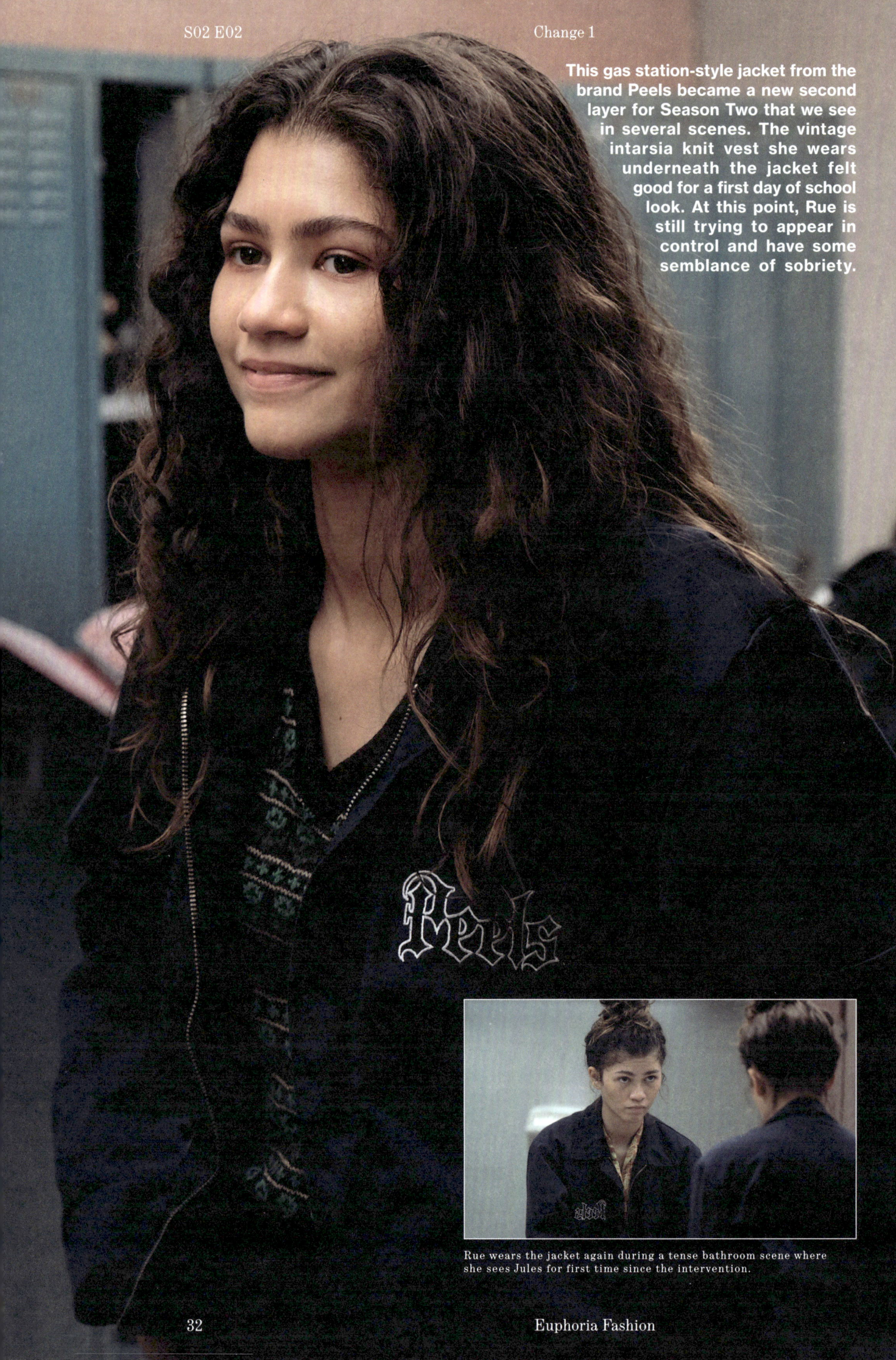

Rue wears the jacket again during a tense bathroom scene where she sees Jules for first time since the intervention.

S02 E02 Change 5
S02 E03 Change 1

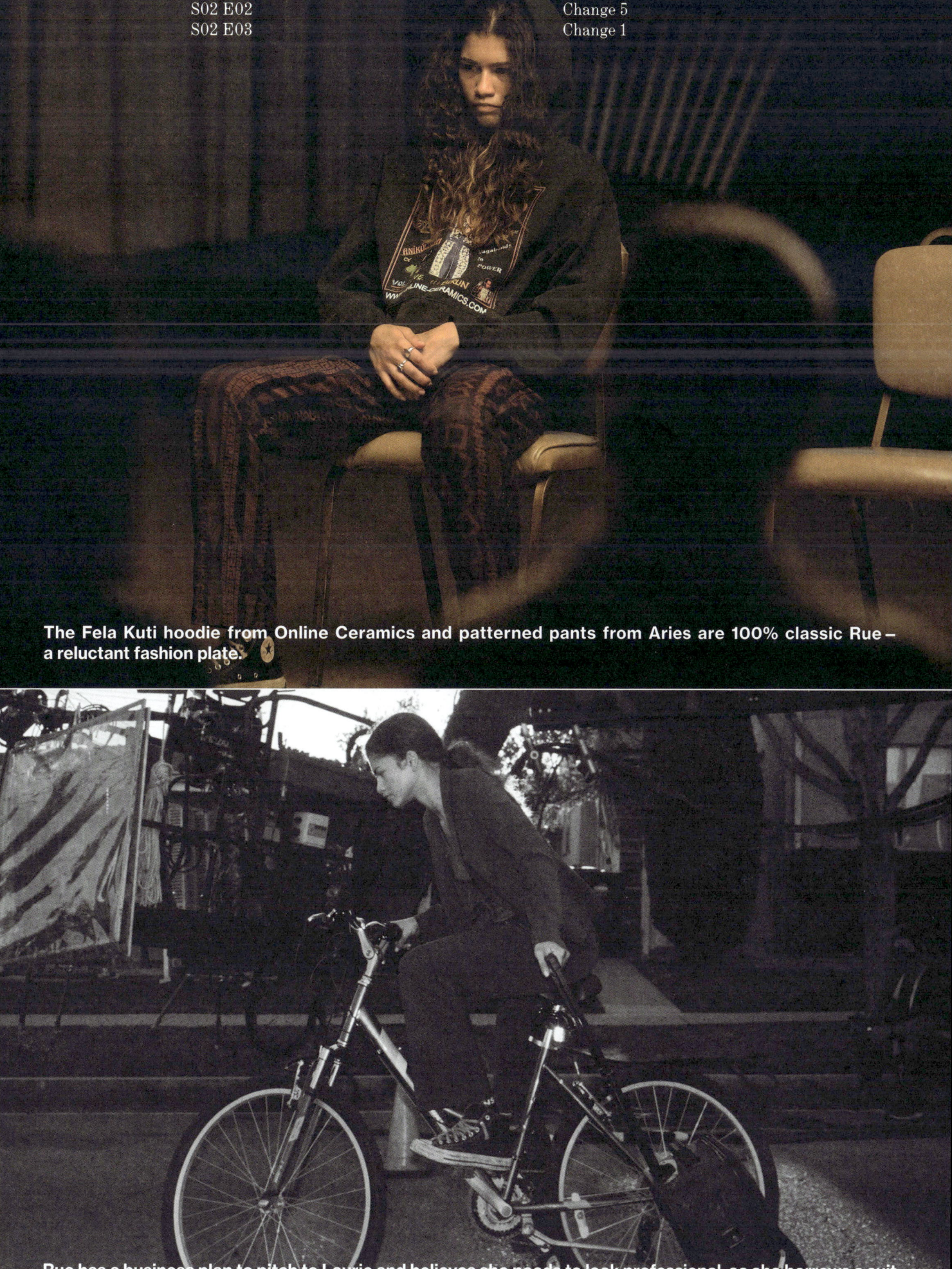

The Fela Kuti hoodie from Online Ceramics and patterned pants from Aries are 100% classic Rue – a reluctant fashion plate.

Rue has a business plan to pitch to Laurie and believes she needs to look professional, so she borrows a suit from her mother's closet. It's a very basic, classic suit worn with a cashmere V-neck knit, black belt, and her requisite Converse.

The Malcolm X graphic T-shirt is from Universal Studios Costume Department in Los Angeles. Although there isn't a tag indicating the original source, fans of the show think it might be from a mid-'80s brand called Mosquitohead.

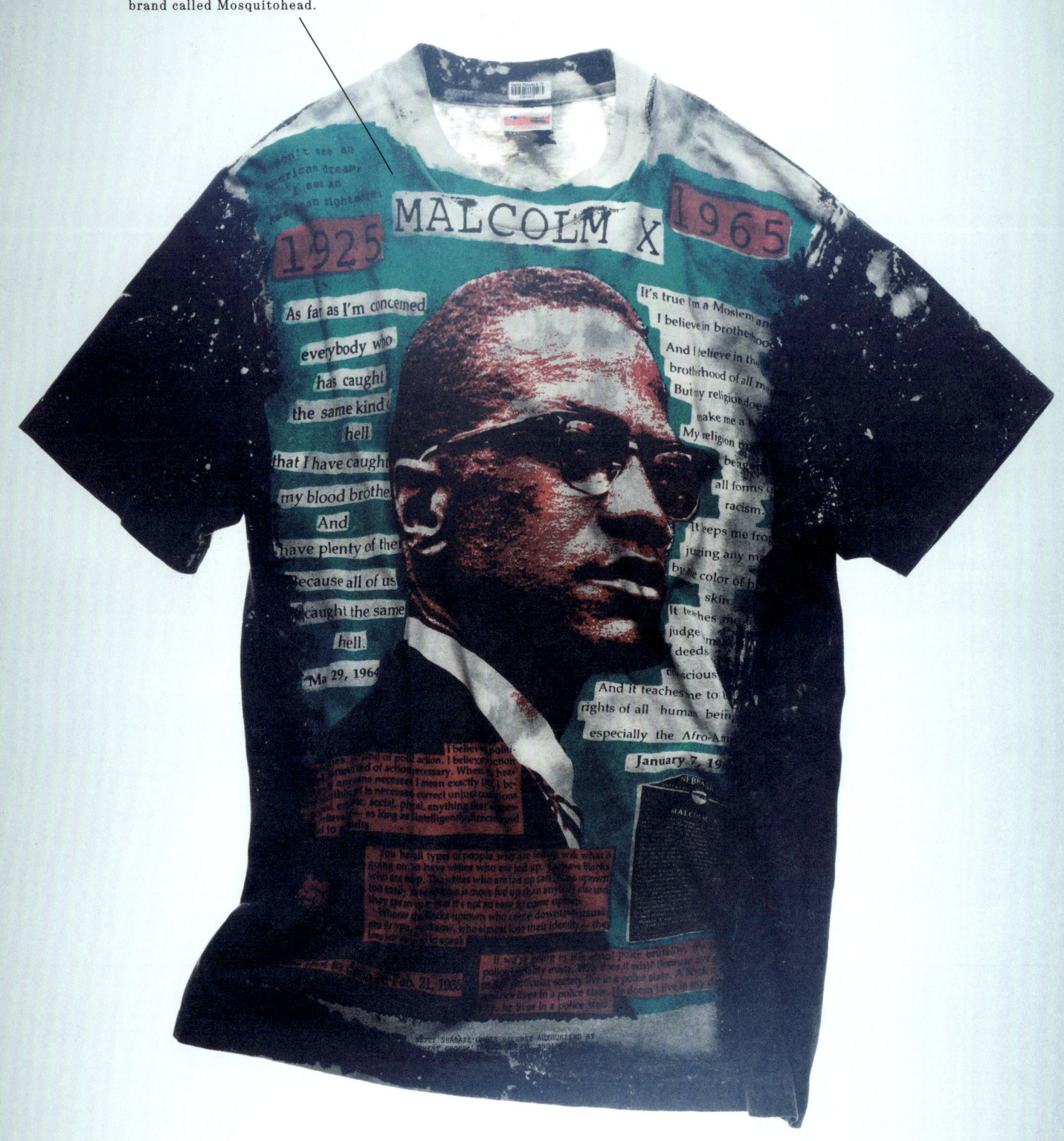

During the diner scene in Rue's special episode, she tells her sponsor, Ali, "Maybe I'll start a revolution like Malcolm X or something." The T-shirt with his image appears as a callback in Episode 206, "A Thousand Little Trees of Blood," as Rue calls Ali to apologize after she's decided to attempt sobriety again.

Vintage T-shirts have become a covetable currency to those who buy and sell them. Some people pay hundreds of dollars for worn-in tour shirts, movie merch, or artist tees. I see Rue as a collector by happenstance, finding her favorite designs at the local Salvation Army or Goodwill thrift stores without much effort. I enjoy using T-shirts with graphics that can be left up to interpretation by the audience — they can decide for themselves if there is any assigned meaning or not.

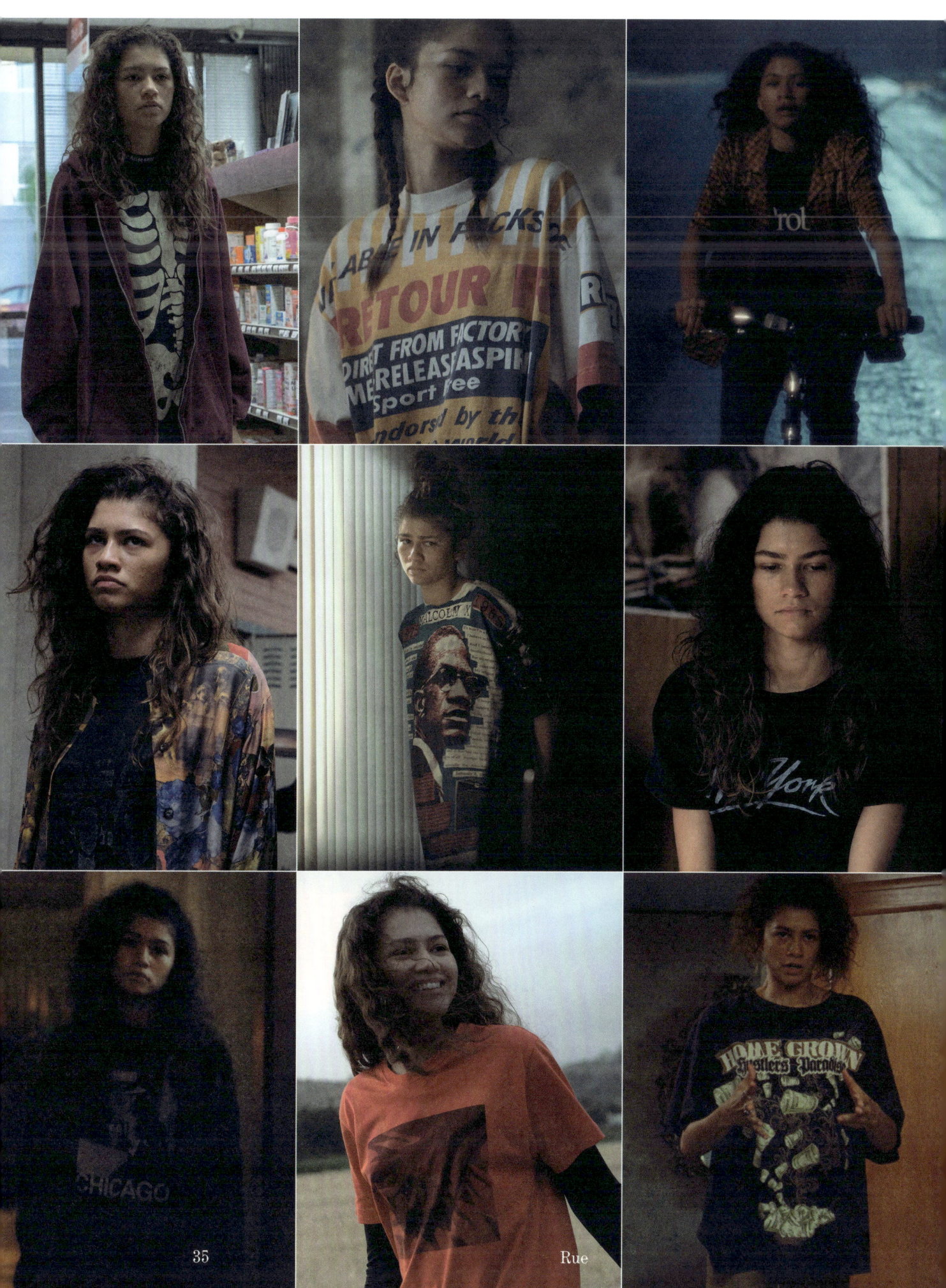

The night of the play (p.254) Rue is clean and sober again, and I felt it was importatnt to create some kind of lightness in spirit with her look. The head of the hair department, Kim Kimble, pulled Zendaya's hair back and gave her a ponytail for a fresh style that felt different from how we usually see her. The graphic on the T-shirt was hand-drawn by Mazzy Star fan and artist Meghan Baas and includes the title of Star's album *So Tonight That I Might See*.

Rue wears vintage patterned pants and a button-down over a Calvin Klein black thermal top for a heartfelt conversation with Lexi in the Season Two finale.

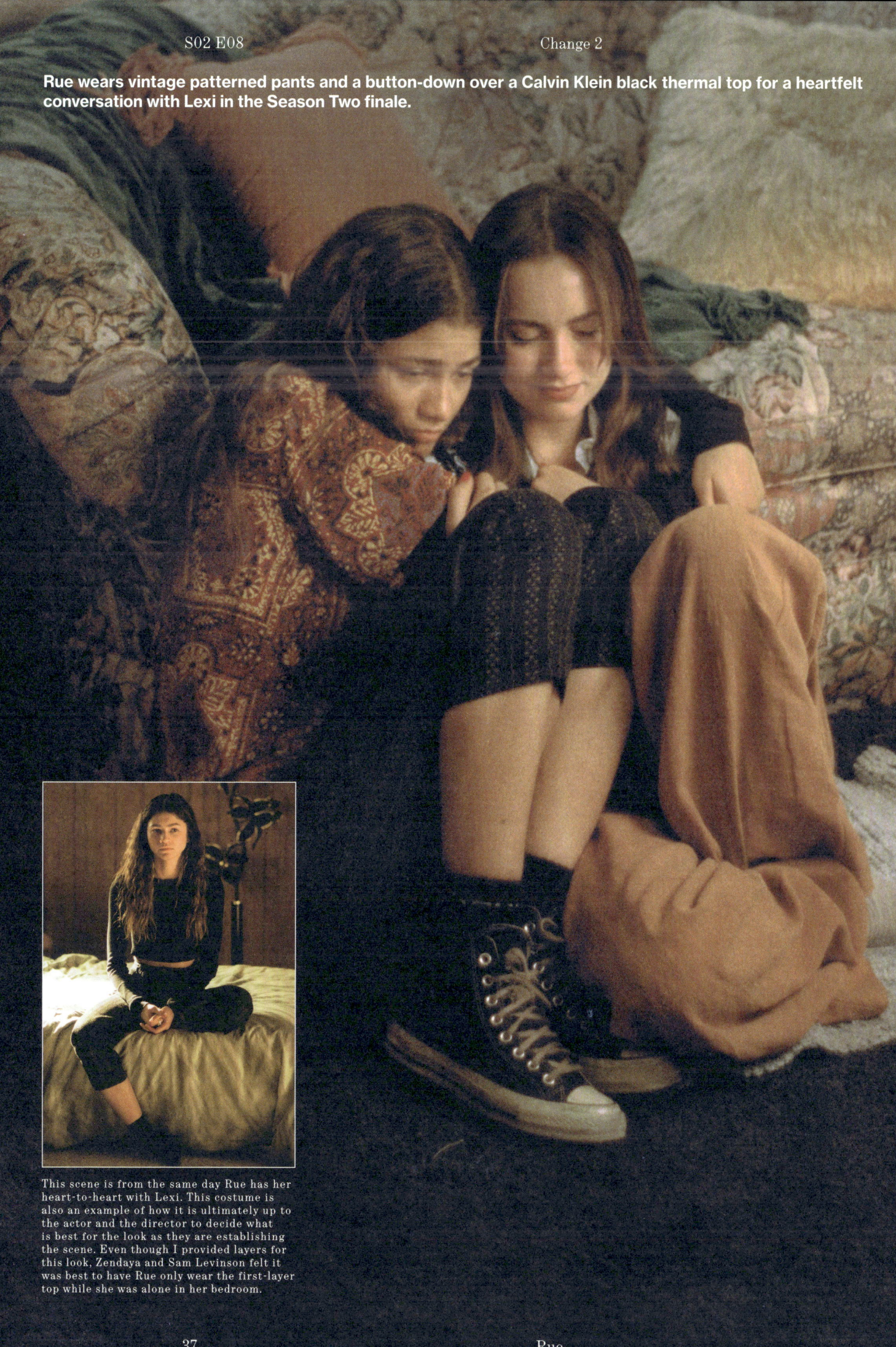

This scene is from the same day Rue has her heart-to-heart with Lexi. This costume is also an example of how it is ultimately up to the actor and the director to decide what is best for the look as they are establishing the scene. Even though I provided layers for this look, Zendaya and Sam Levinson felt it was best to have Rue only wear the first-layer top while she was alone in her bedroom.

EVEN WHEN RUE'S A MESS, SHE ALWAYS KNOWS WHERE THAT HOODIE IS

ZENDAYA IN CONVERSATION WITH HEIDI BIVENS

HB Trust is a huge part of our collaboration process on *Euphoria*. I'm building trust when the cast believes that the choices I'm making and the ideas I'm putting forward are thoughtful.

Z Sometimes it's harder to create an outfit that looks like you genuinely picked it up off the floor of your bedroom. You have this beautiful way of being able to make a very intentional outfit that feels effortless.

Because of where Rue is mentally in Season Two, she's not thinking about what she's wearing.[01] I wanted to adopt that mindset as well. I completely trusted you because I knew that you understood Rue and that you always had an emotional intention behind your choices. Having that trust meant I was able to walk into my trailer and know that you had done all the difficult work of emotionally figuring out what she's wearing.

There was one time where you had set out a black tank top and black pants.[02] We had never worn all black before, and I remember asking about the color story. You said you chose it on purpose because that's Rue's energy right now. She's trying to pass herself off as a functioning addict and wants to fade into the background. I was like, "Say less. I'll go back to not asking any questions," because you had already really figured it out.

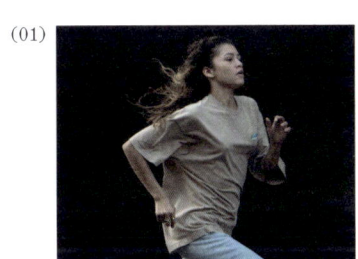
After an intervention, Rue tries to escape a return to rehab by running away, Episode 205.

Rue dons her mother's suit to pitch Laurie on a business opportunity, Episode 203.

HB A lot of that decision-making came from cues that you might not even realize you were giving me—whether it was during a fitting or while watching you on set. One thing that had a big impact on me was a conversation we had at the beginning of the second season. You brought up this idea that there are two versions of the show that exist in the public consciousness: the TikTok meme version of "Euphoria High" and then the version where real, serious, and sensitive subject matter is being explored. That really hit home. It shifted my perspective and made me hone in on what we're actually exploring with the characters.

Z Going back to the idea of trust, you and I developed a kind of shorthand. By our first fitting for the second season, it was almost at a point where we'd put something on, look at each other, and be like, "Nope, not Rue." Or we'd try something and it'd be too trendy, too stylish. We'd even find things that fit a little badly on purpose.

There was a point where our heads synced up in such a way that you know Rue the same way I do, so I don't have to worry. I'm so grateful that we have someone like you who has the gift of putting things together in that way.

When we first started the show, Rue was written a lot more feminine—the script even noted that she was wearing a skirt. I don't know if it's my own personal energy or what Rue felt like in my heart, but we lined up on that quite immediately. She's in more masculine silhouettes,[03] which was really crucial to who Rue is and who she has become. Somehow it ended up getting to a point where we're literally making

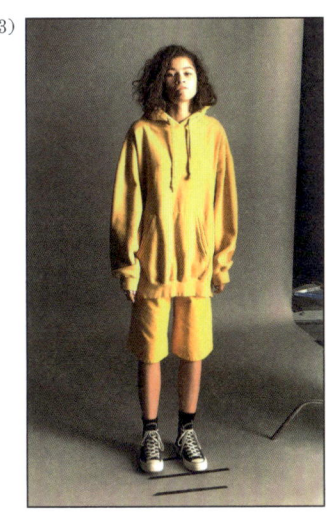
Ahead of shooting the pilot, Zendaya as Rue at the first camera test.

jokes about her wearing a fit and dressing like Seth Rogen (**p.28**), who's actually far more stylish than Rue attempts to be.

What's always so fun is creating little backstories for specific items. I remember talking to you about the hoodie (**p.18**).(04) My grandfather passed away when I was 11, and something that I held so dearly was his clothing—it made me feel like a piece of him was around me. I still wear his shirts to this day. When you said you wanted her to have a signature hoodie, we decided to switch it to a zip-up. You were able to sneak it into other scenes and put Rue's dad in it. I thought that was so special. That hoodie now means so much to me because it's personal—I have a personal connection to it, but also it means so much to Rue. It's like her safety blanket, it's the piece of her holding on to her dad. It even helps me get emotional in scenes—just thinking about what it means to her.

It's about the little emotional pieces we sprinkle throughout—whether it's my rings (**p.19**) or the Malcolm X shirt (**p.34**)—you find these little things, and we create our own stories. Whether people notice it or not, it's really cool to me. Correct me if I'm wrong, but didn't you put Jules in something of Rue's…

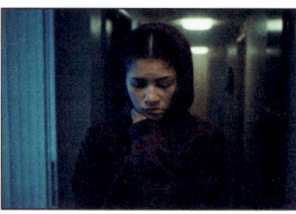

Rue's hoodie doubles as a safety blanket and a memento of her dead father, Episode 204 (top) and Episode 108 (bottom).

HB Yes, Rue's shorts for her special episode—when she's on the therapist's couch, she's wearing Rue's shorts (**p.76**).(05)

Z Yeah, I don't think anybody knew—but we did.

HB I love planting meaningful things within a scene and having that kind of fun with my department—surprising Sam Levinson and the cast—but that idea could have very well come from Hunter. I'm sure we collaborated on that idea. That's the beauty of the connections we have with each other as a crew and cast on the show; we're not afraid to put our ideas forward. The trust goes both ways.

The representation of addiction in film and television and art is so personal. After the first season, I felt more of a responsibility to honor the character of Rue and what she was going through, and to address everything about her addiction in a very thoughtful way. Do you feel like the costumes helped at times?

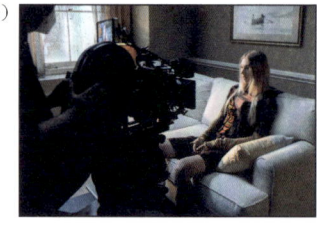

As a means of maintaining a connection to Rue, Jules, in a departure from her typical style, wears Rue's Dickies shorts to the therapist's office, Special Episode Part 2.

Z It's difficult to speak about representing addiction because everybody's story is so different, but I think, for Rue, the first half is her getting by and trying not to be noticed, trying to pretend that she's got this really dark part of her life under control. That's reflected in her clothes. She's dressing up enough to say, "Look, I'm fine. I'm normal, I'm doing everything okay," but also letting go, where there's not much effort being put into it, either.(06)

It's a weird emotional balance. We always go back to these comfort items—her shoes, hoodie, those Dickies that we like—it's Rue's uniform. Those are the pieces of clothing that make her feel safe. There are things she can't control: life, emotions, feelings. The one thing she can control

Rue puts enough energy into dressing to signify she's sufficiently functioning—she's showing up, she's not backsliding, Episode 102.

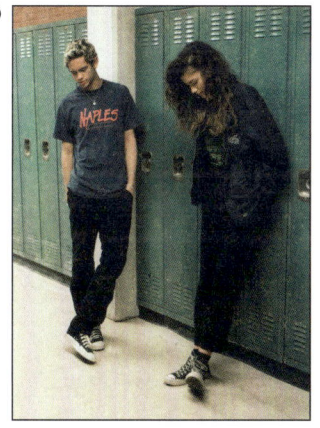

(07) Behind the scenes with Dominic Fike and Zendaya—in her Converse Chuck Taylor All Stars—in the halls of East Highland High, Episode 202.

is her clothes, so it becomes her safety zone, and anything outside of that feels like a bit too much for her.

I don't know if it's superstition, but it was just so important that I keep wearing the same shoes.[07] I just keep wearing them out until they're done because I don't think Rue's buying new shoes. My shoes even get locked up until the next season.

I also like thinking about how that's a shared characteristic with Sam—when Sam gets into production, he wears the same thing every day. He has a uniform. He's got a bunch of the same things, and he just rotates them out, so much so that everybody came to set one day dressed as him. Being that Sam is also Rue, I think it makes sense that she has these core pieces that just go on rotation because that's her comfort. That's her safety. That's how she navigates the world.

HB I always said that even when Rue's a mess and she's probably picking things up off her bedroom floor, she always knows where that hoodie is. If you asked her, there's a good chance she would know exactly where it would be.

Z Always.

HB Do you feel like you've taken a little bit of Rue's style with you into your personal life? I know I tend to do that with characters when I'm doing costumes for them.

Z Of course. I have Rue's clothes. Sometimes you get doubles, or versions of shirts that never came to fruition, and I definitely wear them.

HB Well, Rue's always with you.

Z Always, always, always, always.

ODE TO:

CHUCK TAYLORS

Chuck Taylor All Stars, or "Chucks," are not just shoes—they are *the* shoe, the picture in the dictionary next to the entry for "sneaker." The rubber-soled shoe with a lace-up canvas upper was first developed for playing croquet in the mid-19th century, a civilized alternative sport for middle-class youth in the era of boxing and cockfighting. By 1873, the shoes had acquired the nickname "sneaks"—late 19th-century slang that reflected how the footwear, as reported by tabloid crime reporters, was rumored to be useful in facilitating quiet movement during a theft. In fact, the idea became so ubiquitous that early athletic shoe advertising specified that not everyone who wore the shoes did so with nefarious intent.

But the real origin story for Chucks begins with basketball.[01] It didn't take long after the game was invented in 1891 (by YMCA instructor James Naismith) for its widespread appeal to create a mass market for shoes to play it in. At that time, the sneaker game was run by Keds and Spalding, while the Converse Rubber Company (founded in 1908) was busy making galoshes. But the growth in athletic shoes was too strong for a rubber sole-based footwear company to ignore, and in 1917 the All Star was born: a light-brown canvas complete with a brown rubber toe cap and a patch intended to cushion ankles. Soon after, the moderately successful semi-pro basketball player Chuck Taylor joined the company sales team as an evangelist for the sport, barnstorming America with basketball seminars at schools including a pitch for the best shoes to sweep the courts in.

While basketball was embraced in small schools in the Midwest and in segregated Black schools in places like Harlem, its visual culture was formed in the 1920s as Chuck Taylor promoted teams (and shoes) in the Converse Basketball Yearbook, which featured pro stars, coaching tips, and photos of youth teams. Anyone could be in the yearbook as long as they were wearing

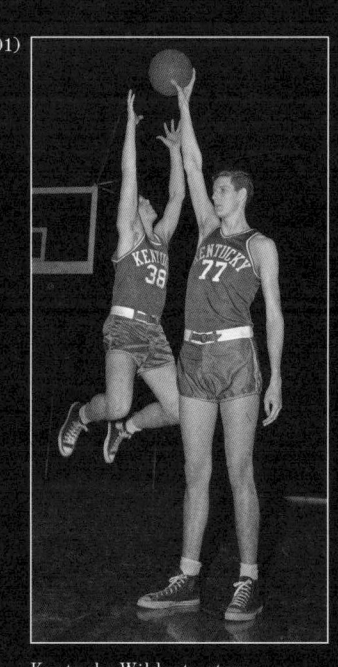

(01) Kentucky Wildcats stars Bobby Watson and Bill Spivey in Chuck Taylors, 1949.

All Stars. By the early 1930s, Taylor had enough of a profile that his signature was added to the ankle patch. Renamed the Chuck Taylor All Star, the shoe went global in 1936 when white Chucks were introduced on the feet of the United States Olympic Team.(02) By the 1960s, color versions were introduced to match school uniforms. And by 1969, before the era of paid endorsements and signature shoes, 400 million pairs of Chucks had been sold.

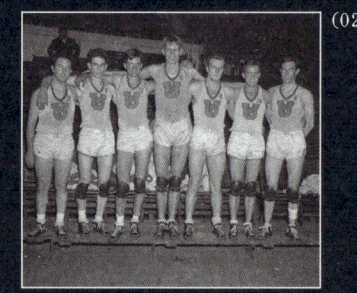

The Universal Pictures basketball team that represented the U.S. at the 1936 Olympics.

The company seemingly lost the thread in the 1970s, when technical innovation in sneakers took off. Plain canvas uppers and an ankle patch weren't going to cut it once the possibility of leather uppers and a wider base were marketed directly to players. But Chucks never left the street. In the inner cities, where leather shoes were cost-prohibitive and outdoor concrete basketball courts were the norm, an ecosystem of street-based basketball evolved outside professional play and high-dollar endorsements.

Julius "Dr. J" Erving emerged from the late-'60s Rucker Park scene in New York City a staunch Converse wearer.(03) Dr. J honed the initially controversial skill of the slam dunk at the Rucker Tournament in Harlem, bringing a more stylish and spectacular form of play to national attention when he went pro. In the streets around those same parks, gang members wore beat-up All Stars to complement their cut-sleeved, customized denim jackets. NYC breakdancers wore them as well, though typically "fresh" and well cared for and matching their carefully selected dance crew outfits. As the shoe outlived its time on the courts, kids continued to customize them for style, even refurbishing them with "fat laces" created by stretching, starching, and ironing the original laces.

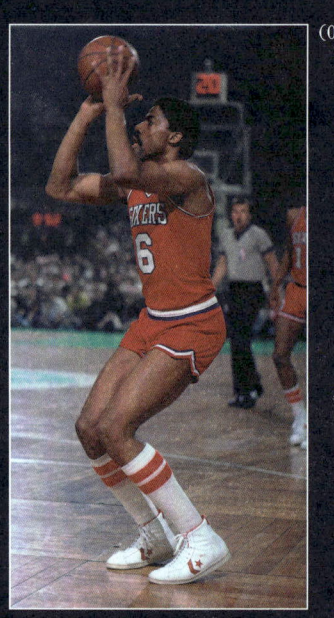

Philadelphia 76ers legend Julius Erving in Converse Pro Leathers, 1982.

Chucks became an unapologetically working-class shoe, notably embraced by punk icons The Ramones, who wore the black canvas Chucks first introduced in 1949. In their beat-up, drawn-on, and broken-in form,

Chucks announced that the wearer lacked any traditional aspiration to success. To step out in sneakers, even into the 1970s, was aggressively informal—an act of resistance. The history of Chucks through the '70s and '80s was written not in sports stats but in photos of rock stars (04) and cool kids whose style was undeniable.

Even while hip-hop hero Tupac Shakur rapped in his 1995 track "California Love" about how "In L.A., we wearing Chucks, not Ballys," Converse remained seemingly indifferent to its shift into fashion. But in the late '90s, the company that had been chasing sports cred woke up to Chucks as a fashion icon. Recognizing the marketing potential of athletic heritage, the company pivoted, launching an ad campaign of posters intended to invite graffiti on the "blank slate" of white Chucks. When Nike acquired Converse in 2003, it was on the strength of the Chuck Taylor All Star brand name— the company's most valuable asset. With sneaker makers well into an ongoing arms (or foot?) race, most recently culminating in $800 Balenciagas, Converse had $2 billion in sales with Chucks by 2017. Though the prices stayed low, a 2021 writeup for the global touring exhibition "Sneakers Unboxed: From Studio to Street" listed Chucks first among equals: the icon, the prototype, the avatar of authenticity.

(04) Kathleen Hanna from Bikini Kill in low-top Chuck Taylors, 1994.

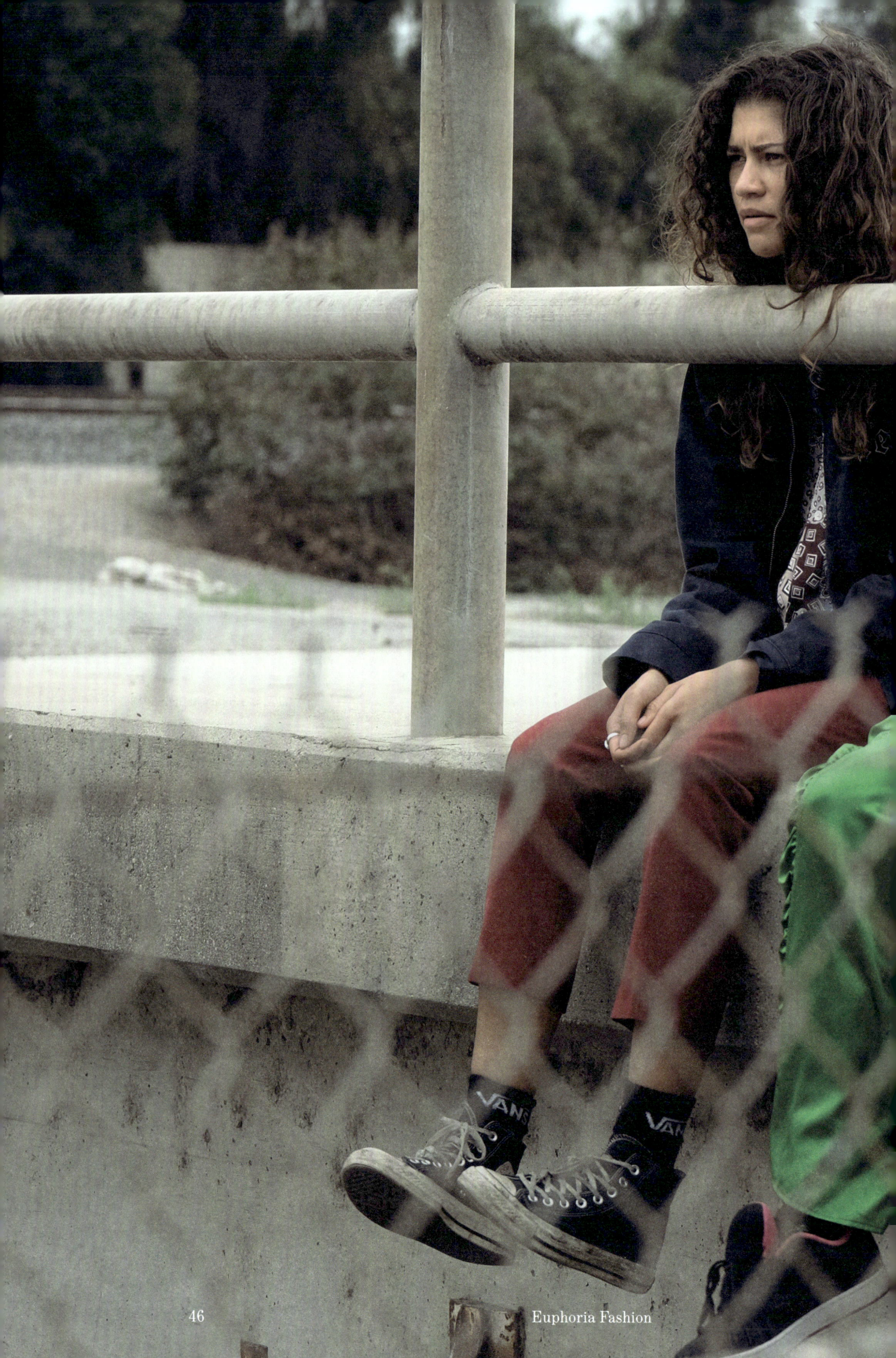

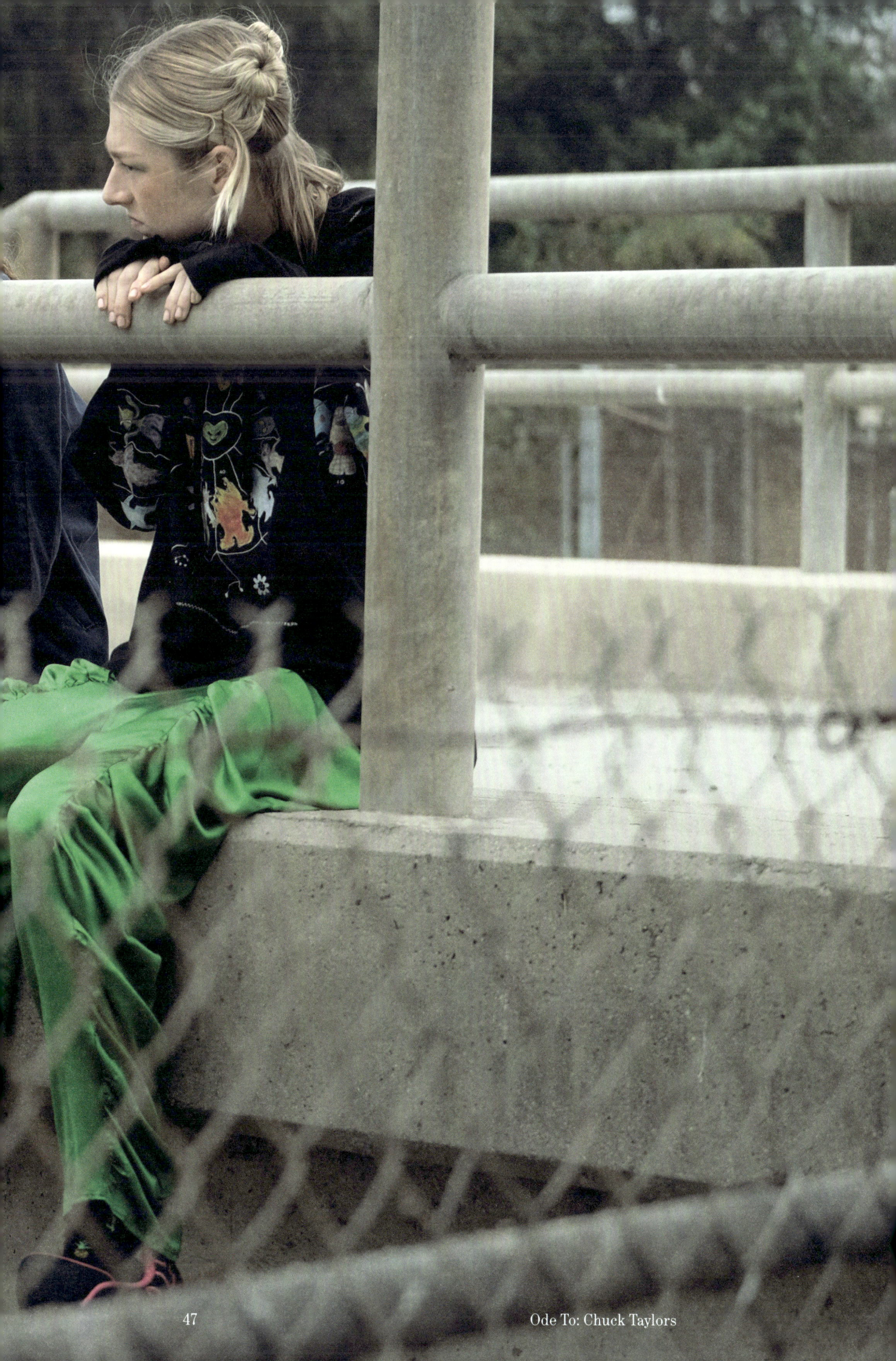

Sam Levinson and *Heidi Bivens* on designing for dream worlds

SL What I'm most impressed by in your work as an artist and a designer is that you have an auteur's sensibility. There's a unified world that you're creating, even beyond *Euphoria*. I know you approach it with a sort of "method acting" perspective, in that you really get into the heads of the characters and what the fabrics mean, what the clothes mean, what the backstory is. How does that process actually work?

HB Most of the time, I'm relying on gut instincts—employing empathy for the characters and a curiosity about the storytelling as well as honoring the vision of the director. In our case, you give me a sense of each character with wardrobe cues, music cues, and details you write into the scripts, and it sends me down a path. I gather what I can and try to turn it into something that feels fresh and isn't too derivative. I think, in essence, that's always been the focus of my process—to pull from many different points of inspiration and create something people hopefully haven't seen before.

I'm really interested in your writing process—you're incredibly prolific. Can you describe your process and your approach to Season Two?

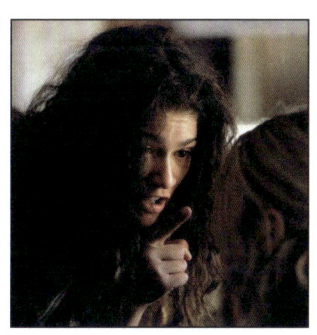

Rue reels against the intervention staged by Jules, Elliot, and her family, Episode 205.

SL It's a bit unusual. I start from a character perspective, and I get really into it, sometimes to the point where I slip into characters without noticing and take on some of their mannerisms or even their thought processes. To me, character is plot. I care more about the characters' emotional ups and downs and how they're growing or evolving.(01)

With Season Two, I didn't want to just make another season of television for the sake of it. I'd rather figure out what excites and challenges me and the actors and collaborators I work with, and what we're yearning for artistically, because I don't want to lose the passion for it. I want everyone to feel like a new season means a new challenge, and that we're not allowing it to become some kind of a factory.

HB With Season Two, you embraced this dream world—whether it was memory, flashback, or fantasy. In terms of costumes, navigating that was exciting because of all the layers of meaning for the characters.

Sam Levinson and Marcell Rév filming the *Ghost* scene in the Lover's Montage, Episode 204.

SL As I began writing Season Two, I noticed that the structure was psychoanalytical in some ways—we're moving through these different characters' experiences, psychology, self-loathing, and senses of belonging. I thought, what if we take that a step further and allow it to enter a territory of the unknown, of the dream world? What if we didn't worry about the logic of a scene? Clarity is the enemy of drama.

It's interesting to enter the characters' imaginations without any concern for aesthetics, morality, or societal constraints. What exists within them? What's inside of Cassie's heart? She wants to be Nate's girl. She wants to be this doll that he obsesses over. Whether that's appropriate by societal standards doesn't matter—that's what she wishes for. Same thing with Rue and Jules and the Lover's Montage (**p.52**).(02) It became an interesting narrative angle that lives just below the surface.

While I was writing it, I would try to lose my mind. I would almost free-associate from one image to another. I wasn't thinking too much about structure or if it made sense. I abandoned those normal writing rules and opened up space for the images, visuals, and the heart of the piece to come alive on its own and go where it goes.

HB In doing that, you gave me full permission to do the same.

SL All of those outfits allow Cassie to be in this dream world of Nate's (**p.205**). We're tapping into her with those pastels and the Tiffany necklace. There's something deeply funny about it and also beautiful and tragic. When those three things come together, it's quite exciting. Same thing with Lexi's journey throughout that whole play (**p.254**).

HB I love how layered the storytelling of the dream world is. After reading the script, I asked about your intention: was a scene actually set on the stage, or is it in Lexi's memory of something that happened? What was reality? What was a flashback? Do the costumes depend on who's having the flashback, or is it more ambiguous?

SL Especially when we're seeing a memory we've already seen from another character's perspective.

HB For the special episodes (**p.29, 75**), you confirmed that in their separate fantasies Rue and Jules would be wearing the same things, which made total sense to me in that it didn't make sense. That's when you're respecting your audience's intelligence, giving them the benefit of the doubt and letting them discover something. Not everything has to be so expository. Like you said: clarity is the enemy of drama.

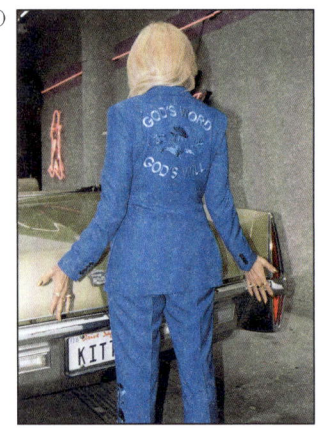

(03) Katherine Narducci as Grandma Kitty in a custom-made embroidered pantsuit, Episode 201.

My favorite part of costume designing the show was getting in the head of a character and figuring out their memory of what someone wore, or sometimes the memory of another character's retelling of what someone wore. For example, in the first episode of Season Two with Fezco's Grandma Kitty: it's Rue's recollection of Fezco telling that story, so Grandma Kitty can be larger than life in Rue's mind—it didn't matter what she really looked like. And that's where the fun begins.

SL Can you talk about the process of making Kitty's pantsuit (03) for the opening of that episode?

HB It was originally scripted to be set in Vegas, and I immediately thought of the famous Nudie suits worn by celebrities like Elvis Presley and country music stars at the Grand Ole Opry.(04) Nudie's Rodeo Tailors were really popular with a lot of recording artists during the '60s and '70s. I didn't want to do their popular rhinestone suits—that's been done a million times. But my friend, Lisa Eisner, who has incredible style, had worn an original blue Nathan Turk look to an event a few years back that I was really inspired by. I took this idea of a bright

(04) Country singer Porter Wagoner, wearing a Nudie suit, with Dolly Parton, 1972.

blue suit, but instead of rhinestones I wanted to do embroidery. And instead of contrast color embroidery, which would normally be used on a rodeo suit like that, I chose tone-on-tone blue metallic thread. I used the original elements of the first inspiration and then something that felt more subtle.

SL Are you often looking at people you know in real life or people you see on the street for costume ideas?

HB I believe one of the best ways to build style for contemporary characters is to take inspiration from real people. Then there's something grounded in reality that I can believe in. All the while, I'm looking for the humanity in the characters; whether they're the most despicable or the most lovable, they all have a right to exist in a story. With *Euphoria*, you gave me permission to tap into a fantasy world outside of reality, and the merging of these two is what has helped the show to have a unique look of its own.

I'm curious about the way you and Marcell Rév, the cinematographer, bridge these worlds. You two often collaborate in this kind of "mind meld" way, where a scene can often become something more through the process of blocking and figuring out how you want to shoot it.(05) Do you and Marcell develop the look of the show over the course of shooting it, or do you know from the beginning how you're going to tell the story visually?

(05) Sam Levinson and Marcell Rév discuss a setup for a scene during production of Season Two.

SL We always set rules for ourselves, so even though it feels like we're doing whatever we want, there are very hard-and-fast rules. For instance, in Season Two, we wanted to eliminate some of the more frenetic camera movement that we did in Season One. We don't do unmotivated pans and we try to keep almost everything limited to as few shots as possible. We also wanted to shoot it on film, particularly Ektachrome, and at night, which puts very big restrictions on where we can move the camera because the exposure won't come out.(06) Those constraints force us to figure out how to tell the story and shoot a scene in, say, two shots instead of six. Sometimes that makes it really hard to shoot a more conventional scene. But we also have to be open to what's happening within the actor, on the set, in the production design, in the costumes. We want to be open to all of the unpredictability of it.

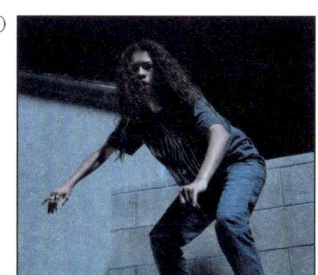

(06) In a dreamlike chase scene, Rue runs away from her family and the cops to avoid rehab, Episode 205.

HB Thinking about Season Three, do you imagine the look will continue to evolve?

SL A hundred percent, or else there's no reason to do it. I want it to have a certain scope, so that might mean less soundstage work and more practical locations. I also want to play with different things in terms of camera and storytelling. But the key is to find ways to challenge ourselves. That's what makes *Euphoria* such a rewarding show—it's fucking brutal to make, but as soon as there's no challenge, it's time to give it up.

"You Who Cannot See, Think of Those Who Can"

S02 E04 — "You Who Cannot See, Think of Those Who Can"

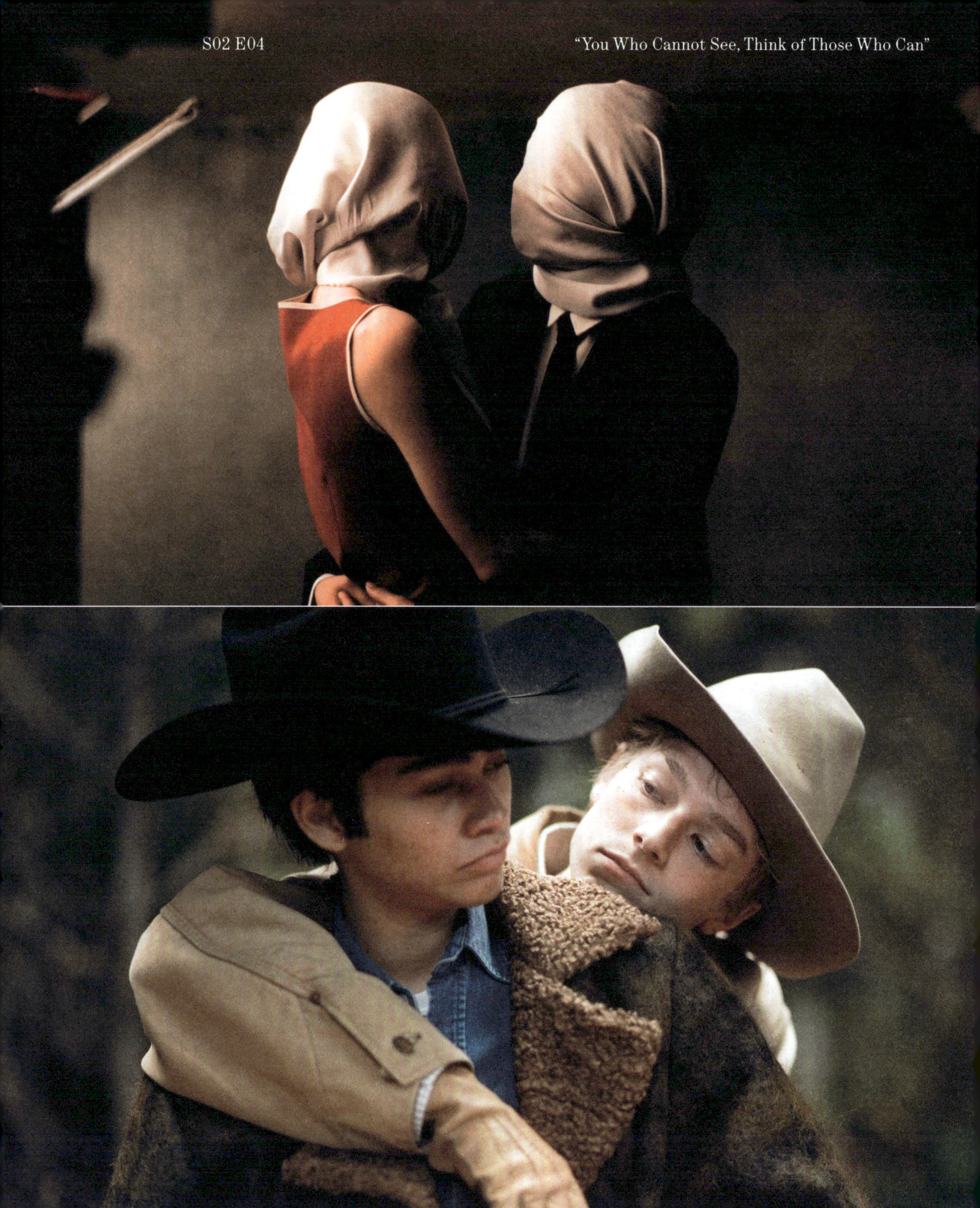

"I don't think you understand how much I love Jules," Rue reflects. Jules performs oral sex on her over scenes of the two dressed as iconic couples from art and pop culture: Yoko Ono and John Lennon, René Magritte's *The Lovers II*, Frida Kahlo and Diego Rivera, and Jack Twist and Ennis Del Mar from *Brokeback Mountain* (2005).

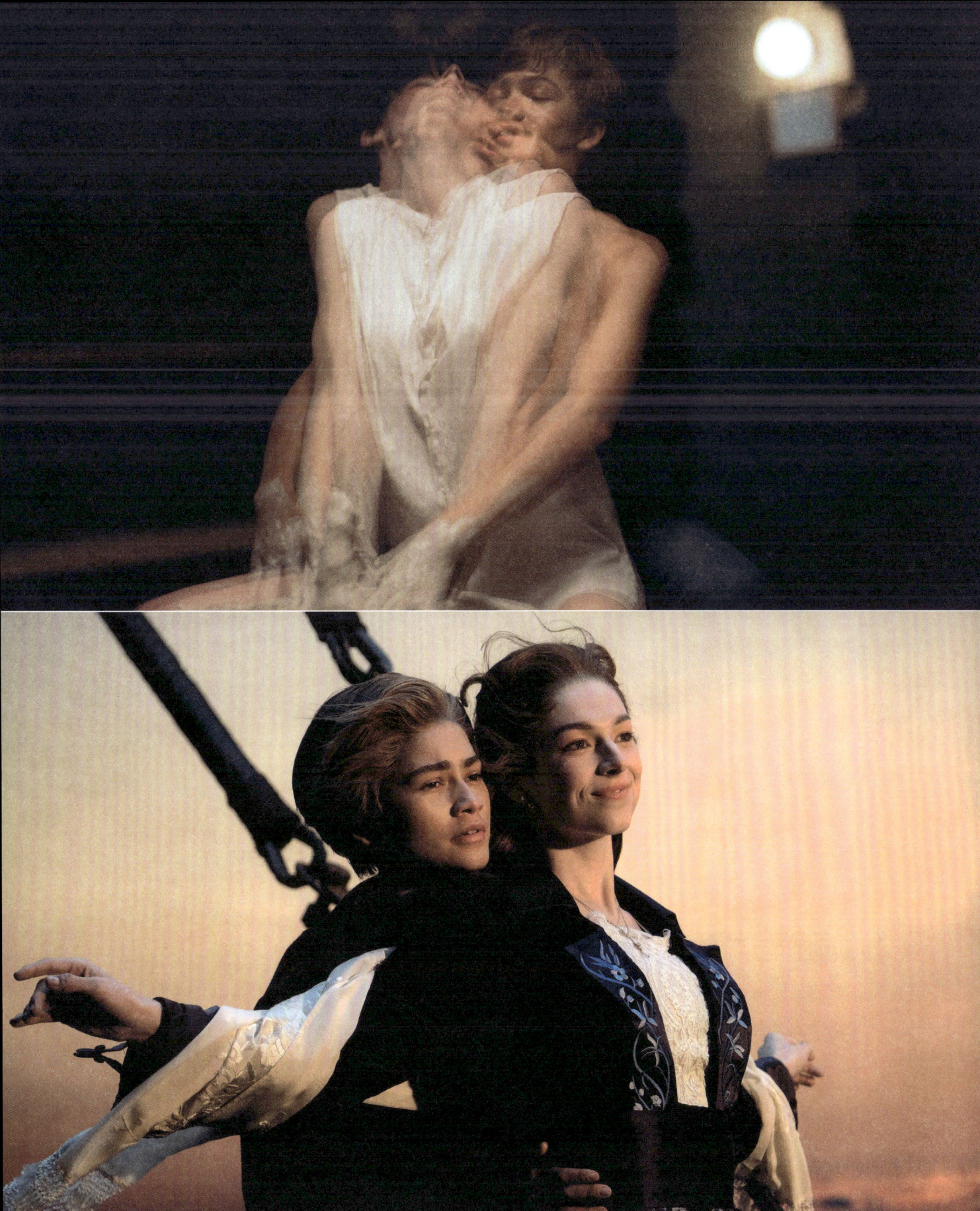

Townes Van Zandt's melodic voice coos, "Close your eyes / I'll be here in the morning / Close your eyes / I'll be here for a while," as the fantasy plays out in Rue's mind. In stark contrast to Rue's emotions, she is so high that she physically feels nothing: Jules "might as well be going down on [her] ankle."

II. JULES

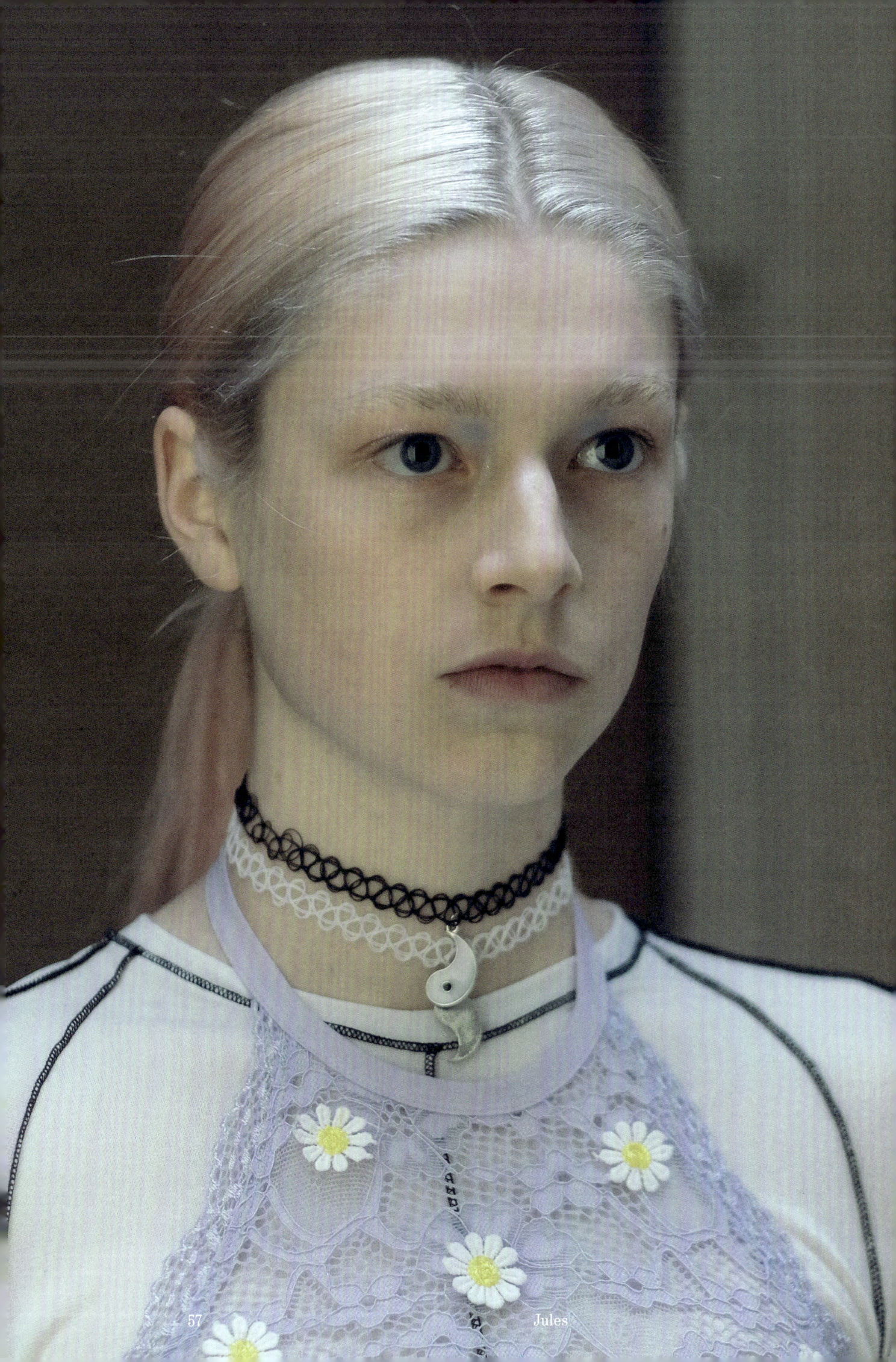
Jules

"I definitely haven't reached my full power."
—Jules Vaughn

Jules looks to fantasy and the ethereal for inspiration when imaging how to communicate who she is to the world through fashion and style. Her interests include anime and drawing, and she dreams of being an artist, a fashion designer, or working in animation. During her early teen years, her personal style gravitated toward what could be considered traditionally feminine looks. She explores her gender identity through conscious choices with her clothing, including color and silhouette, and at times becomes her own avatar of a cisgender teenage girl. For a time, she dresses to attract men, specifically those she meets online. Eventually she realizes there are other ways to explore her sexuality that feel more authentic to her, and so she begins to lean away from the candy-colored, ultra-sexualized looks that defined her earlier style.

After Jules returns from her runaway trip to the "city," she thinks about a life beyond high school. She becomes more uninterested in strict gender binaries. She has a shift in consciousness around how she defines herself. When she forms a triangular relationship with Rue and Elliot, there are times when they dress alike and even share clothes. As Jules becomes more contemplative, her clothing choices reflect a more meditative state of mind. While her spirit still shines brightly, there is a darker thread woven into her style as she navigates experiences of pain and love.

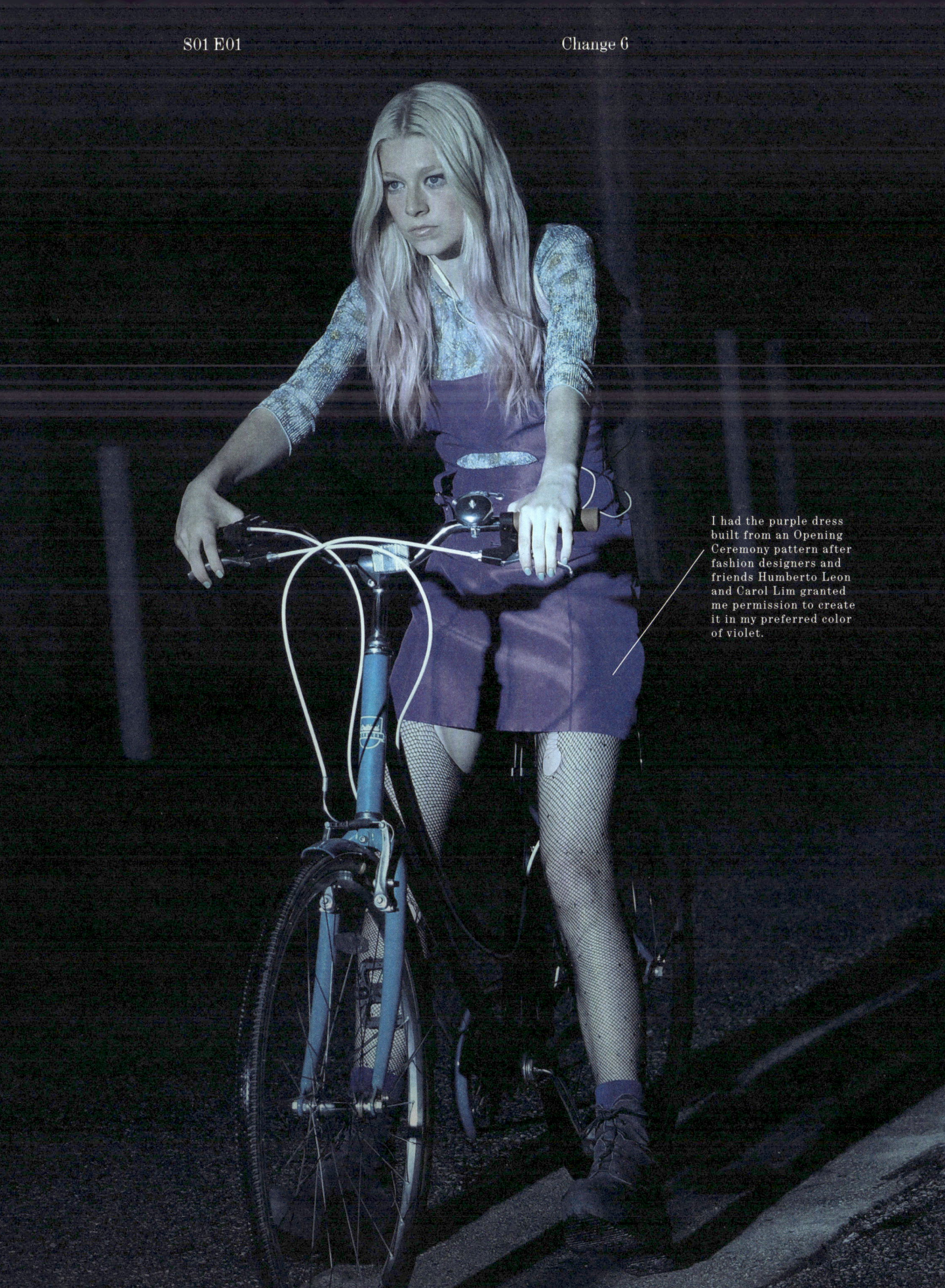

I had the purple dress built from an Opening Ceremony pattern after fashion designers and friends Humberto Leon and Carol Lim granted me permission to create it in my preferred color of violet.

One of the first looks designed for Jules was for McKay's house party (p.12), and it set the tone for an early aesthetic understanding of the character. It was scripted that Jules would ride her bike home with Rue after the party, and I wanted the fabrics in the top and dress to create some kind of reflection and sparkle in low light.

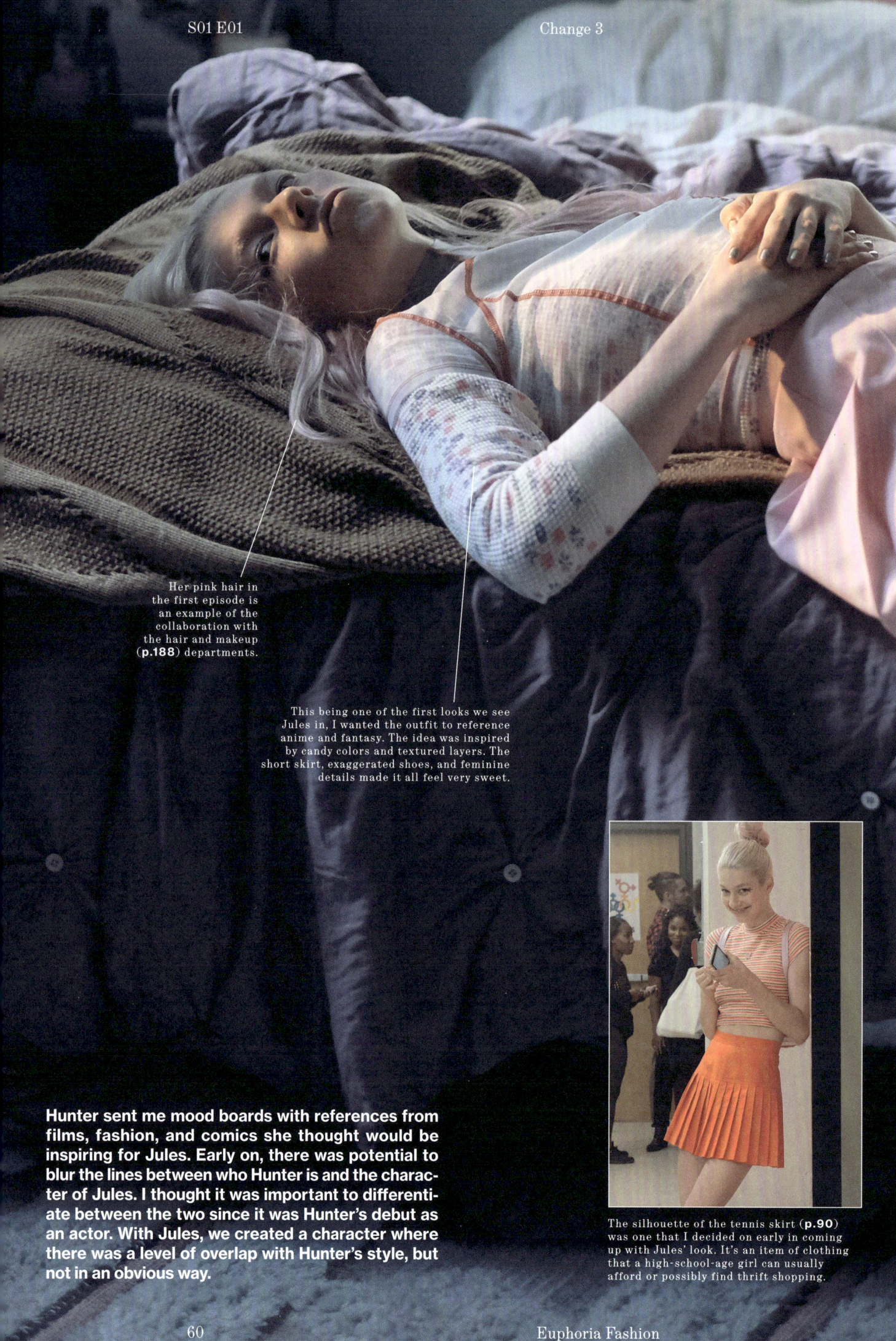

S01 E01 — Change 3

Her pink hair in the first episode is an example of the collaboration with the hair and makeup (**p.188**) departments.

This being one of the first looks we see Jules in, I wanted the outfit to reference anime and fantasy. The idea was inspired by candy colors and textured layers. The short skirt, exaggerated shoes, and feminine details made it all feel very sweet.

Hunter sent me mood boards with references from films, fashion, and comics she thought would be inspiring for Jules. Early on, there was potential to blur the lines between who Hunter is and the character of Jules. I thought it was important to differentiate between the two since it was Hunter's debut as an actor. With Jules, we created a character where there was a level of overlap with Hunter's style, but not in an obvious way.

The silhouette of the tennis skirt (**p.90**) was one that I decided on early in coming up with Jules' look. It's an item of clothing that a high-school-age girl can usually afford or possibly find thrift shopping.

S01 E01 Change 3

Jules always layers her clothes, and her look is often made of a mashup of ideas. The sheer mock neck shirt is Eckhaus Latta, and the style and details reminded me of a rash guard top—a style element Hunter and I wanted to include in Jules' closet.

The floral thermal top was sourced from vintage clothing dealer Please and Thank You in Los Angeles and exemplifies Jules' creativity in the way she approaches her personal style—taking a seemingly ordinary, non-fashion piece of clothing and coordinating it into an outfit in a surprising way.

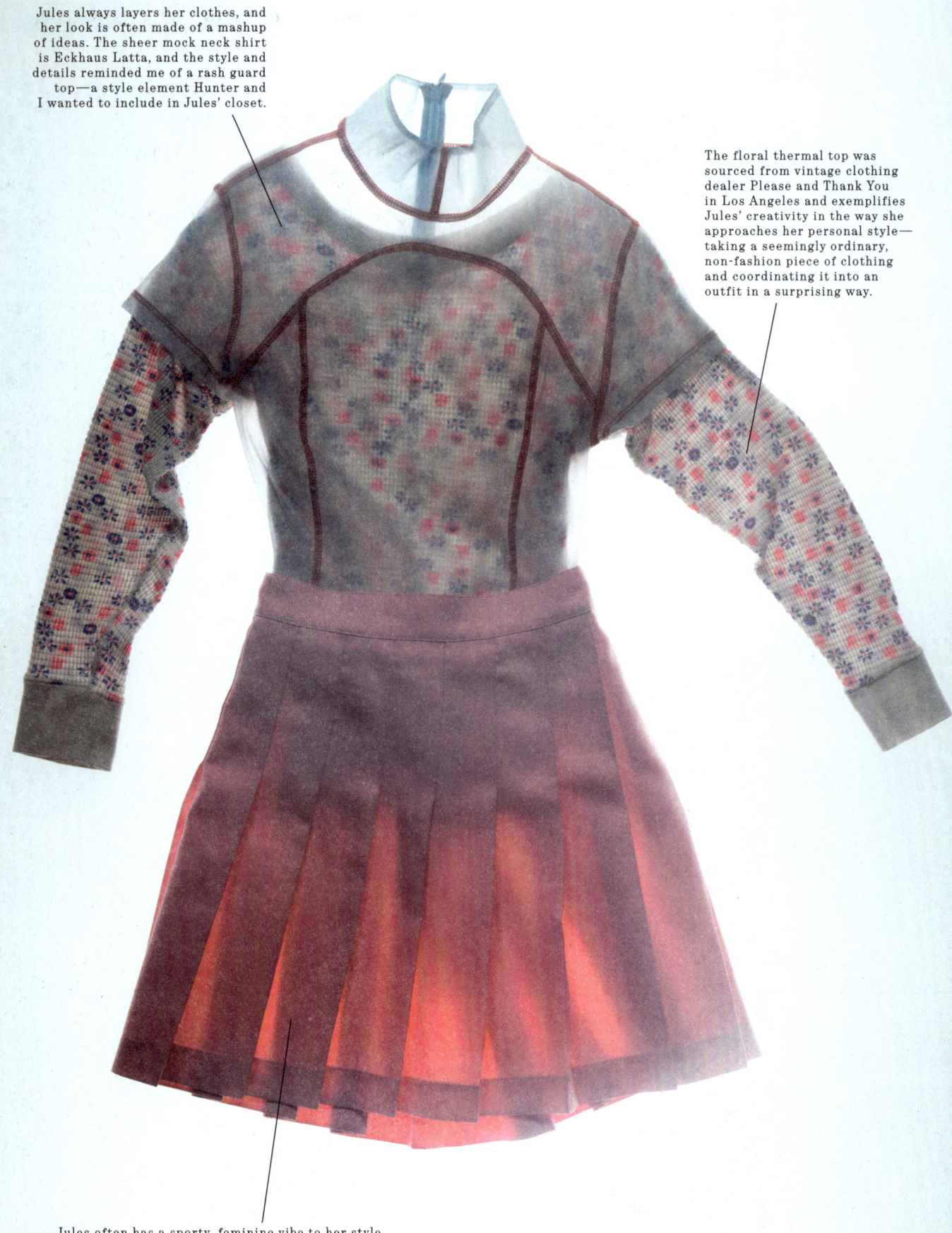

Jules often has a sporty, feminine vibe to her style. The tennis skirt was the perfect staple in her closet. It's an easy piece she can pair with most looks and offered a silhouette that can be identifiable, even in a crowd.

Euphoria Fashion

This became one of my favorite Season One outfits and is an example of how Jules mixes patterns, colors, and textures to create looks all her own. The crushed velvet short-sleeve top is Eckhaus Latta, and the spandex long-sleeve top is Hunter's personal piece she brought to one of our first fittings.

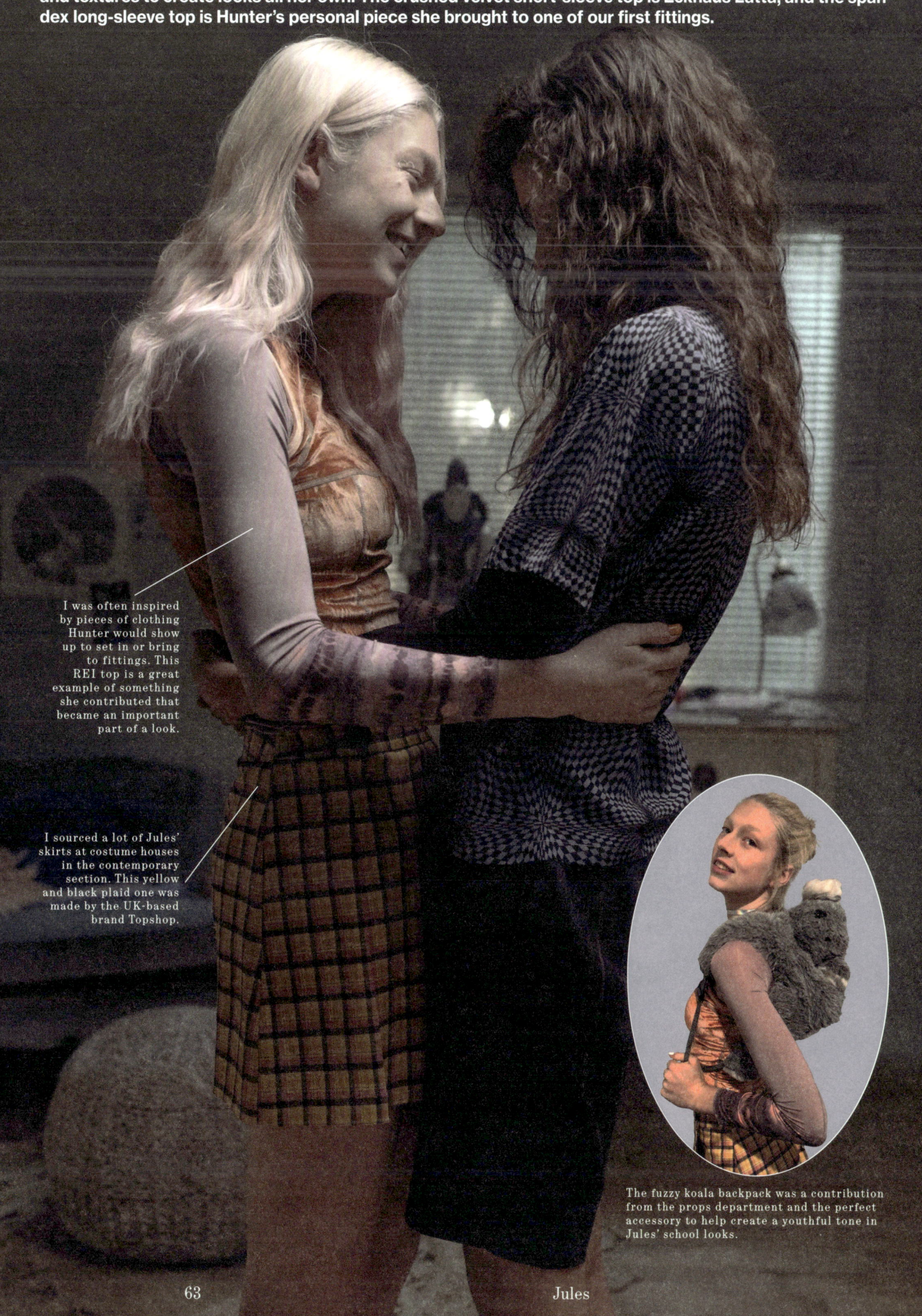

I was often inspired by pieces of clothing Hunter would show up to set in or bring to fittings. This REI top is a great example of something she contributed that became an important part of a look.

I sourced a lot of Jules' skirts at costume houses in the contemporary section. This yellow and black plaid one was made by the UK-based brand Topshop.

The fuzzy koala backpack was a contribution from the props department and the perfect accessory to help create a youthful tone in Jules' school looks.

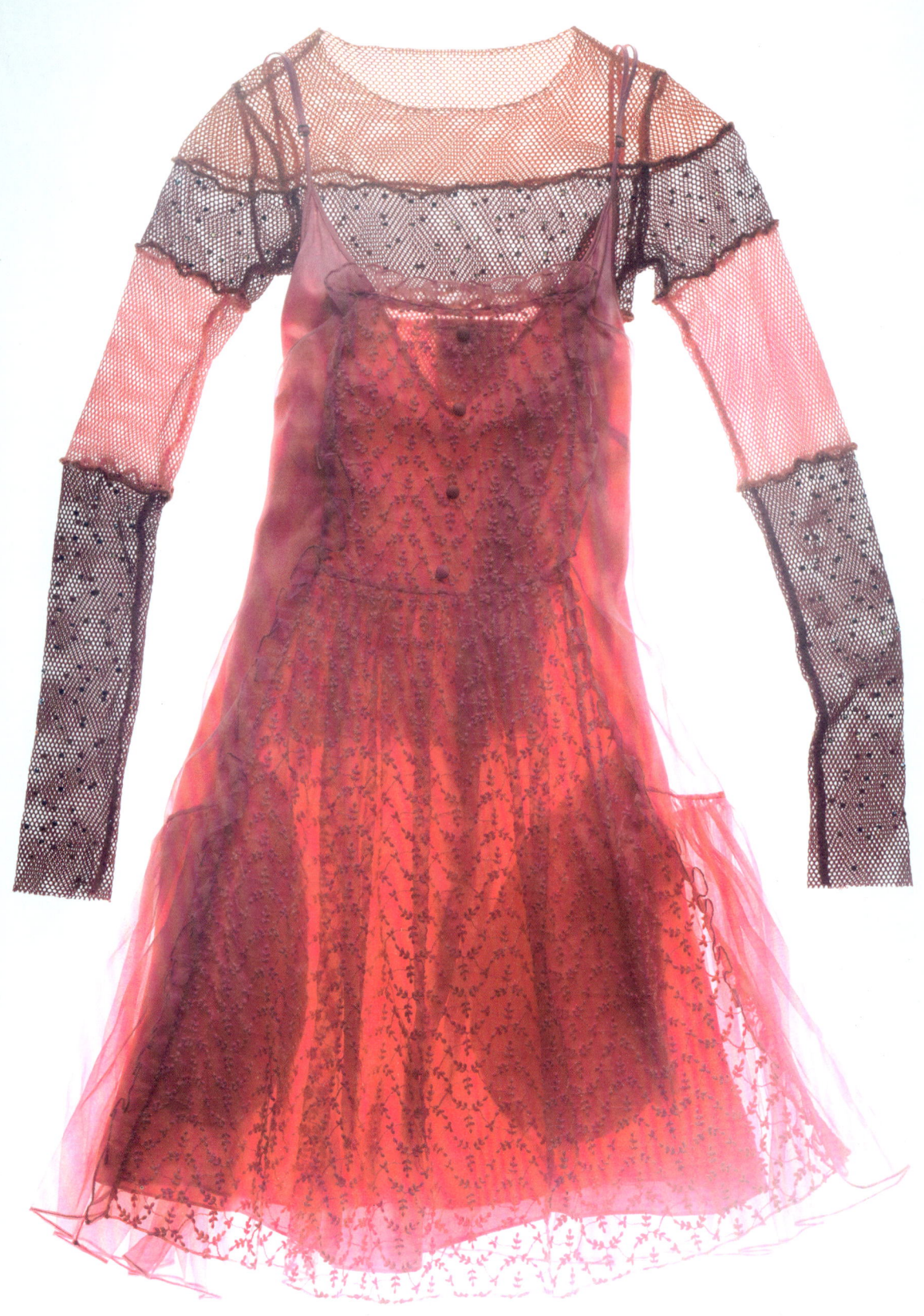

Although I hadn't been looking at runway high fashion when imagining the characters for Season One, I came across an image of this Stella McCartney Resort 2019 collection dress and thought it was perfect for Jules' transformative night at the carnival (p.104). I was attracted to the pinafore style, which calls an apron to mind, and the silk slip it's attached to, with all its feminine connotations.

Depending on the type of camera and film stock being used, colors can look very different on screen. That's important to consider when deciding how you want the clothing to appear. For example, the lighting in *Euphoria* tends to be dark, so I have to think differently than I would for a show shot in bright daylight.

The striped fishnet top is vintage and sourced from a Los Angeles costume house. I knew I really wanted Jules to sparkle and applied Swarovski crystals to sections of the mesh to make them shine for the night exteriors.

Color is a driving force behind a lot of my creative decisions for costumes. For example, the pink color of the silk pinafore dress added a femme quality to the look and worked harmoniously with the hair and makeup design.

The silver boots are reflective in low light and are a nod to Jules' love of fantasy and anime.

Jules

S01 E05 Change 2

This is one of my favorite early Jules looks. The top is in an iridescent ribbed spandex fabric from ABC Costume House. The colored rope Jules wears around her neck is from paracord I sourced from a local hardware store.

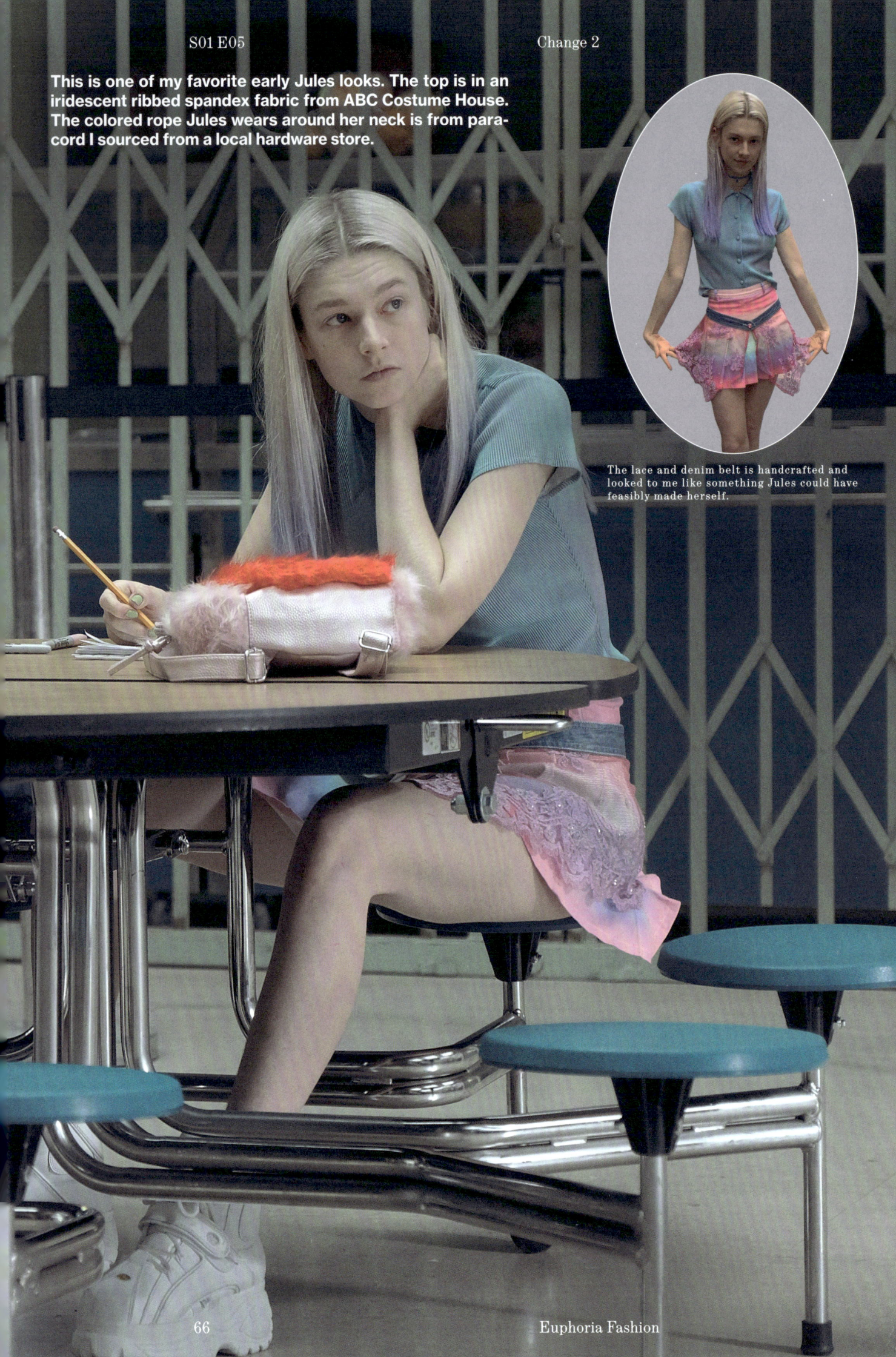

The lace and denim belt is handcrafted and looked to me like something Jules could have feasibly made herself.

Euphoria Fashion

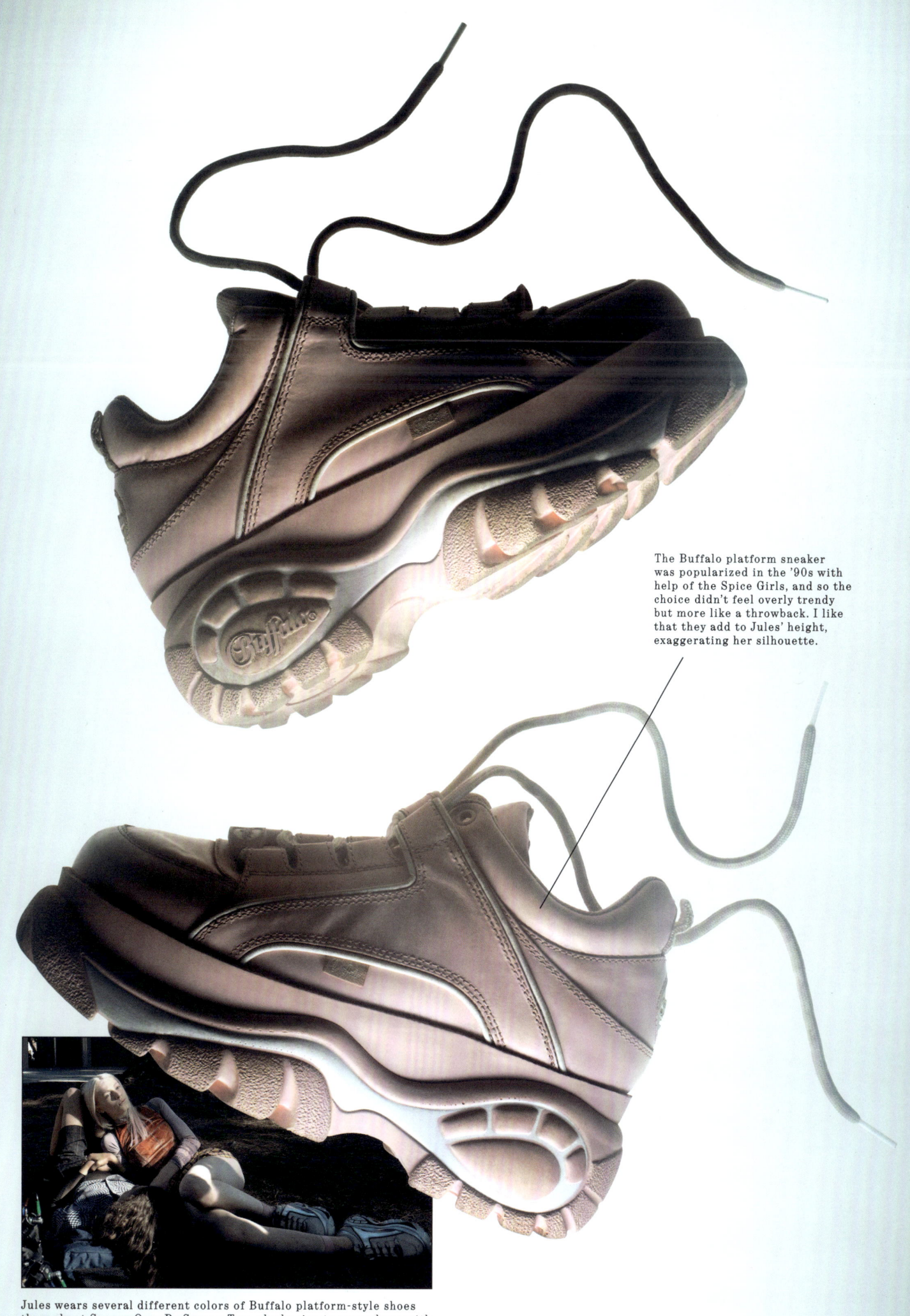

The Buffalo platform sneaker was popularized in the '90s with help of the Spice Girls, and so the choice didn't feel overly trendy but more like a throwback. I like that they add to Jules' height, exaggerating her silhouette.

Jules wears several different colors of Buffalo platform-style shoes throughout Season One. By Season Two, she begins to wear shoes with less of a platform, making her more equal in height to Rue.

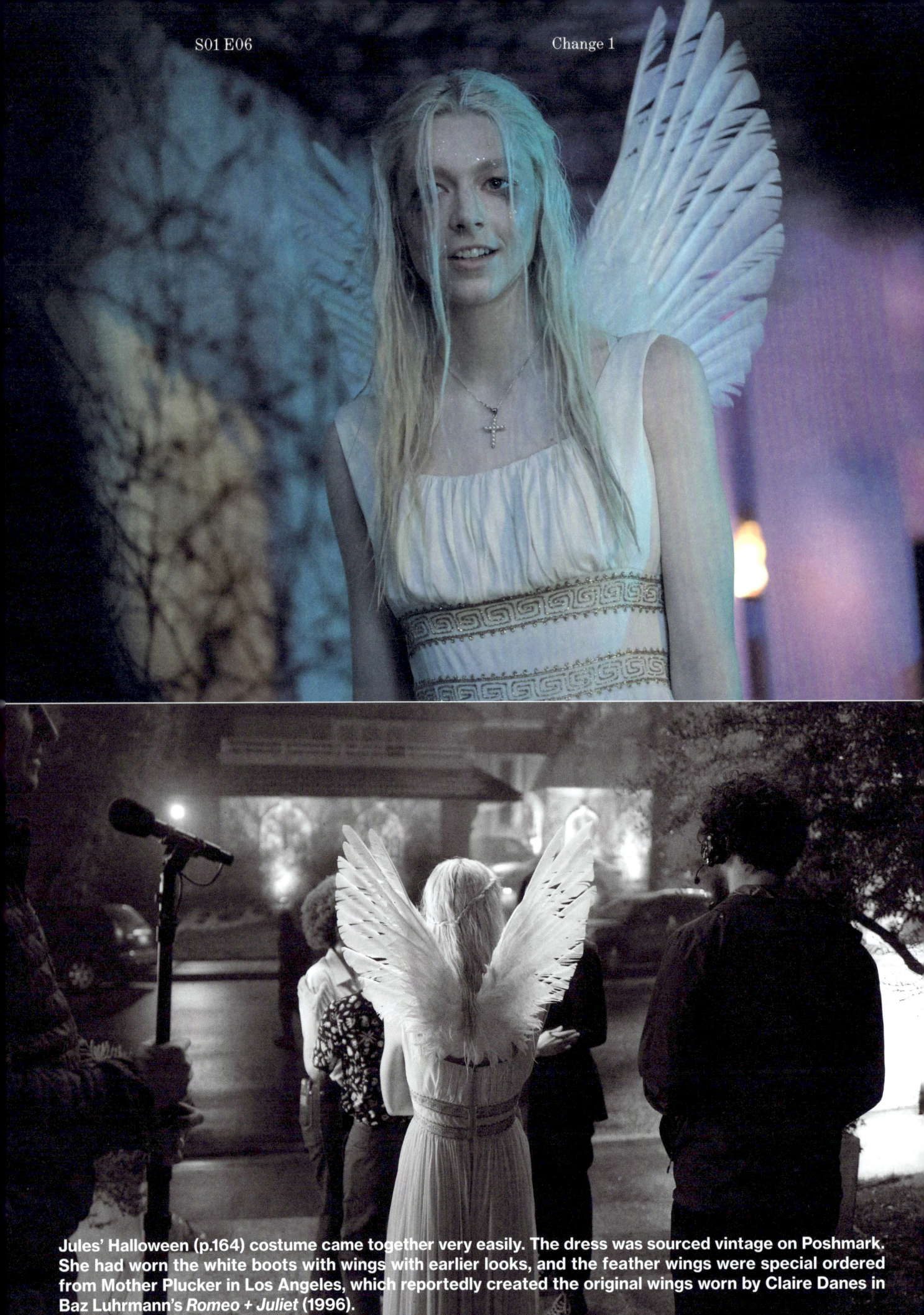

Jules' Halloween (p.164) costume came together very easily. The dress was sourced vintage on Poshmark. She had worn the white boots with wings with earlier looks, and the feather wings were special ordered from Mother Plucker in Los Angeles, which reportedly created the original wings worn by Claire Danes in Baz Luhrmann's *Romeo + Juliet* (1996).

S01 E07 Change 3

For Jules' night out in the city, she wears a Lou Dallas look by Season One collaborator Raffaela Hanley. Her designs have a boundless creativity that I imagined Jules would have if she became a fashion designer.

The different-colored cords that Jules wears around her neck were originally inspired by one that Hunter wore to a fitting.

Hunter and I had discussed the idea of her illustrating the boots with her own doodles, but we ran out of time. Television shooting schedules can move very fast, with details of looks sometimes coming together at the last minute.

This Hyein Seo jacket, a favorite in Jules' closet, first appears in Episode 106, when Jules meets up with Nate and he attempts to blackmail her. Another Lou Dallas piece—the citron ruched body harness—is paired with vintage silk pants from the '80s section at Universal Costumes.

Jules

This blue and red knit and mesh look is an example of Jules' love of unexpected layering. She chooses to pack it when she leaves town to visit friends in the city, with the intention that it's more mature than some of the school looks she usually wears.

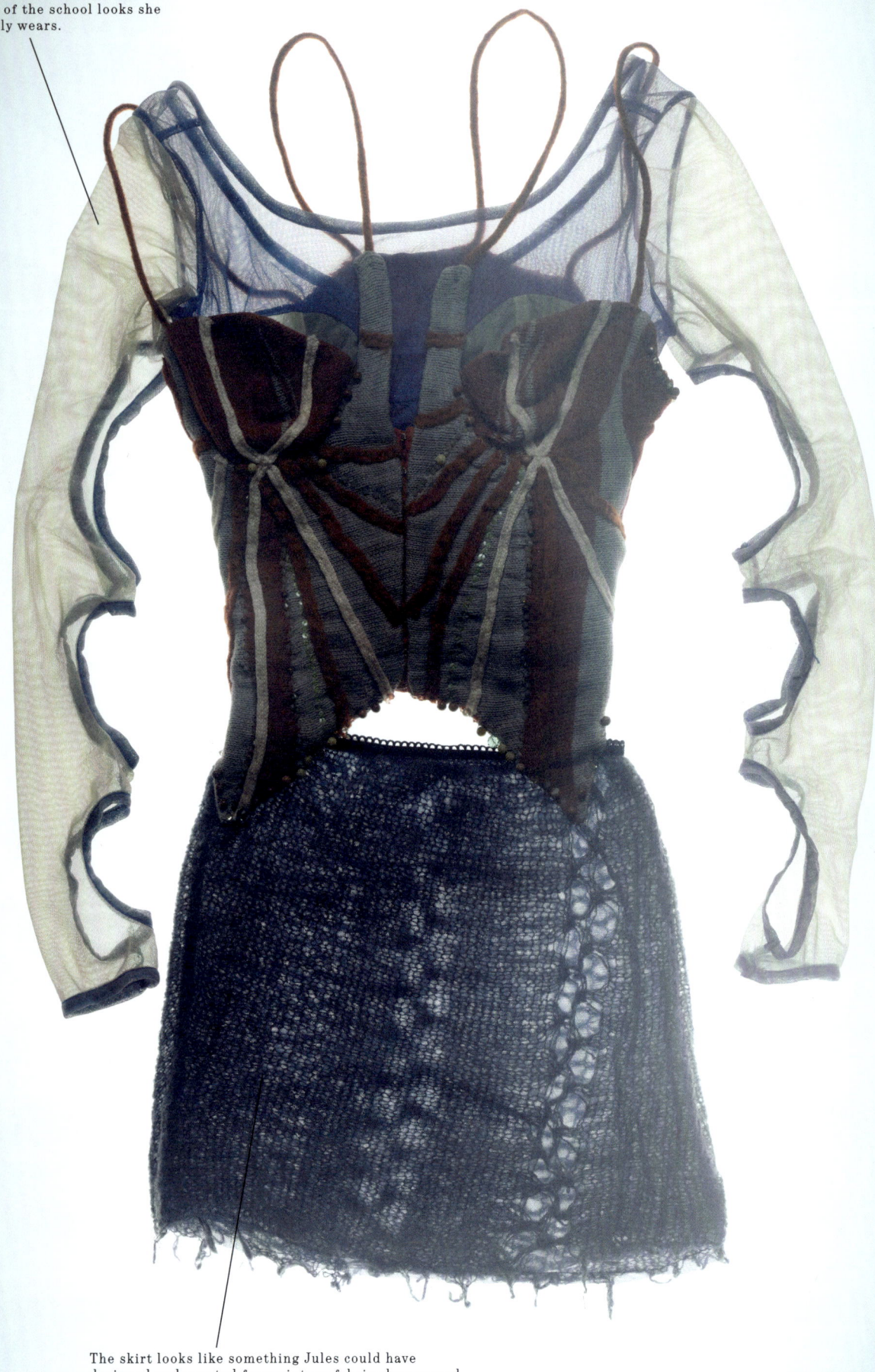

The skirt looks like something Jules could have designed and created from vintage fabric she sourced from an existing garment. I love to have a backstory for a look that the audience may not need to be privy to, but can help me construct the character's motivations about their clothing choices.

It was important to me to feature a look from the incredible designer Jeremy Scott. His designs have a youthful, inventive, iconoclastic spirit about them that I think is akin to a lot of what Jules embodies as a character. Because the scene is a fantasy, I looked to Scott's runway designs for something extraordinary and landed on a Fall/Winter 2018 printed organza set.

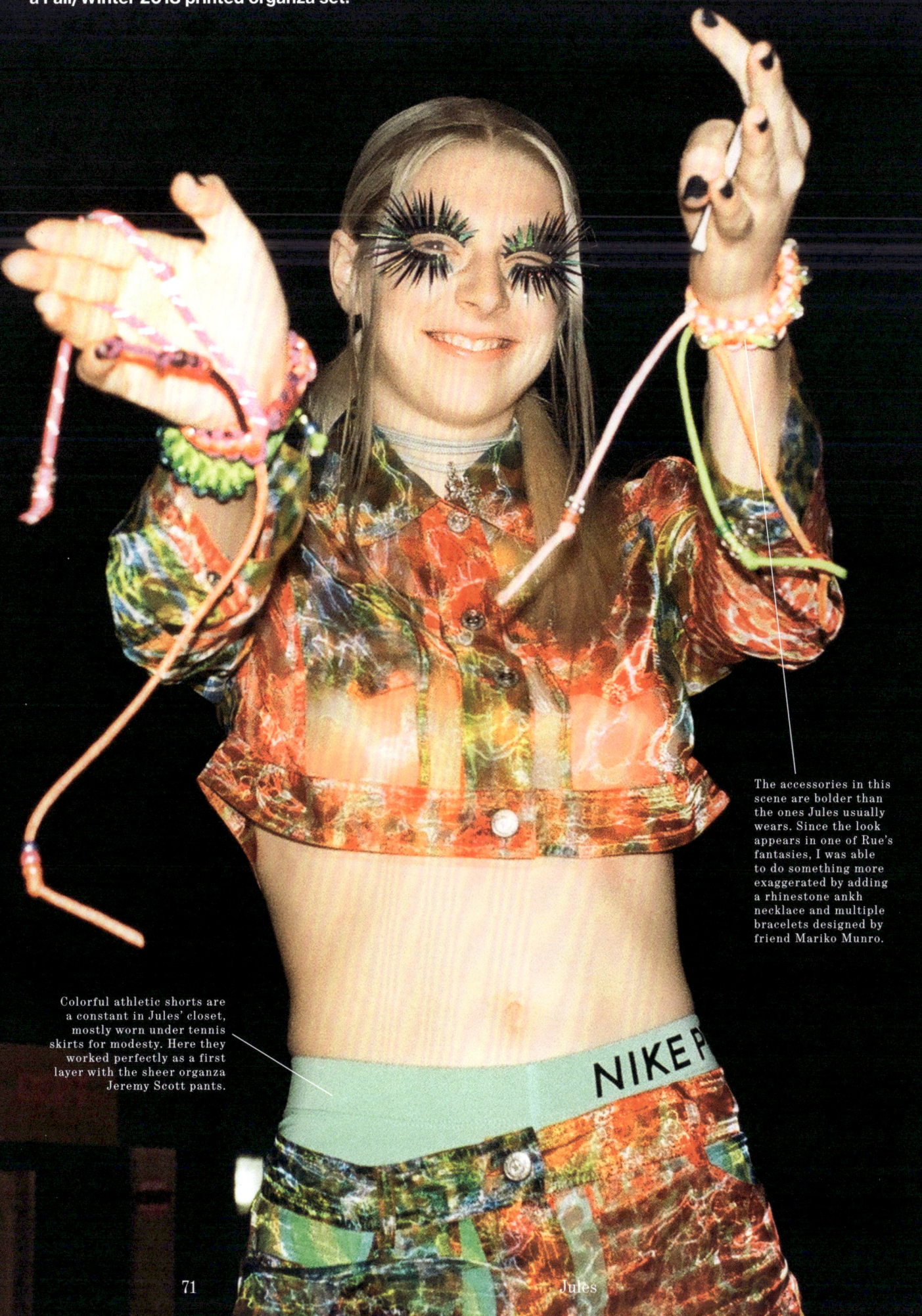

The accessories in this scene are bolder than the ones Jules usually wears. Since the look appears in one of Rue's fantasies, I was able to do something more exaggerated by adding a rhinestone ankh necklace and multiple bracelets designed by friend Mariko Munro.

Colorful athletic shorts are a constant in Jules' closet, mostly worn under tennis skirts for modesty. Here they worked perfectly as a first layer with the sheer organza Jeremy Scott pants.

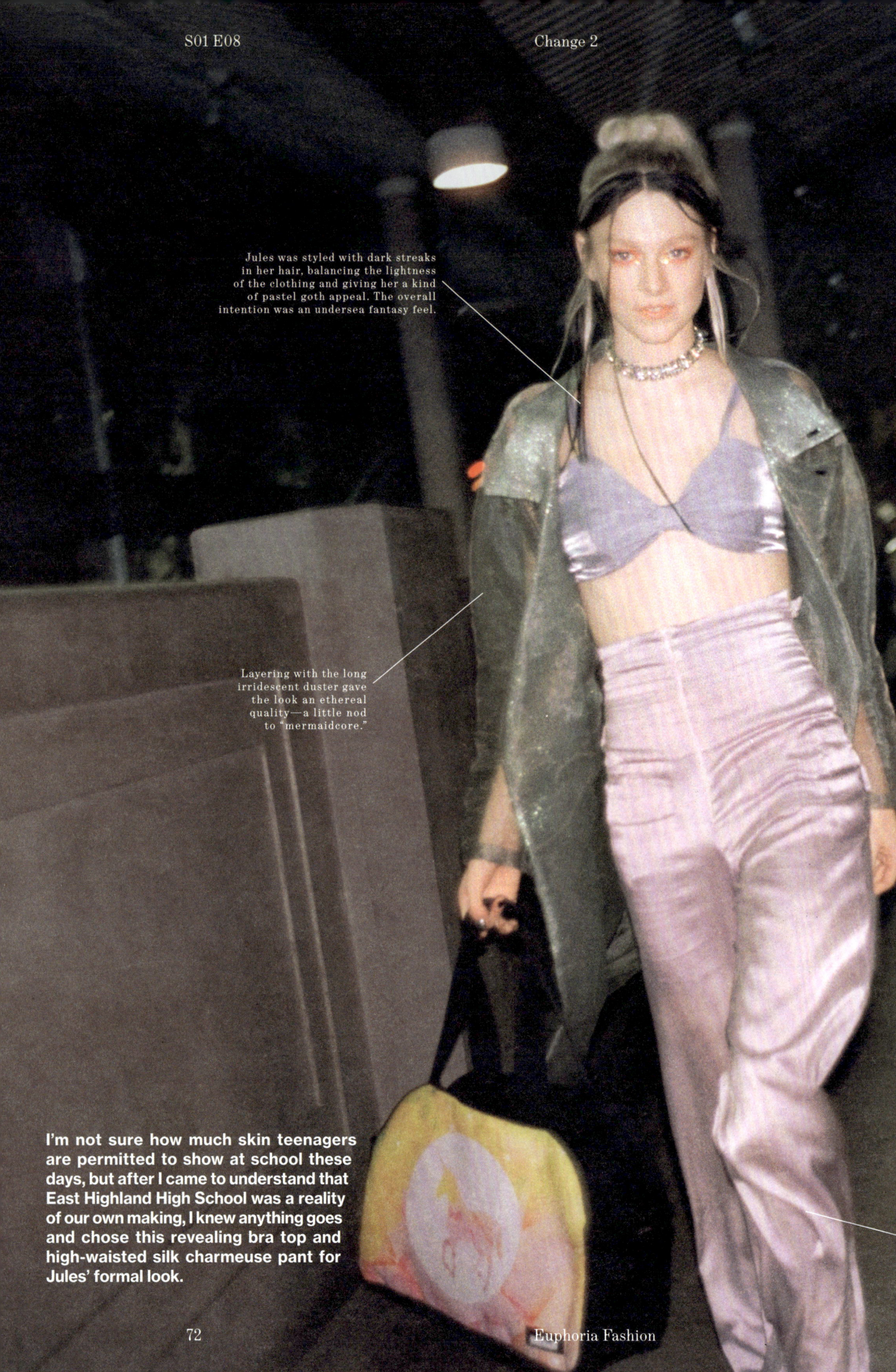

Jules was styled with dark streaks in her hair, balancing the lightness of the clothing and giving her a kind of pastel goth appeal. The overall intention was an undersea fantasy feel.

Layering with the long irridescent duster gave the look an ethereal quality—a little nod to "mermaidcore."

I'm not sure how much skin teenagers are permitted to show at school these days, but after I came to understand that East Highland High School was a reality of our own making, I knew anything goes and chose this revealing bra top and high-waisted silk charmeuse pant for Jules' formal look.

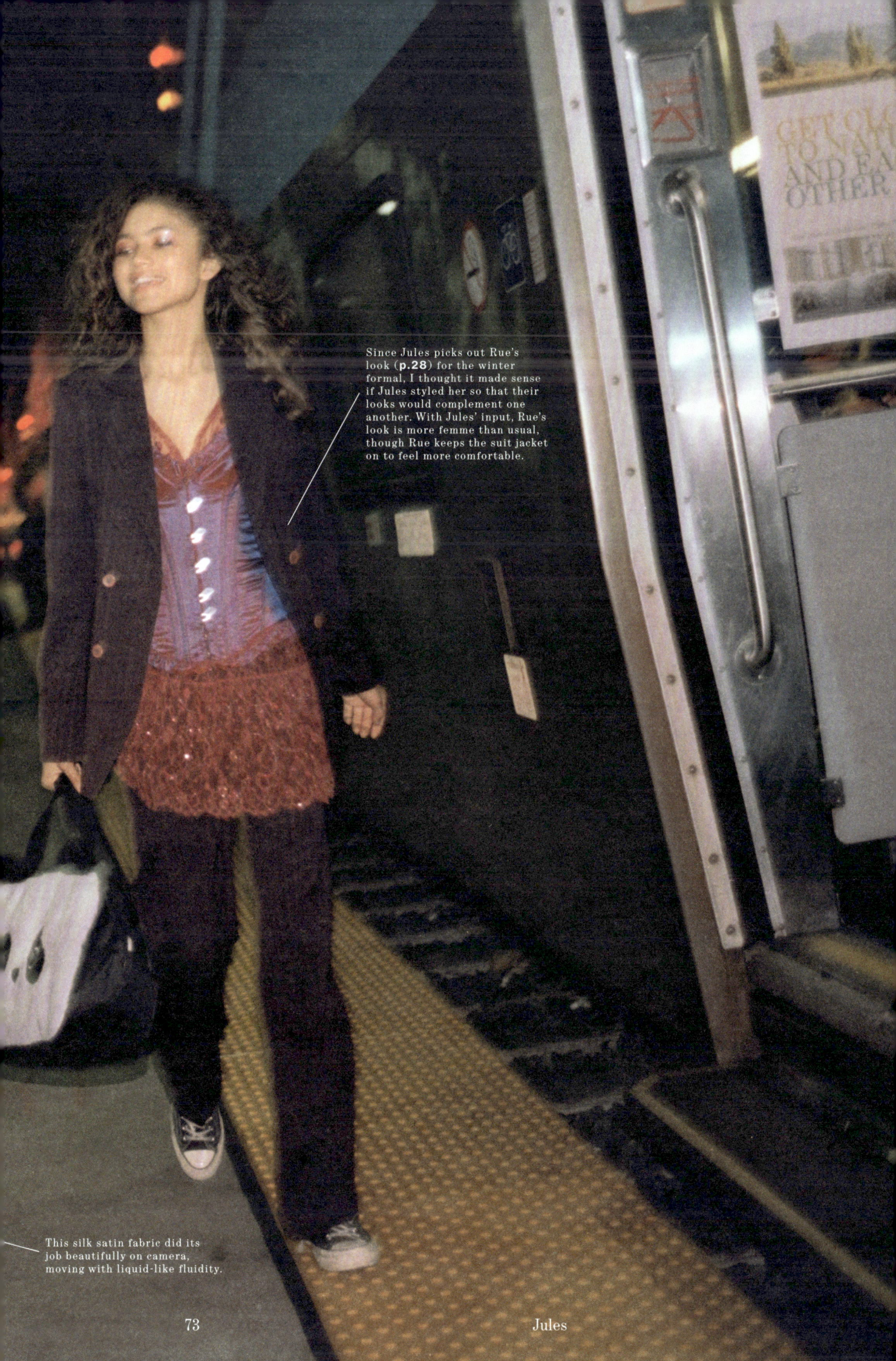

Since Jules picks out Rue's look (**p.28**) for the winter formal, I thought it made sense if Jules styled her so that their looks would complement one another. With Jules' input, Rue's look is more femme than usual, though Rue keeps the suit jacket on to feel more comfortable.

This silk satin fabric did its job beautifully on camera, moving with liquid-like fluidity.

Seth Pratt, a collaborator on the show who has helped build several looks for Cassie, Maddy, and Kat in Seasons One and Two, constructed Jules' sheer trench and completed the beaded embroidery on the back from a sketch that Hunter illustrated.

74 Euphoria Fashion

S02 E00B

Change 5
Change 6.5
Change 27

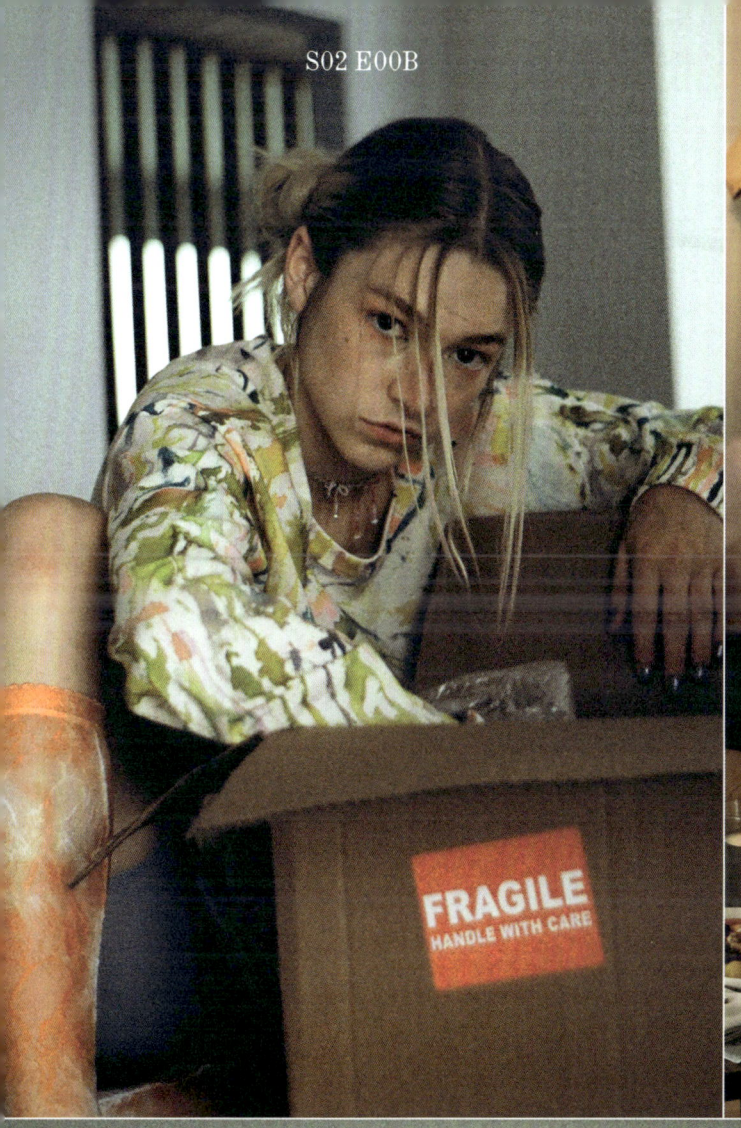
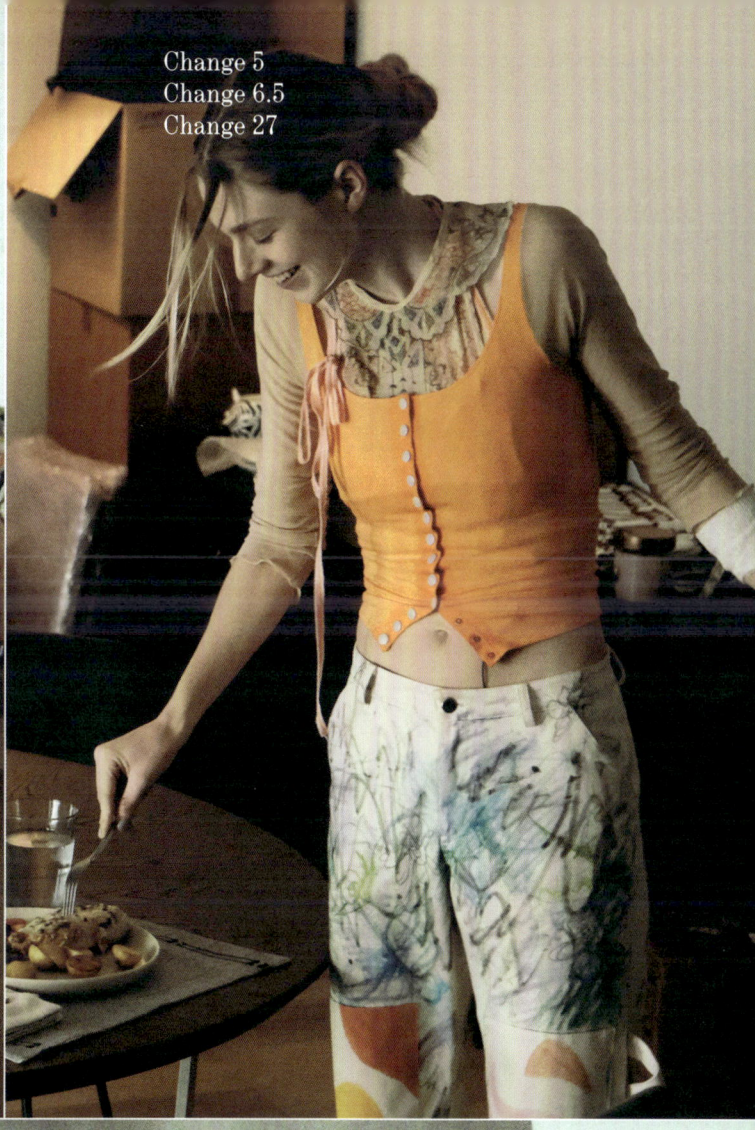
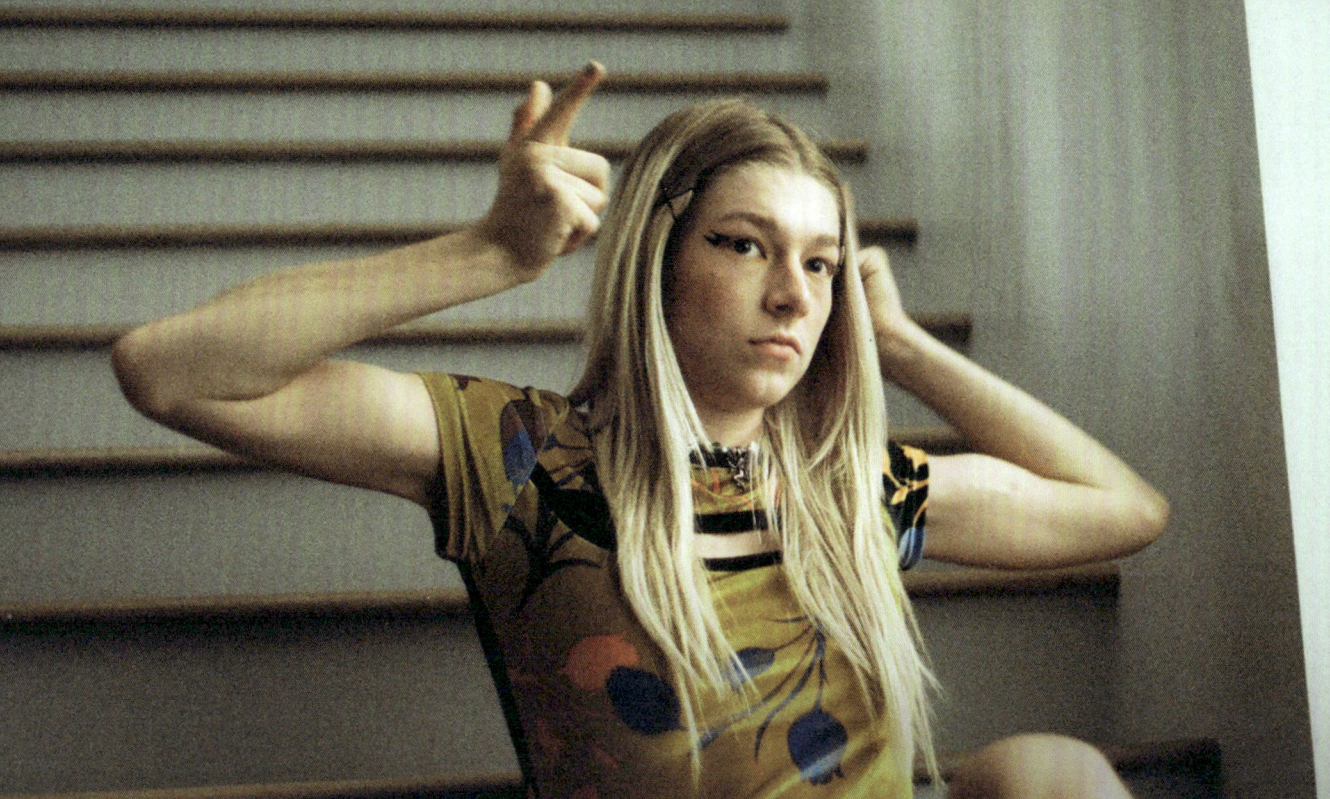

The flashback looks Jules wears in the special episode "Fuck Anyone Who's Not a Sea Blob" mainly kept to a palette of golds, yellows, and oranges to help indicate a specific time in her life — one full of hope for new experiences in a new town and for the future. It's been my desire from the beginning to highlight emerging designers who support the LGBTQ community. The velvet cut-out top Jules wears when her mother, Amy, pays her an unexpected visit is from the New York City-based, Mexican designer Victor Barragán.

Jules

S02 E00B — Change 1

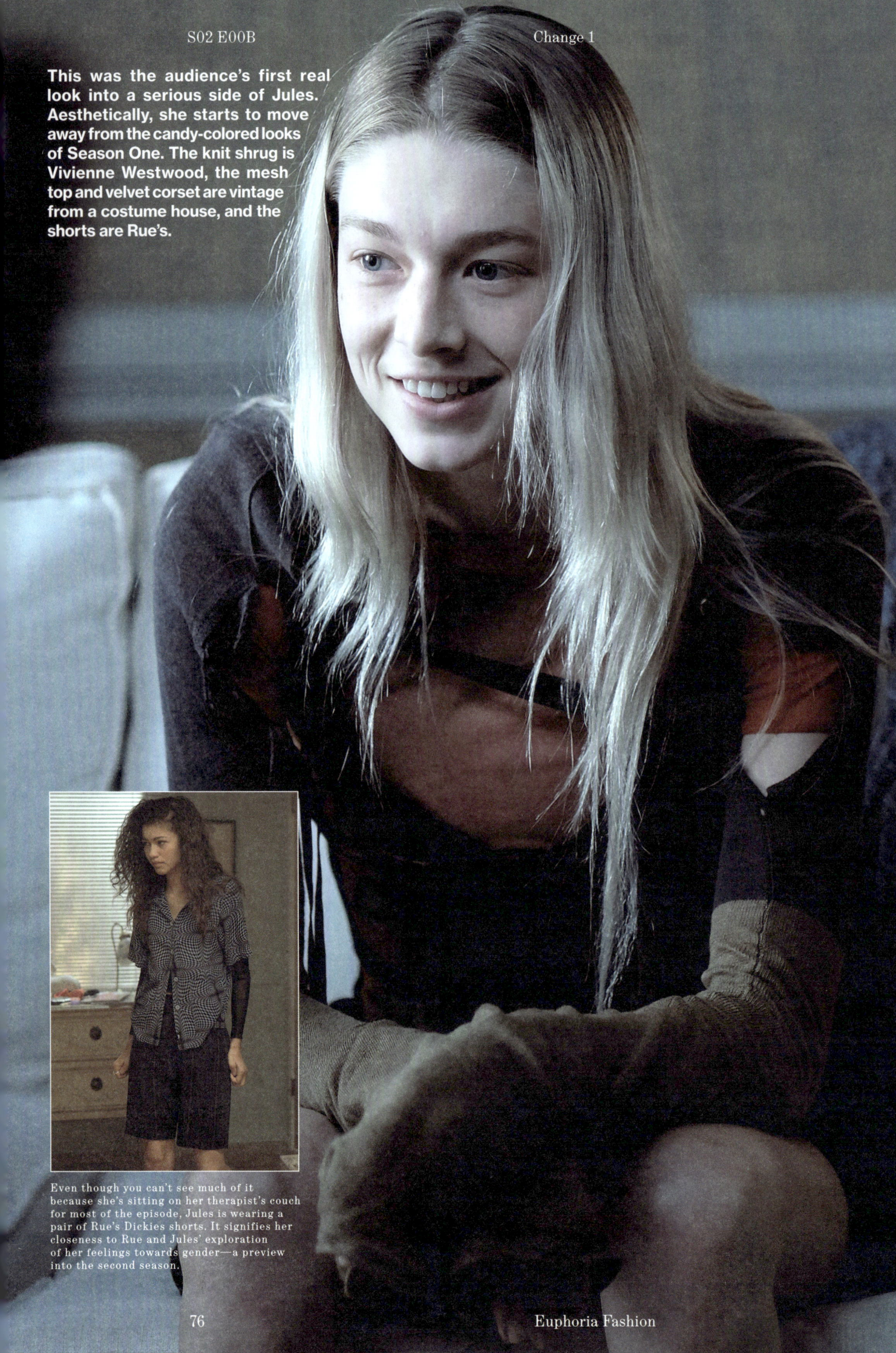

This was the audience's first real look into a serious side of Jules. Aesthetically, she starts to move away from the candy-colored looks of Season One. The knit shrug is Vivienne Westwood, the mesh top and velvet corset are vintage from a costume house, and the shorts are Rue's.

Even though you can't see much of it because she's sitting on her therapist's couch for most of the episode, Jules is wearing a pair of Rue's Dickies shorts. It signifies her closeness to Rue and Jules' exploration of her feelings towards gender—a preview into the second season.

S02 E00B Change 2

For Rue's special episode, it was clear from the script that Jules was living in Rue's fantasy. In Jules' special episode, we are in her fantasy, but Rue's look is the same. It was intentional that they would share the same vision of what their future could look like together. The fantasies are set in a New York City apartment sometime after high school. Jules' look is her idea of professional, as she's headed out the door to an interview or artist portfolio review. Her ensemble is a good mashup of her interests and feels more mature than we are used to seeing from her.

The button-down shirt is Acne and can be thought of as Jules' idea of office casual.

The pants are Ottolinger, a company that I imagine Jules would gravitate toward.

The Maison Margiela Tabi boots are white-washed in paint and echo the same treatment idea as the shirt.

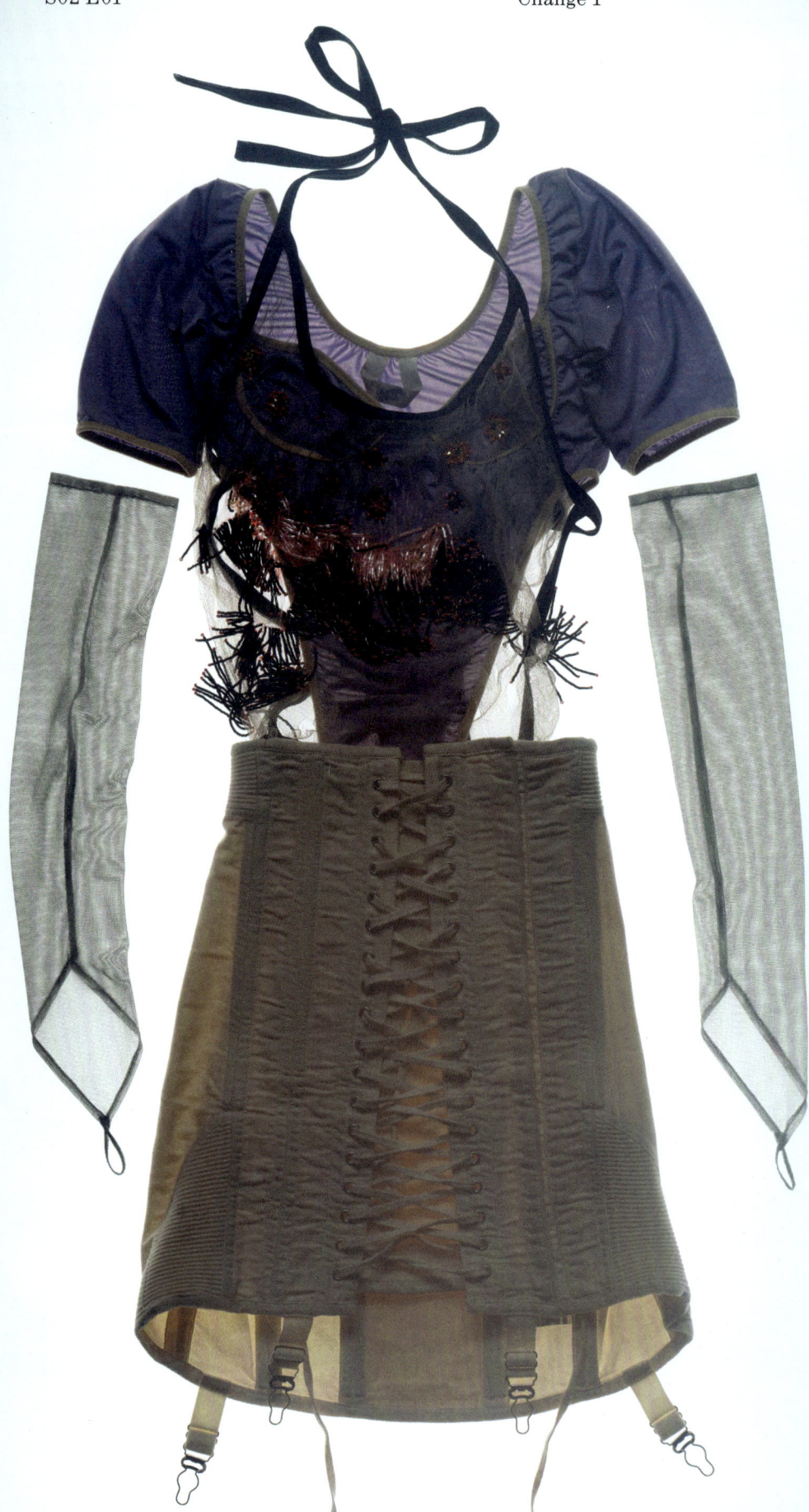

Jules' New Year's Eve (p.232) party look is one of my favorites. We fit this ensemble before production shut down for Covid, when Hunter still had long hair. The black outline of the halter, her boots, and a few more somber colors and details solidified this new idea of Jules for me – she wasn't all candy anymore. This look was a precursor to the Jules of Season Two. Because all the pieces are from different designers, it really embodied Jules' take on fashion, which is to find inspiration from lots of different ideas and then make them her own.

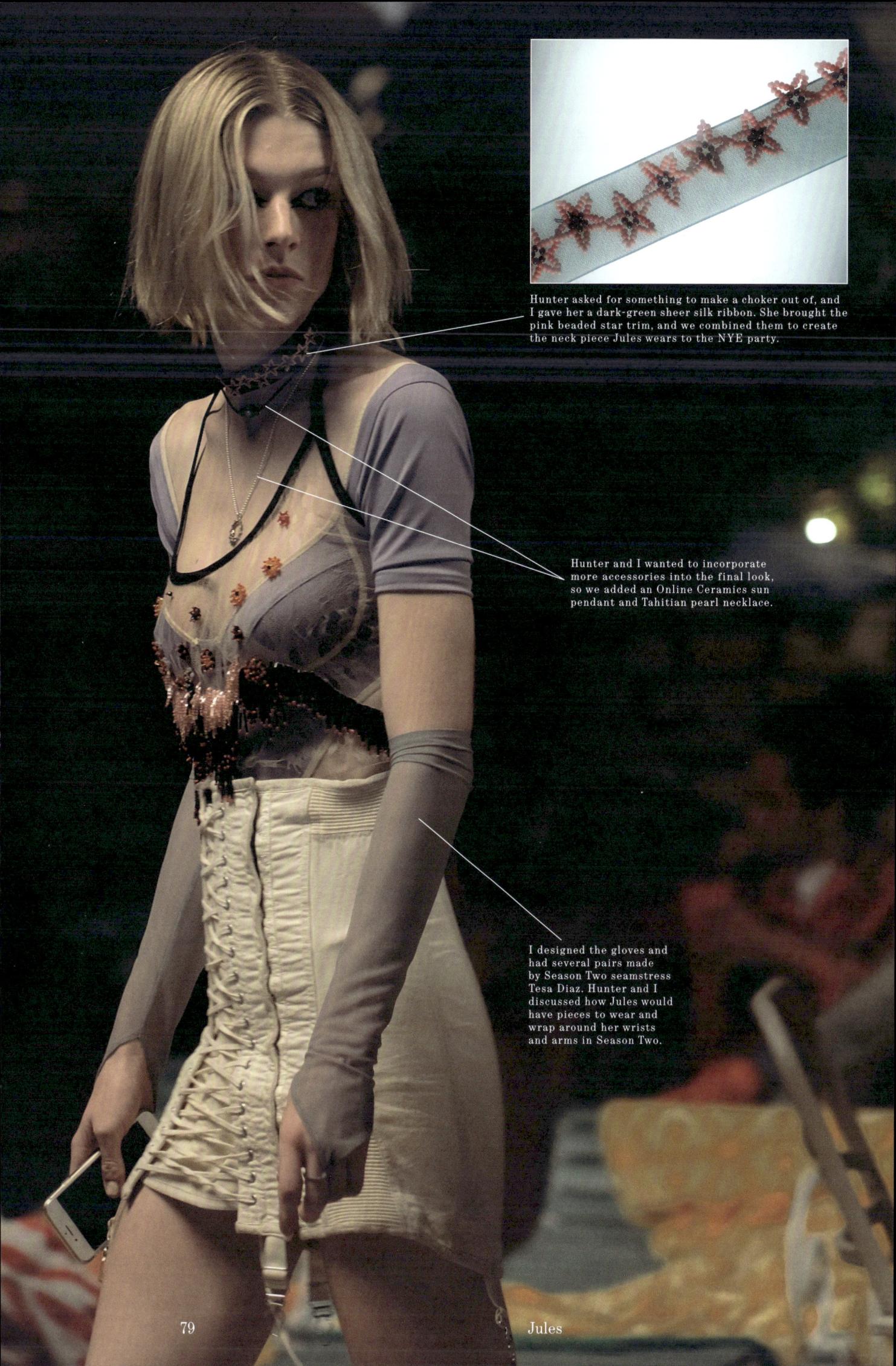

Hunter asked for something to make a choker out of, and I gave her a dark-green sheer silk ribbon. She brought the pink beaded star trim, and we combined them to create the neck piece Jules wears to the NYE party.

Hunter and I wanted to incorporate more accessories into the final look, so we added an Online Ceramics sun pendant and Tahitian pearl necklace.

I designed the gloves and had several pairs made by Season Two seamstress Tesa Diaz. Hunter and I discussed how Jules would have pieces to wear and wrap around her wrists and arms in Season Two.

Jules

S02 E03 Change 3

So much of the storytelling for me has to do with subtle color choices. Even though this look still falls into candy colors, they are more muted here than they were in the first season. When we arrive at Season Two, Jules primarily has the same closet from Season One, but we begin to see subtle shifts in palette and silhouette.

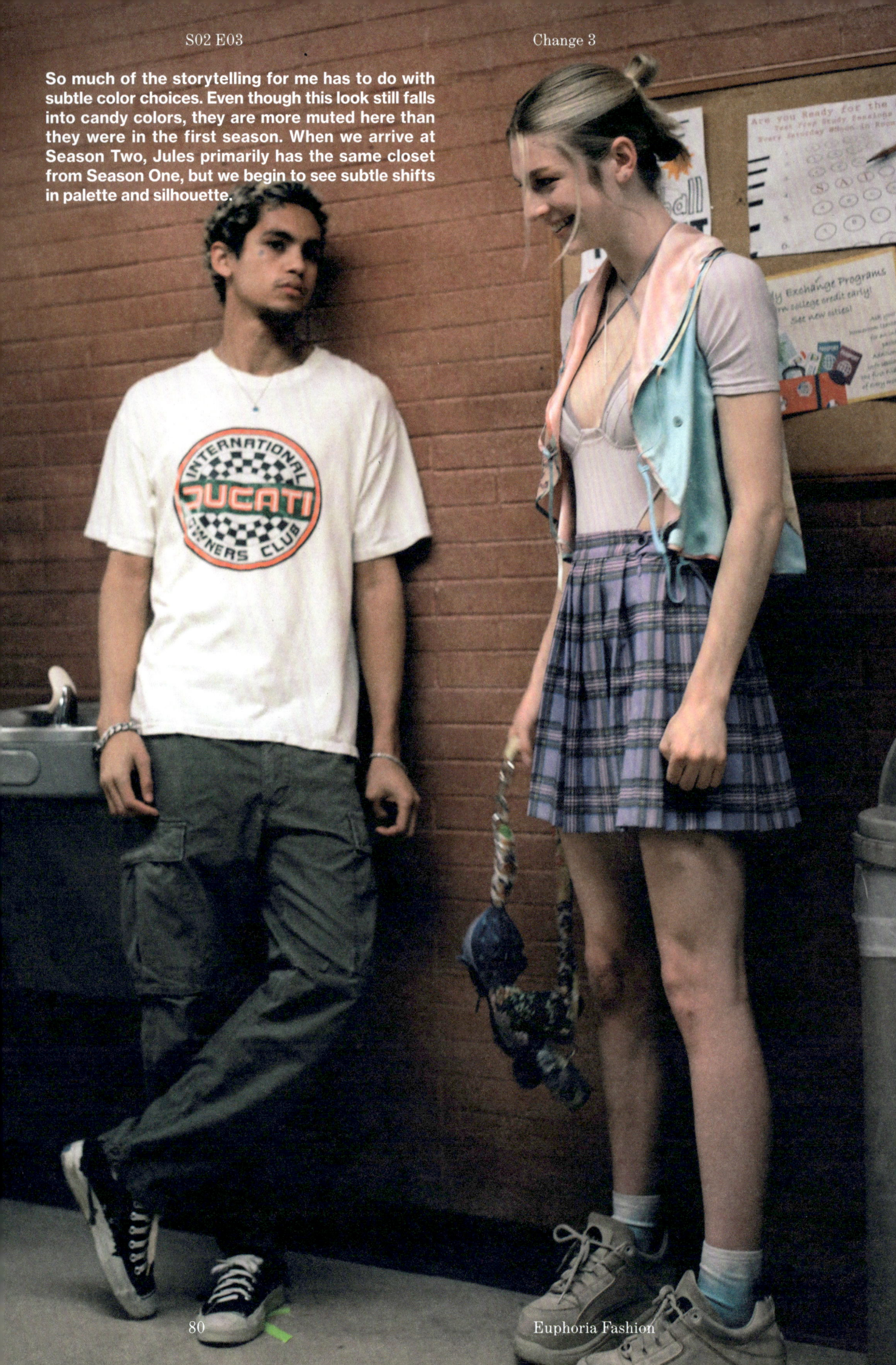

80 Euphoria Fashion

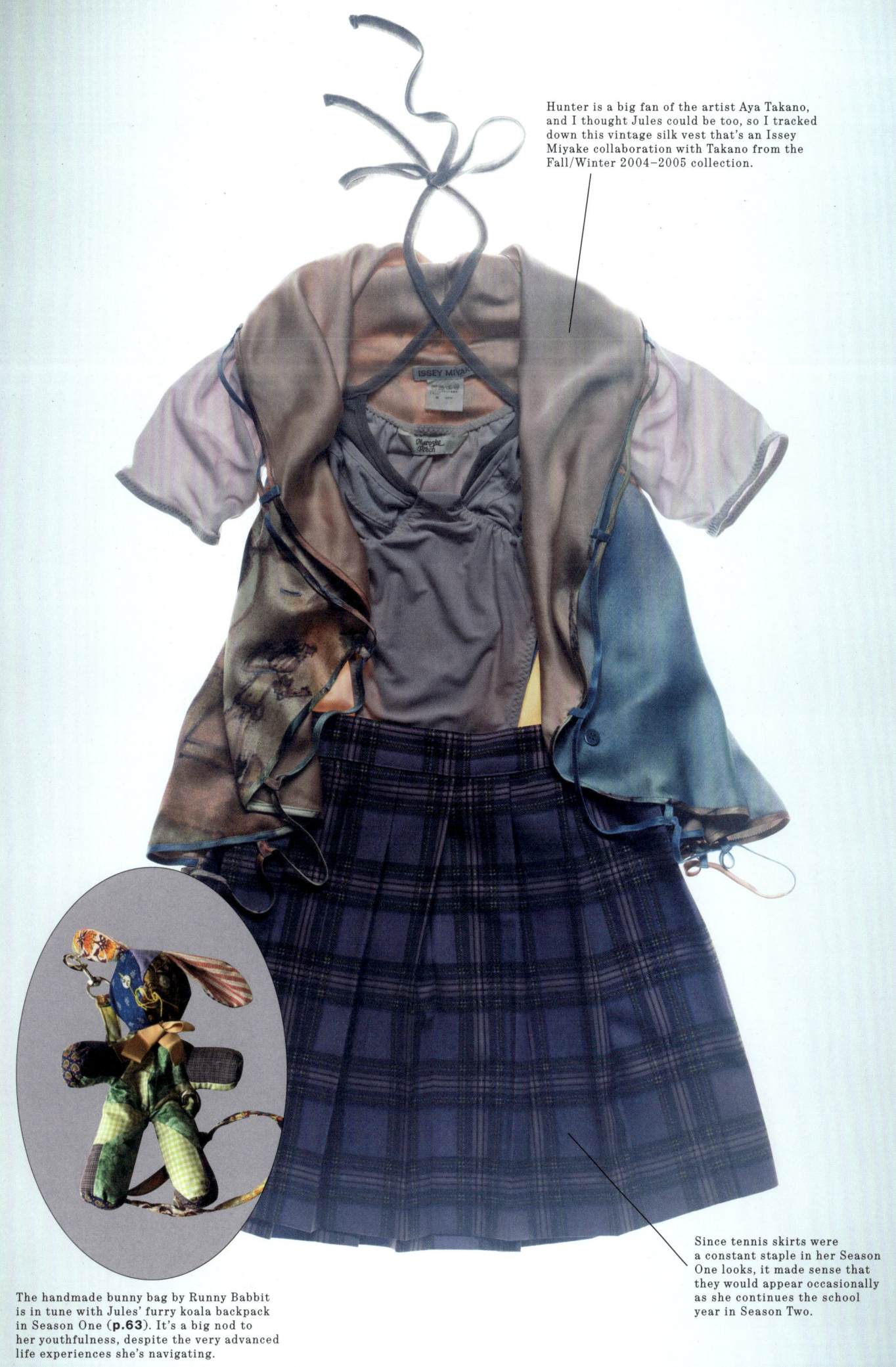

Hunter is a big fan of the artist Aya Takano, and I thought Jules could be too, so I tracked down this vintage silk vest that's an Issey Miyake collaboration with Takano from the Fall/Winter 2004–2005 collection.

Since tennis skirts were a constant staple in her Season One looks, it made sense that they would appear occasionally as she continues the school year in Season Two.

The handmade bunny bag by Runny Babbit is in tune with Jules' furry koala backpack in Season One (**p.63**). It's a big nod to her youthfulness, despite the very advanced life experiences she's navigating.

81 Jules

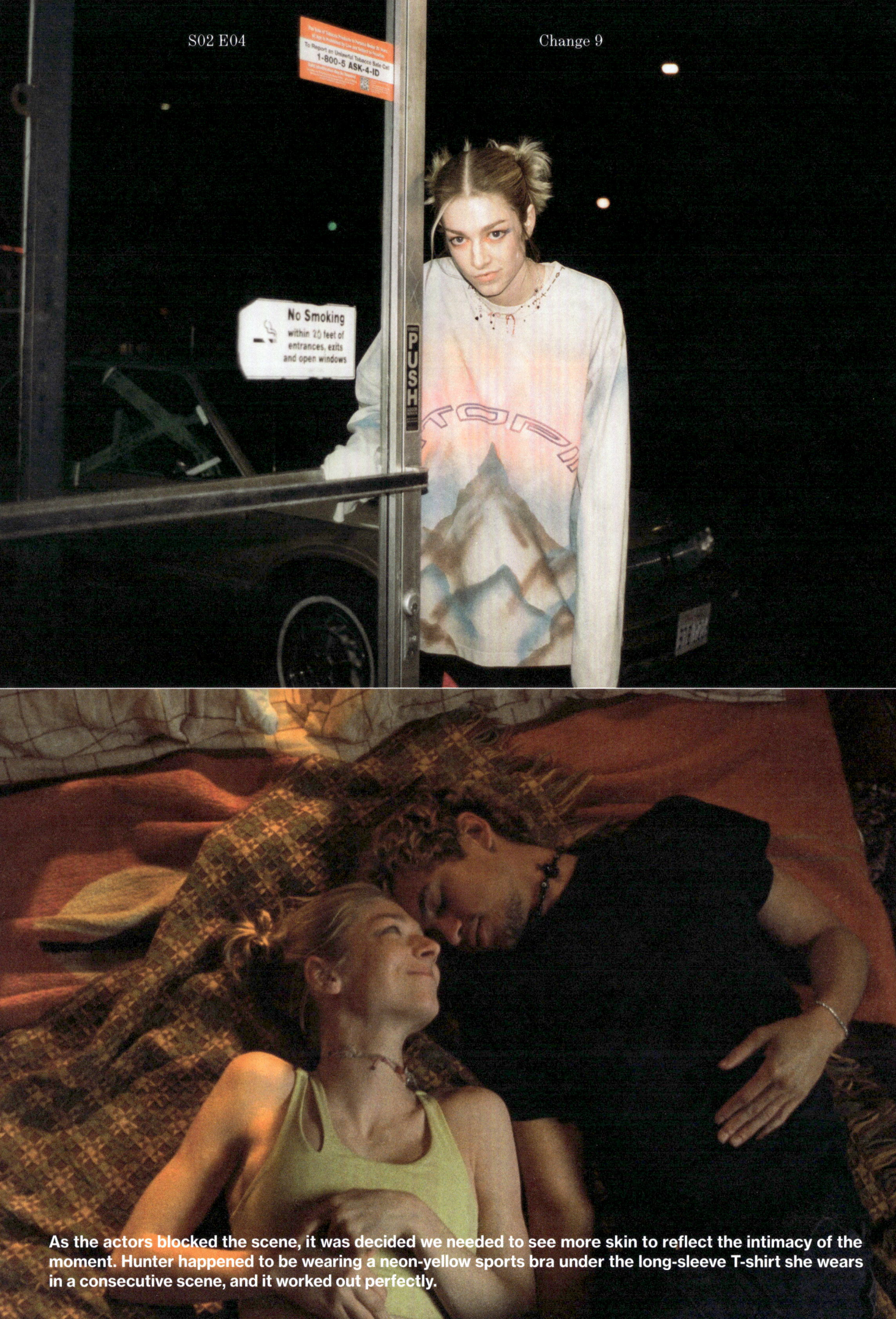

As the actors blocked the scene, it was decided we needed to see more skin to reflect the intimacy of the moment. Hunter happened to be wearing a neon-yellow sports bra under the long-sleeve T-shirt she wears in a consecutive scene, and it worked out perfectly.

S02 E08 Change 1

I wanted to make sure what Jules wears in the audience for Lexi's play (p.254) would stand out in the crowd. I chose a tank dress by the fashion designer Gogo Graham and a vintage dip-dyed cashmere cardigan from ABC Costumes in Los Angeles.

The illustrative quality of the design on the dress is a recurring theme for Jules, like the hand-drawn jeans she wears in Season One.

The bright coral-pink cardigan guaranteed the audience would notice Jules in a wide shot, and the cashmere texture is warm, cozy, and inviting.

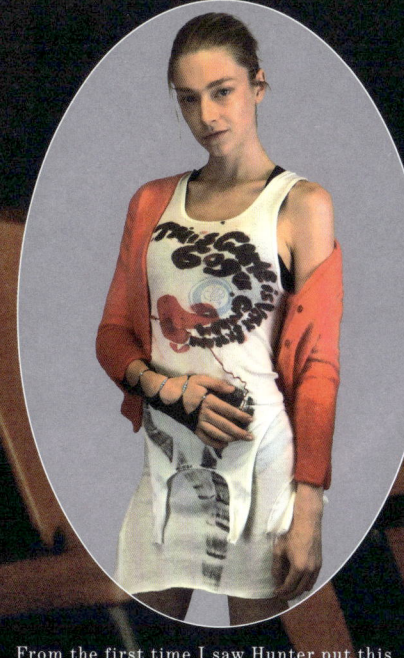

From the first time I saw Hunter put this on, I knew I wanted to use this hand-crafted Gogo Graham dress. I love that it is made from piecing ribbed tank tops together.

JULES WAS THE BEST THING THAT EVER HAPPENED TO THAT TOWN

HUNTER SCHAFER IN CONVERSATION WITH HEIDI BIVENS

HB The collaboration between us was so easy—it felt natural from the start. I talk a lot about trust, and the trust was there between us. You were feeding me ideas all the time, which was so helpful to keep us on mark because you're the one that is playing the character, feeling the emotions. You're the one that has to stand in front of that camera and be that character.

You made me better, and I credit you—and so much of the cast—for the success of the costumes. I often think about how if it was a different cast, it would've been a completely different show. It had everything to do with the ensemble. But in creating Jules, I think the fiber of her has so much to do with you.

HS That's what's beautiful about your process in particular: the work environment that you create and maintain is one of collaboration. You want to hear everyone's ideas. It changes the performance. You can tell when someone is wearing a costume they were just handed—it feels more one-dimensional as opposed to if you've had a conversation and really applied thought, debate, and ideas. For every look, we're thinking about what Jules is going through at that moment and what article of clothing might make sense for this reason. I remember we talked about her wearing a hoodie for two weeks, because hoodies weren't really her thing. But then you found this amazing orange crochet one… (01)

(01) Hunter, behind the scenes, in the orange crochet hoodie.

HB There are certain rules that I set up for myself, parameters for each character so they have their own look and don't start to blend into each other. There are times where we'll deviate from that based on a conversation and an understanding about character development and emotionality. I think having that open dialogue with you made it that much easier to create an authentic character.

HS Jules is a challenging character, costumes-wise, because she has this visual arc. We meticulously planned out these arcs that lasted through both seasons around where her style is heading and why. Moving away from something super high femme to slightly more androgynous, to Season Two where she has some pretty boyish looks. It's pretty true to life that in high school you can move through different styles when you haven't found your "uniform" yet.

HB I would think about how Jules would feel when she was getting dressed in the morning, that day of the story. Anyone doing the job of costume design—waking up, thinking about all the things you have to do, the people you're going to see, what kind of headspace you're in—can locate that in their personal experience. It plays into what you pick up to put on that day.

I loved our approach. It was also so exciting to learn about so many new designers from you. It was really important to me to represent trans designers in a meaningful way on the show, and I remember you bringing that Gogo Graham dress to a fitting. I had planned it for so many scenes

that were eventually cut from the script. But I was determined for it to have its moment, and then it became obvious to me that the play at the end of Season Two was the best place for it (**p.83**).

So your contribution to the costumes went far beyond just mood-boarding or sending ideas my way. You physically brought clothes that we ended up using on the show.(02) And I've talked before about how you would come to set some days when you weren't working, just to visit, and you'd be wearing something that just looked so amazing, and I would stop you and ask what you were wearing. It was like I was shopping off of you.

(02) Jules wears an Airwalk tee sourced from Hunter's closet, Episode 104.

HS In the world of *Euphoria*, everything is hyper-real, but you have a way of grounding the clothing. In some movies or TV shows, everything looks like it was bought off the rack and hasn't had much of a life. But your work has a groundedness that's really refreshing—the vintage pieces you found were insane, and even the shitty T-shirts that Jules wears in her bedroom.(03) It doesn't feel like we just went shopping and then stuck it on Jules.

HB It's the method way of building a closet, which is how people build their closets in real life—you don't get everything from the same place, and you build it over time. There might be some jobs that call for a character who only gets their clothes at one store, but that's going to be rare. And you definitely helped me accomplish that by loaning us some of your personal clothes.

HS At first, Jules and I started off with very parallel styles. Everything we pulled for the pilot (**p.12**) was something I wanted in my own closet. I was 19 when I first played her, and I'm 23 now, and my style has matured, and my circumstances have changed. I have access to different things and different kinds of clothes than I did at that time. I also just have a different relationship to clothing now. It feels less decorative, and I don't care as much anymore. Maybe because we get to play dress up all the time for our jobs, and that itch is very consistently scratched. There's a level of playfulness that Jules has hung on to—making cute outfits is one of her main sources of dopamine. I still like to be playful, but not in my everyday life.

(03) A mix of sources for designer pieces grounds a character's closet, Special Episode Part Two.

HB Do you remember the moment you realized the show could have the impact it has had?

HS When we were shooting the first season, we knew there was nothing really quite like it out in the world at the time. We knew what we were doing was special. But after Season One came out, I understood that the show had a much larger reach than I anticipated.(04) It really hit me when fans started coming up, particularly other trans people, because there just aren't that many trans people in media, and the interactions are always, to some degree, emotional. Even with Season Two, there's a new level of reach, and I felt this massive change...did you feel it?

HB While we were making the first season, I was just keeping my head down and doing the work, and I wasn't necessarily thinking about the results. After the first season aired, I started to understand the potential of the show, and I got excited about the second season because we could do something even bigger.

HS I know it was different for you. For Season One we had to ask designers for stuff, but by Season Two there were people coming to you…

HB You've always made it easy—everyone wants to dress you. Actually, I was curious about how you feel about fashion now. Even before the show, you were modeling and doing runway, and you were planning on going to fashion school before you were cast on *Euphoria*. What is it about fashion that has always made it a creative outlet for you?

HS It was one of my first loves, honestly. Art and drawing was probably my first love, but then fashion was really connected to it. It became much more important to me when I started approaching the part of life where I was more conscious of my body and how it was growing, then trying to take control of how I was perceived and how I presented myself. I found a lot of power in fashion as a tool at that time.

(04)

"Even as a kid, I was trying to create feminine silhouettes," Hunter explains. Still from Episode 101.

Even as a kid, I was always very specific about silhouette. I didn't know it then, but now I realize I was trying to create feminine silhouettes with basketball shorts and T-shirts because I was really specific about the way they fit. When I was in elementary school, I wore basketball shorts every day and I liked them loose, baggy, and flowy like a skirt. I would wear them with really tight-fitting T-shirts. And then, I would wear a monochromatic outfit that would really resemble a dress.

That's an example of how fashion is a powerful tool, and that's the root of my emotional connection to it. But designing, in general, I see as another form of art. I wanted to be a creative director of my own house or another house before *Euphoria* and acting happened, and now my life looks completely different than I ever thought it would. Once I've phased out of the acting I think I still want to try and tackle fashion design. I miss devoting time and energy into making clothes. It's such a beautiful process, having fun with that power that fashion gives you. Do you have early memories where you found power or a special feeling with clothes?

HB I understood early on how making decisions about what you put on was communicating something to the world. I understood the power of navigating different groups of people by choosing whether to stand out or not. I'm sure that feeds into the work now. But you're so instinctive. At the beginning of Season One, you put together mood boards, which were so helpful. Do you remember the initial references for Jules?

HS I was so excited about making the mood boards because in our meetings before the pilot, you wanted to hear if I had any ideas. I really ran with that offering.

HB When I look back on them, I see the groundwork we created—the high femme, juvenile style. And for me, the main inspiration was anime and the idea that Jules would look like something out of a beautiful manga[05]— just otherworldly and out of place in East Highland. Jules was the best thing that ever happened to that town.

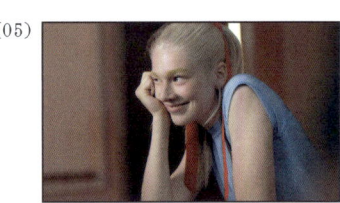

(05) Sailor Moon and other anime characters were early inspirations for Jules' look, Episode 101.

HS Anime is integral to what I tried to emulate in my everyday clothing—even silhouette-wise. I remember making that mood board and daydreaming about what you were going to pull. In the first fitting, I was enthralled that you had access to all of these clothes and that I got to try them on because I didn't have the money to be wearing Eckhaus Latta shirts—even those American Apparel skirts that were $50. That fitting was four hours. We tore it up.

HB What pulled you in when you first started watching anime and reading manga? It has such a feeling of fantasy.

HS In my childhood I was struck by how androgynous the male characters in particular were. I could say I was dressing like a boy, but an anime boy. I used to watch *Pokémon*, and Ash (the main character) had hair that was all spiky and cute.[06] I was always so pissed that my hair didn't do that. The level of fantasy and the way anime characters are styled and dressed usually defy a few laws of physics, which is really exciting. Do you watch anime?

(06) The *Pokémon* crew: Misty, Ash, Pikachu, and Brock, 1998.

HB I think *Belle* is one of my favorite films that I've seen in a very long time—it's gorgeous. I was so thrilled to see that you voiced a character. You're an amazing artist—voicing characters, writing the script for the Jules special episode with Sam Levinson, and I recently watched the music video you directed.

HS The *Euphoria* set is basically like free film school if you pay attention to everything that's going on.[07, 08] I'm lucky in that I've developed a really beautiful friendship with a lot of the creative people on the show, and that companionship allows a lot of room to learn and grow from working with them. Jumping into acting and then making a home there, then producing that episode with Sam, and then writing… all of those approaches fit well into what I do as an artist.

(07) Sam and Hunter discuss a scene during production of Season Two.

I'm still writing scripts and have ideas and dreams of what movies I can hopefully make one day. Music videos are a great place to start because anything goes—it's a perfect format to experiment as a first-time director. Immersion in the film world has been artistically fulfilling at every step. But it's that feeling you get when you've made something—it's a yummy warmth or contentedness. I'm just following the feeling. It's a feeling worth chasing.

HB I think one of the signs of a successful director is when they take the freedom to imagine boundlessly. It's this idea that when you're

coming up with a story or a visual idea of the world you want to create, that you're not thinking about any constraints. You're not thinking about budget, you're not thinking about what is possible and what's not possible.

That's one of the reasons why I love animation, because you can write and create in this way where you're not having to think about any boundaries of what's possible. Anything's possible. To be able to do that with live action is such a feat. You're right about this idea of being on the set of *Euphoria* as a crash course in cinema or in directing, because Sam has such a limitless mind when it comes to what's possible. He and Marcell Rév together, they just don't accept no as an answer to what's possible.

HS It's really inspiring just to be around them. I've picked up on that mindset and have been able to apply it elsewhere in my life, where I throw an idea out there and someone laughs because it's so crazy. But no, I'm serious, I'm dead ass. Let's fucking make it.

(08)

Hunter biking behind the scenes, Episode 108.

ODE TO:

THE TENNIS SKIRT

there was no reason to exclude women from the game. But the separate spheres of men's and women's athleisure required comically heavy dress for women on the courts: corsets, petticoats, high collars, low heels, and long, sweeping skirts. In 1884, Maud Watson, the first women's Wimbledon singles champion, scored her victory under the bulk of a bustle skirt of white linen.[01] Her hefty tennis whites (a strict rule at Wimbledon) were less likely to reveal sweat, which women weren't supposed to do.

Slowly but surely, the impracticalities of the Victorian tennis skirt were addressed. In 1880, an item called a "skirt lifter" hit the market for women who wanted to temporarily lift up the floor-length tennis skirt during play. Ads for special tennis aprons (which included a pocket for the ball) ran in *Harper's Bazaar* around 1881. By 1896, some women wore knickerbockers (baggy knee-length underwear) under their skirts, but fashion magazines recommended petticoats for less cling. In 1899, *Vogue* noted a short skirt about four inches off the ground would be most sensible. But every inch mattered. When the American May Sutton played at Wimbledon in 1905 in an ankle-length skirt, the match was halted at her opponent's insistence that her skirt be lengthened. She won anyway.

But that early tennis skirt had crossover appeal. *Vogue* editors listed it as part of a fashionably correct ensemble for a woman of moderate income when visiting the newly minted "American Riviera" resort scene along the Florida Coast—an affordable way of passing available to young women who were not as well-off as the skirt would imply. In 1912, a white pleated version was popularized when the young French champion Marguerite Broquedis wore a tennis

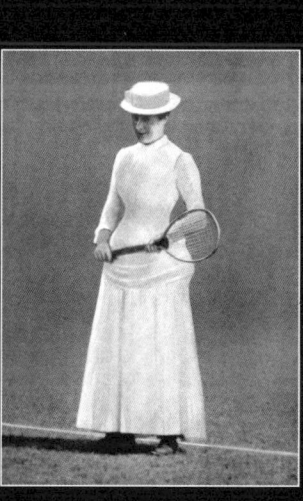

Maud Watson, the first Wimbledon ladies' singles champion, 1884.

skirt of white voile with knife pleats all around.(02) More remarkably, the skirt was worn without a petticoat and was lightly transparent. This perfect fusion between appropriateness and sex appeal would continue even as the hemline inexorably rose.

By the 1920s, fashion magazines embraced women tennis players as icons of independence and empowerment. In 1914, French player Suzanne Lenglen(03) hit the courts in her first championship game at age 14 and, following WWI, rose to fame with bobbed hair and was known for wearing "short" skirts as well as smoking and drinking cognac on the tennis courts. Lenglen played hard—she was the first woman to serve overhand—and was expressively angry and competitive on court (most people ate it up). In 1926, when she swept the United States as a full-on celebrity, she brought 11 trunks of clothing designed by French couturier Jean Patou. And so began the association between tennis and the iconography of a peculiarly appealing type of sports star, one whose athleticism was tempered by a preoccupation with contemporary women's fashion.

By the 1930s, the tennis skirt was perfected in the context of the crisp, functional country club weekend look that became a quintessential part of American style. For wives, it was tennis skirts at the club with two rackets in one hand and a stiff drink in the other. Their college-aged daughters took up the tennis skirt when shorts were banned on campus. At an inch above the knee, they were the shortest skirts on the market.

The tennis skirt remained a staple of activewear and resort wear well into the 1950s, when it gained a well-publicized and devoted couturier in the form of Teddy Tinling. He caused a scandal at Wimbledon in 1949 by adding lace trim to the panties under tennis star Gussie Moran's skirt, which enticed photographers to capture "upskirt" photos. He was duly banned from the courts for a time. Tinling's tennis skirts broke with the form in other ways too: his skirts had color, novel

Marguerite Broquedis and Suzanne Lenglen, 1914.

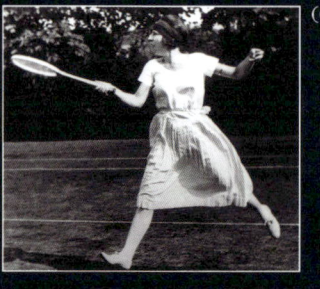

Suzanne Lenglen in action, 1921.

Ted Tinling with models wearing his tennis dresses, 1970.

A Willi Smith skirt for Digits, Fall/Winter 1972.

Naomi Campbell in Chanel, Spring 1993.

trims of little rackets or poodles, and other nods to current fashion trends,[04] but they were still suitable for vigorous sport and worn by champion players. And if a champion's dress got attention, he made a version for the retail market, claiming that his special gift was that he could make a dress suitable to be "viewed by millions at every angle, when the girls wearing them are hot, tired, and often wringing wet." His tennis skirts could make even sweaty athletes pretty.

By 1968, tennis moved beyond the confines of the country club, when women players took on professional status, and the cigarette brand Virginia Slims became a promoter with countless magazine ads. Tinling designed custom looks for the women who played under Virginia Slims sponsorship, including a tennis dress in "menthol green." By 1975, *Women's Wear Daily* acknowledged that Tinling was "largely responsible for developing active sportswear as a fashion classification." As his era ended, several American designers rushed into the 1970s tennis market, with Calvin Klein, Anne Klein, Ralph Lauren, and Willi Smith[05] all producing designer tennis skirts. It was the polyester micro mini era, and, as had always been the case, the skirt's feminine profile made the workout-to-walkout transition seamless. A fashion icon was cemented.

As activewear began to infiltrate high fashion in earnest in the 1990s, the tennis skirt's pedigree as a component of the proper lady's wardrobe made it an easy pivot for French and Italian luxury houses.[06] It could be used to integrate the unstoppable juggernaut of athletic dress into collection pieces that sold at opulent price points. Meanwhile, the accessible activewear tennis skirt stayed on the market in ever brighter and more eye-catching variations while retaining all of its easy-moving, twirly elegance. There's a reason the tennis skirt has persisted for over a century and occupied a space in the closet of anyone who wants the promise of femininity under stress or sweat, without compromise.

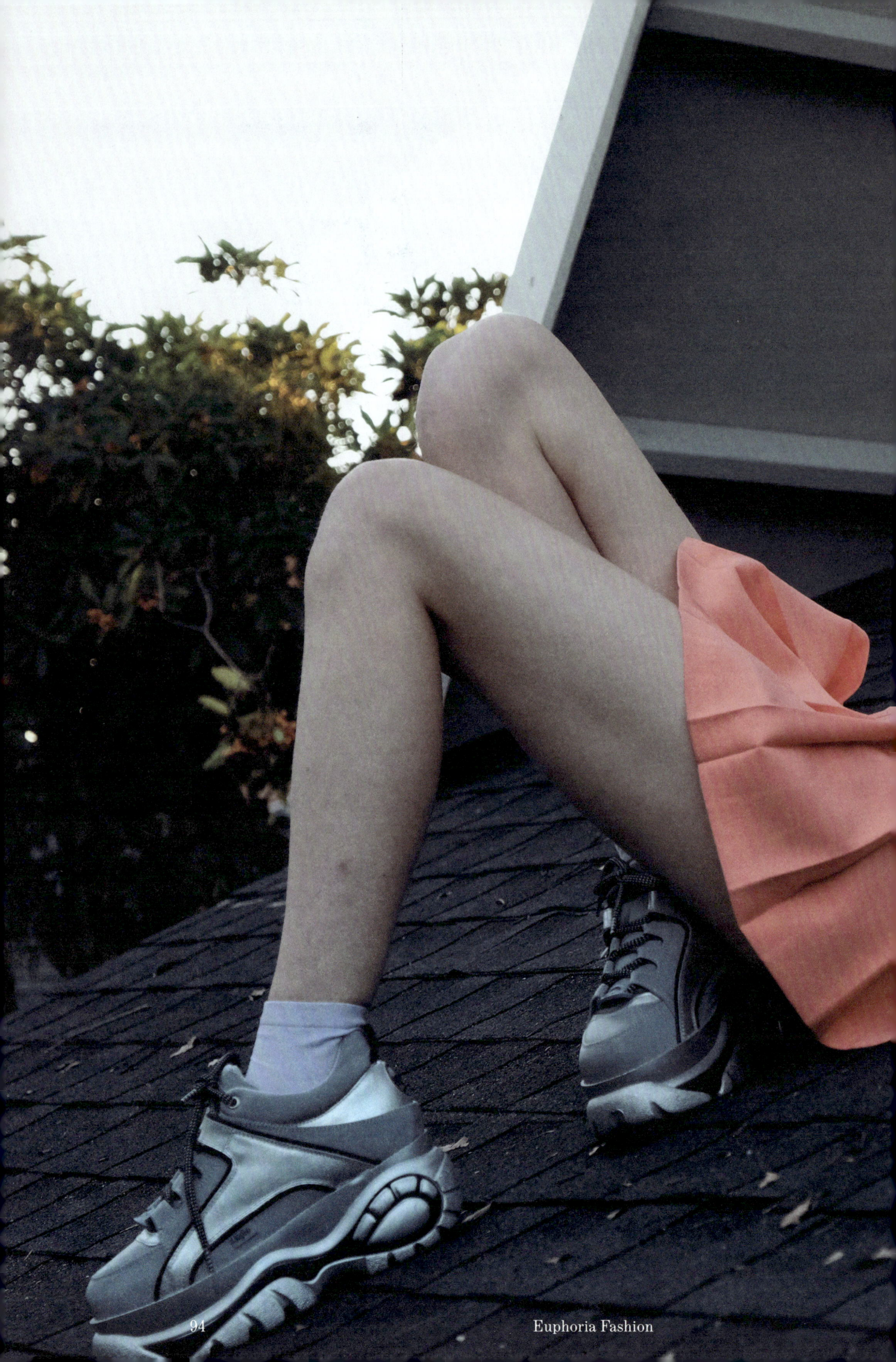

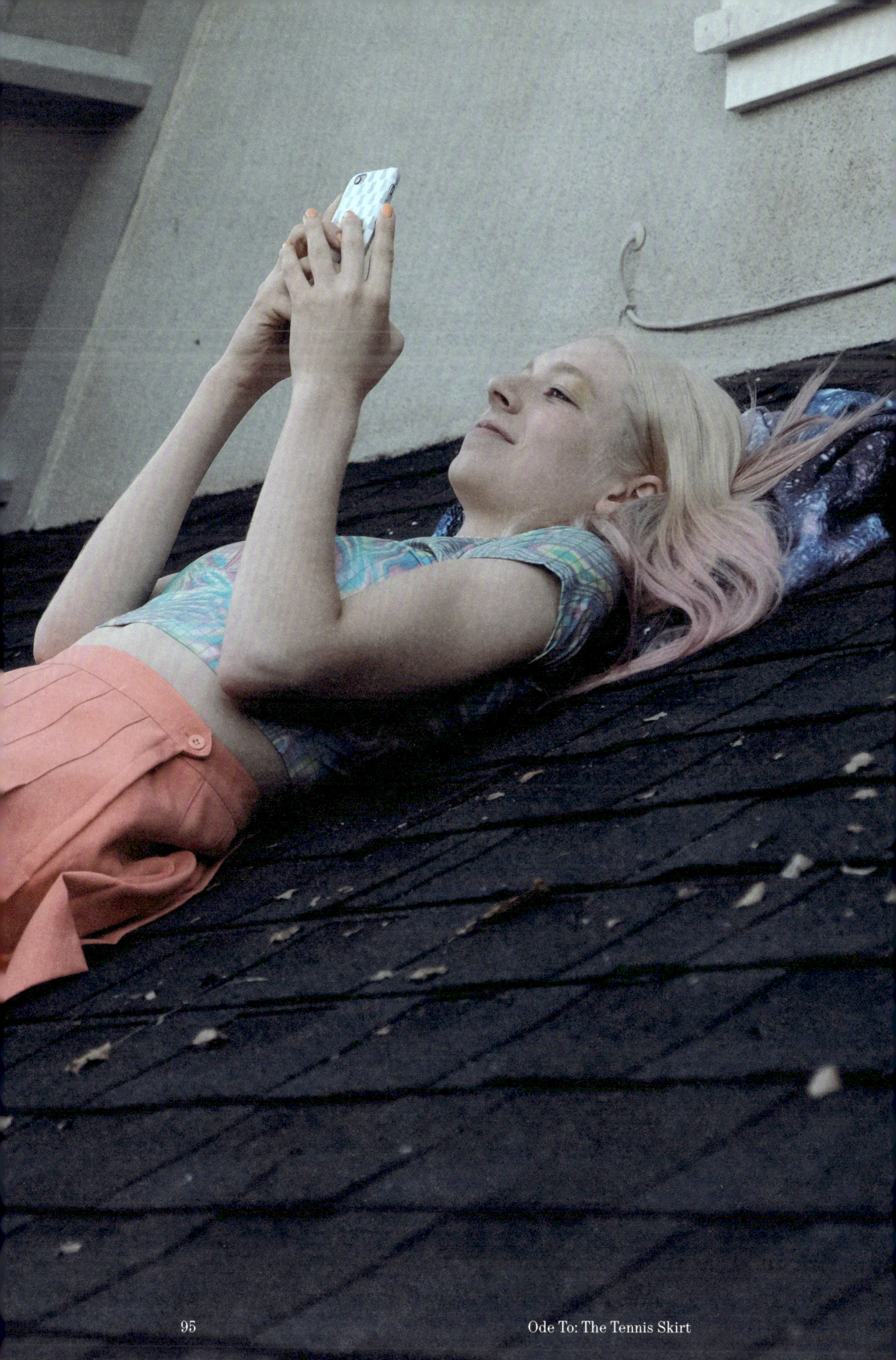

Costume designers *Arianne Phillips* and *Heidi Bivens* on creative survival, breaking into the industry, and gut instinct as the "secret sauce" of their work

HB Starting out in the industry, I was told by people who I really trusted and looked up to for advice that I needed to focus on one thing: choose fashion styling or choose costume design. I didn't listen to those people.

One of the reasons is because I had you as an example. I saw you working with Madonna, styling for *Italian Vogue*, working on films and music videos—you were doing all of it. You've done theater, designed lines of clothing based on your costumes, and you've paved the way for so many people. You've inspired a feeling of confidence that anything is possible—that there's no reason to limit oneself. I must have brought up your name in conversation hundreds of times because even though we had never met, I saw you as a mentor. Since my 20s, I would reference your career and your work.(01, 02)

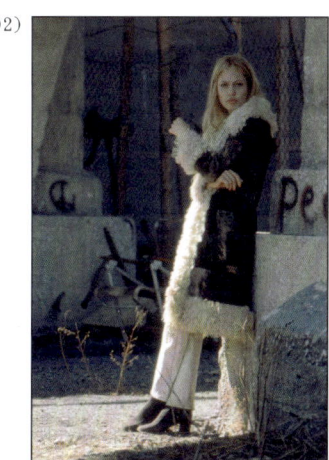

Phillips' early costuming work in *Tank Girl*, 1995.

Angelina Jolie wearing a costume designed by Phillips in *Girl, Interrupted*, 1999.

AP First of all, thank you so much. Working for ourselves, being wholly responsible for our successes and our failures, and trying to find a path forward is hard. It's also very easy to get marginalized, being a woman in a role that is traditionally female. The fact that I have set some sort of example for your path is mind-blowing because it was really creative survival for me. Like you, I was told at every turn how I should be doing things creatively. I realized very quickly that I didn't fit in.

It's a reflection of the way I was raised. I was the kid at school who was friends with everyone but didn't belong to a single group. I couldn't pick one lane, not only because of my curiosity, but also as a strategy for my creative survival. I was taking risks, but I didn't know it. I was told that I had to focus on one thing, and I couldn't figure out what that was. So I just kept switching gears. I was a college dropout, and I believed that if I stayed in one lane, I might become redundant. I decided that I would just satiate myself creatively based on what was truly interesting to me.

I always believed that if you're a creative person, you should be able to flow between disciplines. Now it's more acceptable to cross genres. We both worked between fashion and film and television, and I'm really curious about your origin story.

HB I grew up in Northern Virginia, right outside of D.C., and I started styling my own shoots while in college. I was always interested in the power of fashion and visual self-expression. I came across photographs recently of myself at 19 years old with racks of clothes in my parents' front yard during a photoshoot I was styling for an independent magazine. I used to read my mother's *Vogue* and *Harper's Bazaar* and go to local thrift stores and try to recreate the looks featured in the editorials.

My trajectory had a lot to do with what opportunities I was able to uncover for myself, which wasn't always easy. I moved to New York to study filmmaking at Hunter College, but I also studied journalism and got my first internships at *W* and *Women's Wear Daily*. From there, I went to *Paper* magazine and worked as the market editor. Kim Hastreiter and David Hershkovits, co-founders of the magazine, were very supportive of me from the beginning and became a surrogate family for me in New York.

AP They're so great with spotting and nurturing talent. That magazine was such an incubator for downtown creatives. I love Kim and David.

HB That was a really special time for me.

AP That's so similar to my story and my experience where I was mentored by Annie Flanders and Ronnie Cook at a downtown New York magazine called *Details* (before it was bought by Condé Nast and turned into a men's magazine). That must be critical in terms of starting in that print world.

HB Definitely. But even though I had a great experience working in magazines, simultaneously, I wanted to work in film. It was really tricky to get even a production assistant (PA) position because I didn't know anyone in the industry. So, I started styling. I assisted Rachel Zoe when she was styling the Backstreet Boys and Britney Spears…

AP …And that's a cultural moment, right? All that stuff goes into your creative memory.

HB It wasn't until I became friends with a stylist who became the assistant costume designer on *Eternal Sunshine of the Spotless Mind*[03] that I got my break. I was a PA on that film.

AP I always say that becoming a PA on a film, no matter what department you're in, is so great because it gives you the opportunity to experience how all the different departments work. That was one of the most important films of the past 20, 30 years.

HB I became friends with Michel Gondry and started working on all his music videos. Then I met David Lynch and was able to work on *INLAND EMPIRE*. That's when people were willing to take a meeting with me.

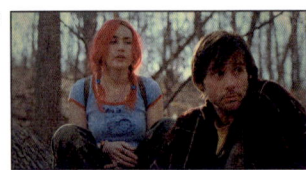

(03) Kate Winslet and Jim Carrey in *Eternal Sunshine of the Spotless Mind*, 2004.

AP When people ask me how I got started, I always say that when you choose jobs, no matter what level, it should reflect what you're creatively interested in and inspired by. You were able to focus on talent who you were inspired by, like Michel Gondry and David Lynch, because those were big cultural moments at the time. It's important because your resumé is a reflection of your creative identity.

HB All those experiences definitely reflected my personal interests. But this idea of diversifying was always in the forefront of my mind. Even after I got a break in the film world, I was still working in fashion. Seeing you do the same was always reassuring to me that if I took a break from doing one thing, I could go back to it—that my work in one industry could inform my work in another.

AP Yes! For me, my interest in fashion is working with photographers and in the tableau form—fashion as still life. I always say styling is about

balance, like creating a sculpture. In the tableau form, I'm able to be micro-focused on details. Moving between film and fashion allows me to reset and be sustainable. The visual side of creating film with fashion helps my eye with working in the development of characters and layering.

HB How would you define your approach to the work?

AP For me, no matter what, it's story—narrative—and asking myself if I have something I want to express or bring creatively to the project. Am I going to grow from this?

HB I really respect what you said about taking projects that speak to the heart—whether it's a story or a script or photographers who I want to work with. It could be a model or a brand. It could be anything, but really it's about going with my gut.

I talk a lot about that when people ask me about my process. It's sometimes hard for me to answer those questions because it's a gut thing, an instinct, a wash of feeling.

AP That is the skillset—the beautiful secret sauce about this is that instinct. I feel this reflected in your work on *Euphoria*, and I identify with that on such a deep level. A big reason why the show's so successful and why people love these characters so much is because you use your creative intuition to create layers of story and identity with the actors as they grow and as the plot develops.(04) You're using your gut to hunt and gather, or even design these pieces. It's clearly why this work sings so much. What makes a great designer is being willing to have the characters show up in the fitting room.

What people also have to understand first about our work is that it's a lifestyle. We don't start work at nine and finish at six. We give up a lot of our life to be part of this—we're living, breathing it. The people we work with become our family. It's a privilege to do this work, but it's also all-encompassing. The work is hard, and our culture shifts constantly.

Now that you've had two seasons to express your ideas with the characters in the story, how has your process evolved?

(04) Even as Kat's style evolves from Episode 102 to Episode 108, her red color story signals that her core understanding of herself remains intact.

HB When I was first sent the script for the pilot, I'd never done TV. I wanted to work in television because I realized there was a great opportunity for storytelling. You could have more time to meditate on the process. With film, depending on the budget and the shooting schedule, sometimes we only get five weeks of prep. But with television, there's this idea that the prep could be ongoing for months, and I could be creating these characters for longer periods of time. That's such a gift for a costume designer.

AP What was it that inspired you when you read the pilot? As we know, oftentimes costume designers will be asked to do pilots, and someone else will do the series.

HB It was a great script. Sam Levinson is a fantastic writer, and he has such a good handle on dialogue. I asked his wife, Ashley Levinson, who's also a producer on the show, "How does Sam know how to write for teenage girls?" And she said, "He watches a lot of YouTube." I thought it was hilarious, but I was really blown away by his grasp of how teens talk.

He also writes in visual cues that are very exciting for a costume designer. There were times in Season Two where he would write an idea for a wardrobe cue into the script. And then he would write: "Let Heidi do her thing."

AP That's so amazing.

HB Trust is huge, right? And the trust was there from the beginning. He's so gracious in that way to all his department heads. Once the pilot got picked up, and I saw everyone's work on the show, I was really moved. I was so excited to work with the whole cast. After we finished Season One, I was completely amazed at the response. Even if you think it's going to be good, it's hard to predict how people are going to perceive the show.

I remember thinking, "I don't know if I can go back and do Season Two," because the work just consumes me. Some days we were working 12–16-hour days, plus weekends. But when I realized how much potential there would be to step it up in Season Two, I was excited. I was holding back in the first season because I tried to keep it grounded in some aspect of reality, even though Sam said he didn't care about reality. I didn't want the costumes to pull the audience out of the emotionality of the story.

Cassie's manic exploration of style through Episode 203 leads to the visual punchline of her *Oklahoma!* look.

AP The *Oklahoma!* episode is a perfect example of that—it's about the costume (**p.208**).⁽⁰⁵⁾

HB Yes. The second season gave me a lot more freedom because it rides the line of: whose reality are we in? What is reality? ⁽⁰⁶⁾ I saw the opportunity to really have fun with it. I just said, "I'm going to go for it and not be worried about people pointing out stuff or nitpicking."

AP Do you build a closet for your characters? They're so beautifully defined, and yet you're also able to surprise and illuminate these turns in the narrative.

HB On the practical side, I have two approaches. With the first season, I loved going down the rabbit hole of who these characters were, building my own backstories. When the actors come to us for fittings, that's where they're forming their characters. Oftentimes they haven't gotten real backstory or notes from a director. If it's not written into the script, we're coming up with it in the fitting room.

Then, in the initial fittings, I really like to try everything I think is in line with the character. I don't often put looks together before the fittings. I know which pieces are my favorites and what I want to work with, but I really like to get in the room and just use my gut.

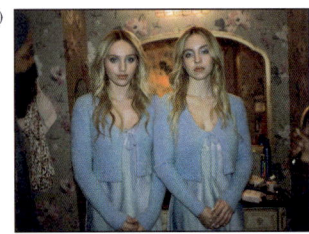

Behind the scenes of Lexi's play, Episode 208.

Euphoria Fashion

Rue's hoodie is a security blanket and becomes a visual cue for her mental state, Episode 108.

I start putting things together and handing the talent things, and it just starts happening. Then we get excited, and it keeps happening. And it just gets better and better.

After that first fitting, I build out a closet. A lot of the looks for the first and second seasons came out of those first fittings. It's great for TV because you always have these pieces to go back to. There's always going to be scenes added, or someone will have an idea that they need something specific for.

AP I also love seeing how you've repeated pieces, which is important for the authenticity of the characters. Rue's hoodie (**p.18**), for example, grounds her in reality. You see her downward spiral reflected in her costuming.(07) That's what allows your fantasy to sing for me: you're able to work in those two ways.

Do you know what will happen to the characters at the start of each season?

HB From what I understand about television, it's rare to start a season and have all the scripts up front. With *Euphoria*, the way Sam's mind works is he's always coming up with new ideas. His brain works very fast, and he gets excited about new things and will change the story in ways I can't always predict. I equate it to being a catcher behind home plate, always ready to catch the ball.

AP You obviously have these strong closets, so you have a foundation, and you work, and you improvise.

HB You have to have the foundation and a good team.

AP So what comes with Season Three?

HB I'll still be part of the *Euphoria* family, but in a different capacity. My plan is to pass the torch and to come on as a producer.

AP Congratulations! You know, the only other time I've heard of this is Lou Eyrich and Ryan Murphy.[1]

HB The amount of times I've used Lou as an example of what's possible reminds me of how I've referred to you as an example, even before we even met! The fact that she's been able to have that working relationship with Ryan where once she hit that glass ceiling, she was able to become a creative director for him—that's something we can all aspire to. Her example has shown producers and directors in Hollywood that this kind of new role can work. She's made it possible.

AP You are paving the road! I'm so excited because this just underscores how valuable costume designers are. When it comes to the contribution that costumes make to film and television, it is a shortcut to character

[1] Ryan Murphy, a director and producer, and Lou Eyrich, a costume designer and producer, have consistently worked together since his 1999–2001 television series, *Popular*. In 2018, Eyrich became a producer on *American Crime Story*. Her creative collaboration as a producer has been integral to every Murphy production since.

development, and it adds value on so many levels. Yet we don't own our own IP, we're work-for-hire, and we don't make royalties or benefit when our designs become merchandise, Halloween costumes, and the like.

HB To navigate a conversation about our value as costume designers has everything to do with the creative collaborations we nurture with the actors, the other creative departments, and the director. Costume designers have traditionally been women, and we've been marginalized. If you look at a sliding scale of how below-the-line crew is paid, assistant costume designer, for example, is at the very bottom—the very bottom. My hope is that these conversations bring light to the value of the collaborations. I want to be the kind of producer that can both lift the costume department up and advocate for them.

AP You will be that kind of producer. We are the only department that, when we meet an actor, we're like, "get naked." It's a really intimate collaboration for character development, and you can see it in your work with *Euphoria*. Costume design is identity development, character development, and expressing the nonverbal. If the sound goes out on your TV, by looking at the costumes, you can understand the tone, the feel, and this really informs the audience so much.[08]

It's a collaboration of course, but there's no other department that also inspires Halloween costumes or toys or dolls or lines of clothes. If you think about Dorothy's dress in *The Wizard of Oz* or Darth Vader's helmet in *Star Wars*, these are iconic costumes, and they're stand-alone experiences of the costume designer's development. Often, when things don't make sense, we're the ones who are talking to the assistant directors and the producers and the director because the missing thread can be the timeline and the character development that we see in the script as costume designers. Every project I've worked on, I've been able to add to the storyline or create something that helps things make a little more sense in terms of how we're dressing someone from one day to another or how that character is seen.

In terms of value during the process, first of all, we set the tone with the actors. When a new actor comes to set, they see us first and they want to know, "What's going on in this story?" We're the ones who help them assimilate and ease them into the storytelling. We give them their "beam-me-up suit" and help them physically become that character. We're there to help them adjust and change. And once the audience sees the show, to see people dressing up as Cassie and Jules—if that's not valuable…

HB I often get messages from friends telling me about people they see on the street who are seemingly dressed like characters from *Euphoria* or inspired by the show. It's fun to think that I could have had some impact on how teens are dressing right now, primarily because the whole spirit behind the look of the show is about expressing yourself and feeling safe to do that.

(08)
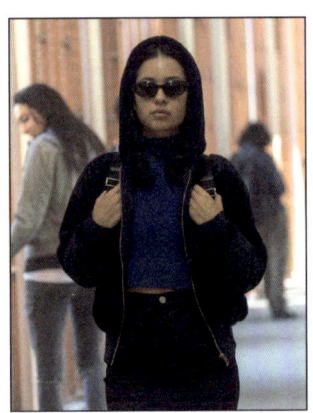
As Maddy sinks into mourning after being attacked by Nate, she dresses in black to cover up not only her physical bruises but also her emotional wounds, Episode 105.

AP Especially with teenagers right now and the conversations about identity in the show. But I think you should let the success of that sink in a little bit. You're being humble, and I understand. There is that thing of always wondering, "Am I impacting the culture, or is the culture impacting me?" That is the beautiful conversation between art and reality. In a time when kids have so many platforms to express themselves, these characters have given kids permission to be individuals.

HB My hope is that people can be inspired by *Euphoria* to express themselves in a way that maybe before they would've been reluctant to do because of a fear of being judged or bullied. Not just Gen Z teens, but even 40-something-year-old women have told me that I've inspired them to dress more like Maddy, for example. It's been really rewarding to hear personal stories about how it's opened people up to expressing themselves through the way they dress.

AP I realized that I was doing something that was impacting the culture 25 years ago when I was traveling in Thailand. Our friend took us to a midnight drag show in Bangkok, and these drag queens had recreated the costumes I had done for Madonna's video "Nothing Really Matters"(09) to a T. Having been that kid who hung out at the Pyramid in New York and was inspired by drag icons, I started crying. I was like, "Oh my god, that's the dream!" The fun part is to see your work out in the world, part of the zeitgeist.

(09) Madonna in the "Nothing Really Matters" music video, 1999.

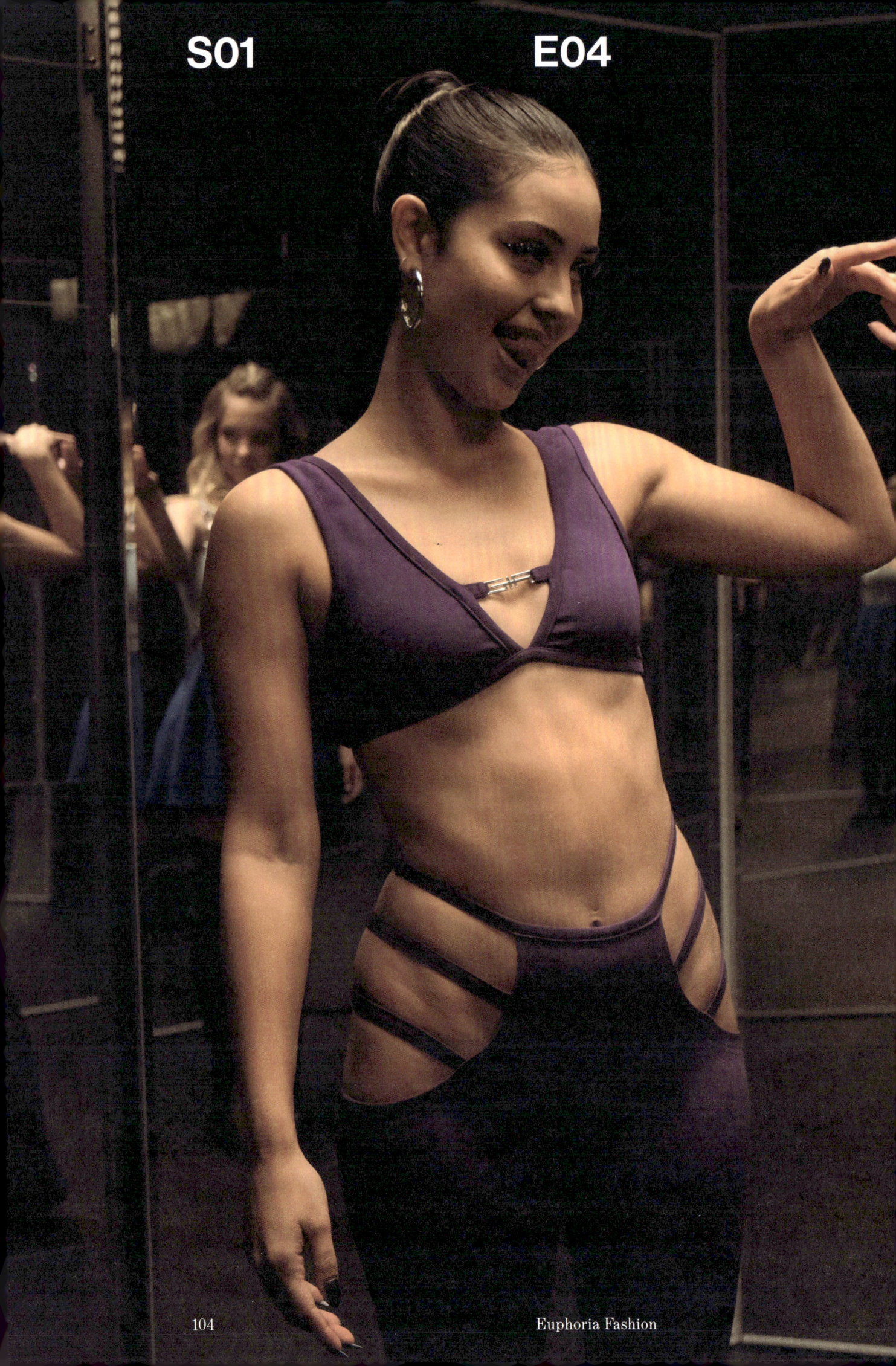

"Shook Ones Pt. II"

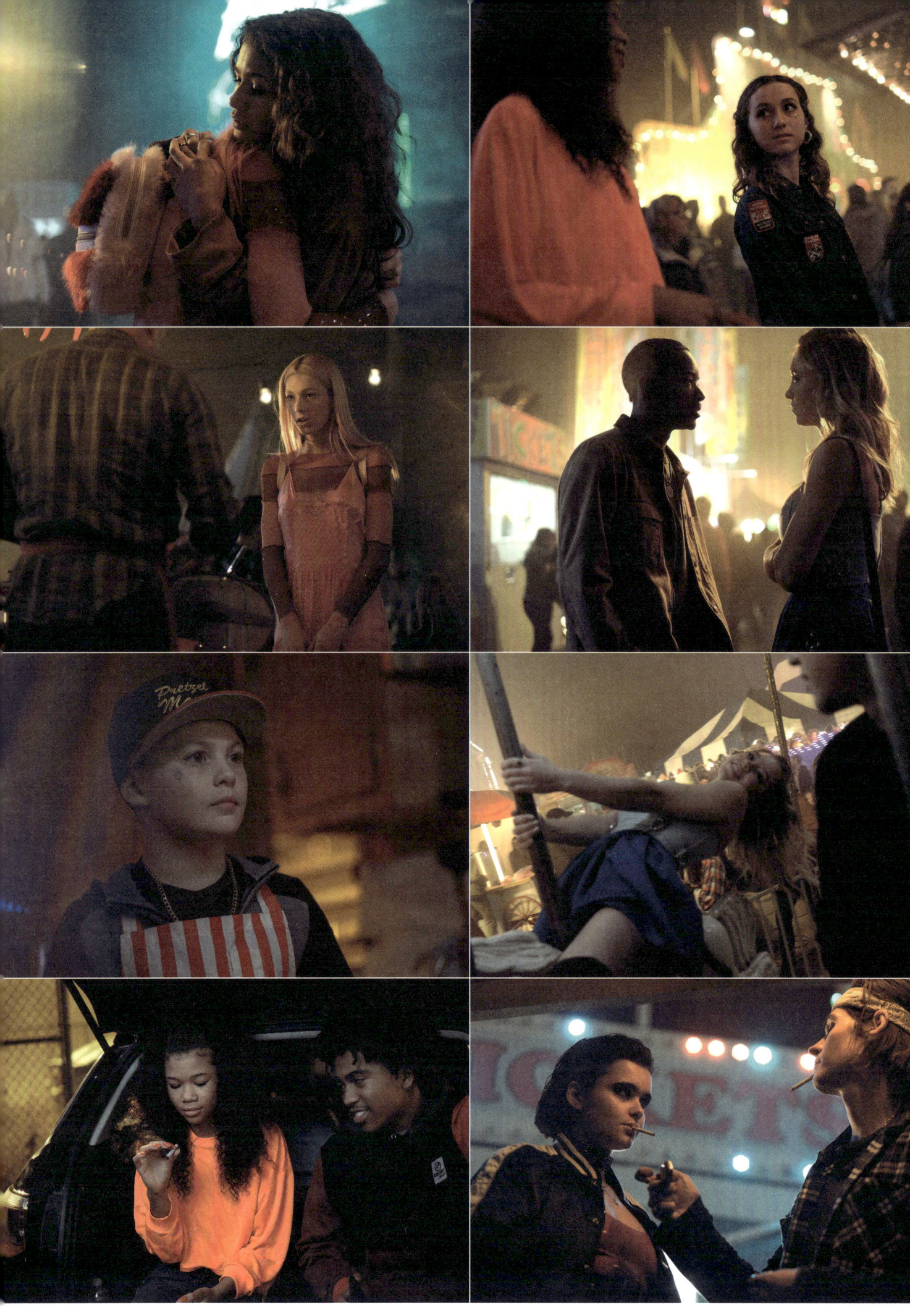

The entire town is out for East Highland's annual carnival, featuring the all-important chili cook-off. Although Rue and Jules have not spoken since their awkward kiss, Rue, along with her childhood best friend, Lexi, go to chaperone her younger sister, Gia.

Maddy and Nate are back together and bickering, as always. They can't seem to find one another amongst the crowd, setting the tone for the smoke and mirrors of the night. When they finally meet up, Nate asks, "Why are you dressed like a hooker?" He's there to support his dad Cal's participation in the chili cook-off, and he doesn't want his family to see her in that outfit (**p.114**).

As Kat and Jules get ready to board the Rotor ride, Jules spots Rue in the distance, leaving Kat to ride alone, where she runs into Ethan, a classmate with whom she has a blossoming romance. Rue and Jules warmly embrace. Gia turns to Lexi and says, "I think she's in love with her."

McKay and Cassie walk by Cal's chili booth where Nate taunts McKay by asking whether the two are in a relationship. McKay replies, "No, we're just chilling." When she later confronts him, he reveals that he knows what she's "done," alluding to the sex tape.

On her way to buy Molly (MDMA) from Fezco's pretzel stand / drug dealing operation, Maddy runs into Cassie. The two discuss their fury-inducing relationships. Maddy reveals she went through Nate's phone, "and it was weird."

Jules and Rue explore the carnival together and spot Cal in the distance. "That's him. The guy from the motel," Jules says. Rue dares Jules to prove they hooked up by ordering a cup of chili. Cal's hands shake as he hands it to her, dropping it on the counter. Nate eyes the interaction with suspicion.

Later, Kat spots Ethan speaking with another girl, assumes the worst, and leaves without saying goodbye. Cassie and Maddy, high on Molly, enter the hall of mirrors and make a pact to "pick the hottest, most confident, bad bitch version of ourselves and be that for the rest of the school year."

Over at the carousel, Cassie causes a scene with heavy breathing and overtly sexual gyrating. As Cal is crowned the winner of the chili cook-off, the crowd parts to reveal Maddy, slow-clapping long after the applause has died. She storms the booth, tips over a pot of chili, and calls Nate's mom a "cunt."

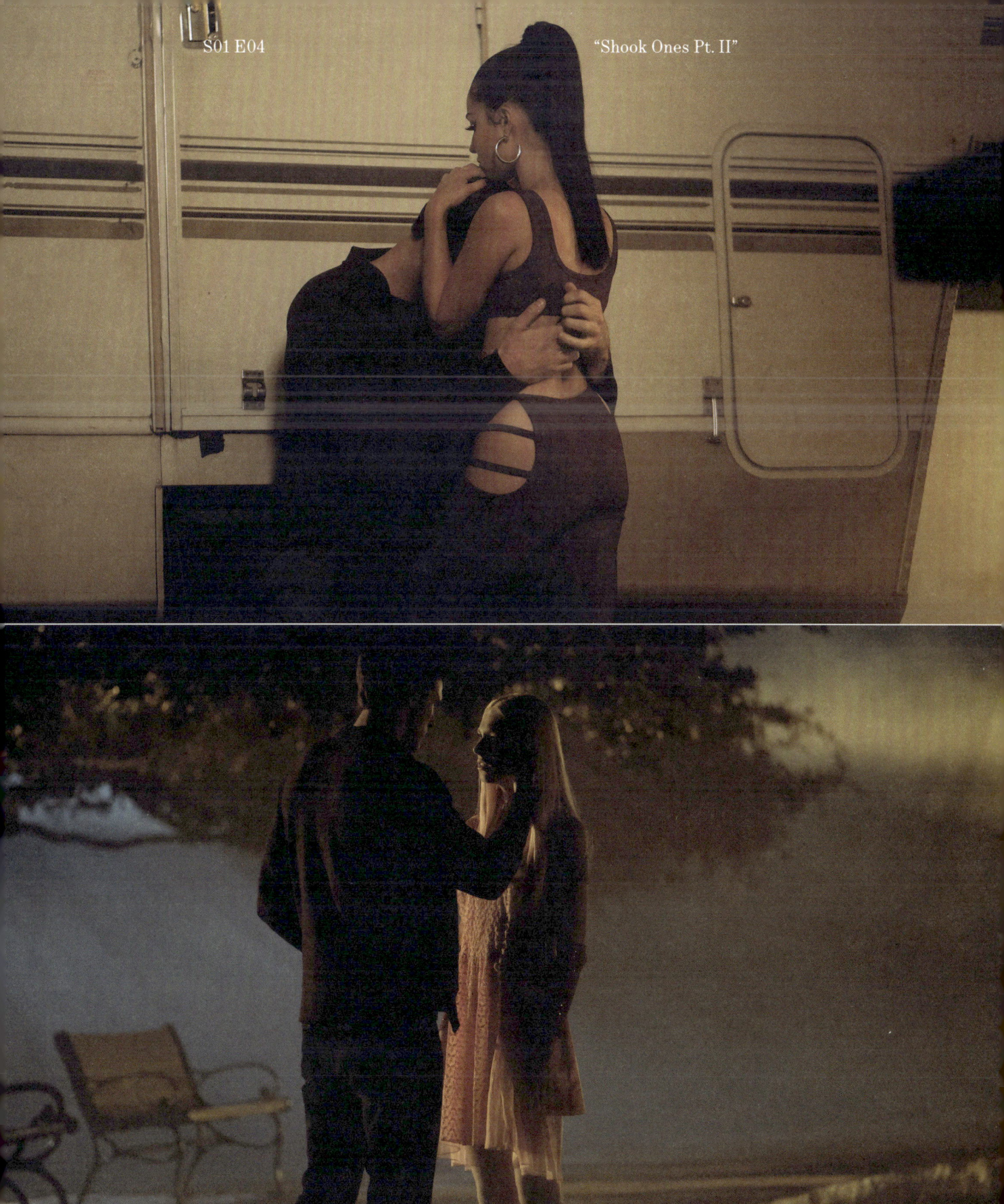

Nate drags Maddy to the outskirts of the carnival, grabs her by the neck, and says, "You're fucking dead to me." She confronts Nate about the pictures of other people's dicks on his phone. Cal goes on a tear to find Jules and begs her not to ruin his life. Jules assures him that she won't. As he walks away, Jules receives a text from "Tyler," who she's been texting with on a dating app, to finally meet in person.

III. MADDY

"Ninety percent of life is confidence. And the thing about confidence is no one knows if it's real or not."
—Maddy Perez

Maddy has had an innate sense of confidence since childhood. Pageantry was an early passion, and the glitz of the costumes and the attention she received left an indelible impression. When her mother stops her from competing in beauty and talent shows, the world becomes her stage. As a teenager, she's revered as the queen of East Highland High School, receiving a mix of respect and fear from friends and fellow students. Despite typical school dress code, Maddy chooses to live by her own rules and makes style choices that are often perceived as overly provocative, especially by Nate. Even though they share a bond, ultimately the relationship is toxic and unhealthy for them both. Maddy does her best not to let her emotions get the best of her, but when Nate attempts to shame her for what she wears to the carnival (**p.104**) in Season One, she refuses to back down and instead causes a scene. She claims her space and lets the world know she will follow her own path, regardless of the consequences.

She dreams of leaving her small town and living a life of opulence, which she gets a taste of while babysitting for Samantha, a wealthy mother, in Season Two. The royal purple, sequined Norman Norell mermaid dress (**p.124**) Samantha gifts her (**p.127**) is both a symbol of her ideal future and a nod to the purple set she wears in Season One (**p.114**).

Maddy understands optics, and despite her meager financial means, she always looks put together. As she navigates her breakup with Nate and the betrayal by her best friend, Cassie, Maddy delves into a more daring, mature vamp beauty style that signals she's moved on to the next phase of her life. Although the shift is first prompted by mourning her relationship with Nate, in her heart of hearts, she believes she's destined for bigger, better things.

S01 E02　　　　　　　　　　　　　　　　　　　　　　Change 6
　　　　　　　　　　　　　　　　　　　　　　　　　Change 10

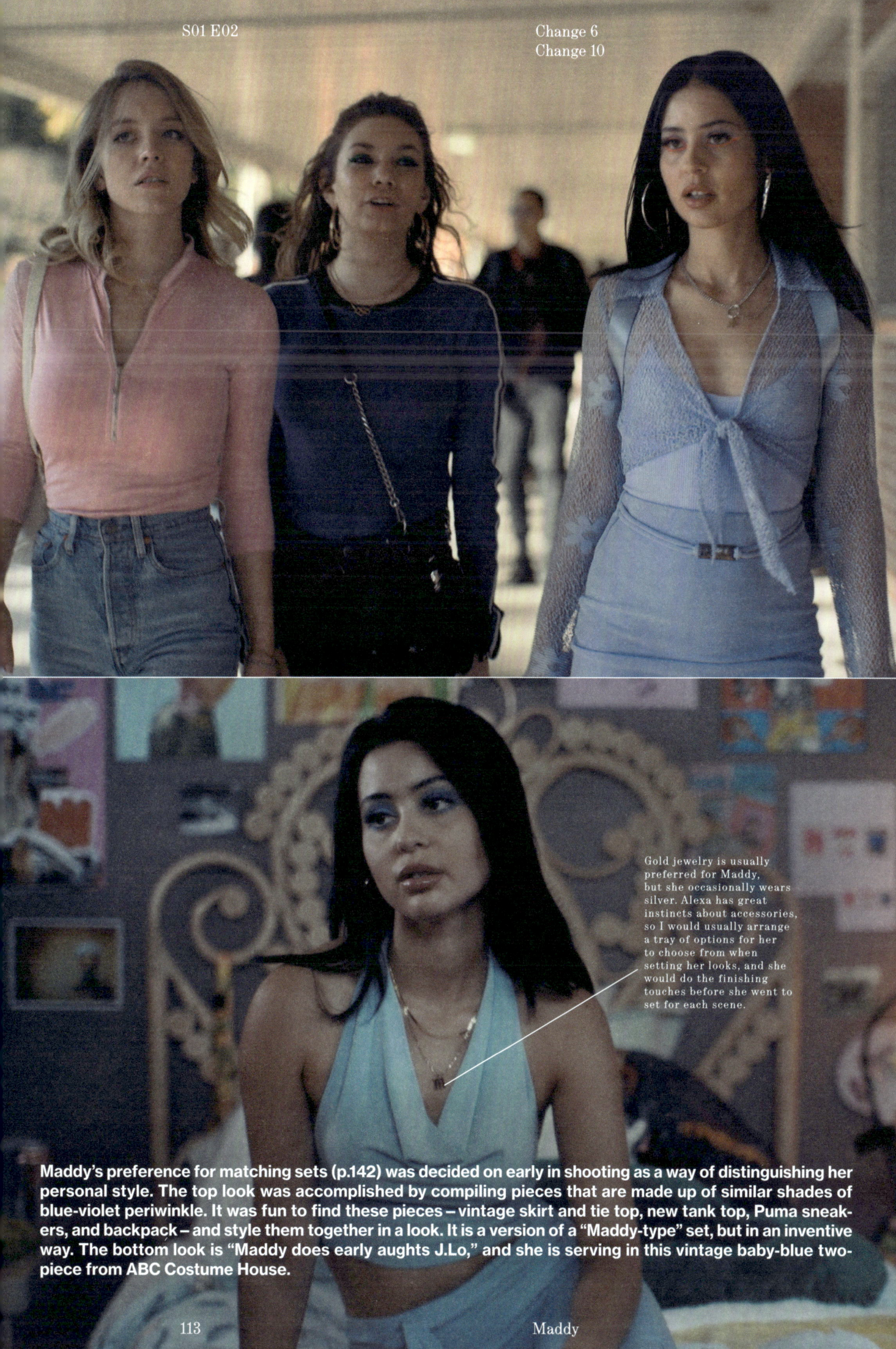

Gold jewelry is usually preferred for Maddy, but she occasionally wears silver. Alexa has great instincts about accessories, so I would usually arrange a tray of options for her to choose from when setting her looks, and she would do the finishing touches before she went to set for each scene.

Maddy's preference for matching sets (p.142) was decided on early in shooting as a way of distinguishing her personal style. The top look was accomplished by compiling pieces that are made up of similar shades of blue-violet periwinkle. It was fun to find these pieces – vintage skirt and tie top, new tank top, Puma sneakers, and backpack – and style them together in a look. It is a version of a "Maddy-type" set, but in an inventive way. The bottom look is "Maddy does early aughts J.Lo," and she is serving in this vintage baby-blue two-piece from ABC Costume House.

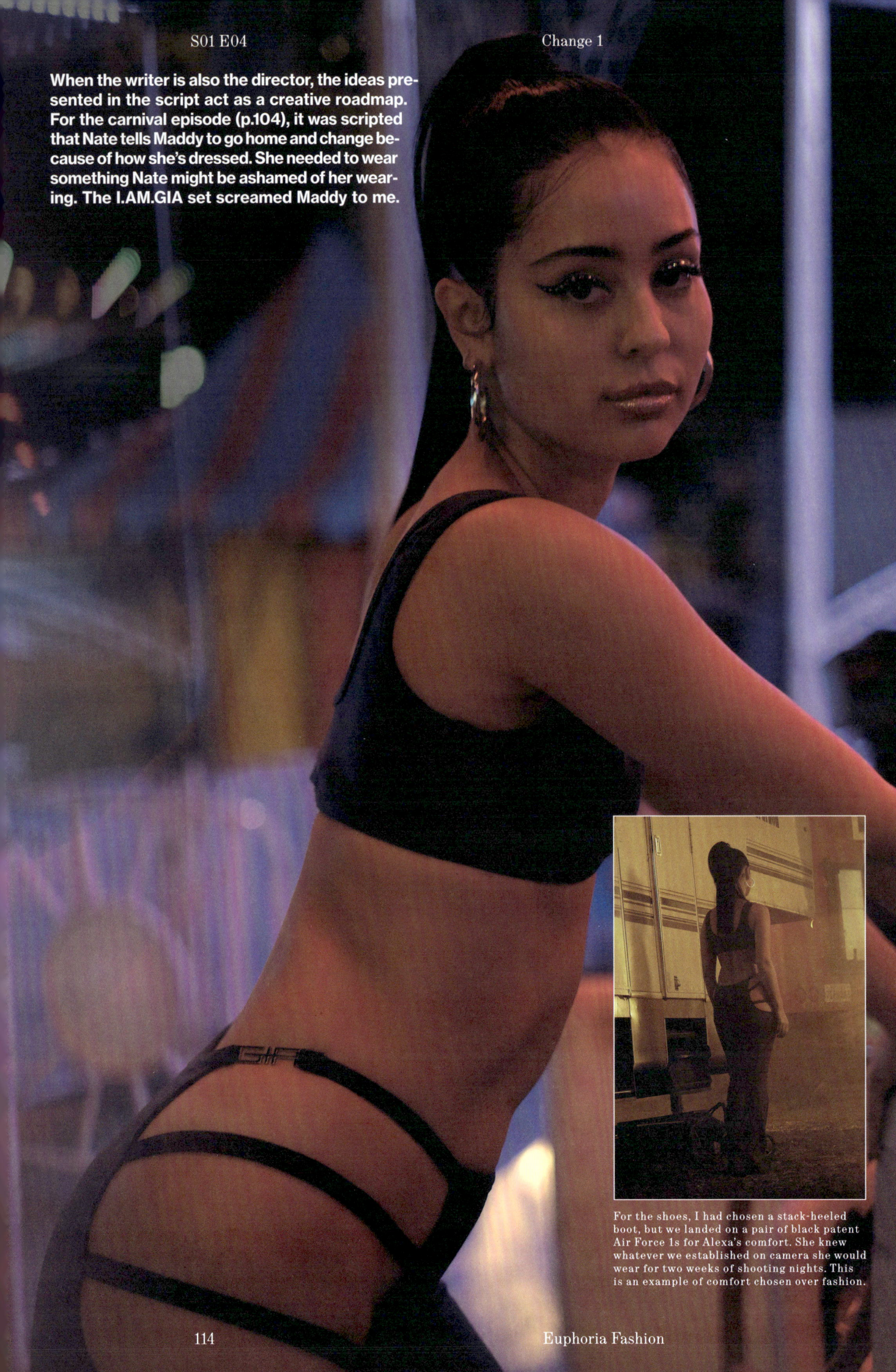

When the writer is also the director, the ideas presented in the script act as a creative roadmap. For the carnival episode (p.104), it was scripted that Nate tells Maddy to go home and change because of how she's dressed. She needed to wear something Nate might be ashamed of her wearing. The I.AM.GIA set screamed Maddy to me.

For the shoes, I had chosen a stack-heeled boot, but we landed on a pair of black patent Air Force 1s for Alexa's comfort. She knew whatever we established on camera she would wear for two weeks of shooting nights. This is an example of comfort chosen over fashion.

The I.AM.GIA hardware was used out of respect for the brand's original design.

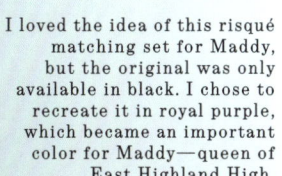

I loved the idea of this risqué matching set for Maddy, but the original was only available in black. I chose to recreate it in royal purple, which became an important color for Maddy—queen of East Highland High.

S01 E08 — Change 1

Thinking about the winter formal (p.212), I wanted to channel Rose McGowan's look on the 1998 VMAs red carpet. To be that provocative would be character-building for Maddy and assert her don't-care attitude.

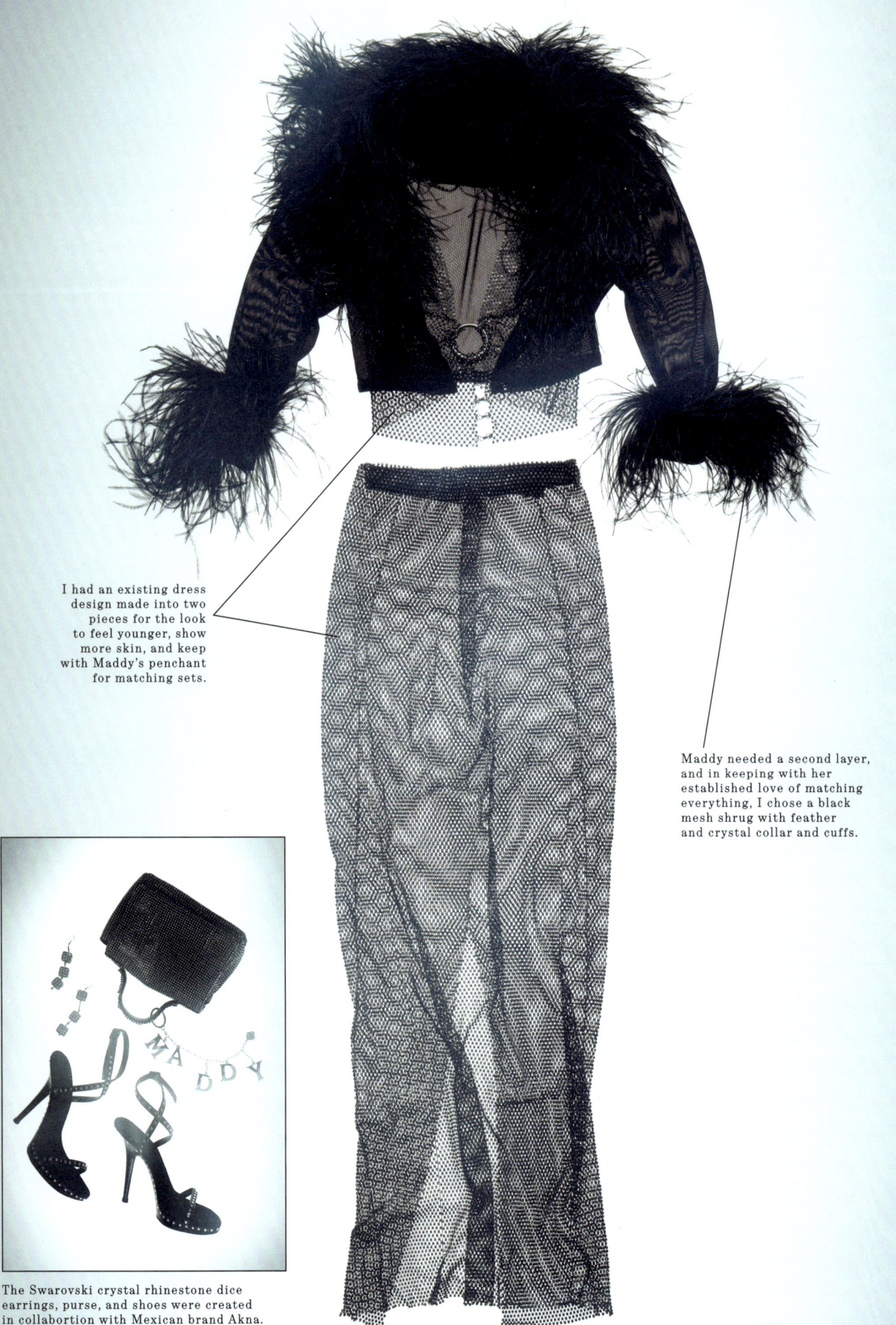

I had an existing dress design made into two pieces for the look to feel younger, show more skin, and keep with Maddy's penchant for matching sets.

Maddy needed a second layer, and in keeping with her established love of matching everything, I chose a black mesh shrug with feather and crystal collar and cuffs.

The Swarovski crystal rhinestone dice earrings, purse, and shoes were created in collabortion with Mexican brand Akna.

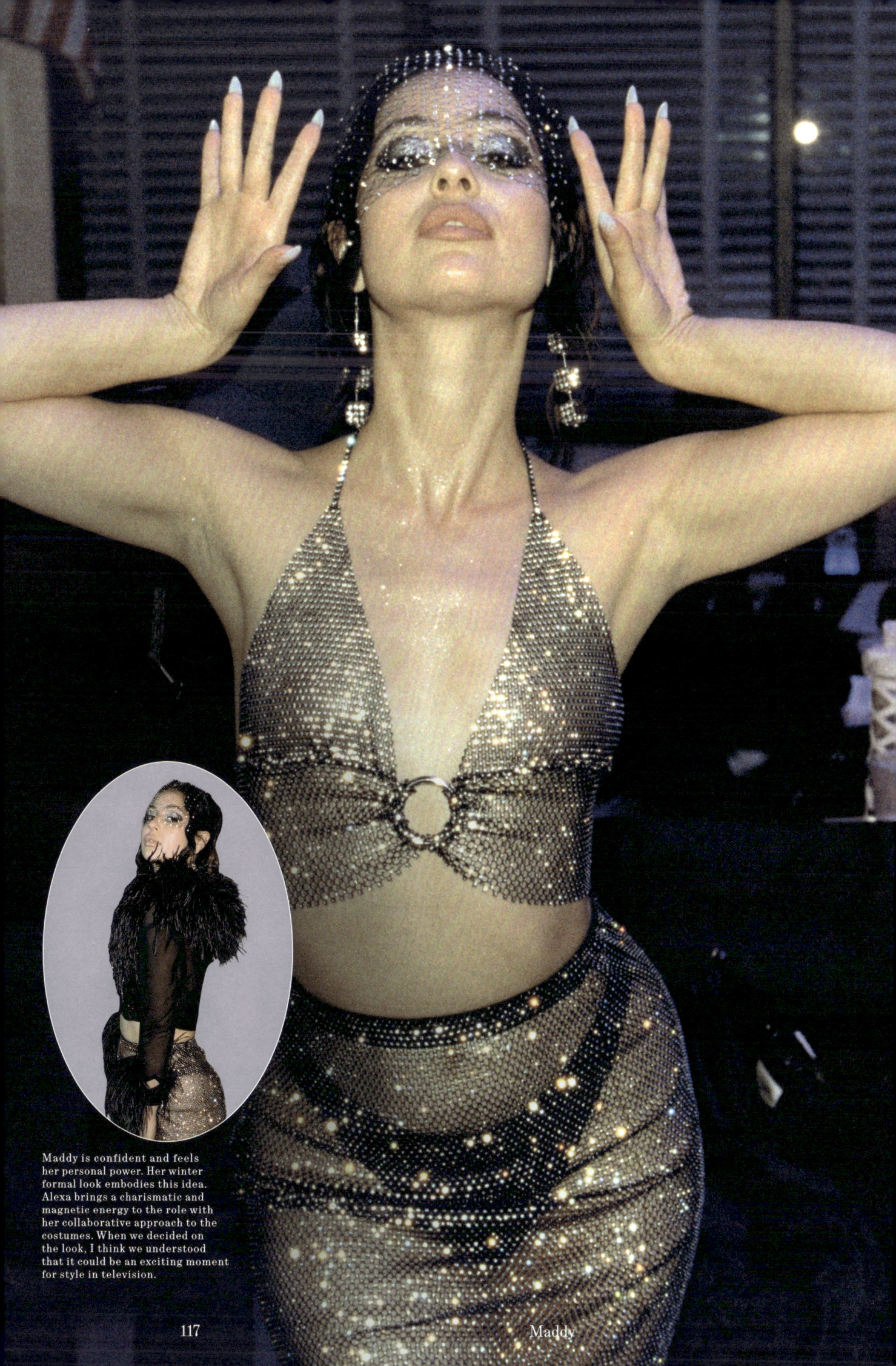

Maddy is confident and feels her personal power. Her winter formal look embodies this idea. Alexa brings a charismatic and magnetic energy to the role with her collaborative approach to the costumes. When we decided on the look, I think we understood that it could be an exciting moment for style in television.

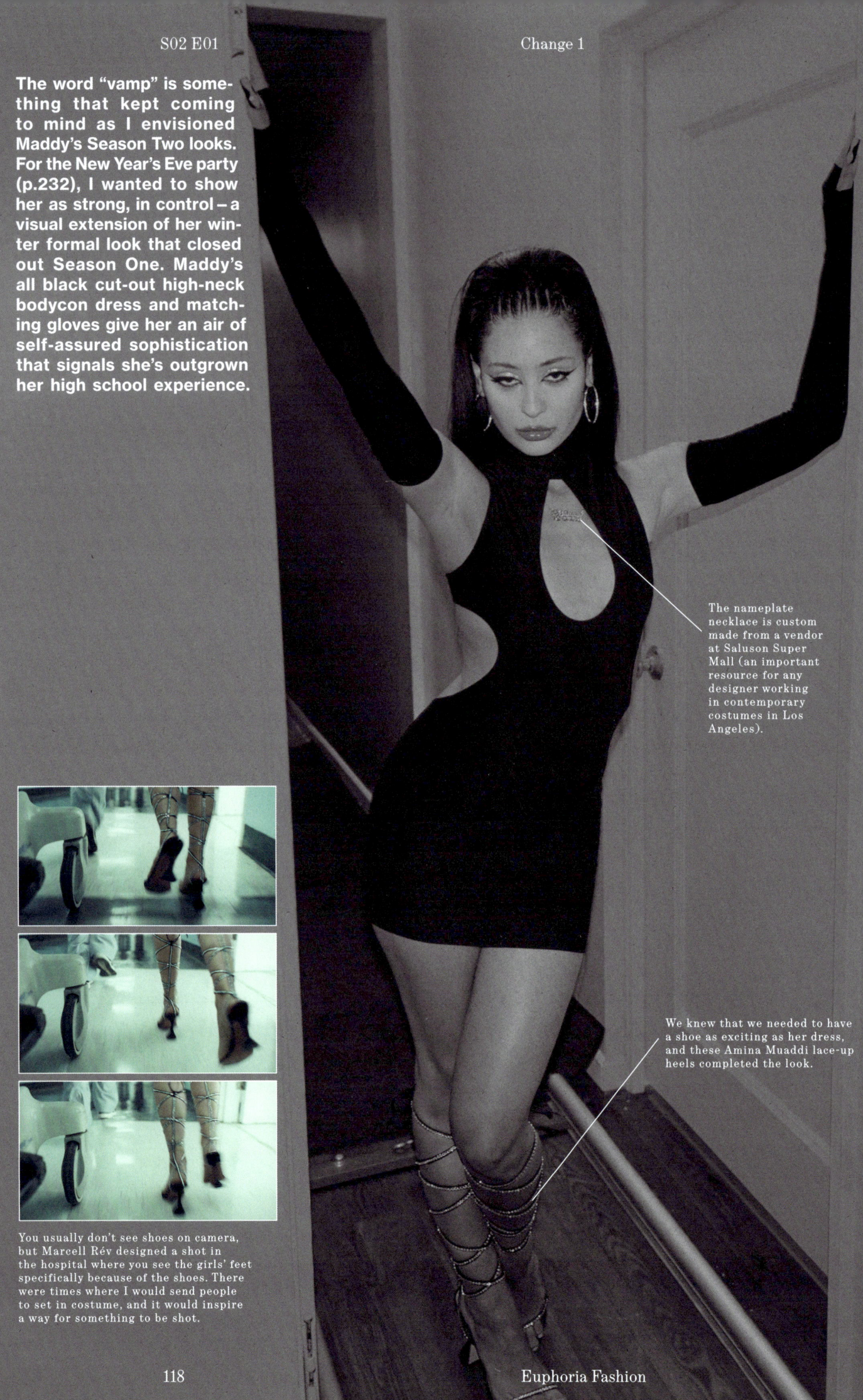

S02 E01 — Change 1

The word "vamp" is something that kept coming to mind as I envisioned Maddy's Season Two looks. For the New Year's Eve party (p.232), I wanted to show her as strong, in control — a visual extension of her winter formal look that closed out Season One. Maddy's all black cut-out high-neck bodycon dress and matching gloves give her an air of self-assured sophistication that signals she's outgrown her high school experience.

The nameplate necklace is custom made from a vendor at Saluson Super Mall (an important resource for any designer working in contemporary costumes in Los Angeles).

We knew that we needed to have a shoe as exciting as her dress, and these Amina Muaddi lace-up heels completed the look.

You usually don't see shoes on camera, but Marcell Rév designed a shot in the hospital where you see the girls' feet specifically because of the shoes. There were times where I would send people to set in costume, and it would inspire a way for something to be shot.

Euphoria Fashion

S02 E02 — Change 6

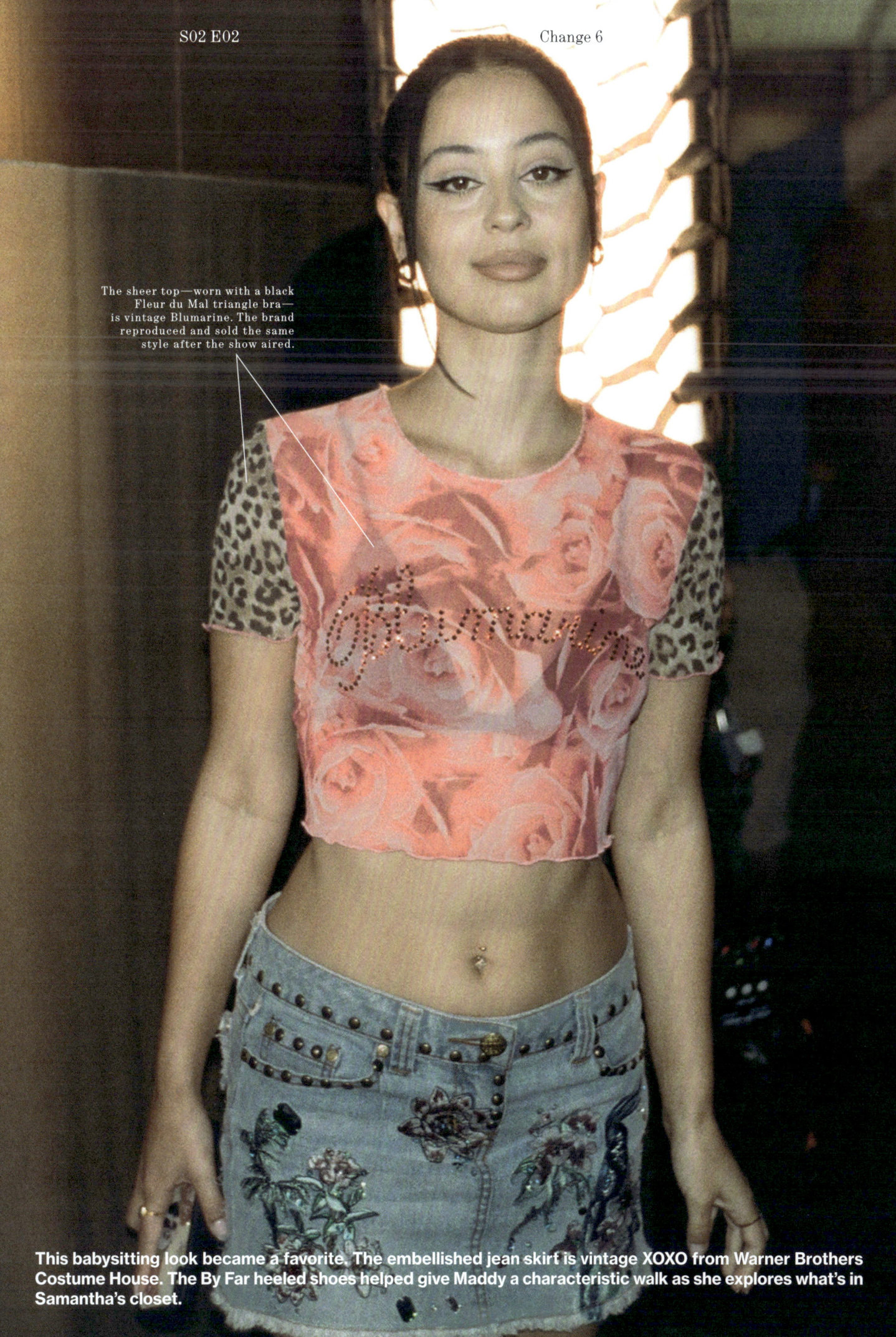

The sheer top—worn with a black Fleur du Mal triangle bra—is vintage Blumarine. The brand reproduced and sold the same style after the show aired.

This babysitting look became a favorite. The embellished jean skirt is vintage XOXO from Warner Brothers Costume House. The By Far heeled shoes helped give Maddy a characteristic walk as she explores what's in Samantha's closet.

Maddy

When I was in high school in the '90s, I looked at fashion magazines like *Harper's Bazaar*, *Elle*, and *Vogue* to see the latest runway fashions. Without any kind of budget to run out and buy any of it, I became resourceful, frequenting the local thrift stores in my town in an attempt to recreate the runway looks with anything similar I could find. I imagine Maddy creates her looks in a similar way. She is imaginative and meditative about her personal style. Along with her hair and makeup, she is conscious of creating her own personal brand that is *Maddy*.

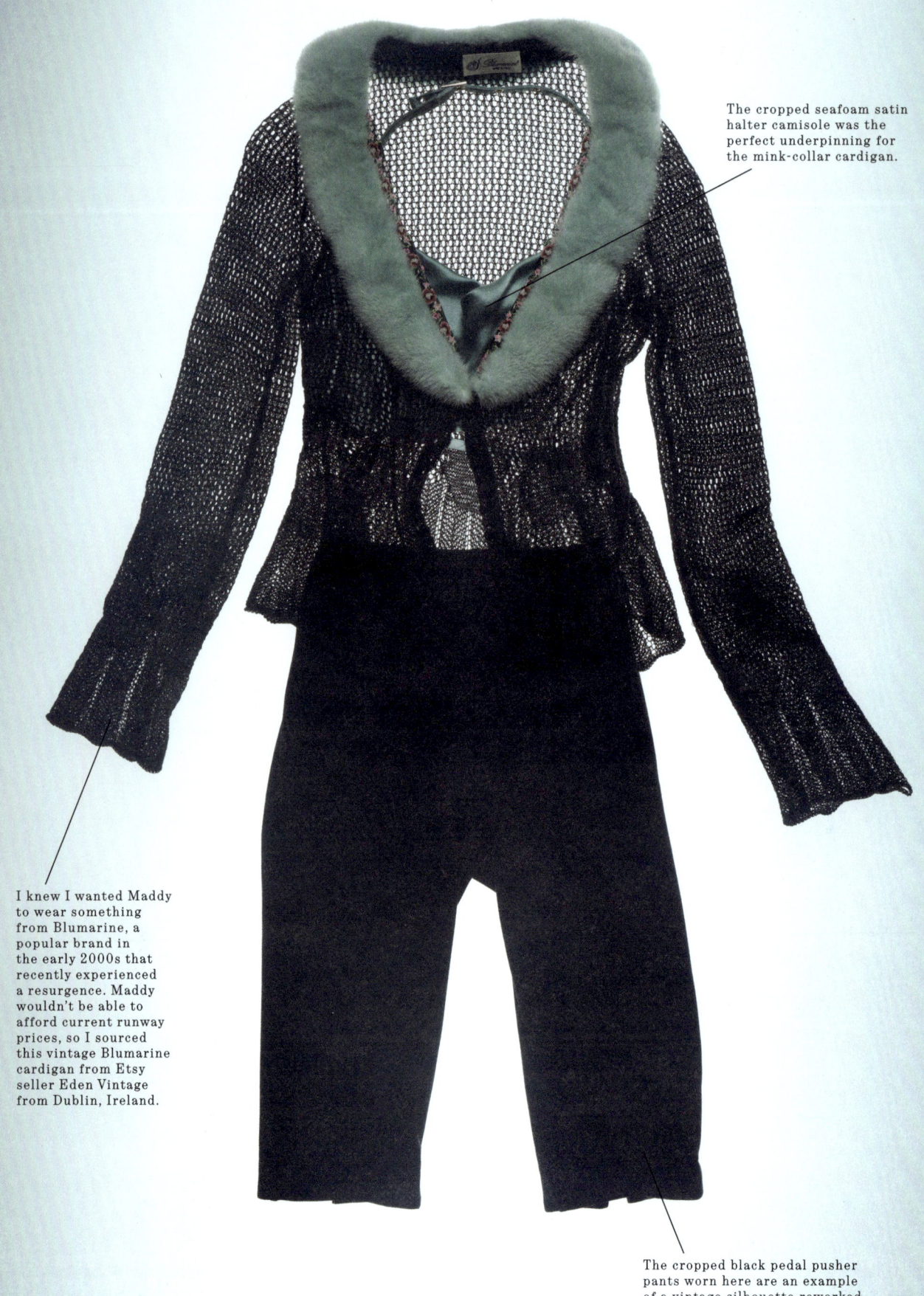

The cropped seafoam satin halter camisole was the perfect underpinning for the mink-collar cardigan.

I knew I wanted Maddy to wear something from Blumarine, a popular brand in the early 2000s that recently experienced a resurgence. Maddy wouldn't be able to afford current runway prices, so I sourced this vintage Blumarine cardigan from Etsy seller Eden Vintage from Dublin, Ireland.

The cropped black pedal pusher pants worn here are an example of a vintage silhouette reworked into a more modern look.

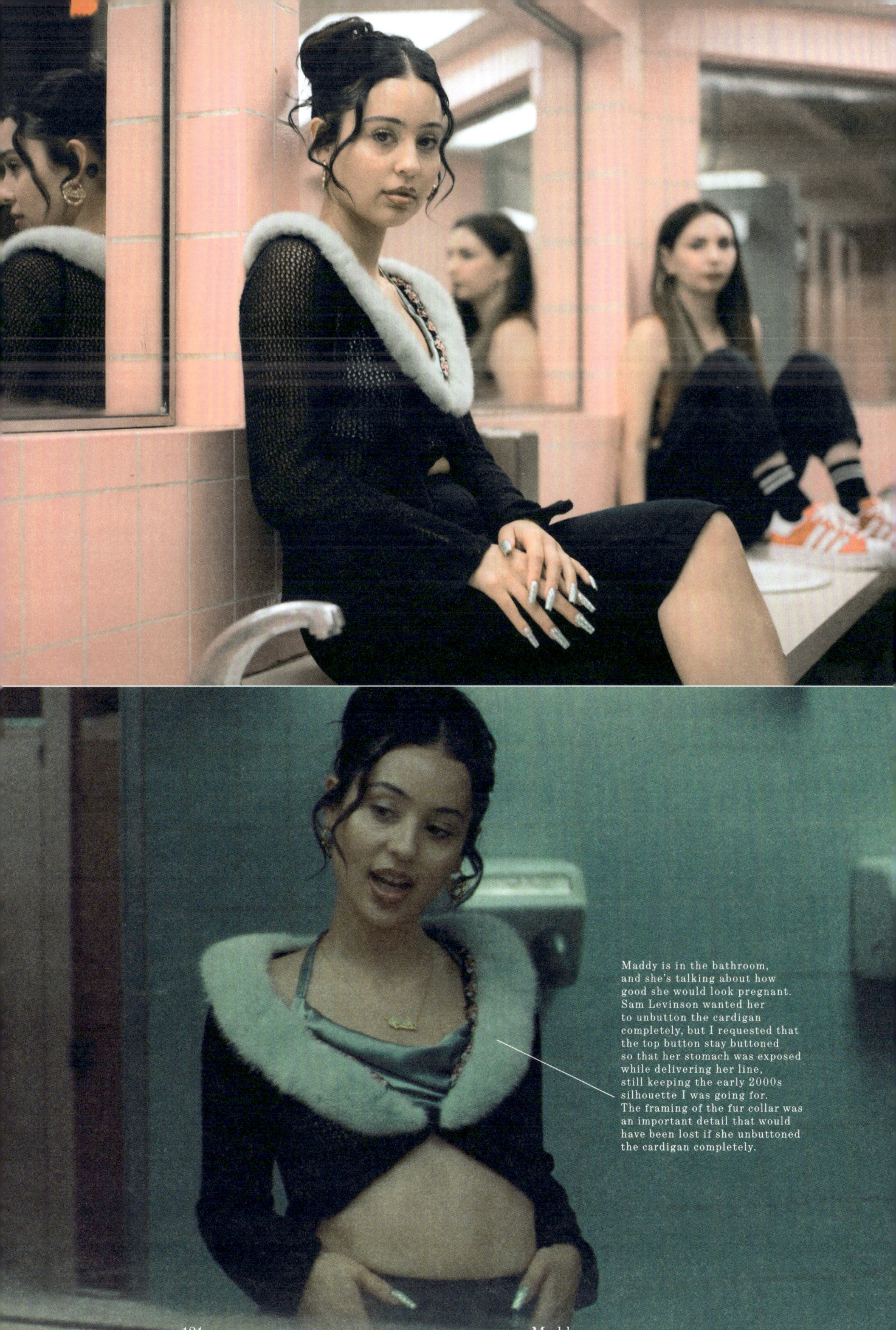

Maddy is in the bathroom, and she's talking about how good she would look pregnant. Sam Levinson wanted her to unbutton the cardigan completely, but I requested that the top button stay buttoned so that her stomach was exposed while delivering her line, still keeping the early 2000s silhouette I was going for. The framing of the fur collar was an important detail that would have been lost if she unbuttoned the cardigan completely.

Maddy

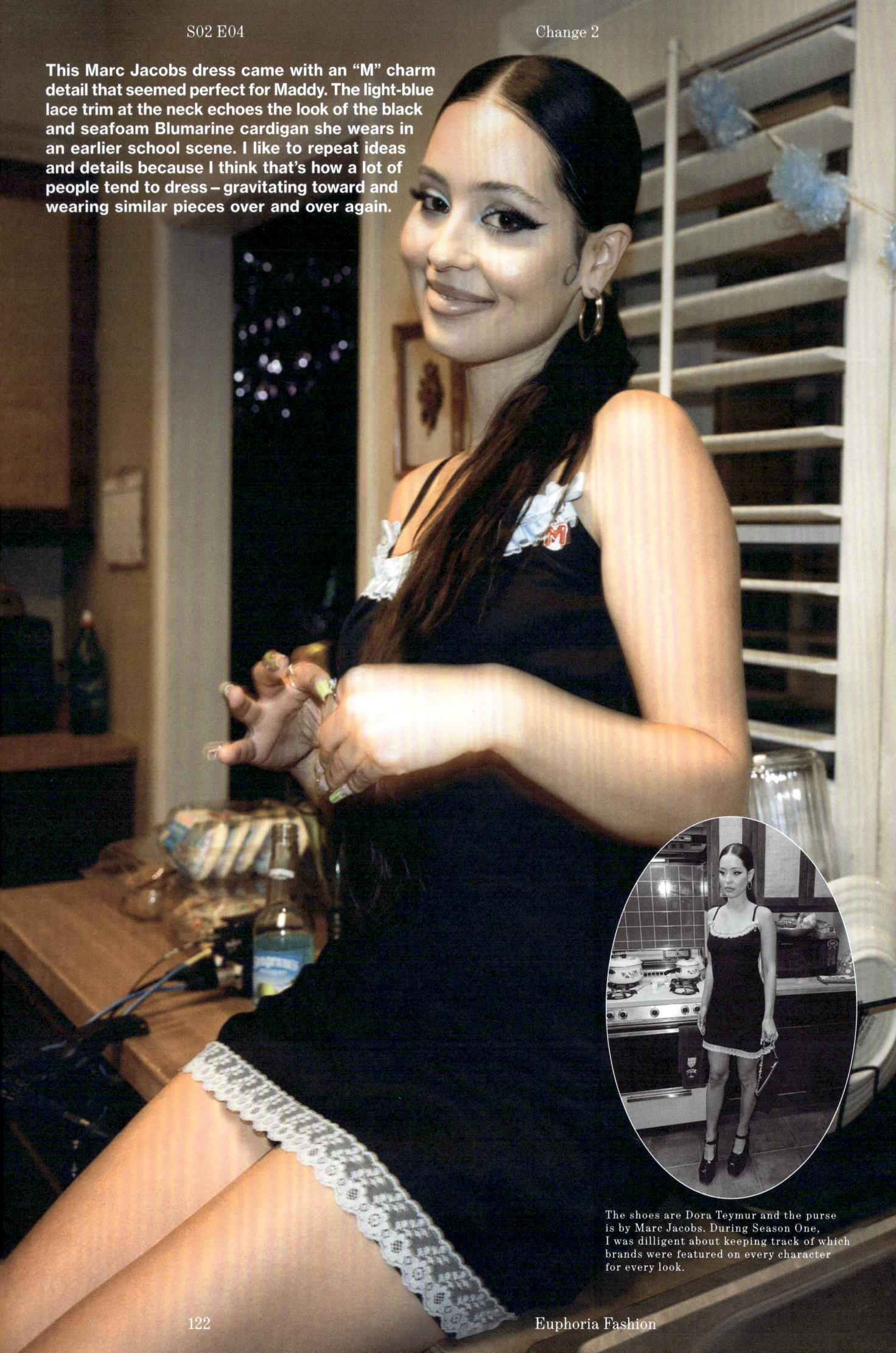

S02 E04 — Change 2

This Marc Jacobs dress came with an "M" charm detail that seemed perfect for Maddy. The light-blue lace trim at the neck echoes the look of the black and seafoam Blumarine cardigan she wears in an earlier school scene. I like to repeat ideas and details because I think that's how a lot of people tend to dress — gravitating toward and wearing similar pieces over and over again.

The shoes are Dora Teymur and the purse is by Marc Jacobs. During Season One, I was dilligent about keeping track of which brands were featured on every character for every look.

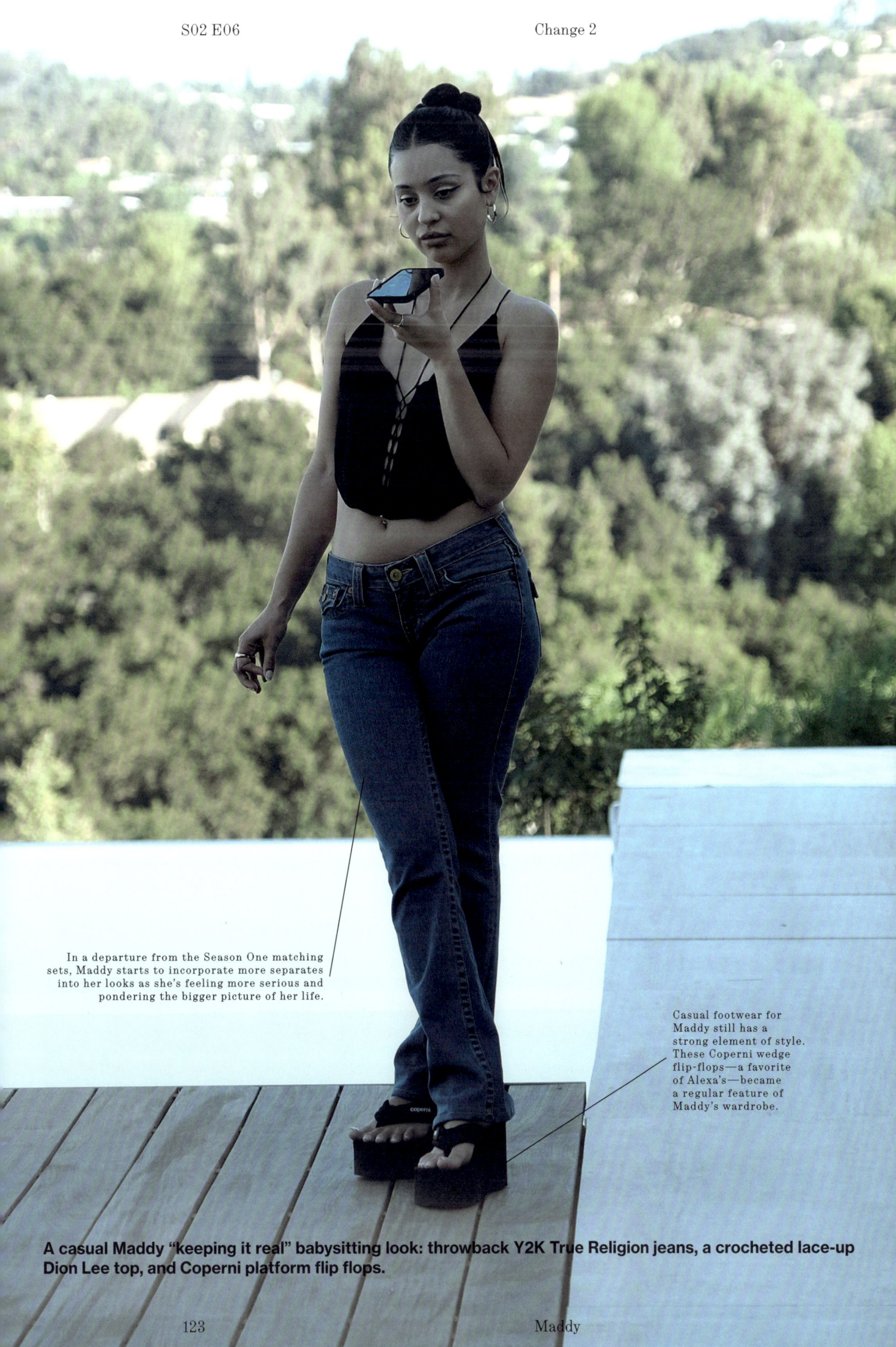

In a departure from the Season One matching sets, Maddy starts to incorporate more separates into her looks as she's feeling more serious and pondering the bigger picture of her life.

Casual footwear for Maddy still has a strong element of style. These Coperni wedge flip-flops—a favorite of Alexa's—became a regular feature of Maddy's wardrobe.

A casual Maddy "keeping it real" babysitting look: throwback Y2K True Religion jeans, a crocheted lace-up Dion Lee top, and Coperni platform flip flops.

S02 E06 Change 3

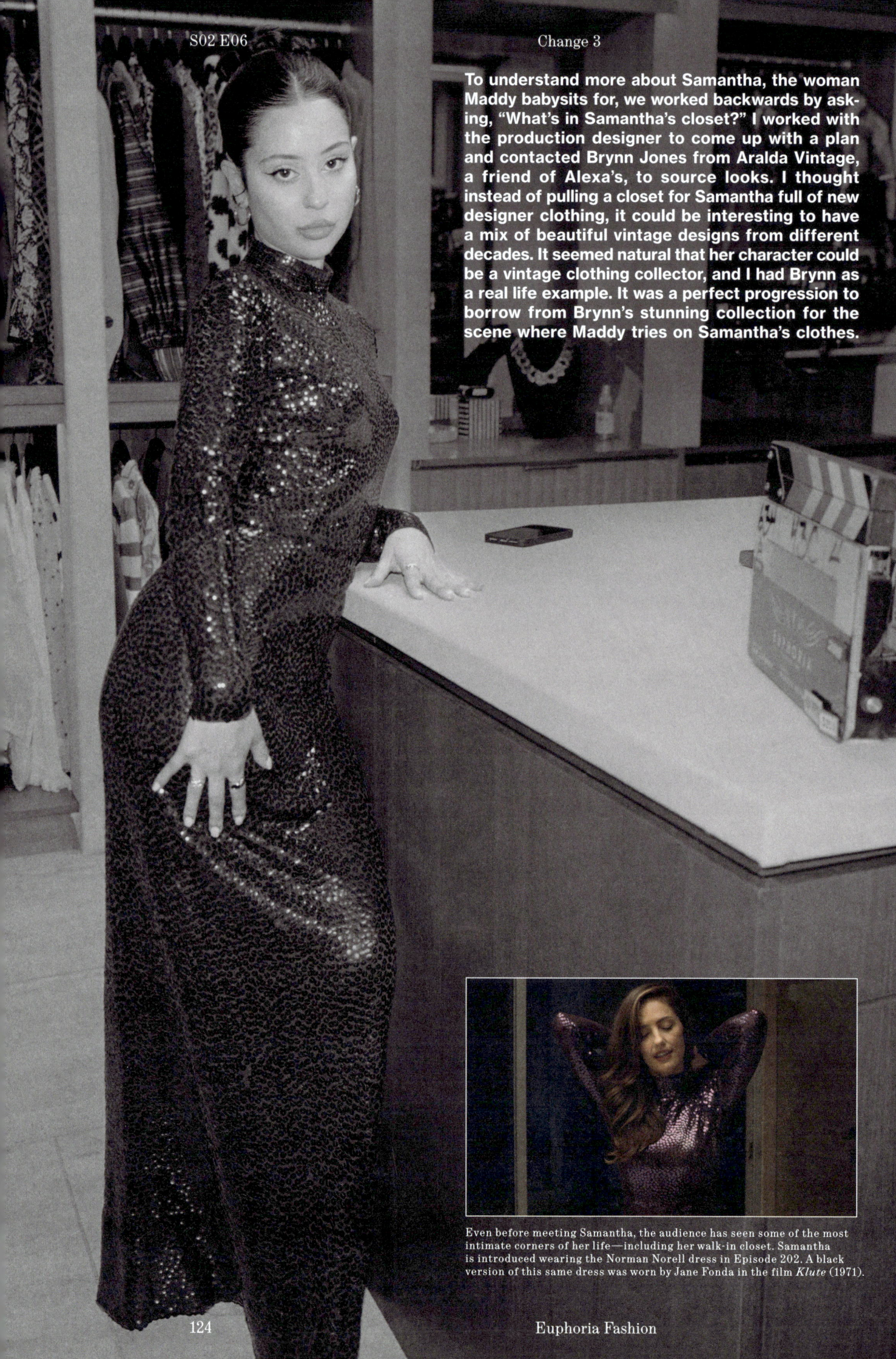

To understand more about Samantha, the woman Maddy babysits for, we worked backwards by asking, "What's in Samantha's closet?" I worked with the production designer to come up with a plan and contacted Brynn Jones from Aralda Vintage, a friend of Alexa's, to source looks. I thought instead of pulling a closet for Samantha full of new designer clothing, it could be interesting to have a mix of beautiful vintage designs from different decades. It seemed natural that her character could be a vintage clothing collector, and I had Brynn as a real life example. It was a perfect progression to borrow from Brynn's stunning collection for the scene where Maddy tries on Samantha's clothes.

Even before meeting Samantha, the audience has seen some of the most intimate corners of her life—including her walk-in closet. Samantha is introduced wearing the Norman Norell dress in Episode 202. A black version of this same dress was worn by Jane Fonda in the film *Klute* (1971).

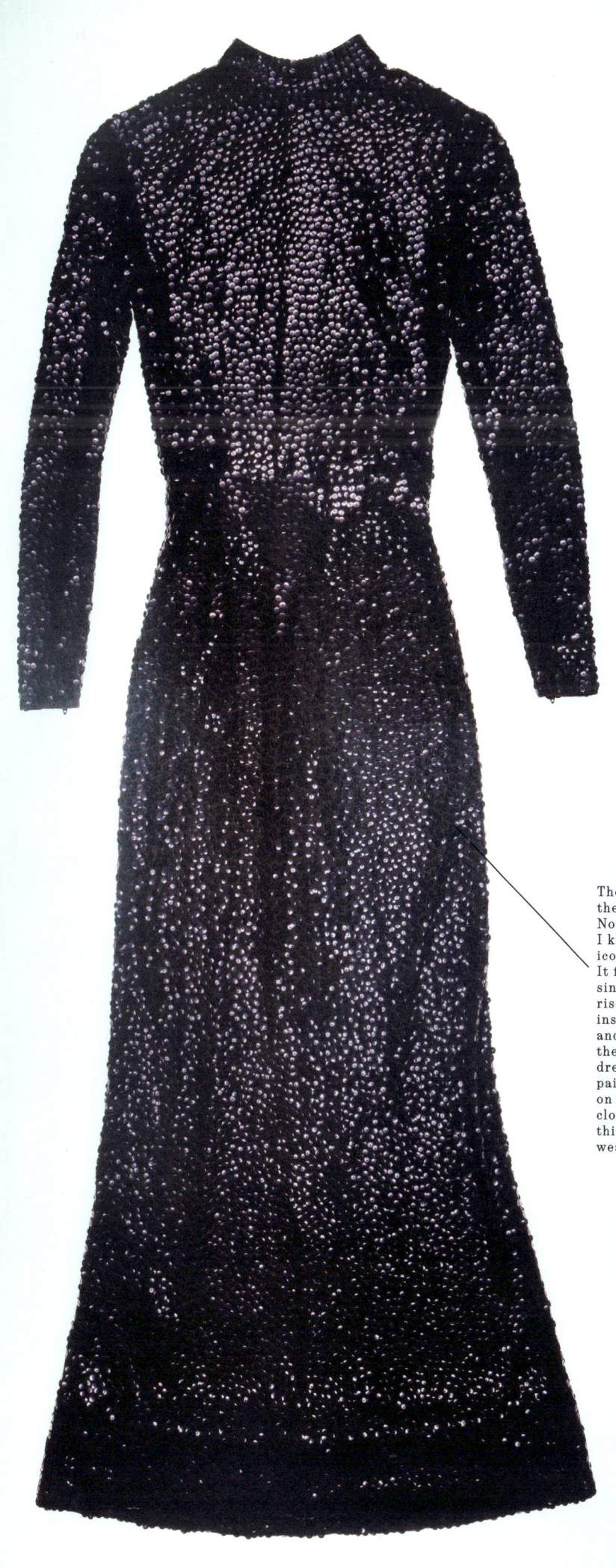

The first time Alexa tried on the vintage purple sequin Norman Norell mermaid dress, I knew it would make for an iconic moment for Maddy. It felt like a full circle moment since seeing her in Season One's risqué purple carnival look—instead of being provocative and scantily dressed, she had the opportunity to wear this dreamy full-length purple paillette gown. As Maddy tries on the dress in Samantha's closet, she is also "trying on" this aspirational life of a chic, wealthy woman.

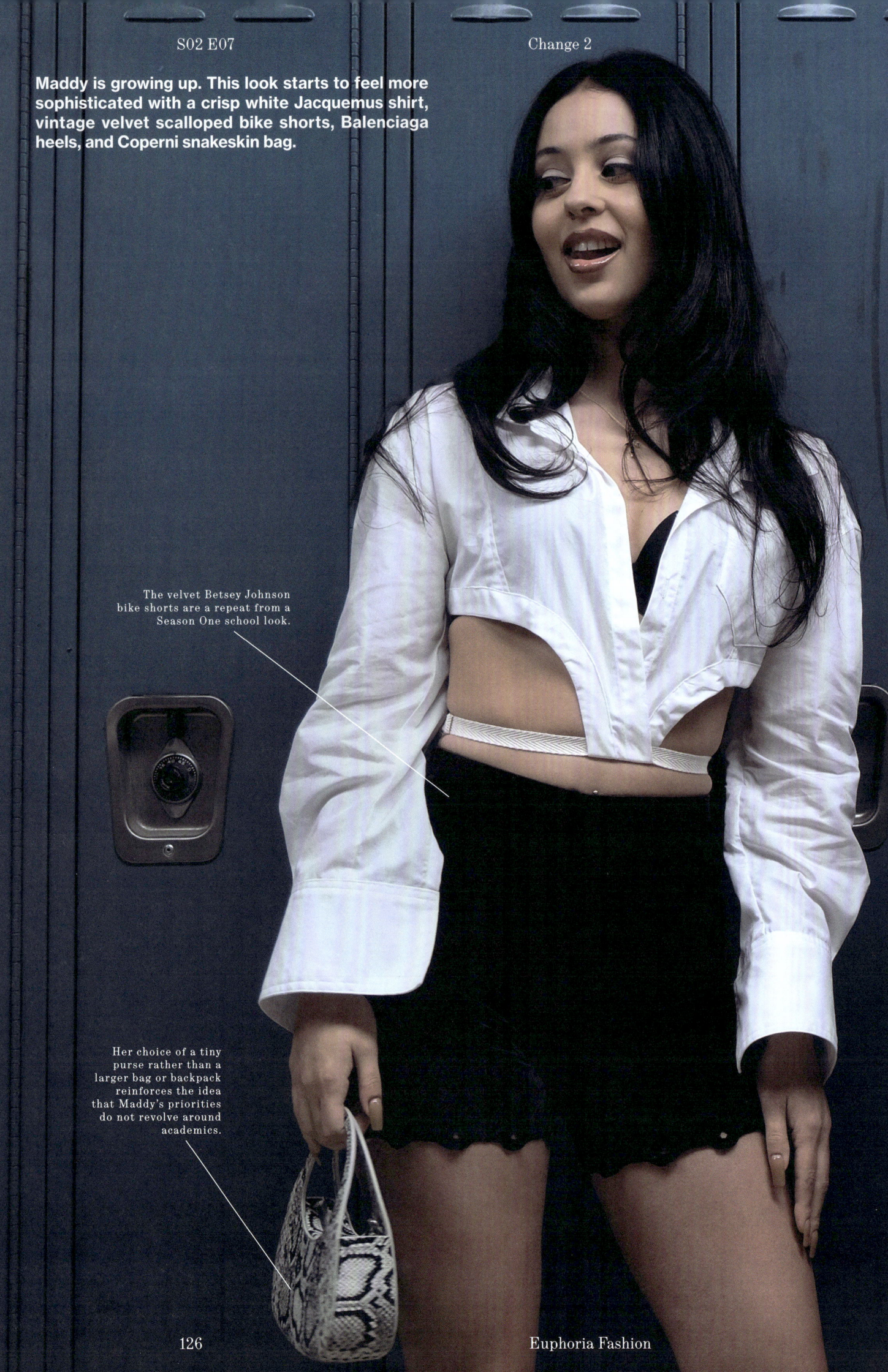

S02 E07 Change 2

Maddy is growing up. This look starts to feel more sophisticated with a crisp white Jacquemus shirt, vintage velvet scalloped bike shorts, Balenciaga heels, and Coperni snakeskin bag.

The velvet Betsey Johnson bike shorts are a repeat from a Season One school look.

Her choice of a tiny purse rather than a larger bag or backpack reinforces the idea that Maddy's priorities do not revolve around academics.

Euphoria Fashion

S02 E07 — Change 6

In this scene, it's revealed that Samantha gives Maddy the purple sequin Norman Norell dress (p.124). The gift helps Maddy imagine a future she longs for and sparks hope for a charmed life like the one she imagines Samantha and her family have.

127　　　　　　　　　　　　　　　　Maddy

IF MADDY'S GOING TO DO ANYTHING, SHE'S GOING TO PUT HERSELF TOGETHER

ALEXA DEMIE IN CONVERSATION WITH HEIDI BIVENS

HB We first met when you came in for a fitting for Jonah Hill's film *mid90s*.

AD Anytime I was in a fitting, my body would get really hot because I would hate everything they were putting me in. But with you, I felt so relaxed and safe in your hands—just really trusting. And I mean, it looked amazing.

HB That's a gift. When I have your trust, it makes me that much better. The work that we were able to do in *Euphoria* Season One, and especially in Season Two, was successful because of the way we were able to collaborate. You and I created costumes for your character, Maddy, in a way that was exciting for me. With your focus and attention to detail, we were really able to hone in on the look.

AD We were in sync from the beginning. I came to the pilot with mood boards for the costumes and makeup—images from my old private Tumblr account and old folders I had saved.
 I like to come with mood boards because I'm not just thinking about the emotions of my character or what she's going through, but the full breadth of who she really is. I've been collecting images since I was young—living at home, locked in my bedroom, just researching things. When I shared my board with you, we had a lot of the same images.

HB It's such a common thing for young people to mood-board their life these days with social media and Pinterest. It really helps me as a designer to have some idea of what the actor has formulated in their head, and visuals like your style references you brought for Maddy were a big starting point. Oftentimes I go into a fitting where a cast member hasn't thought about their backstory at all, and that's okay, but it's more fun for me to build on ideas when the actor has spent time thinking about their character's history.

AD It creates this flow, this back-and-forth. It's easier to look at something than try to describe it. Coming in with the mood board sparked a lot of ideas. All these years of collecting images, I was vision-boarding, and I didn't even know it.

HB You're a designer too, in a way. There were times when I credited you for co-designing with me—from fabric-swatching to multiple fittings to get the look exactly right. A lot of cast members don't have that kind of patience. Not only do you have the patience, but you get excited about it, which makes my job all the more worthwhile because I feed off your enthusiasm.

AD I've always been a lover of fashion, costumes, makeup, and hair—the whole vision. If I'm allowed to go to the fabric store and get swatches for you, I like that. I like to be a part of the process. It's also going on my body—I want to look and feel my best and bring what's best for the character. I think you get the best results when you're open and collaborative.

HB As I was developing the characters, I remember asking Sam Levinson about their parents and socioeconomic backgrounds. Do you remember coming into Season One and having ideas about Maddy's backstory?

AD I actually wrote out a lot of Maddy's backstory and where she came from, even though we didn't have all the scripts in the beginning. I didn't know the pageant element,[01] but I created this world of who her parents were that was weirdly in line with what I found out as we kept filming.

A young Maddy basks in the glow of pageant queendom, Episode 105.

Growing up, my family did not have money. I shopped at Goodwill and thrift stores, but I looked fucking good. When I met people, they assumed my parents were wealthy because of how I looked, but I just knew how to throw stuff together. You can get a piece of fabric and make it look expensive and chic. It doesn't matter how much it costs. I wanted to take that element from my own personal story and relate it to Maddy. If you come from a home that doesn't have a lot of money, resources, or access, but you love something, you find a way to make it happen.

HB I've talked about the twin set (**p.142**) a lot with Maddy's character. When we were shooting the pilot, we wanted a matching top and skirt set for her party look (**p.12**), but I couldn't find good options, so we made one out of that pinky-peach velour fabric.[02] Shortly after, I saw twin sets everywhere. Thinking about it now, I realize there are pictures of me in high school wearing twin sets. I came from a similar background as you, and it always made me feel like I was really put together. I imagined I looked like I had money because I had a matching outfit—I could afford the whole look. Probably, subconsciously, I wanted to express the same idea with Maddy. It was less about a trend and more about this idea that she wanted to feel put together.

Maddy wears a pinky-peach velour matching set to McKay's house party, Episode 101.

AD If Maddy's going to do anything, she's going to put herself together. It's one of her tools that she uses to feel confident. When she puts herself together, it makes her feel like her life is more together. There was a lot of intuitive energy between you and me—we weren't looking at what was happening in fashion.

HB No, the world of the show and inspiration behind the look were very insular. We had a mind meld. Essentially, Alexa is creative directing. I'm the costume designer—she's the creative director.

AD I really appreciate that because I'll creative direct something, and I never get the credit. People don't want to believe that, as a woman, you're capable of more than one thing. With designing, fabrics, or even tailoring, we would go to a tailor and tweak and create our looks.

We would find emerging designers on Instagram, and if they seemed in line with what we were creating for Maddy, I would show you a designer that might be able to make something for us. It's such a rare opportunity to be able to give a bigger platform to these emerging designers in a major way.

HB For me, so much of contemporary costumes has to do with building the closet from many different sources so that it doesn't feel like it's one-note or all shopped from one place. It's why it was important for us to tap into so many different design resources—whether it was an up-and-coming designer who already made something that Maddy might buy off the rack, or a designer we could collaborate with to change a preexisting design using a slightly different silhouette or a different fabric.

Then there was vintage. That was such an important part of Maddy's closet because of her backstory—things she would find at the Goodwills and the Salvation Armys of the world.(03) We were also able to work with people like Brynn Jones of Aralda Vintage, who you brought in. It's exciting to be able to give these people a platform with millions of viewers, many of whom are curious enough to track down the looks and investigate the work of the designers.

Plus, I love an Easter egg. I like to put pieces in Maddy's closet that people can't easily call out. They have to really do their homework.

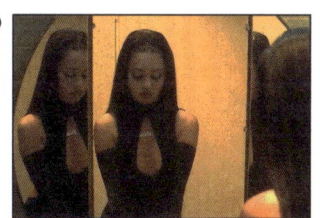

(03) A vintage two-piece set that calls to mind early 2000s J.Lo, Episode 102.

AD In Season Two, we leaned into more vintage and custom. We would think of something and consider a designer who could recreate it for us in a fabric we chose, but we ultimately ended up making the looks ourselves. I've never seen a show have such an impact on culture the way *Euphoria* does. When I'm on Instagram now, I see hundreds of versions of the black dress(04) that I wore for the New Year's party scene (**p.234**), or now we see that Blumarine brought back their vintage silhouettes that we were wearing in the show (**p.119**).

(04) Maddy's internet-breaking black custom New Year's Eve dress, Episode 201.

HB Blumarine really hit big when we were shooting the second season. Because of our timeline for shooting the show and how in-demand the new Blumarine collection was that season, I wasn't able to secure the specific looks I had requested. So I sourced vintage Blumarine to dress Maddy,(05) and now they've brought back those exact silhouettes—they even did a campaign with a model who looks like Maddy, shot in a set that looks like Samantha's closet.

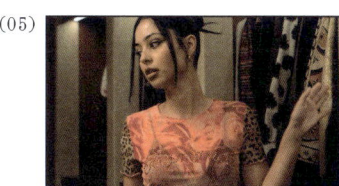

(05) Maddy babysits (and peruses her boss' closet) in a vintage Blumarine top, Episode 202.

AD Those exact silhouettes.

HB The vintage approach to Maddy specifically stems from how I explored my personal style in high school—seeing something on the runway, wanting to have that silhouette, and then finding a way to make it yourself so that it looks as good as it does on the runway, or even better.

AD There was also an idea that every character would have a specific color…

HB Maddy's primary color is purple because it's a royal color. For the first big set piece of the carnival (**p.104**), and after we meet her at the party, she wears a color that represents royalty. Later, toward the end of Season One and the winter formal (**p.212**), she dresses in black with this

veil of sorts (**p.117**), and we instinctively know she's in mourning over her relationship with Nate. The purple color comes back again when she tries on the sequin Norman Norell mermaid dress in Samantha's closet while babysitting (**p.124**).

Now that we've done two seasons, do you identify with Maddy's style more?

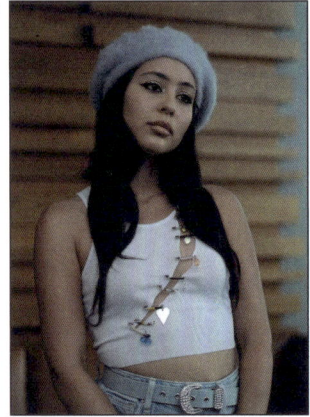

(06) Maddy's choice of outfit when attempting to donate her eggs at a local fertility clinic, Episode 202.

AD The reason I appreciate being able to embody Maddy is that when I was growing up, I went through this phase of wanting to hide, so I would wear a lot of baggy clothes. I walked home from school a lot and was always a little on edge, so I'd put a hoodie on or wrap it around my waist. I wasn't as expressive of my feminine energy as Maddy is. Being able to wear tighter and shorter things and feeling super confident in them was really revolutionary for me. I felt safe to wear these looks and be that side of who I am.(06)

After Season One, I really embraced Maddy and wanted to carry her energy. I don't think I dress like her in my day-to-day life, but I love her, and I always think about when I can get back into her clothing. She's in her feminine power and confident in what she wears, and I think that's a really important and powerful thing.

HB I'm often asked about the transition for the characters from Season One to Season Two. For Maddy, I talk about a more mature aesthetic in Season Two that has everything to do with her transporting herself to this future life she wants to have.

(07) A knit Jacquemus look in a striking green color for Lexi's play, Episodes 207 and 208.

AD There's a natural progression as you start to mature and go through different experiences that affect who you are and how you present yourself. By the end of Season One, it was getting darker. She's coming into her own by Season Two. From a visual standpoint, remembering Maddy in that little pink set, it felt like a lot of her energy was being sent out to Nate or to family. By Season Two, it feels like she's gathered all the energy she's given to everyone else and brought it in, leaning in to her growth and maturity.(07)

HB Do you have any favorite costumes from the show?

AD So many—definitely the vintage Blumarine.

HB The Norman Norell, the purple sequins.

AD I mean, all the gowns I tried on in the closet…(08)

HB …were iconic.

AD So iconic. Dream gowns. When do you see a teenage girl try on a Halston on TV?

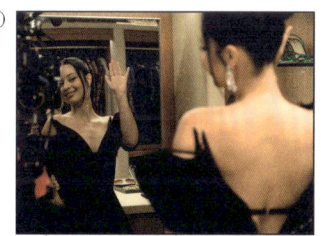

Maddy trys on a vintage Mugler from Samantha's closet, Episode 202.

HB I'm so glad we decided to create our own backstory for the character of Samantha and determined that she was a vintage collector. It really allowed us to cross all genres of fashion and retain the believability that it was one person's closet. We got stuck thinking about what runway designers and which looks from current collections we should use, but it wasn't as fabulous. Also, people who love vintage are fanatics. To be able to serve up this sequence of you trying on these different iconic dresses made for really special television.

AD There were a lot of synchronicities and special moments within the show. What were your favorites?

HB That's really hard. The closet sequence, for sure. Being able to give Maddy a look that felt like it was referencing the best of the past, but also felt very modern, was like this unspoken direction of creating future classics like…

AD The diamond robe?(09)

HB Oh yes, yes. The diamond robe.

AD With the vintage Miu Miu heel.

HB Yes. There are so many. You made my job easy.

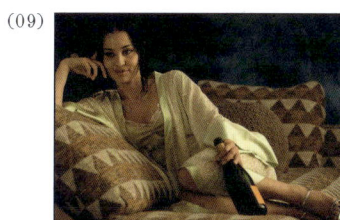

A custom-built slip and robe. Maddy borrows this from Samantha's closet for Nate's visit, Episode 204.

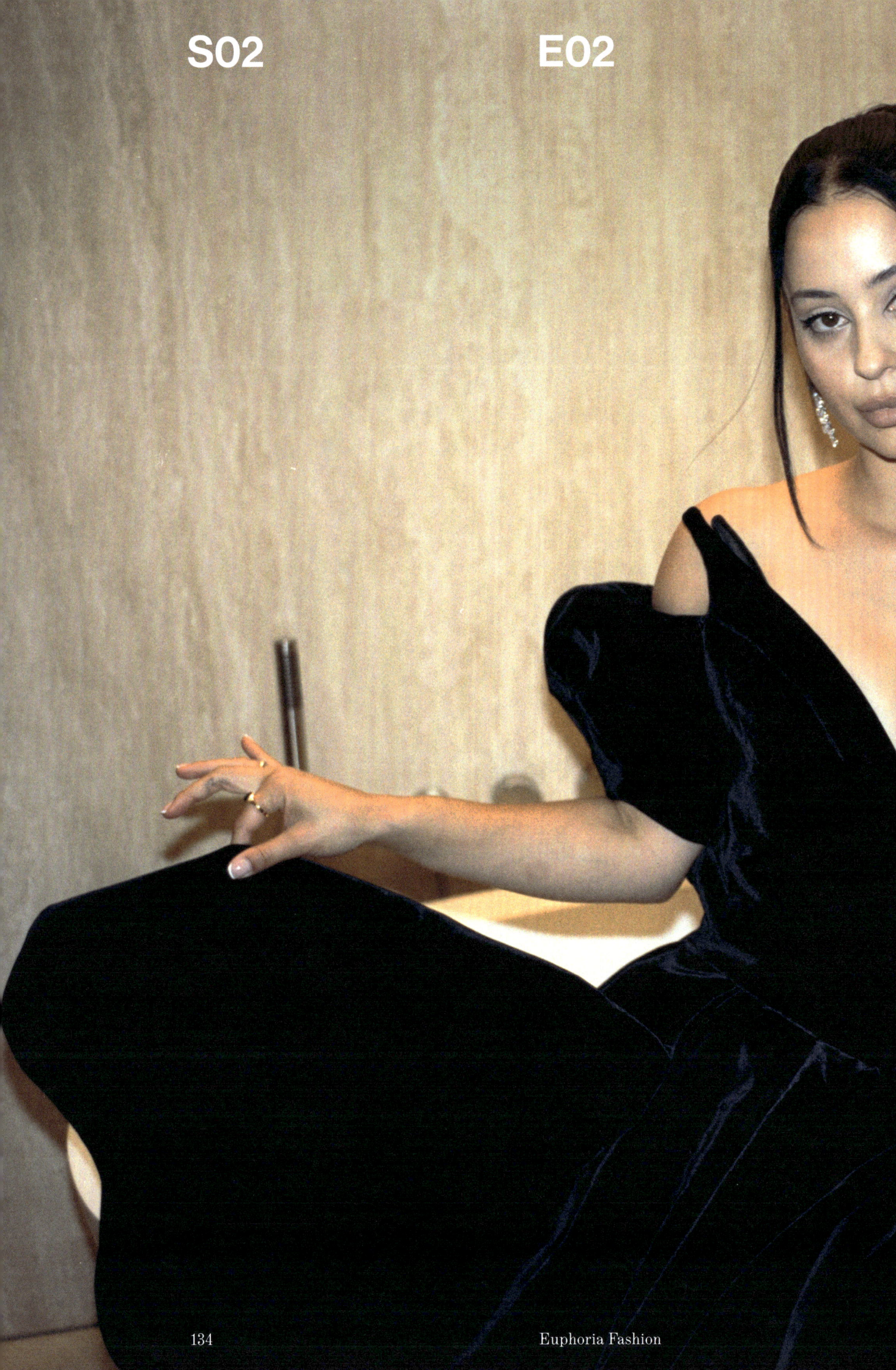

"Out of Touch"

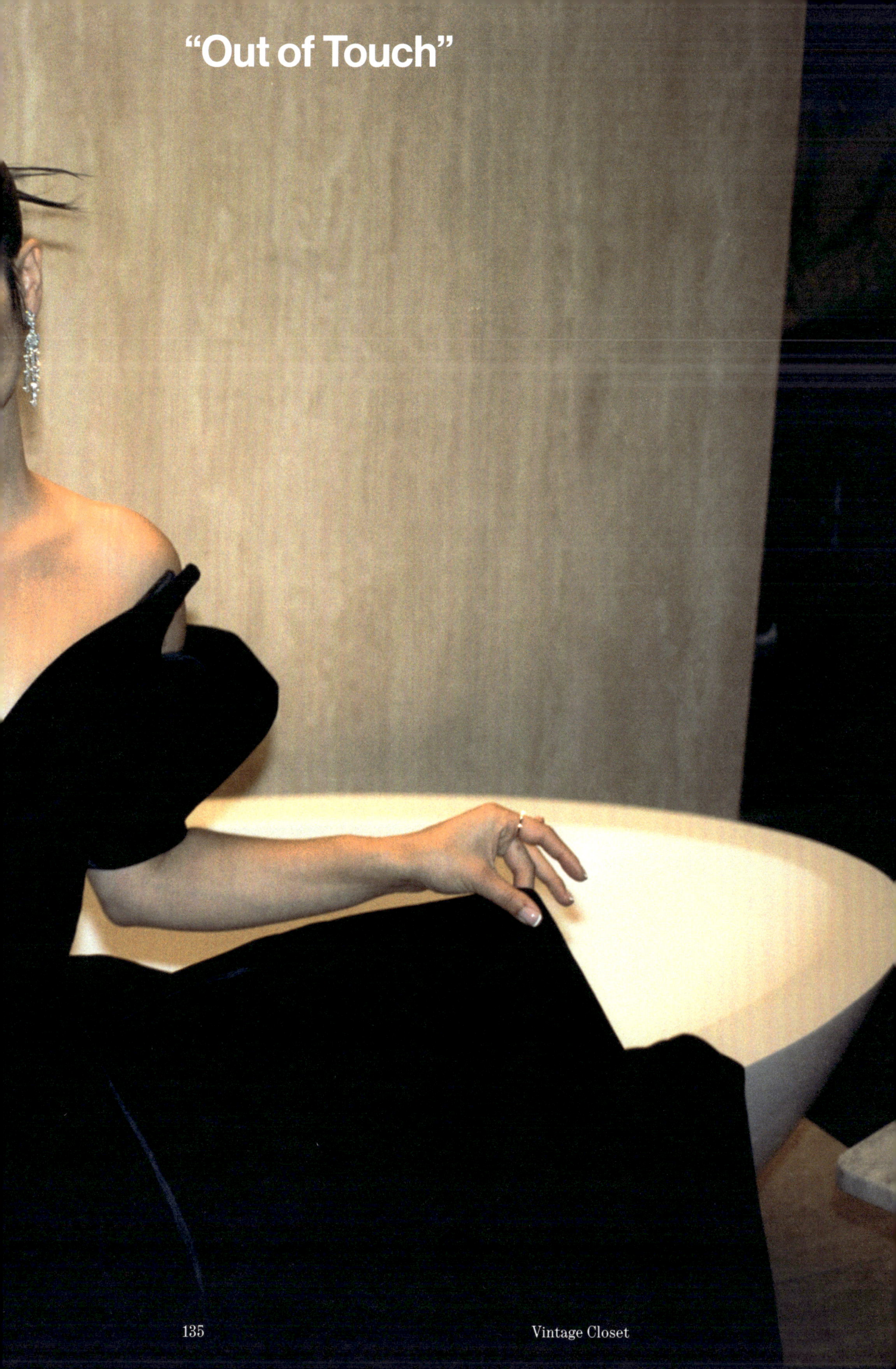

Vintage Closet

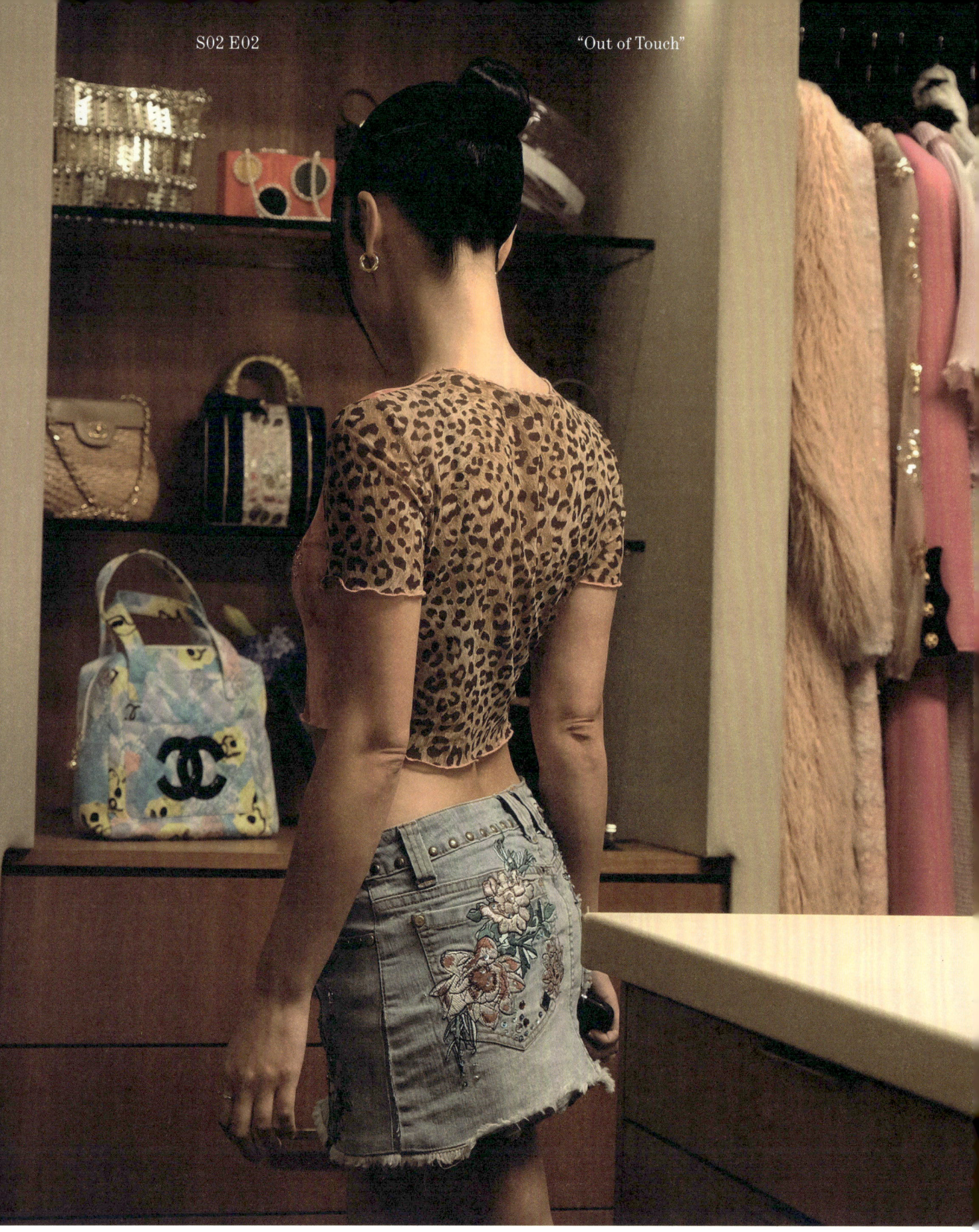

It's New Year's Day, and Maddy is floating poolside in the hills of Los Angeles at a house where she babysits a young boy named Theo. Rue narrates, "Babysitting wasn't her first choice of a job. She liked the kid she babysat for. But what she loved most was…" Maddy plays dress up in the incredible walk-in closet of Theo's mother, Samantha, an avid vintage collector with impeccable taste in high-fashion pieces and gowns from across various decades.

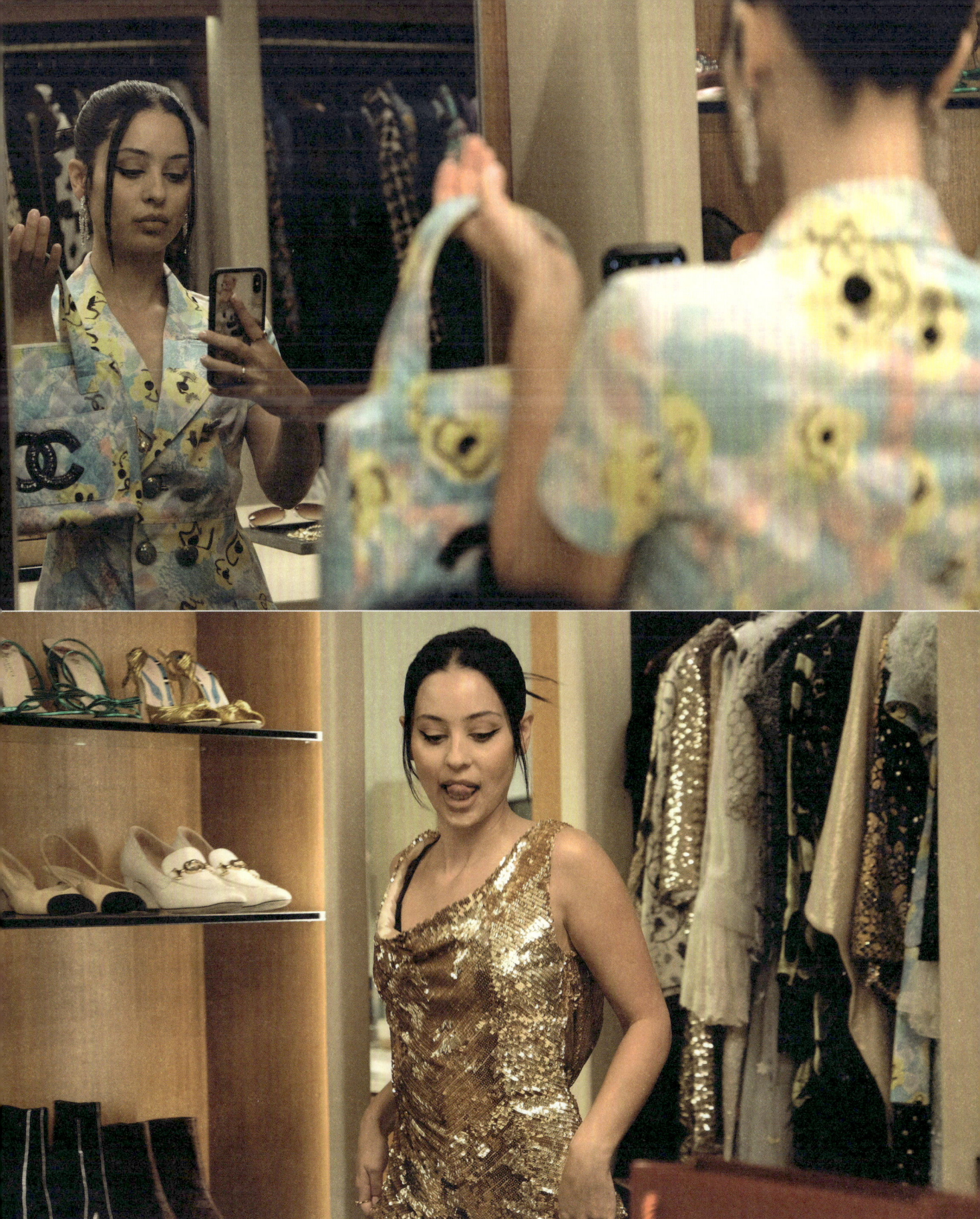

One night, Samantha arrives home early while Maddy is in the middle of trying on dresses, living her fashion fantasy. Afraid of getting caught, Maddy frantically hangs up the clothing and puts her own back on. Samantha, dressed in a shimmering purple sequin mermaid gown (**p.124**), asks her to come to the closet. The suspense recedes when Samantha asks for help unzipping the dress and thanks Maddy for being so sweet.

Vintage Closet

Recho Omondi, fashion journalist and podcast host, and *Arnaud Vaillant* and *Sébastien Meyer*, designers of the fashion brand *Coperni*, on fabricating the fantasies of youth and the energy of American teen culture

RO First of all, have you seen *Euphoria*?

AV Of course! It's our favorite TV show. We are obsessed with it. Every Monday, we would wait to watch the next episode. The story is beautiful, and the casting is everything. I even read about the way they used film to get certain special effects—it's unbelievable. We were so proud when we saw some Coperni pieces in the show.[01] It was everything.

RO What was your first impression? Did it remind you of your youth?

SM I think the first impression—maybe because we are French—was that the show was intense.

AV It was a shock.

SM We aren't used to seeing this kind of thing in France. We work in fashion, so we see these kinds of images a lot in magazines, but on TV it's very rare.

AV The whole thing about the dating apps, the drugs, the sex—it's good to see these kinds of things. It's so refreshing to see such freedom from a TV show, to see strong subjects and strong conversations. Because it's a conversation. The purpose of *Euphoria* is not to tell kids to take some drugs. It's actually the opposite. It's like, "See how they destroy you." It was impressive...all of our friends love it.

RO Can you take yourself back to that time as a teenager yourself? Describe what you were like.

SM I was a little bit crazy, so my parents sent me to military school.

AV You were fearless, as well. You were not scared of anything. You were a bit of a rebel. And I was the opposite. I was very optimistic, very healthy, very curious about people, and very open. I was a good kid. I smoked some cigarettes, but that's it.

When Sébastien and I met right after high school, there were still these differences between us. We were in the same fashion school, but he was in design, and I was in business. I did all the best internships at Chanel, Balenciaga. I was very scholarly. Sébastien was the super rebel. He never went to school, but he always found a way to get the best results. He would come on the last day to deliver his project to the professor, and he'd do this crazy project full of poetry or magazines. You were really fun. You have a bit of *Euphoria* in you. I guess the French teenager is very different from the American teen.

(01) No room for school books in Maddy's Coperni mini purse, Episode 202.

SM The way we see the American teenager is very colorful, very full of life. In France, it's totally different. We all wear black, very grey, more monotone. So it gives us some hope and joy to see these American kids.

But it also reminds me…we have an expression in French when you show people a joyful side to hide the anxiety and sadness.

RO Right. It reminds me…you're from the South of France, right? In the United States, if you're from anywhere else, you come to New York or Los Angeles for the lights and action. I think of Paris in the same way. If you're from outside Paris, don't you move to Paris for the energy?

AV For a lot of French teenagers, it's the dream to move to Paris because it's the capital of design, fashion, and culture. When you leave your hometown and come to Paris, it's the first feeling of freedom. But at the same time, it's still a traditional city. The French are much more conservative, for sure.

SM And melancholy, maybe. When you come to Paris, everybody is snobbish and very classist.

RO What is it about that time in our lives that we, specifically in the fashion industry, are always trying to capture? What's the value in it?

Coperni Fall/Winter 2022.

AV I think it's this idea of freedom and fearlessness, passion and dreams. The fact that you are still building yourself. You may be in high school but you know deep inside that one day you are going to be this actor or designer, or maybe a lawyer or a surgeon. The value of capturing the coming-of-age moment is the purity and also the danger. It's also good to fail and to make some mistakes that you think are the end of the world, but then, when you look back, you realize that it was just a tiny part of building yourself and the discovery of your body.

SM We used lockers for the set of our last show.(02) I love the reference to the school hallway—it's like your first runway show. On the first day of school, you had a new outfit, and you might have felt uncomfortable. Everybody judged you, and you were trying to find yourself. It's a fashion show. We really wanted to pay tribute to that moment, which is so pivotal.

Coperni Fall/Winter 2022.

AV With this idea of coming of age, I think that sexuality is an important value. We constructed the show by starting with very radical silhouettes, very strict, like if you were going to boarding school—slightly religious, very minimal. Then it evolved into something a bit more rebellious. We had a model wearing leather mini skirts with some shirts, a bit sassy. By the end of the show, they were going to prom, and we did some latex dresses that were so beautiful but so hard to make. We had these flowers on the dresses, like corsages, but the contrast with the latex fabric was interesting because it's a fabric usually found in sex shops. The poetry of flowers with this erotic fabric…I loved this last show. It gave me a lot of pleasure to do it.(03)

RO Do you think teenagers today are more mature or self-possessed than we were in our teen years? Even Jules, the way she owns her sexuality with such confidence…

AV It's a TV show, so I guess that it's an amplification of reality, but they're all dressing unbelievably, so gutsy, so much risk and so much freedom. The styling of the show was insane. I want to be in that school.

Fun fact: I bought this tie-dye T-shirt with an alien on it (**p.20**) that I gave to Sébastien for Christmas. Zendaya was wearing it in Season One.[04] I think it was Gosha Rubchinskiy.

But how are teenagers today? I hope they're dressing the same, because it's so inspiring. And it's not only at school. It's also through social media, where teenagers are exposing themselves so much. For sure, I was not dressing like that.

SM I think we were more classic because we didn't have social media. And so the outfit was more for us and less for the rest of the world.

RO We are so impressionable at that age. Even the makeup looks in *Euphoria*—these young people are so skilled at doing their makeup. You forget that underneath it they're these gentle souls who are still forming, yet their presence is so commanding. Perhaps they're aspiring to that level of confidence, but it's quite convincing.

(04) Rue's tie-dye alien T-shirt is a fan favorite, Episode 101.

ODE TO:

MATCHING SETS

A Chanel suit? Matching purse and shoes? Silk lingerie sets? The pink cashmere tracksuit? There's something so deliciously bougie and retrograde about the matching set—the armor shielding the soft power of glamor and leisure. Evoking a time when the confidence to wear a head-to-toe look could be a woman's full-time job, matching sets have long been the hallmarks of ladies who lived to lounge.

The matching set got its start in accessories: specifically, a set of logoed luggage that implied the kind of travel where other people unpack for you. (Although Louis Vuitton was one of the first brands to have great success with logoed luggage—their monogram was patented in 1896—rich people donned matching accessories for centuries.) Matching sets moved into day wear in the 1920s as "sport" dress for well-heeled country clubbers—first for the ski season and then for summer resorts. Those early sport sets and the smart young debutantes who wore them were eclipsed by matching sets with stretch and suppleness that slinked out of transgressive Parisian nightclubs by the late '20s. These silk sets of "evening pajamas" in bias-cut jersey were inspired by the underground nightlife looks of rich lesbians in tailored trousers. First worn in public by the risqué cabaret performer Mistinguett, the louche matching sets of this moment were wrought to perfection by French couturier Madeleine Vionnet[01] for society dames who wanted the frisson of menswear for women, but under a designer label. They were then taken up with enthusiasm by Hollywood costume designers looking to dress the archetype of the brassy and demanding trophy wife and to write affluent debauchery onto the silver screen.

The ultimate daytime matching set was introduced in the 1950s when Coco Chanel created her iconic suit.[02] The simple, practical uniform for women drew particular interest from the American customer, who wanted to move freely while signaling wealth from underneath

A Madeleine Vionnet dress and cape, 1935.

A matching Chanel suit from Spring/Summer 1983.

fashion sketches.

The Chanel-style set was toppled in the 1970s by Halston's matching ensemble of slippery synthetics that reprised Vionnet's subversive evening pajamas. Halston's disco jumpsuits[03] rejected the conservative values of Chanel with ensembles designed for decadence and the privilege of parties. Instead of offering boxy twill armor, Halston defiantly exposed the body with plunging necklines and high-slit skirts, dismissing middle-class obligations of propriety and reimaging the look of urbane independence. The Halstonettes, who were the inception of the supermodel, posed relentlessly through paparazzi photos of the decadent club scene at Studio 54. Designers like Stephen Burrows and Diane von Furstenberg captured the age with expensive uniforms for life outside the box of wife and mother.

By the 1980s, matching sets moved into a greater fashion consciousness. Harlem clothier Dapper Dan was creating luxury logoed leather matching sets[04] for discerning hustlers and hip-hop founders at his uptown boutique. Creating the opportunity for his customers to package their affluence as compellingly as any other magnates of the 1980s, his menswear matching sets were modeled after New York street style, albeit in custom leather. At the time, Louis Vuitton still only specialized in accessories, but that didn't stop Dapper Dan from designing head-to-toe "Vuitton" tracksuits made with

(03)

Halston Four Models by Harry Benson, 1978.

(04)

Eric B. & Rakim in Dapper Dan suits on the cover of *Follow the Leader*, 1988.

Opposite Page: Top, Maddy in a vintage Chanel-inspired set, Episode 103 / Bottom, vintage Louis Vuitton set, Episode 102.

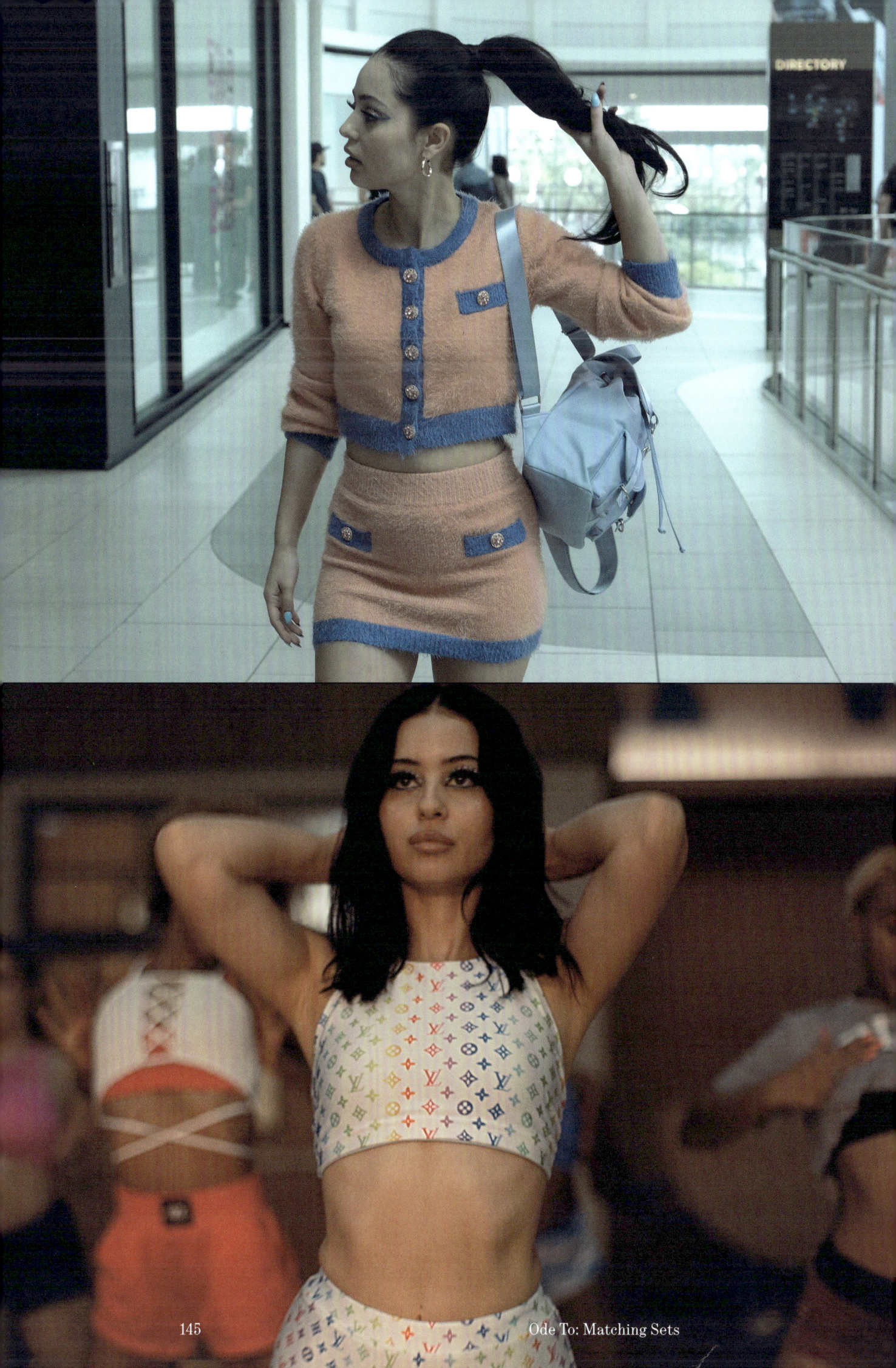

Ode To: Matching Sets

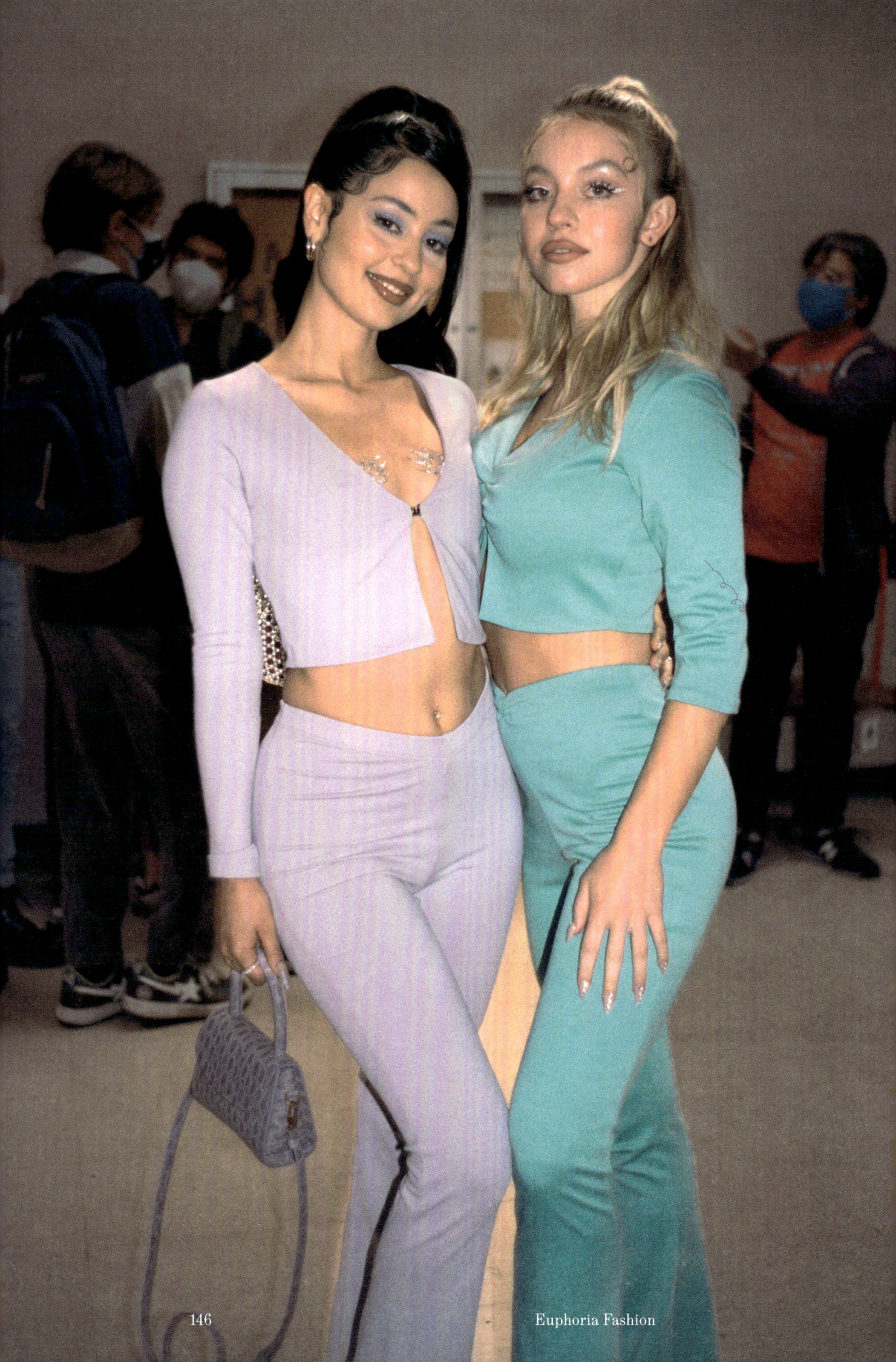

leather he silk-screened with luxury logos in a workspace adjacent to his Harlem atelier. Dan's work was worn to convey power, money, and control on 125th Street. He invented a matching set of luxury streetwear a decade before Karl Lagerfeld decided to embrace hip-hop aesthetics with interlocking C's (for Chanel) and F's (for Fendi) on his European design house ensembles.

The tracksuit deluxe was reclaimed as womenswear in a soft, unctuous velour version by Juicy Couture in the late 1990s. Bedazzled in a logo borrowed from Chicano car culture and tattoo art, the Juicy Couture tracksuit was designed for the young, unapologetic Hollywood set at a price point accessible to middle-American mallrats. The brand was worn iconically by Britney Spears, J.Lo, and especially Paris Hilton, who ushered in our current celebrity culture decked out head-to-toe in the rhinestoned, logoed velour set.[05] As the first coming of the athleisure boom, Juicy Couture's tracksuits in bright colors and body-conscious stretch became a late-'90s California lifestyle icon. It was a power suit for the woman who could be famous for just being famous.

Recently resurgent, the matching set has become the uniform for a highly specific, sexy army that embodies all these histories. Sometime at the end of the 2010s, a flash of recognition went viral among social media influencers as they discovered the full-package power of the matching set: lux leisure, hip-hop swagger, and unrepentant body-conscious cling. As fast fashion retailers made the signifiers of privilege available to high schoolers on a budget, the matching set multiplied in every color and texture to meet the demand of a new generation. Expensively knit or poly-blended, logo-patterned or floral-printed, cropped or fitted or both, the matching set projects the unapologetic confidence of a person who puts themself together with casual precision, projecting confidence, power, and leisure—a person who aspires to have it all.

(05)

Paris Hilton goes shopping in Beverly Glen, 2010.

Opposite Page: Alexa and Sydney behind the scenes in similar matching sets, Episode 205.

IV. NATE

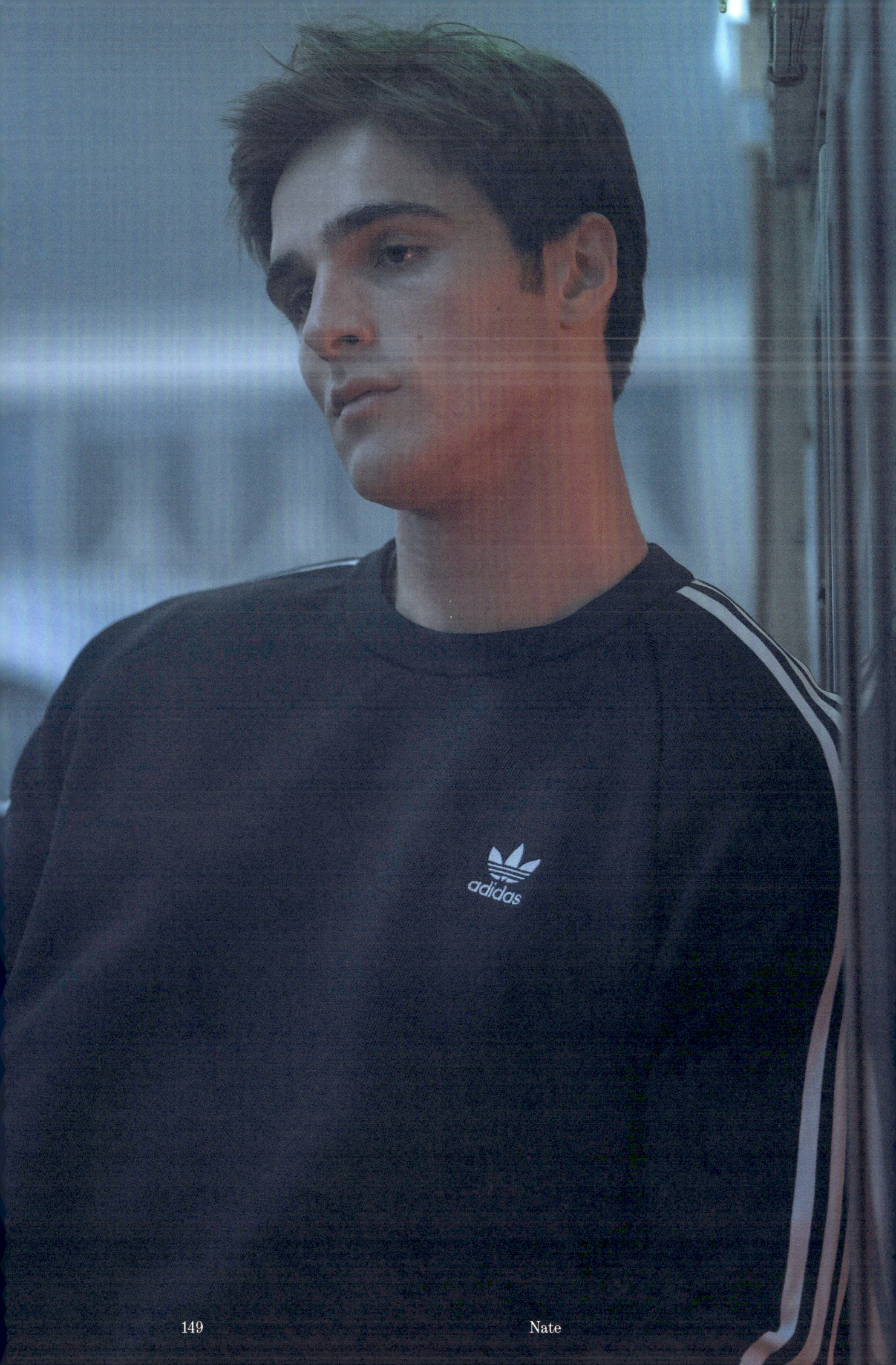

"You deserve whatever the fuck it is in this world that you want. So keep your head down. Keep your mouth shut. Don't try to ruin my life, and I won't have to ruin yours."
—Nate Jacobs to Jules Vaughn

Nate might be a sympathetic villain. He's a product of a father with secrets and a mother who's turned a blind eye. He feels alone within his family. At school, he is popular and plays the role of the hyper-masculine star quarterback on the high school football team—a classic confident jock archetype. His everyday uniform consists of jeans, T-shirts, sweaters, sweats, and sneakers. Nothing deviates from that. There is no thinking outside of the box for him. He desires rigid control in his life and relationships to compensate for his lack of confidence about his own masculinity. He carries shame surrounding his complicated relationship with his father.

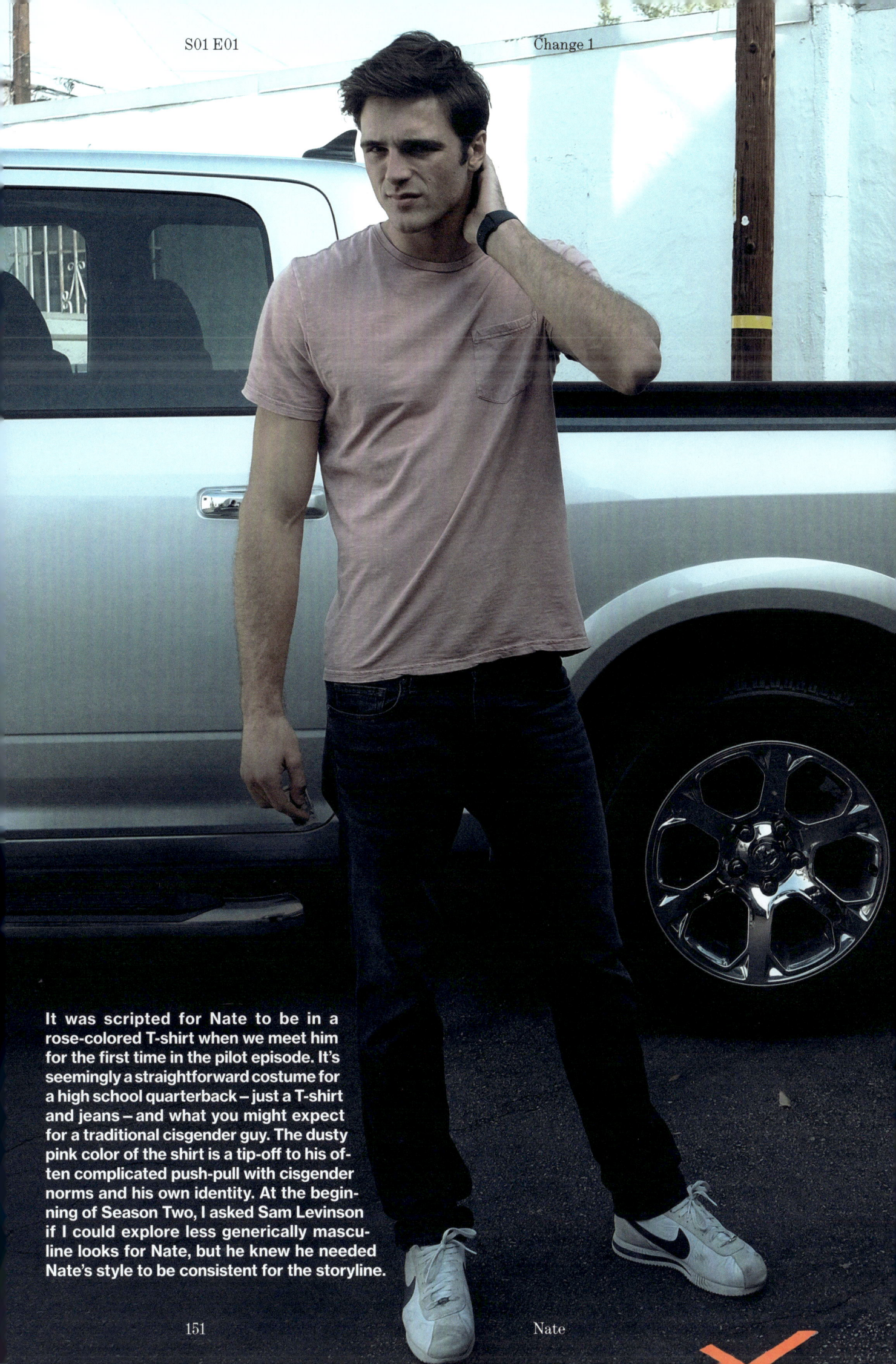

It was scripted for Nate to be in a rose-colored T-shirt when we meet him for the first time in the pilot episode. It's seemingly a straightforward costume for a high school quarterback — just a T-shirt and jeans — and what you might expect for a traditional cisgender guy. The dusty pink color of the shirt is a tip-off to his often complicated push-pull with cisgender norms and his own identity. At the beginning of Season Two, I asked Sam Levinson if I could explore less generically masculine looks for Nate, but he knew he needed Nate's style to be consistent for the storyline.

S01 E02 Change 10

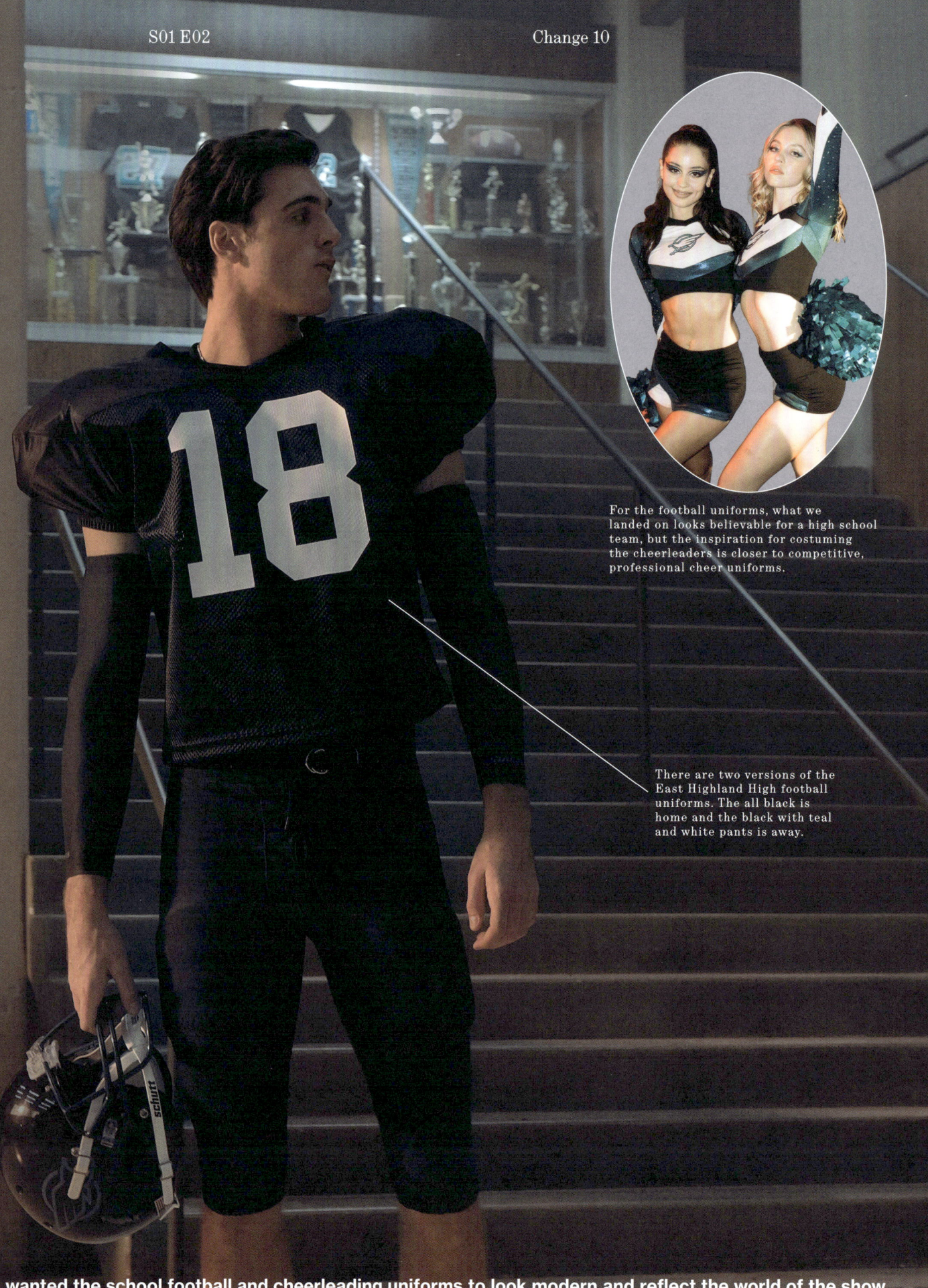

For the football uniforms, what we landed on looks believable for a high school team, but the inspiration for costuming the cheerleaders is closer to competitive, professional cheer uniforms.

There are two versions of the East Highland High football uniforms. The all black is home and the black with teal and white pants is away.

I wanted the school football and cheerleading uniforms to look modern and reflect the world of the show somehow, which meant taking some creative liberties as to what might be thought of as realistic. I researched professional football team colors and styles, which often feel more elevated in design than your average high school football uniforms. My takeaway was that using black felt modern since traditional uniforms are more colorful. In collaboration with the production designer, the teal was chosen, and, with white as an accent color, we had a color combo that felt stark enough for our school setting.

Choosing the school colors was a collaboration with production designer Michael Grasley and director Sam Levinson. The uniforms were custom made for the show with the help of Teamwork Athletic Apparel.

The blue-green Pantone color is known as 321C and most commonly described as Makita Teal.

There is a shot in the pilot episode where Nate is wearing a gold-color football jersey—a school color chosen for East Highland High before we went to series and decided on teal, black, and white.

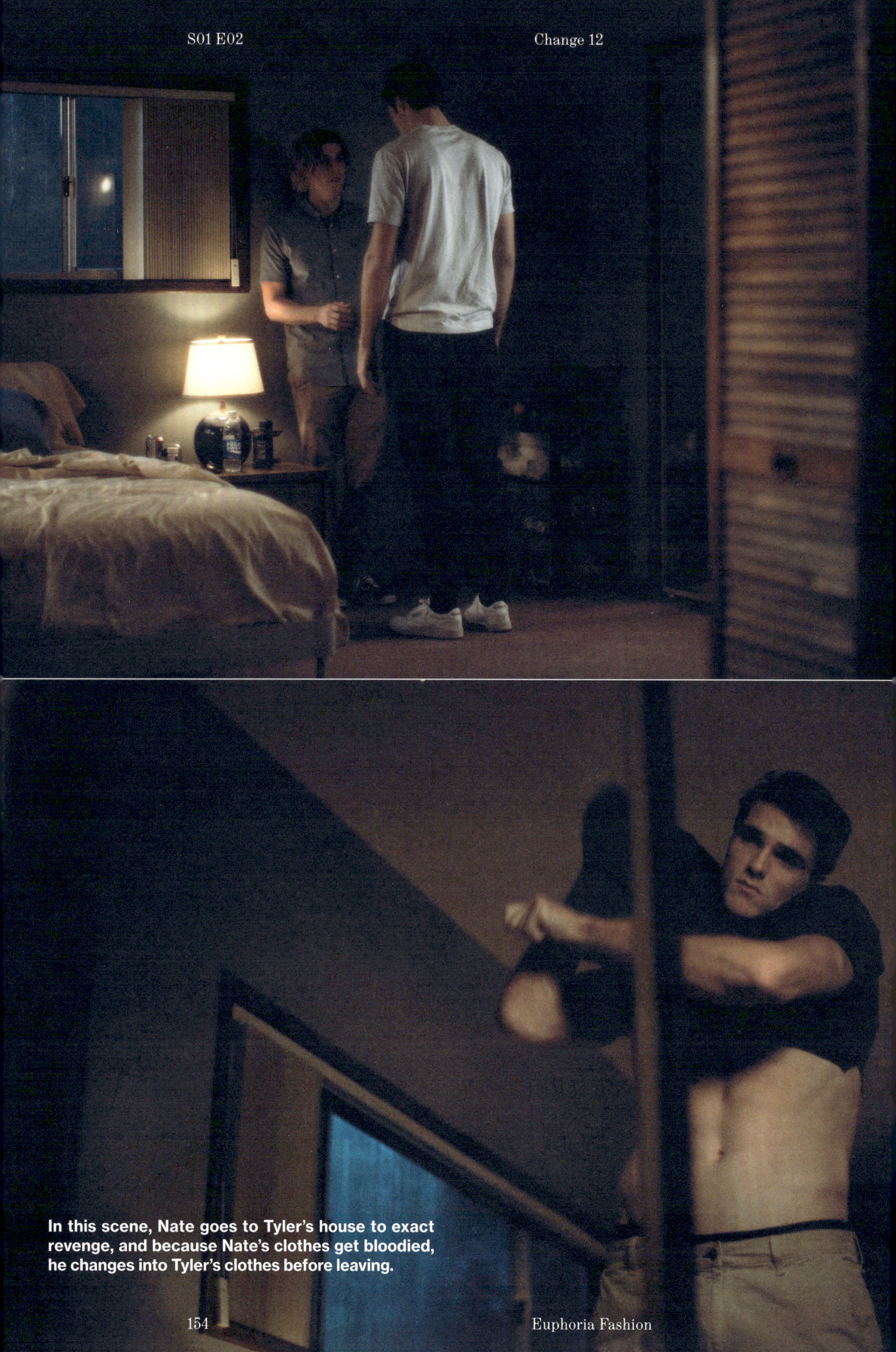

In this scene, Nate goes to Tyler's house to exact revenge, and because Nate's clothes get bloodied, he changes into Tyler's clothes before leaving.

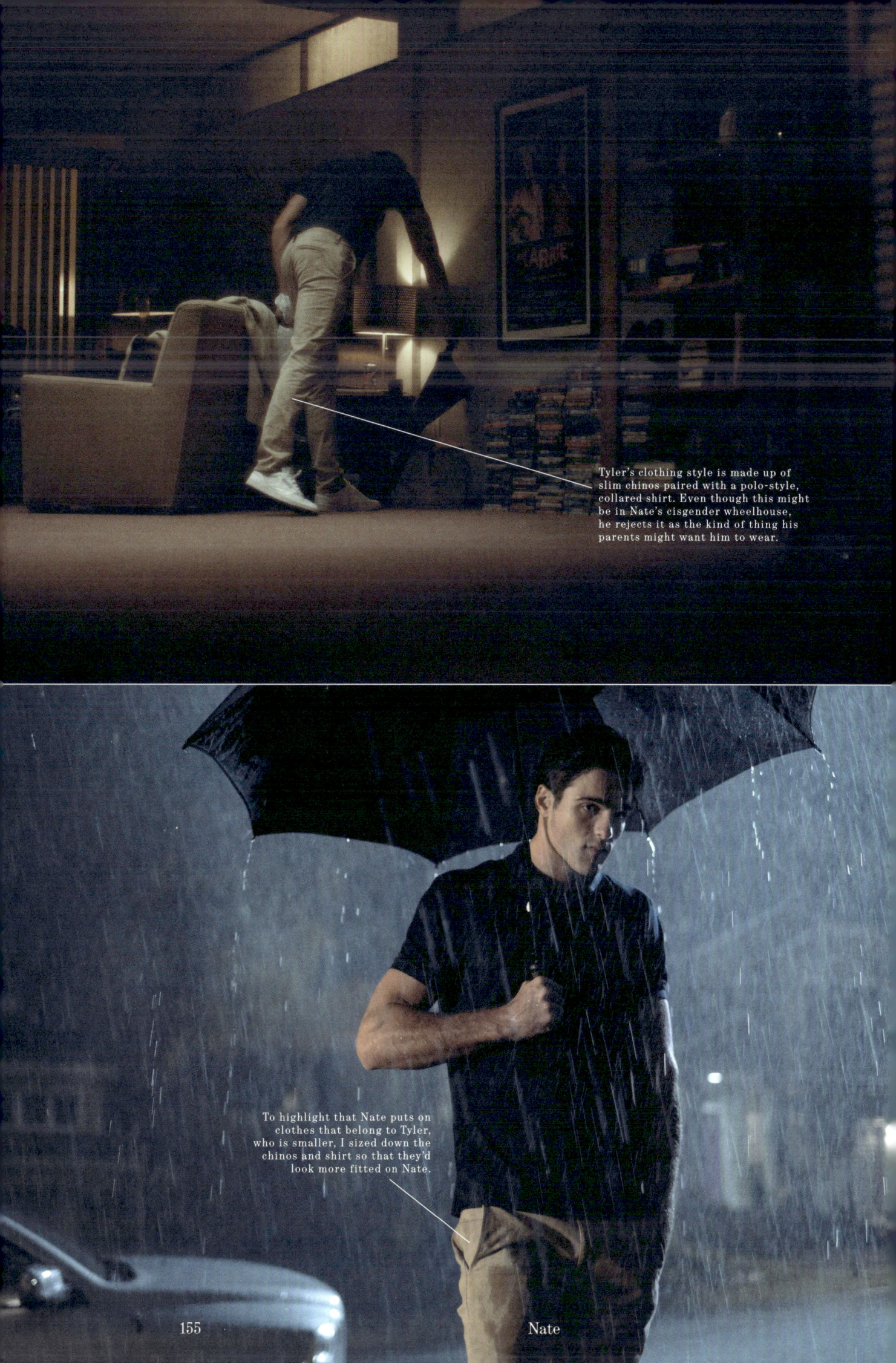

Tyler's clothing style is made up of slim chinos paired with a polo-style, collared shirt. Even though this might be in Nate's cisgender wheelhouse, he rejects it as the kind of thing his parents might want him to wear.

To highlight that Nate puts on clothes that belong to Tyler, who is smaller, I sized down the chinos and shirt so that they'd look more fitted on Nate.

S01 E07 — Change 4

There's a hint that something is going on beneath the surface with Nate. In Jules' fantasy at the nightclub, he has glitter on his face, and he is shirtless, his jacket unzipped to reveal his chest. Even though it's a scene in Jules' mind, it signifies there could be something else going on under Nate's masculine jock persona.

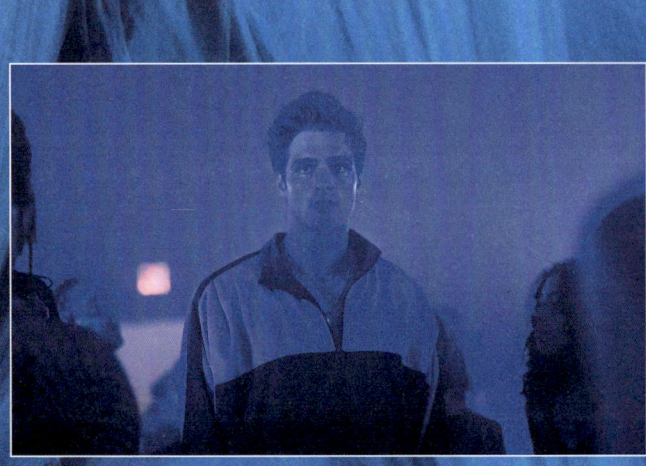

The necklace was something Jacob wore to set, and it worked with Jules' dream version of Nate—a more fluid and daring form of the character.

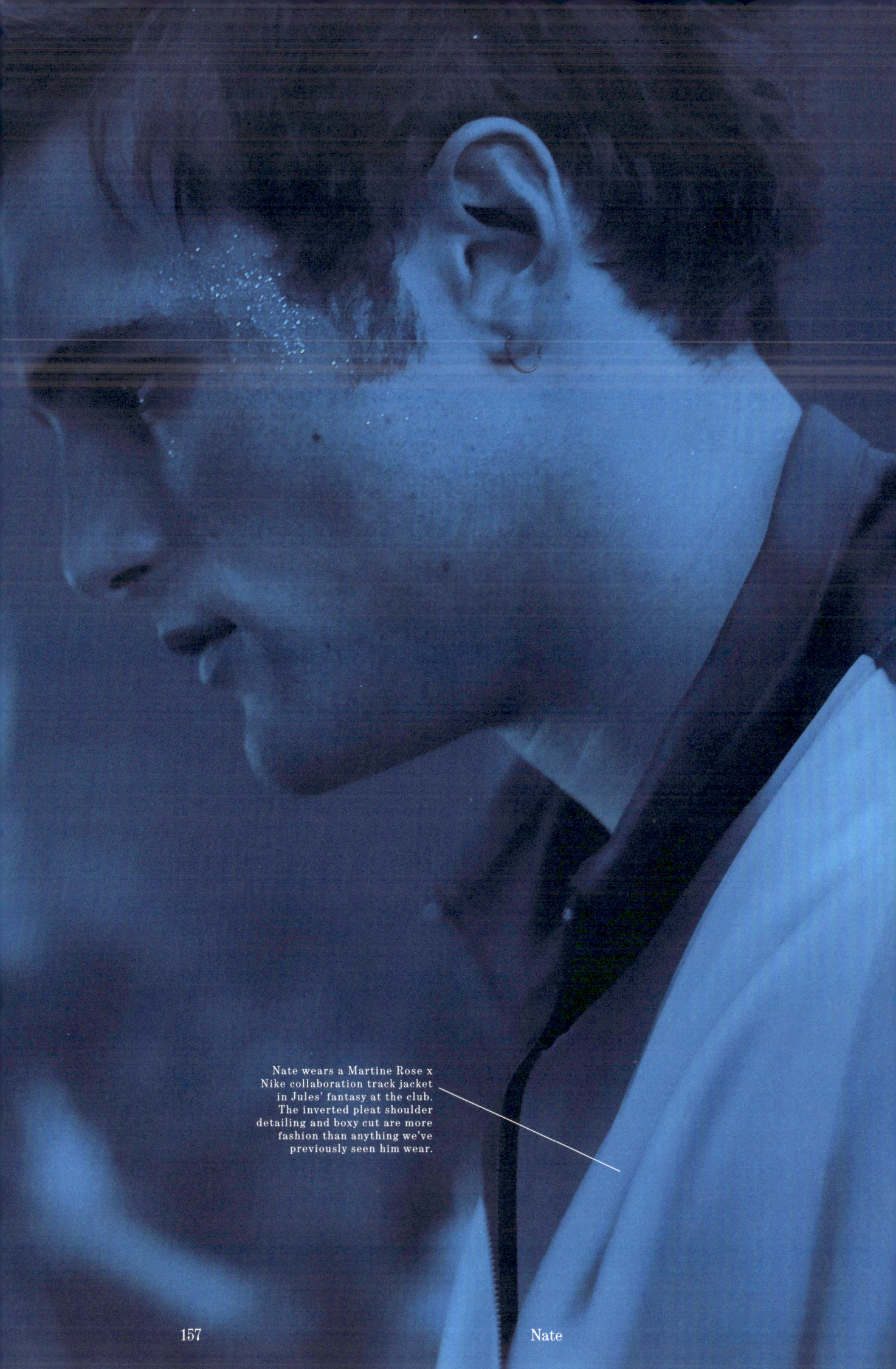

Nate wears a Martine Rose x Nike collaboration track jacket in Jules' fantasy at the club. The inverted pleat shoulder detailing and boxy cut are more fashion than anything we've previously seen him wear.

BOUND: NORMCORE AS FASHION BONDAGE

William Van Meter

Kat works it as a cam girl, mixing lace and leather—and a kitty mask, Episode 207.

Both Nate (top, Episode 103) and Cal (bottom, Episode 104) dress to hide their inner lives.

S&M isn't just a look, it's a lifestyle, and Kat certainly got the bondage memo for her Season One arc. She began the series a virgin, wearing retro, owl-like glasses (**p.175**) and floral-print thrift store blouses, but swiftly evolved into a leather-clad cash-dom cam girl,(01) parlaying her newfound self-esteem, crypto earnings, and Amazon wish list into a wardrobe of corsets, suspenders, O-ring collars, and Zana Bayne harnesses (**p.177**). But her makeover and hypersexualized larping turns out to be illusory escapism. Is camming a way to explore sexuality and earn some Bitcoin, or is it just staring into the void? Who, in fact, is holding the whip?

Yes, chokers are very on-trend at East Highland High, but, in a broader sense, a more metaphorical form of bondage fashion pervades. Each main character is an easily recognizable archetype with a style as definitive and singular as a superhero's costume. Their looks ebb and flow and reflect their states of mind, actions, and discord. But what about the two most sartorially nondescript characters, Nate and his father, Cal? It's hard to zero in on their iconic outfits, and that's by design. Give either a gift card, and they could go into any big-box chain store and find some pants.(02)

They each strive to look average, but there is something much more insidious going on. Both are predators. They are wolves in sheep's clothing—and honey, those sheep are kinky, conflicted, and norm to the core. If each member of *Euphoria*'s menagerie dresses to be seen, the opposite can be said for Nate and Cal. They dress to disappear, to convince those around them that they are who they are not. Their outward extension of self-denial serves as both camouflage and hindrance—and their ordinary button-downs and crewneck sweaters are constricting the life out of them. Pressurized denial and rage churn just beneath the surface. Both are ready to burst, Hulk-like, through their chinos and button-downs.

Nate and Cal's entire existences are formed around the constructs of their secret lives, and, to a degree, the pursuit of a sexual outlet. Their 24/7 roleplay extends to their attire too. It can't all be about deflection. In fact, their mundane garb is essentially unorthodox BDSM gear. Their costumes turn them on and project what they want to be: virile, regular dudes. Nate has taken roleplay a step further with his hobby of being a scheming sex-app catfish wielding fake dick pics and a closet stocked with hooded sweatshirts. Devoid of insignia, pattern, or logos, they say nothing about the wearer. Flip up the hood for a sporty, casual prowler or Grim Reaper look.(03)

Nate cloaks himself in the guise of conventionality before his violent attack on Tyler, Episode 102.

His father, clad in a succession of utilitarian work shirts, specializes in exhibiting meat-and-potatoes masculinity. On occasion, he ventures into plaid. Otherwise, he and his son rarely stray beyond the dark, patternless clothes of their blank-slate shadow selves. At home, Cal opts for black loungewear. He disappears into the background, emerging spectrally now and then, a floating head issuing gruff, hard-knock edicts and advice. "He fucking owns half this town," Rue tells Jules. "He fucking built it." But one would never know by looking at him.(04)

Cal slinks off into the night, Episode 202.

Nate is also devoid of wealth signifiers. Although father and son exude entitlement and reap the benefits of presenting normativity, they both drive pickups. With chillingly calm violence, Nate attacks a rival who slept with Maddy. He casually steals his victim's clothes (his were covered in blood): khakis and a polo (**p.154**). Nate's selection of preppy mainstays are more fitting for his status but also allow him to sublimate part of himself into another persona.

It's not that fashion isn't on Nate's radar. But his views mostly pertain to womenswear and are a sexist mélange of outdated gender constructs, light-kink ideation, and latent homosexuality. As Rue, our narrator, states in a voiceover, "He liked tennis skirts and jean cutoffs, but not the kind so short where you can see

the pockets. He liked ballet flats and heels and hated sneakers and dress shoes, but was fine with sandals as long as they were worn with a fresh pedicure."

Nate is perhaps most comfortable in a football uniform (**p.152**). On the field, he is nameless and faceless #18. He excels in ability and prowess. But postgame, in the locker room, the jerseys and helmets come off. Nate is anxiety-ridden, fearing his teammates will see him glance downwards in the showers. Without the shoulder pads and headgear, he is naked, exposed, and vulnerable. He is himself.

Nate's most revelatory attire appears in the pilot, when he wears the subliminal tell of his sexual complexity: the salmon-pink T-shirt (**p.151**).[05] It's rare to not see him in navy, grey, or black. So when he opts for this stereotypically feminine color, it's the one time he strays from his palette for the entirety of the series. Later on, his uninspired jailbird Halloween costume (**p.166**) is indicative of his inherent criminality. By junior year, he's already adept at breaking and entering, domestic abuse, blackmail, extortion, and generally being a conniving dickhead.

Nate's pink shirt, worn in the character's debut scene, is a subtle allusion to his complex sexuality, Episode 101.

His father fears his own behaviors could have trickled down to his son. Sex is the ultimate escapism, but Cal takes it one step further, in what must be a purely unconscious predilection that he hasn't fully analyzed. While he's drawn to people who can express themselves, who are liberated from masculine/feminine constructs and gender norms,[06] in a moment of despair he admits to a motel hookup: "I spent my whole life trying to keep this part of me separate. But I feel like it's poisoned everything." Cal is beginning to see the light. After being beat down by Ashtray,[07] a small if street-tough boy, he enters a period of breakdown and revelation.

Emerging from the fight, head bandaged, he strikes an equilibrium of madness and clarity and embarks on a drunken bender, spewing riddled half-truths and losing himself in flashback reveries. In a callback

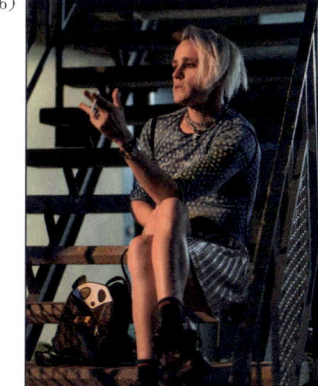
After Cal abandons his former life, he begins to associate with people who are more liberated from traditional gender norms, Episode 205.

Cal's life is thrown into disarray after a beatdown from Ashtray, Episode 203.

Nate confronts Cal at the warehouse hideout in the Season Two finale, Episode 208.

Left: A family portrait: (clockwise from top) Cal, Marsha, Nate, and Aaron, Episode 102.

to Nate's fear of nude exposure and of truth, Cal whips his penis out and tells his assembled family, "I'm a man. I'll fuck whoever I want whenever I want. I'll fuck men. I'll fuck women. I'll fuck transsexuals. And I'll have a mighty fine time doing it." His secrets and lies are on the table (and his piss is on the foyer floor). He abandons his family, which in essence were just a facet of his charade. They are all strangers. "I know nothing about you," he tells Nate, witheringly.

In the Season Two finale, Cal is partying in his drab warehouse, surrounded by a motley group of new friends. Sexually and gender nebulous, they are exemplars of modernity and his infidelities. Cal, disheveled with his shirt unbuttoned, is in the process of crossing over. Part of his darkness has been excised, and the viewer feels a makeover is imminent. A montage of him going shopping with his squad would be so major, but a buzz-kill instead of a spree is on the horizon. Nate barges in.

Backlit in silhouette, the men are strikingly similar, down to their white sneakers.(08) An enlightened Nate can now see what's at their core. "You know what we have in common?" he says. "We both get off on hurting other people." They are one and the same—self-flagellating faux dominants masquerading as butch he-men who are, in actuality, subsumed by and submissive to their own paranoiac shame. Nate's retaliation isn't just about his father's misdeeds. Cal's revelation of true self brings Nate's own suppressed identity dangerously closer to the surface. They were both playing the game, but Cal quit and shed his bondage gear in the process. Nate turned the tables. He will be the alpha, inheriting the sins and trappings of the father, and Cal, no longer dominant, will be bound and subsequently cast out by society, and not just metaphorically.

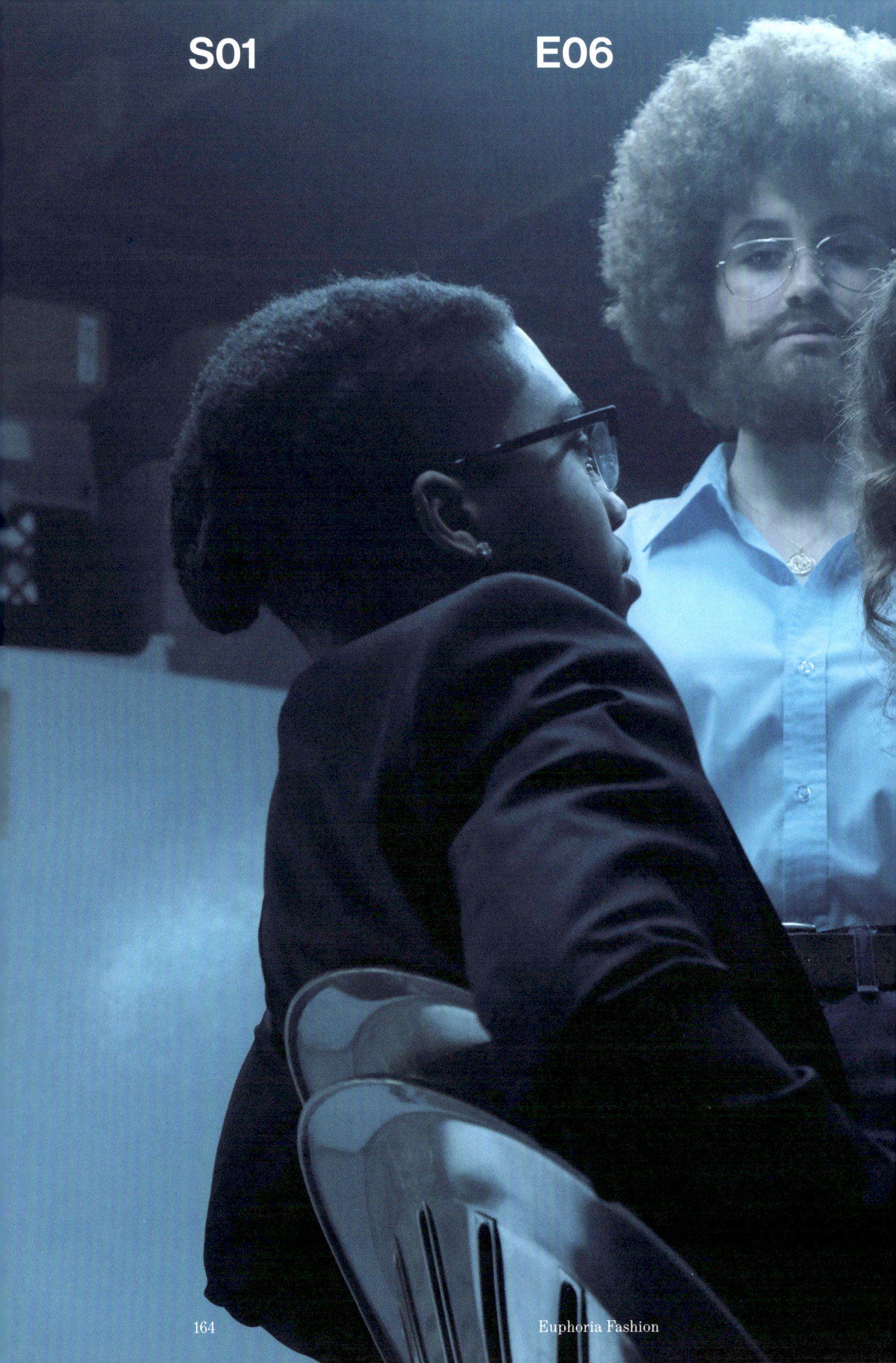

"The Next Episode"

Halloween

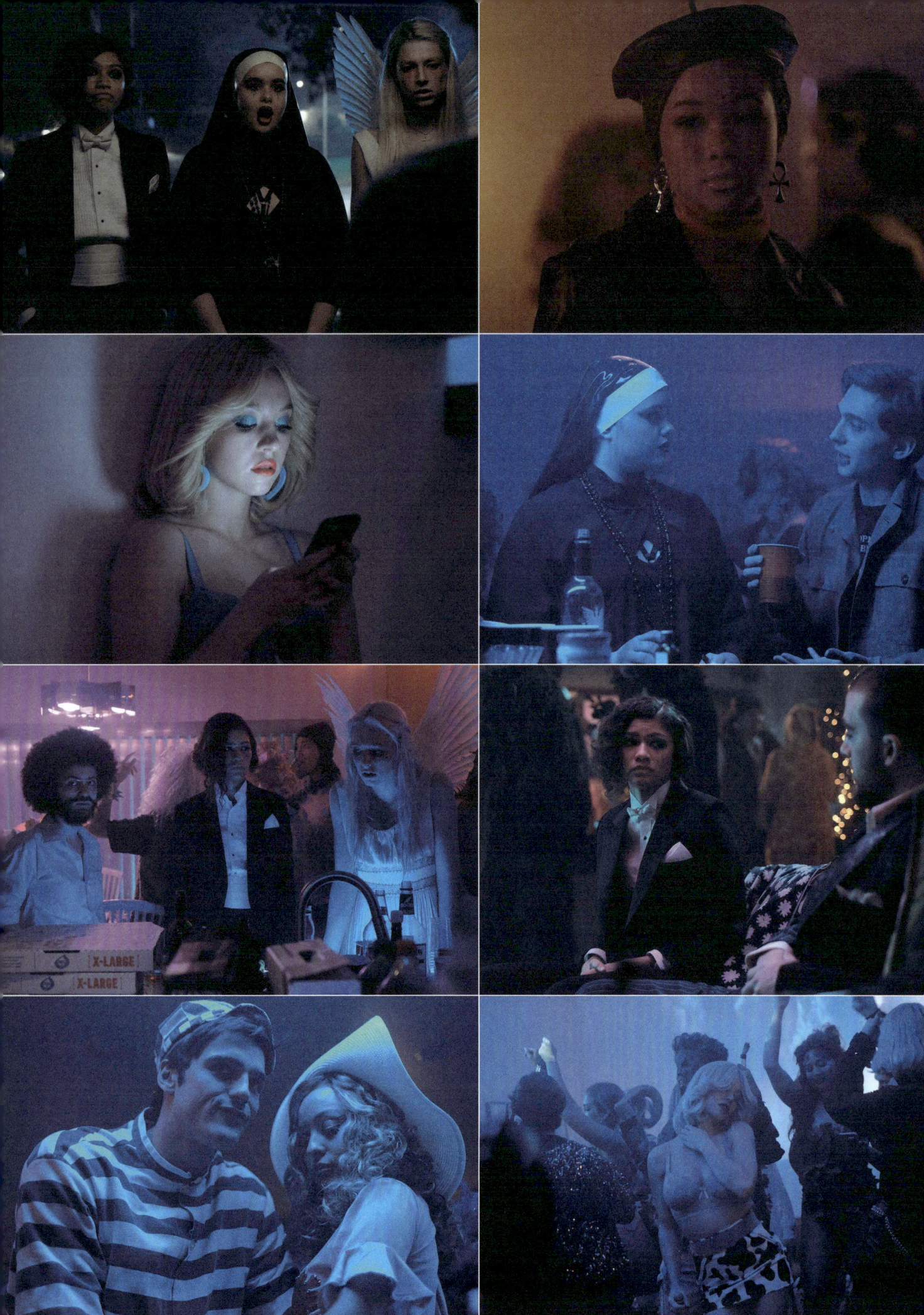

When Rue, dressed in a tuxedo as Marlene Dietrich (**p.26**), sees Jules in an angel costume (**p.68**) replete with feathered wings—a reference to Claire Danes' Juliet in Baz Luhrmann's 1996 film, *Romeo + Juliet*—she says, "Wow, you look fucking amazing," to which a drunk Jules replies, "Thank you. I don't really feel it." On Halloween night, looks can be deceiving.

Daniel, Cassie's current crush, is throwing a house party dressed as the serial killer Ted Bundy, and Cassie, in an aqua blue bustier, is Alabama Worley from *True Romance* (1993) (**p.201**). Dressed in a latex habit as Thana from Abel Ferrara's 1981 film, *Ms .45*, in a latex habit and rosaries (**p.179**), Kat channels her recent success as a cam girl dom with four "pay pigs."

Lexi's costume—Bob Ross, the PBS painter (**p.242**)—draws blank stares. Suze, Lexi and Cassie's mother, tells her, "The whole point of Halloween is to look attractive."

Despite Nate's suspension in the wake of the legal case surrounding his physical assault on Maddy at the carnival (**p.104**), he continues to psychologically torment Jules. Reeling from Nate's threats, Jules uncharacteristically drinks at the party while Rue remains uncharacteristically sober.

Ethan, dressed as a self-described street vampire, finds Kat and asks her what happened the night of the carnival. She gets defensive, shuts him down, and he walks away, baffled.

Rue finds Fezco dressed as Tony Montana from *Scarface* (1983) in a pinstripe suit (**p.229**) and apologizes for lashing out at him when he refused to sell her drugs. She describes her newfound sobriety as weird because the "highs are high, and the lows are low."

Cassie and Daniel head to his room; Ethan takes Kat to the bathroom to finally kiss. McKay arrives looking for Cassie, but Lexi throws him off before he can open the door to Daniel's room where they're hooking up.

Cassie stops Daniel from going too far, and he shames her for being a "tease." After Ethan performs oral sex on Kat, she ghosts him. Nate and Maddy arrive late and notably together, sporting provocative looks—he in classic jailbird stripes and she as Iris from Martin Scorsese's 1976 film, *Taxi Driver*. The crowd at the party cheers their triumphant entrance with chants of "Nate! Nate! Nate!"

S01 E06 "The Next Episode"

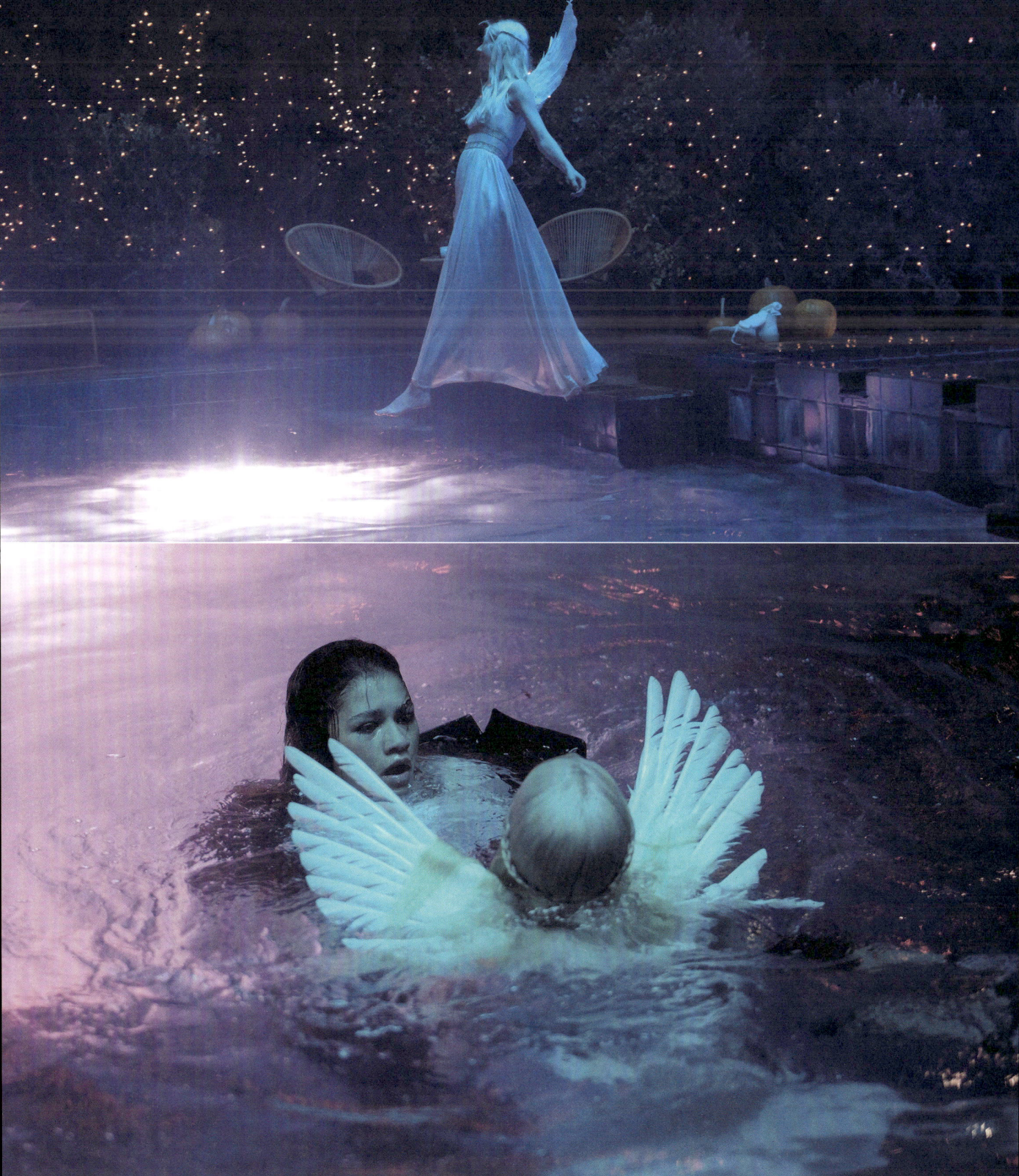

Jules, stumbling and drunk, falls face-first into the swimming pool. She emerges from the water reciting verses from Act II of *Romeo and Juliet*. Rue crouches poolside, and Jules pulls her into the water, where they kiss—a nod to Marlene Dietrich's famous scene in the 1930 film *Morocco*, in which she kisses a woman. Later, Rue breaks down, assuming her addiction is the source of Jules' burden.

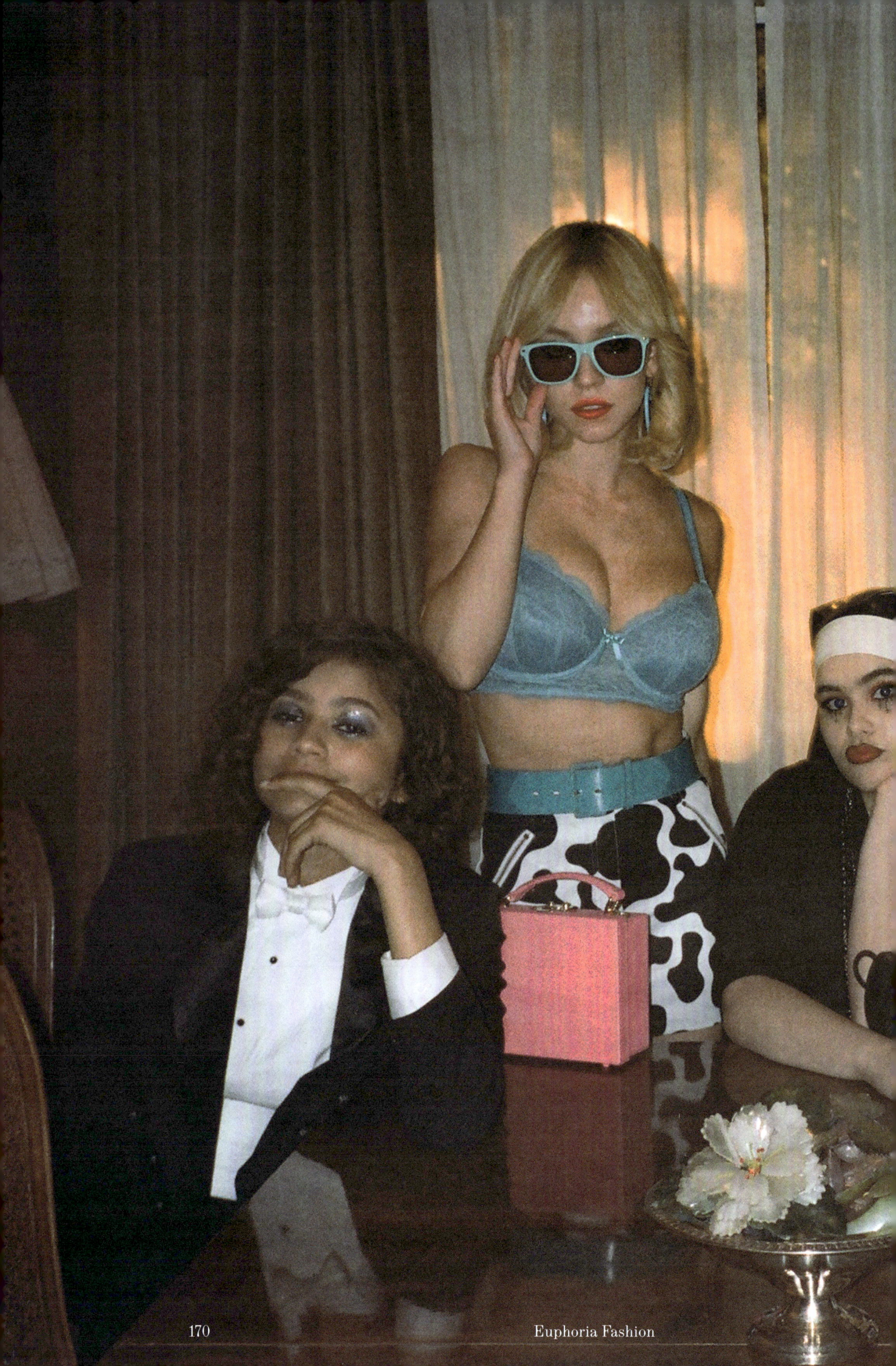

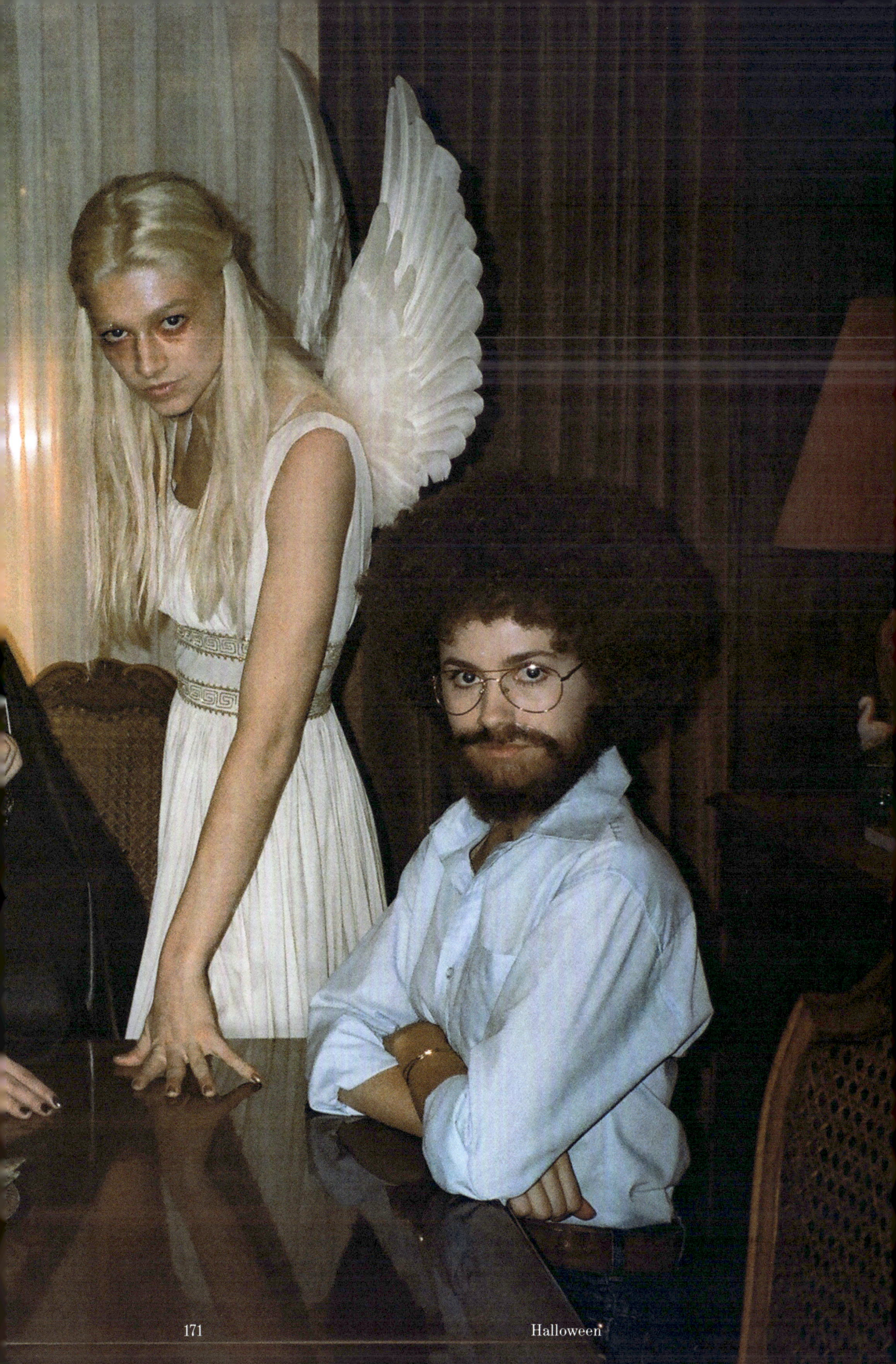

V. KAT

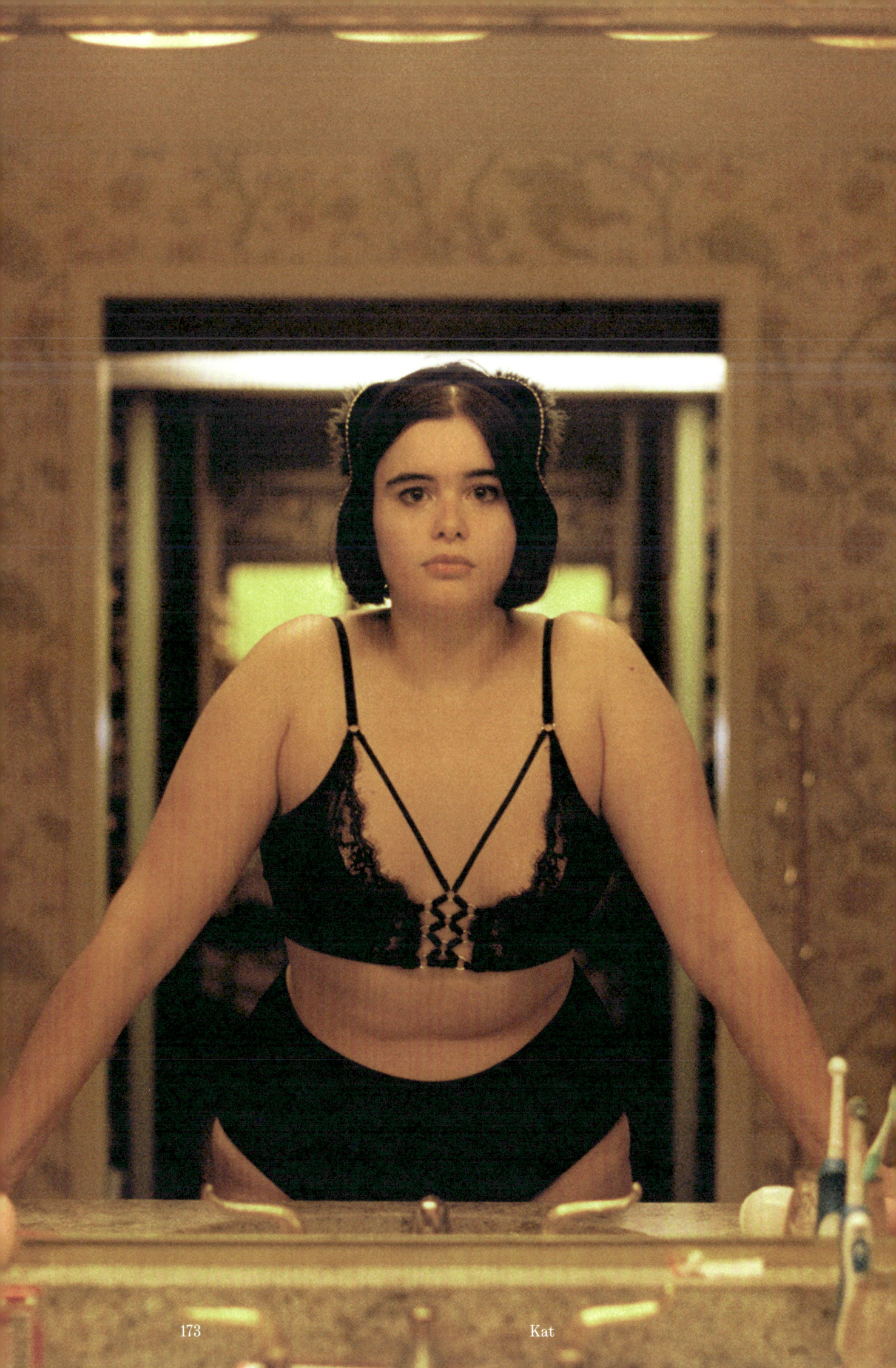

"I spent my whole life afraid people were going to find out that I was fat. But honestly, who gives a shit. There's nothing more powerful than a fat girl who doesn't give a fuck." —Kat Hernandez

Kat led a perfectly well-adjusted early life, but after the breakup with her first-grade boyfriend, she became increasingly riddled with confusion, self-doubt, and identity issues. Like her style icons, Enid Coleslaw of the graphic novel *Ghost World* and Daria from the eponymous MTV animated show, she identifies as a misfit and approaches the world with both wide-eyed curiosity and cynical detachment. Kat has a distrust of social acceptability and often finds herself wanting to reject the world before it can reject her.

After finding overnight popularity online with the steamy fan fiction she writes as a modest hobby and a means of escapism, Kat learns how to navigate the world of East Highland. Buoyed by her newfound self-confidence, she pushes the boundaries of her online persona in pursuit of empowerment and financial gain, becoming "Kitty Kween," a cam girl for fetish fans. She begins to wear her primary color—a bold, head-turning red—like a scarlet letter, proud and unashamed. She uses her wardrobe as an active tool of rebellion, especially at school. For example, when Ethan sits next to her in class and asks her about her dramatic new look, she explains by telling him, "I've changed." With the introduction of leather and latex (gifts from her online suitors), Kat realizes her seemingly liberating style choices feel more like a costume than a reflection of her true self. Like many of the female characters of *Euphoria*, Kat's sexual discovery is vividly exemplified by the clothing she wears. On the precipice of adulthood, she realizes her life online is not the viable strategy for long-term happiness she originally thought it could be. In Season Two, she reverts back to what could be considered a less extreme look, abandoning the bondage wear and cultivating a tamer, more authentic self-image.

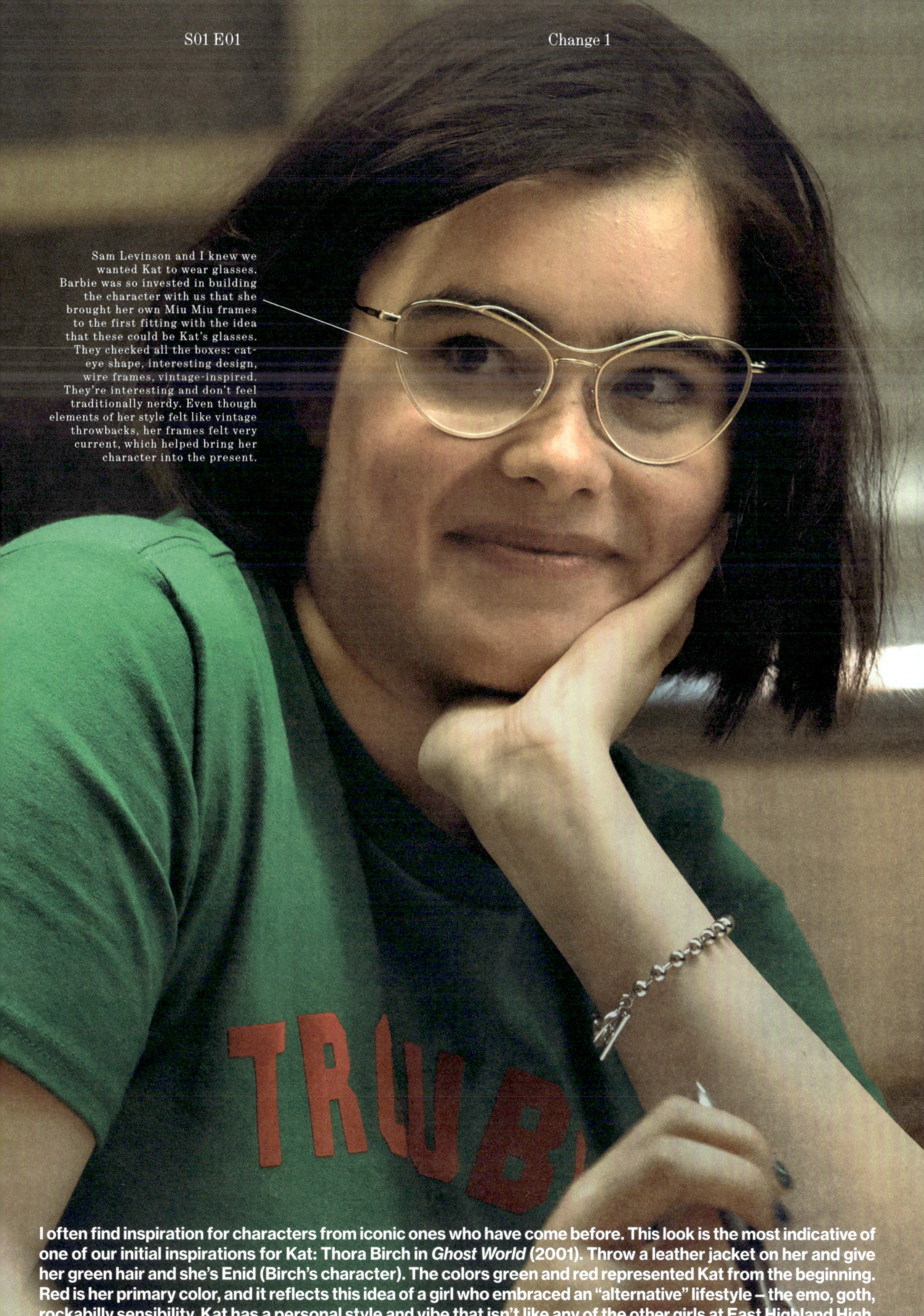

Sam Levinson and I knew we wanted Kat to wear glasses. Barbie was so invested in building the character with us that she brought her own Miu Miu frames to the first fitting with the idea that these could be Kat's glasses. They checked all the boxes: cat-eye shape, interesting design, wire frames, vintage-inspired. They're interesting and don't feel traditionally nerdy. Even though elements of her style felt like vintage throwbacks, her frames felt very current, which helped bring her character into the present.

I often find inspiration for characters from iconic ones who have come before. This look is the most indicative of one of our initial inspirations for Kat: Thora Birch in *Ghost World* (2001). Throw a leather jacket on her and give her green hair and she's Enid (Birch's character). The colors green and red represented Kat from the beginning. Red is her primary color, and it reflects this idea of a girl who embraced an "alternative" lifestyle — the emo, goth, rockabilly sensibility. Kat has a personal style and vibe that isn't like any of the other girls at East Highland High.

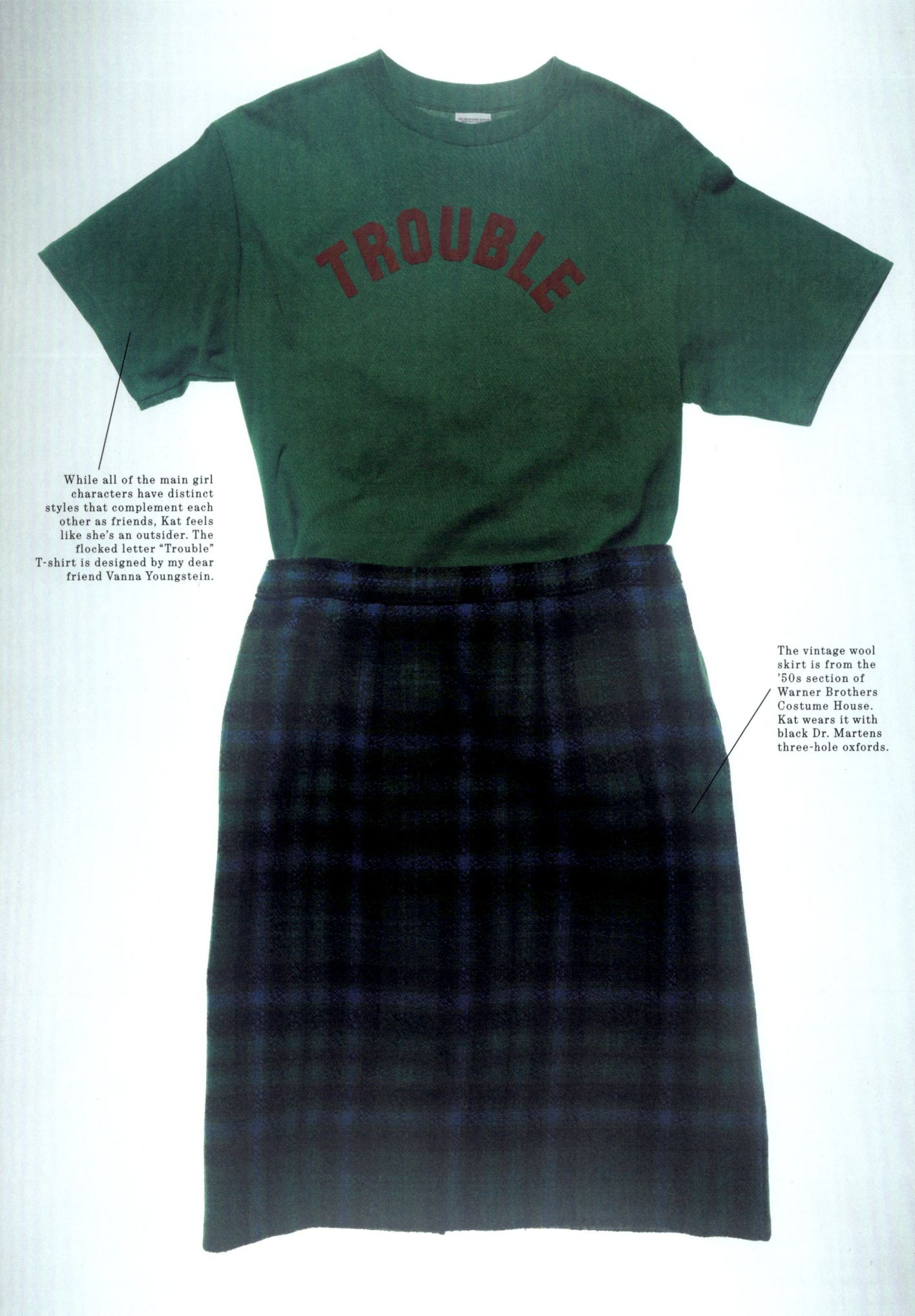

While all of the main girl characters have distinct styles that complement each other as friends, Kat feels like she's an outsider. The flocked letter "Trouble" T-shirt is designed by my dear friend Vanna Youngstein.

The vintage wool skirt is from the '50s section of Warner Brothers Costume House. Kat wears it with black Dr. Martens three-hole oxfords.

It was scripted that Kat buys her transformative look from a store like Hot Topic at the local mall. I wanted it to seem attainable and affordable because this jump start to her self-empowerment happens before she starts making real money online.

Sam is inspired by a series of films by Nami Matsushima (a.k.a. Matsu the Scorpion) from the '70s starring Meiko Kaji, a Japanese actor and singer who was most famous for playing outlaw characters. There is a series of films called *Female Prisoner: Scorpion*, and at some point when we were speaking about Kat, he said that he loved the idea that she would watch these films.

The corset bustier piece that goes over the T-shirt reveals just enough of the image to give a nod to the subversive Pinky Violence film genre.

I chose a short, straight plaid mini skirt to differentiate from the pleated-style minis Jules tends to wear.

S01 E05 — Change 1, Change 3

In Season One, Kat is empowered, but she still looks like a teenager — she's opening herself up to new experiences, but there's still a kind of innocence about her. The youthful "Baby Girl" graphic tee is a vintage piece I found at Universal Costume House. The script is glitter heat transfer printed on mesh fabric.

This Jean Paul Gaultier "Soleil" top is Barbie's personal piece. I did an early fitting at her house, and we were trying on some latex pieces for her post-transformation look, and I saw it and knew we had to use this top to complete the red look. I had been looking for red denim but couldn't find the shade needed, so I dyed a pair of jeans to match the red in the top.

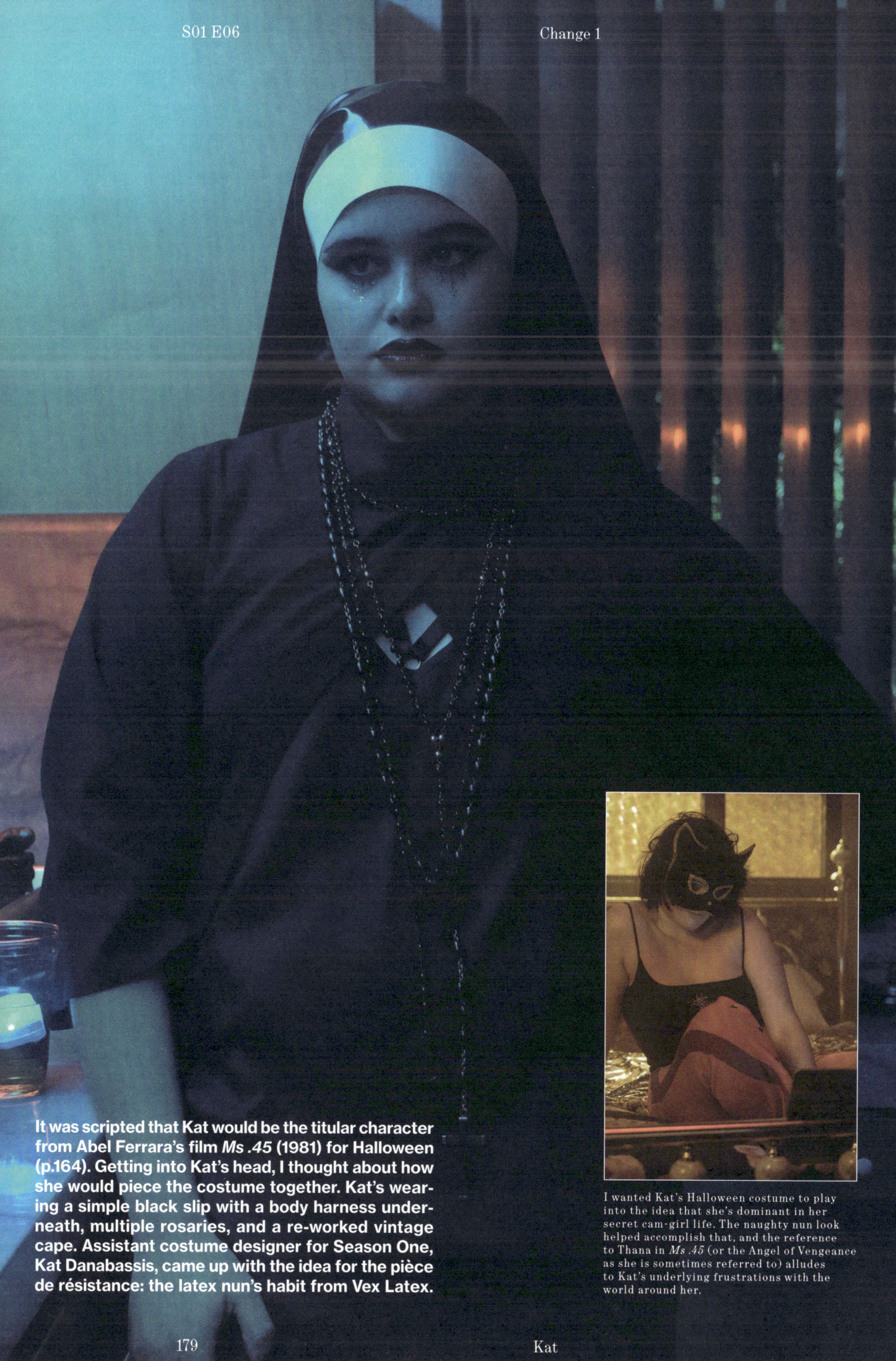

It was scripted that Kat would be the titular character from Abel Ferrara's film *Ms .45* (1981) for Halloween (p.164). Getting into Kat's head, I thought about how she would piece the costume together. Kat's wearing a simple black slip with a body harness underneath, multiple rosaries, and a re-worked vintage cape. Assistant costume designer for Season One, Kat Danabassis, came up with the idea for the pièce de résistance: the latex nun's habit from Vex Latex.

I wanted Kat's Halloween costume to play into the idea that she's dominant in her secret cam-girl life. The naughty nun look helped accomplish that, and the reference to Thana in *Ms .45* (or the Angel of Vengeance as she is sometimes referred to) alludes to Kat's underlying frustrations with the world around her.

S01 E08 — Change 1

I chose Kat's signature, stand-out red color for her winter formal look (p.212). I called on Zana Bayne and Seth Pratt to help me create an original look. I had been working with both designers on creating pieces for the show and thought it would be a great opportunity for us all to collaborate.

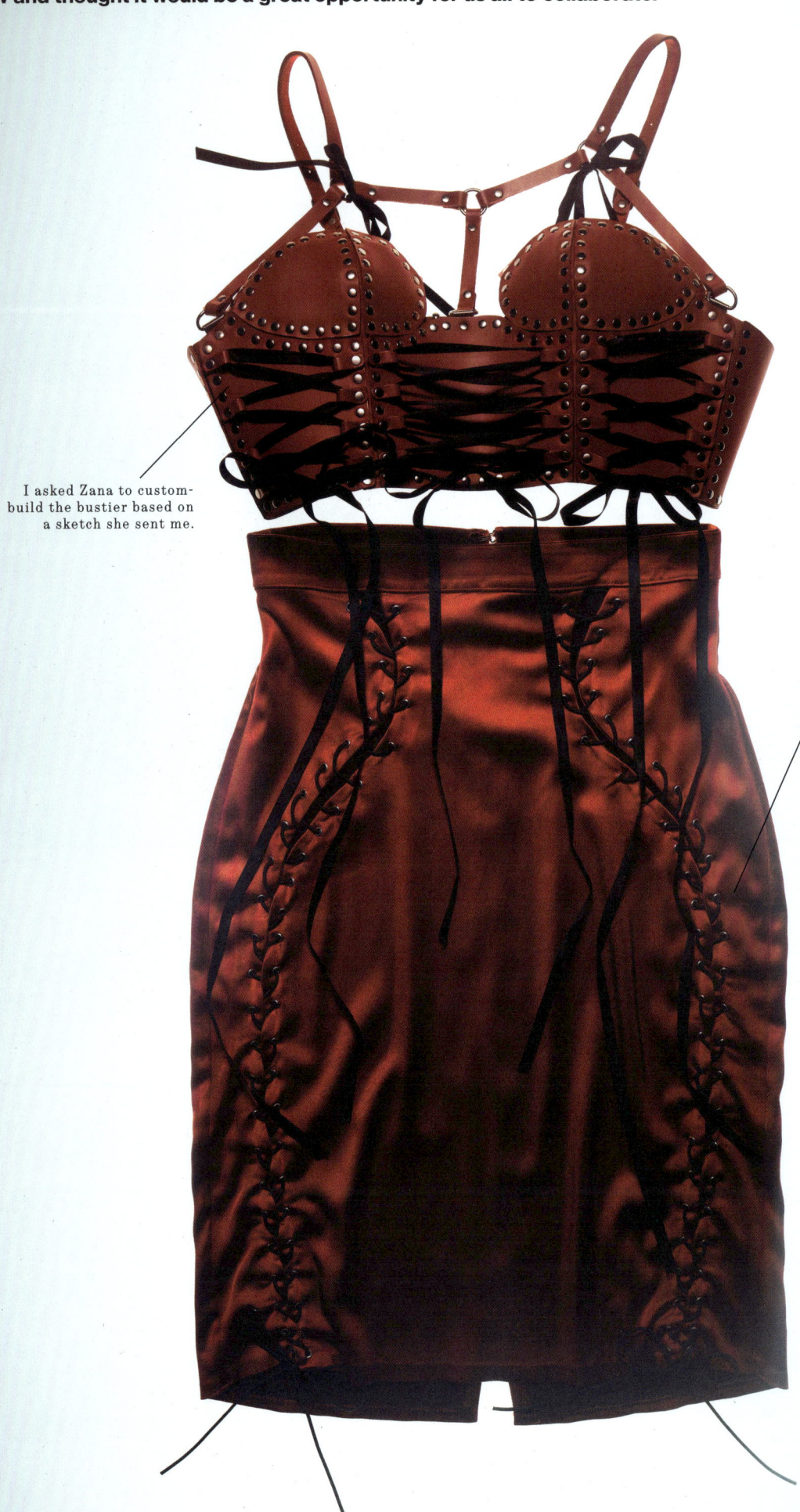

I asked Zana to custom-build the bustier based on a sketch she sent me.

I shared a visual reference for the skirt with Seth as well as Zana's sketch for the bustier so he could see what was planned for the top. We fabric-sourced a stretch polyester satin for comfort and shine.

Euphoria Fashion

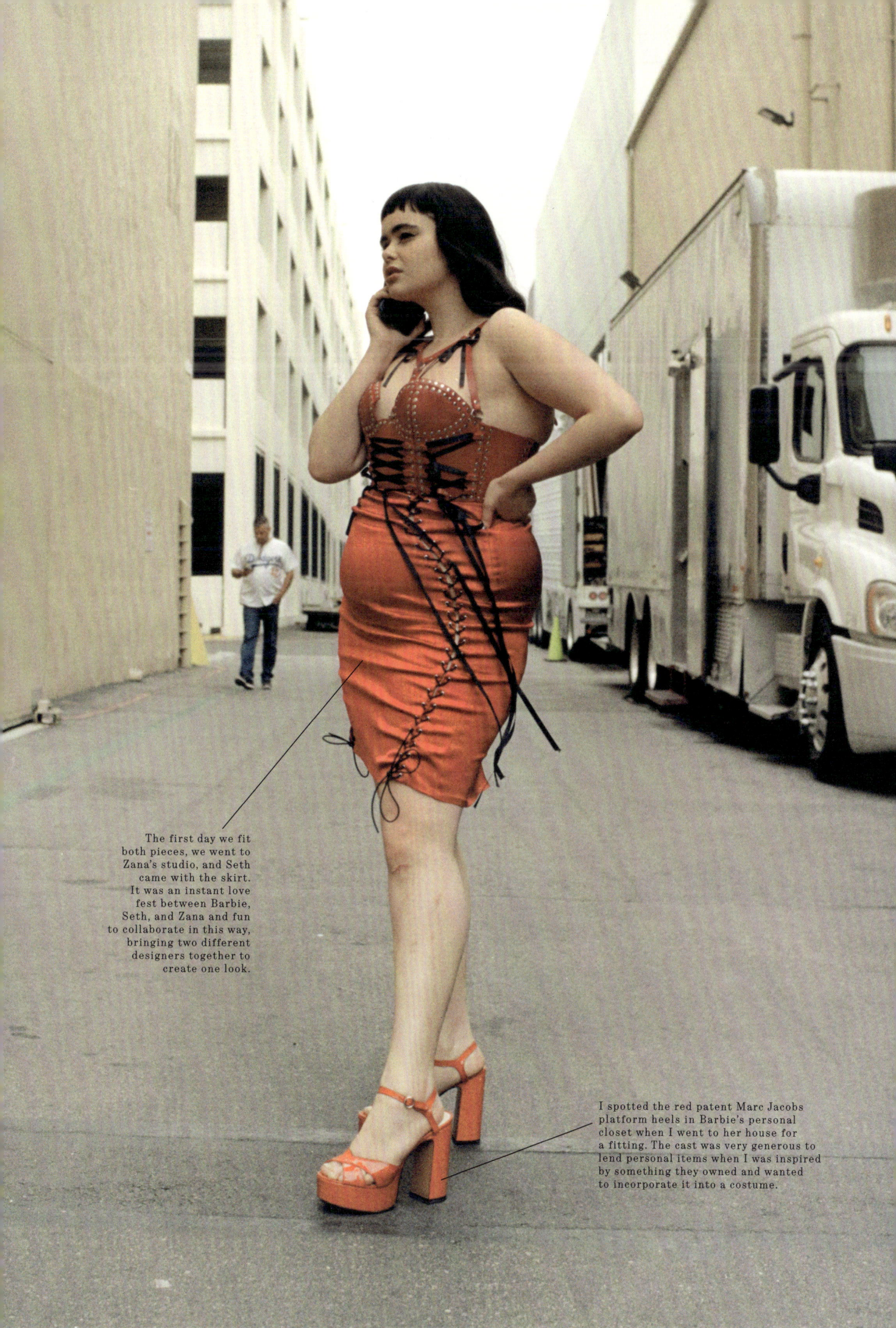

The first day we fit both pieces, we went to Zana's studio, and Seth came with the skirt. It was an instant love fest between Barbie, Seth, and Zana and fun to collaborate in this way, bringing two different designers together to create one look.

I spotted the red patent Marc Jacobs platform heels in Barbie's personal closet when I went to her house for a fitting. The cast was very generous to lend personal items when I was inspired by something they owned and wanted to incorporate it into a costume.

Kat

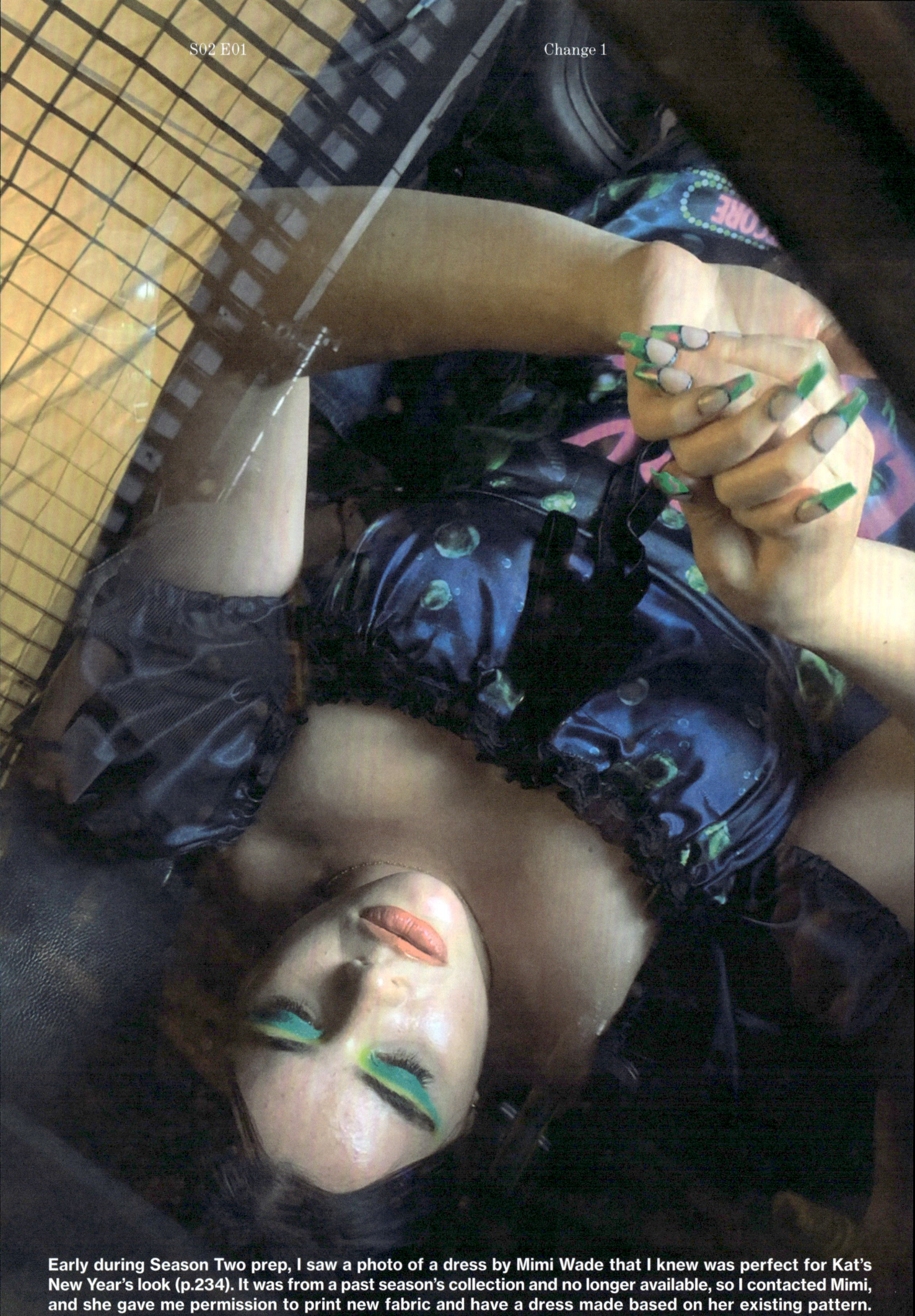

Early during Season Two prep, I saw a photo of a dress by Mimi Wade that I knew was perfect for Kat's New Year's look (p.234). It was from a past season's collection and no longer available, so I contacted Mimi, and she gave me permission to print new fabric and have a dress made based on her existing pattern.

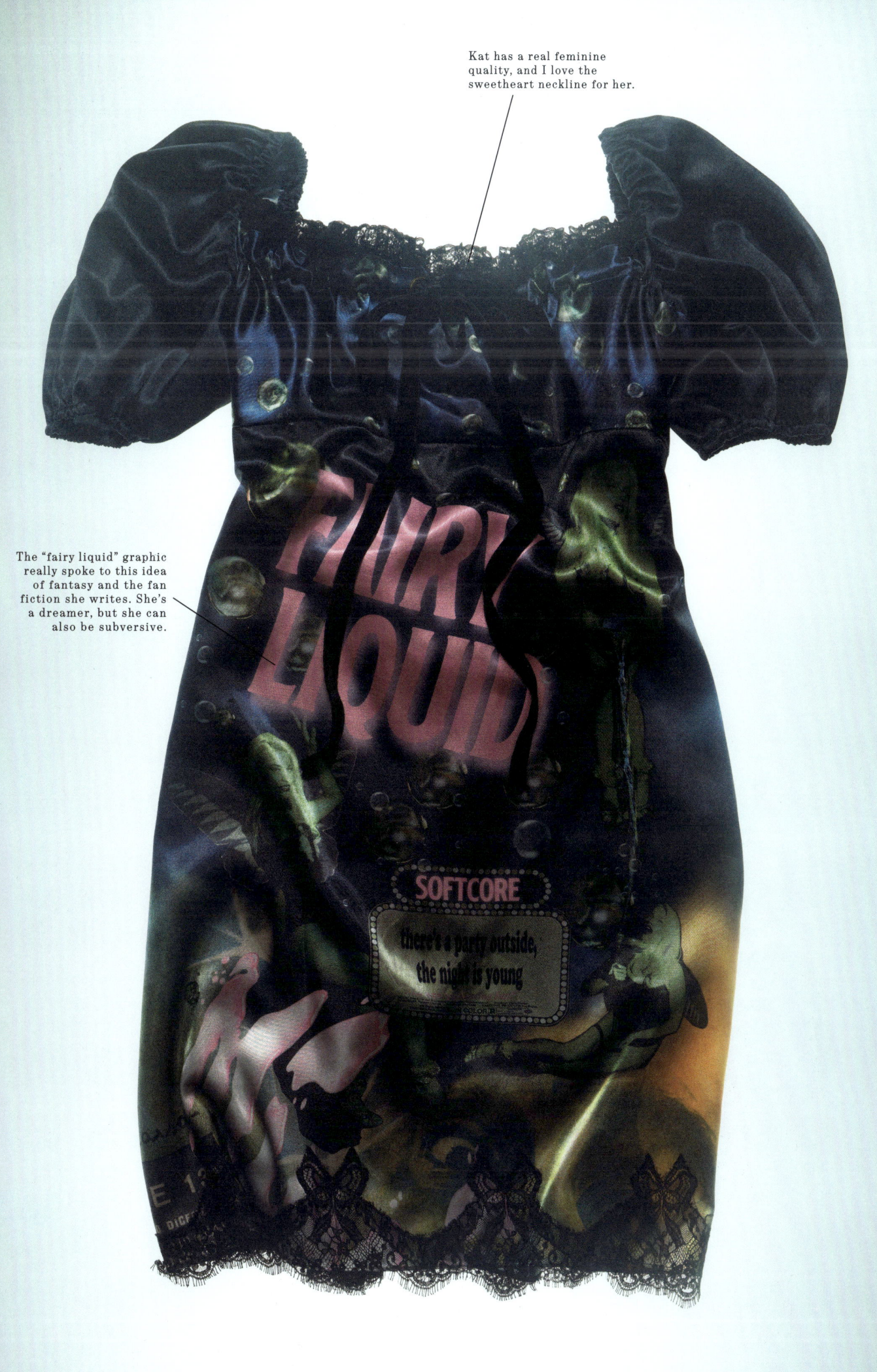

At times I imagine Kat as a '50s pin-up girl. Her taste in music, films, and books has an influence on her fashion choices. This first day back to school look tells us Kat is still on a path to empowerment.

The Cramps T-shirt felt subversive for Kat. She enjoys having interests that are different from her friends. She doesn't care what music Lexi, Maddy, and Jules are listening to. The T-shirt design, mostly obscured by the green mohair cardigan, features The Cramps' lead singer Poison Ivy in a crouched position over the title of the song "Can Your Pussy Do the Dog?"

The tie-dye heart skirt is from internet / social media brand OMIGHTY. I made an effort to include designers who young people watching the show could possibly afford.

I kept thinking about the graphic Frankenstein T-shirt that Kat wore in Season One, but she's lying down on a couch with her mom, and you can hardly see it. I loved the graphic, and it made me think of "Monster Mash" by Bobby Pickett and the Crypt-Kickers, which made me think of the Misfits, which made me think I'd like to put Kat in a band shirt— and what better graphic than The Cramps logo.

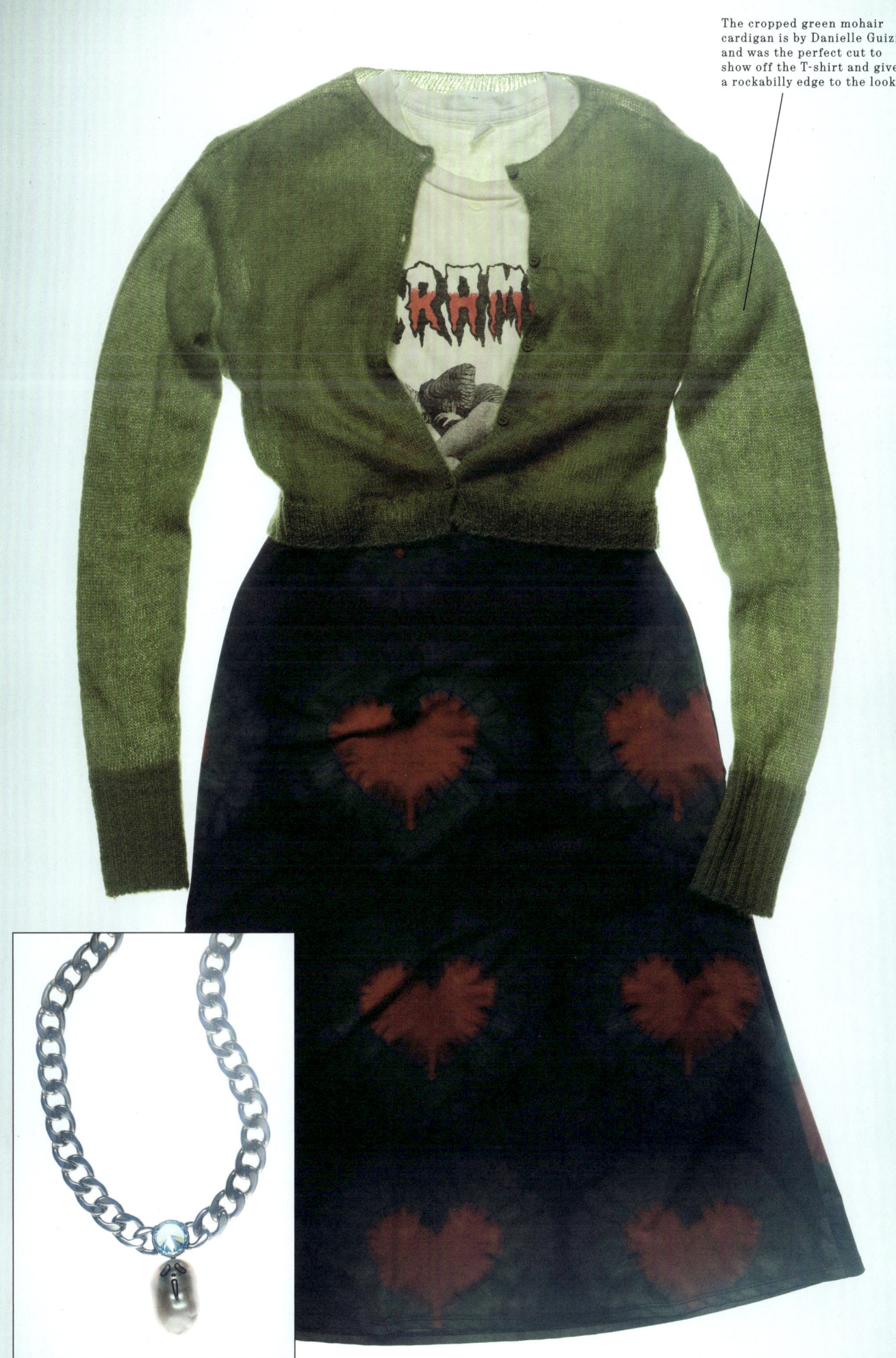

The cropped green mohair cardigan is by Danielle Guizio and was the perfect cut to show off the T-shirt and give a rockabilly edge to the look.

The Jiwinaia Urlo necklace made a great statement—the ghost face is painted on an uncultured pearl.

Kat

S02 E07 Change 1
Change 2

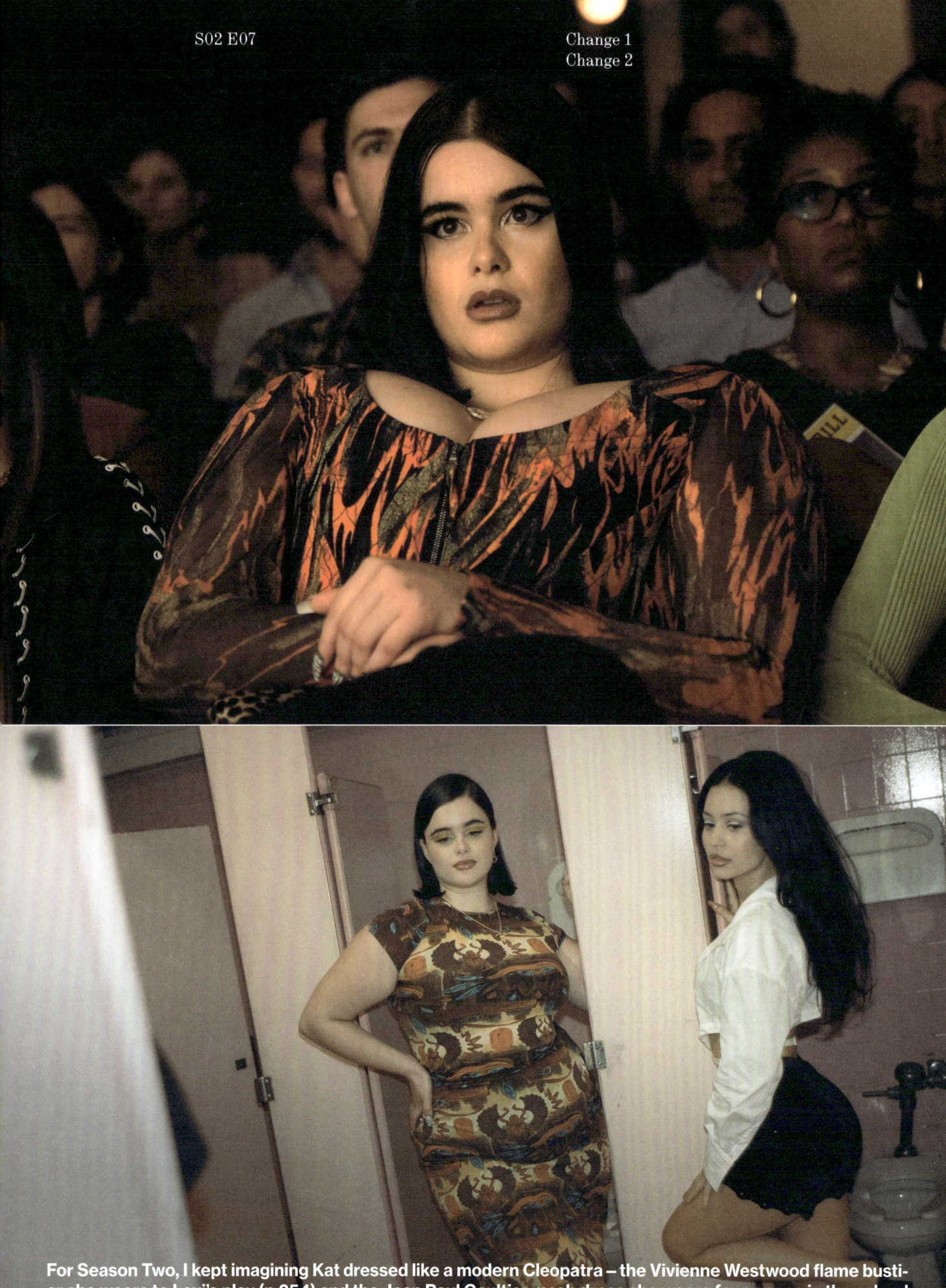

For Season Two, I kept imagining Kat dressed like a modern Cleopatra – the Vivienne Westwood flame bustier she wears to Lexi's play (p.254) and the Jean Paul Gaultier mesh dress she wears for a scene in the school hallway were looks put together based on that inspiration. They have a more sophisticated quality compared to the changes worn by Kat in Season One. The scarab pendant she's seen wearing throughout the season represents renewal and rebirth.

The funeral look was a chance to remind the audience about Kat's earlier, younger emo style and to provide visual contrast to how far she's come with her more recent, bolder fashion choices.

Makeup artist *Doniella Davy* and *Heidi Bivens* on character, color, and collaboration in the costumes and makeup of *Euphoria*

HB I want to start by pointing out that throughout this journey of making *Euphoria*, we have seldom had a chance to talk about our collaboration. This is the first time that we're getting to delve into our experience together. I'm so interested in your take on what it was like to go from the pilot, when we had little idea of how the show would be received, to today.

DD It's funny because what we do, in simple terms, is a collaboration, but we seldom have the time to actually talk to each other. In terms of how the cast looks, you establish and build the foundational vibe Sam Levinson has written. When I come in, my job is to blend into your vibe and build on it in a way that clearly makes sense and continues the vibe, but also to add layers of nuance like you do. You're so insanely good at what you do because of that nuance and specificity that you procure, through color, texture, layers, detail, lived-in moments, aspirational moments, cheeky moments, little hidden things too.

 There's something collaborative happening between us, but it's almost unspoken. You do your thing, I respect your thing, and I build on it. Somehow it comes out harmoniously, and people have deeply appreciated and related to the costumes, the makeup, the hair. And then our work merges with every other creative department and comes to life with our cast's performances.

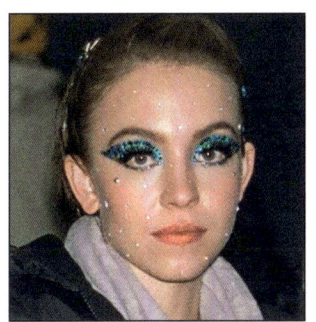

(01) Behind the scenes with Sydney preparing for Cassie's ice skating dream, Episode 107.

HB It's like a mind meld. We have that connection where so often things just worked out seamlessly without us having to overthink it. I really appreciate your approach to character building through makeup design where you think about all the psychological aspects of a character, a scene, and the character arcs. Hearing your commentary on specific looks has been great. For example, the makeup you did for Cassie for the ice skating sequence in Season One (**p.202**) was really exciting for me to see because it wasn't often that we got to sit around on set and chat about what we were going to do next.(01) It was really just putting one foot in front of the other, trying to get clothes and makeup on people in time to be on camera.

DD It's very much like a game—you make a move, I make a move, and then you make a move. There's never enough time, and we have to make decisions quickly. You're busy handling costumes that are two weeks down the line, and I'm more in the moment with how I work because makeup is much more malleable and can shift more on the day.

HB Sometimes I can't anticipate things, though. I always have something in my back pocket because a cast member can call me to their trailer before they go to set and have a thought about the scene they're about to do and the emotionality of it. They could have an instinct at the last moment and need something else for their character to be able to really be their best. There were times where the cast helped me be better. I can remember shooting the scene where Cassie walks down the hallway with Nate in Season Two, and Maddy turns to Kat and says,

Applying finishing touches on Sydney, Episode 203.

"Well, she looks the part." That was such an intense time during shooting, and I hadn't thought about the scene in the same way Sydney(02) had—she's living with the character in her head. I got a call over the walkie that she wanted to change the costume, and what we ended up going with was so much more dramatic and important (**p.211**). She understood that the walk down the hallway needed to have a visual impact in a way that I underestimated at that point. So the collaboration obviously extends beyond just our departments. We also lean on the cast. I'm excited to hear more about what it was like for you to collaborate with the cast.

DD Yes! The "she looks the part" Cassie scene is so quick but so effective in the audience understanding where Cassie is at with Nate. She really looked like a sterile, beautiful, haunting mannequin in that fuzzy hot-pink bra-top. That was an awesome last-minute scramble.

I have not found a "one size fits all" way to streamline my creative and collaborative process with the cast, but what I do know is I 100% need their input. My approach with each cast member is different, ever-evolving, and very much relies on my and my team's ongoing communication with them throughout the season. They may have discovered or dreamt up something new about their character's evolution since the last time we spoke about an upcoming scene. That might mean that what we spoke about and what my team prepared for last week no longer works.

It's easier to plan looks in advance and stick to the plan, but I kind of thrive on the pressure of improvising and totally winging it because it can activate a new level of creativity and result in a more authentic portrayal of what a character is going through. At the same time, planning and prepping for makeup looks in advance helps me set my team up for success. I think juggling this is the hardest part of my job.

HB It works differently with every team. From what I understand, you delegate in a way where certain members of your team are looking after specific cast members.

DD This is where the portrait books came in handy—each main cast member had a binder filled with photorealistic face charts that were actually their own faces.(03) Every look involves a full-on conversation with me, assistant department head Tara Lang Shah, and assistant makeup artist Alex French. We'll use the portrait books to try different looks on our characters, share ideas with one another, and show the cast what we're thinking.

Portrait books for each of *Euphoria*'s female leads.

Behind the scenes with director Jennifer Morrison and the character "Young Maddy," Episode 106.

I look at each character and the number and order of their scenes to determine how many opportunities I have to show their character evolution through their makeup before getting to the end of the season.(04) For example, if we are ending the season with an empowered Lexi on stage wearing a bolder makeup look, then I need to slowly build to that more confident moment. Even a very quick scene where Lexi crosses the frame in the school hallway is an opportunity for me to send a message through her makeup that she's evolving in a certain way, for example by putting a darker shade of her signature red lipstick on her.(05)

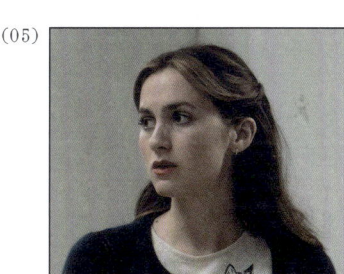

Lexi's character transformation parallels her evolving makeup, Episode 203.

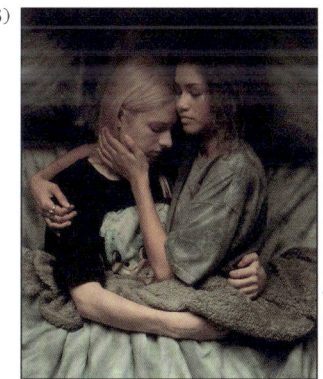

A simple makeup moment in bed with Jules and Rue, Episode 103.

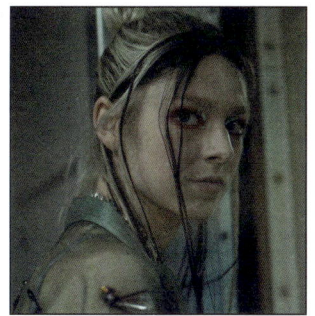

Jules' darker makeup appears in Episode 108 for the winter formal.

HB Speaking about color, it's such an important aspect of what we both do. In Season One, I mapped out ideas about the color story behind each character so that I could differentiate them as an ensemble cast. Because they're all young and in high school, there was this potential for them all to kind of look the same. Color was a way for them to have clear identities.

I'm guessing you had more freedom because there can be so much more variation and subtle gradations in makeup. I'm curious how you approach the colors for each character.

DD Knowing your color and texture stories for each character is essential for me entering the season. I also love looking at the textures, colors, and styles of their bedrooms. In the pilot, that gave me all the clues I needed to get started.

But the realism comes in when we lean a little away from their starting points. A group of girls who are friends are going to be inspired by each other. We'll see certain colors or makeup styles repeat on different characters. In the same way, the girls aren't always made up every time we see them. The makeup feels more real when sometimes it's not there at all. And same with the costumes, like I love when all the style is just gone. Just a baggy T-shirt or basic pajamas.(06) The ebb and flow of the stylized moments is what makes it convincing.

HB You said that the work I do in the beginning helps you navigate your approach to each character, but there were times when the makeup influenced what I did. For example, I didn't know that Jules was going to have darker makeup and streaks in her hair, leaning into this more goth vibe for the winter formal.(07) It was surprising to me, and I loved it.

That really influenced what I did with her costuming in her special episode (**p.75**) and then going into Season Two. It also made sense for the script that Hunter wrote with Sam for the special episode— the more serious subject matter has Jules leaning away from all those candy colors she wears in the beginning of Season One. There were so many times we were on the same page without having these sit-down conversations…it was a fast-moving train.

DD Totally. Making decisions, trusting, and taking a chance. The worst thing that can happen is Sam isn't sold on it. That's okay, that's what makeup wipes are for!

HB There was one time I remember that happening specifically, when neither of us nailed it. There was comfort in the fact that you also didn't understand what was in his brain. I talk about how Sam's brain works so fast. He's always coming up with new ideas—he's developing his vision as he goes. A lot of it is him reacting to how scenes play out.

DD I also was comforted by the fact that we both missed. *Euphoria* is makeup bootcamp in the best way possible. It's vital that we nail the mood and

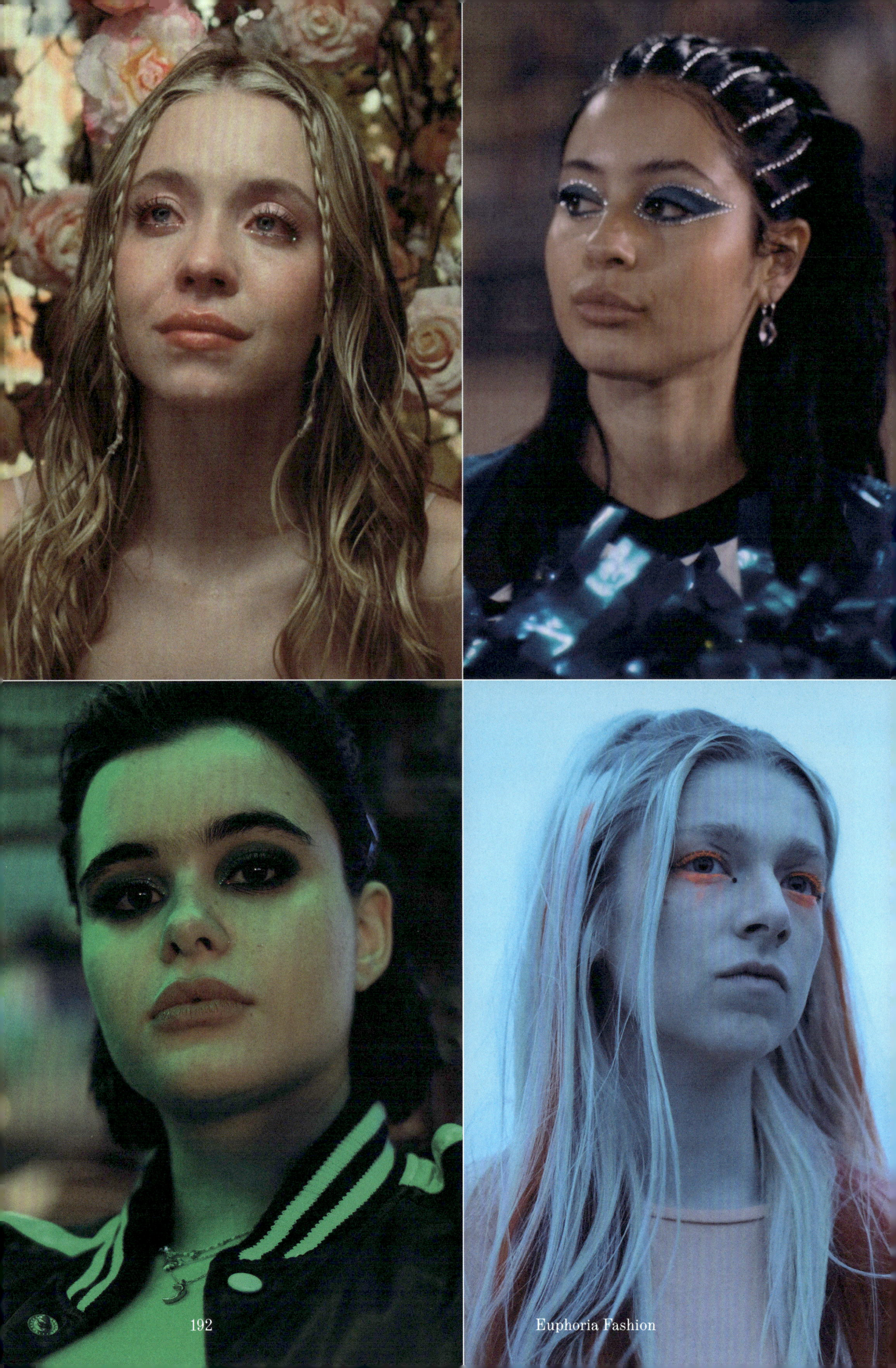

aesthetic for a scene, but like you said, sometimes Sam's vision and the outcome of a scene evolves or changes right before we start filming it (or even during!), as he and Marcell Rév are working through the cinematography and storytelling and anticipating how things will be edited. This is why one specific creative formula or approach is not suited for every situation! My team and I are constantly evolving, and part of that is understanding that what we come up with is not always going to work for the scene, or no longer works for a scene. So we pause, re-evaluate, and re-do the makeup. We're here for Sam's vision.

HB I bet you're asked so often, but what are your favorite makeup looks from the show?

DD That question is so hard. Season Two was tricky for me to figure out how to continue the conversation of expressive makeup, but showcase a different, less colorful and sparkly aesthetic. Sam really helped me figure this out. He wanted a flushed, anxious makeup feeling for Cassie, and more fresh-faced moments on Kat.[08] I love the mania of Cassie's makeup, the flushed heat and sweat showing through her makeup, and how she imitated styles we've seen on Maddy and even Jules.

A close-up of Barbie glowing behind the scenes, Episode 204.

HB Let's not forget, there were quite a bit of special effects that you did during the show—it's not always about pretty makeup.

DD There's a lot of special effects in the show and a lot of character makeup. Laurie and her whole crew is a great example of some of our character makeup work. We designed, drew, and printed our own fake tattoos. Sometimes we would even hand-draw the tattoos right on the actors' bodies. Doing this made the tattoos sort of feel like a mish mash and added to the realism of crappy tattoos. I didn't want it to look like these people went to high-end tattoo shops. On the other hand, I wanted Fezco's Granny's tattoos to look higher end.[09] Custer's look is one of my favorites. We make him look like a disaster—a broken nose, subtle scabs and acne, unwashed skin, dirt under his fingernails, a unibrow. He had a Faye tattoo, which I don't know if people really picked up on, but it's a heart with "Faye" in it.

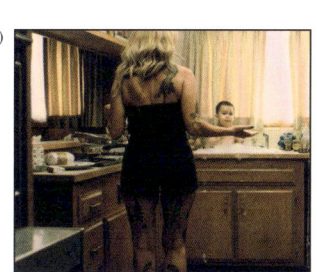

The makeup team is also responsible for special effects ranging from tattoos, Episode 201, to Cassie's prosthetic pregnancy belly in Nate's fantasy, Episode 202.

Tyler Chase, who plays Custer, was like, "Tara, can we do a heart with Faye written in it?" I considered whether to text Sam and ask. I just told Tara to do it and bring makeup remover to set just in case. I don't remember if Sam actually noticed that we had put it there, but I hope he did.

HB Sam loves these surprises. It's like a gift for him. I remember the scene with Kat when she fantasizes about the *Game of Thrones* guy enrapturing her on the bed in Episode 202. She's wearing a locket, and we put a picture of the *Game of Thrones* guy inside. The audience never sees it, but it was an Easter egg for Sam.

DD Did he see it?

HB Yes, I love those little surprises. And then for prosthetics, there was of course the pregnancy belly for Cassie…(10)

DD …Nate's prosthetics, the fake arm with the morphine going into Rue's arm, the neck stabbing, the bleeding on Custer, the gash in Mouse's head, and the stomach bleed out on Fezco…

HB You got to do it all!

DD Aside from Maddy, because her character's personality places a high importance on appearing snatched at all times, I consider all the other beauty looks on the show to be character/beauty hybrid looks. We dial up the lived-in feel of it and then show a range of made up and undone throughout the show. Sam was really into the idea of no foundation in Season Two. Sometimes foundation looks terrible on camera, but I get how it can be helpful too. The less makeup we use on the skin, the more real the looks feel on camera. Sam said, "Trust me, their skin will look great." He also gave us signs to put in our trailer that said "Sam says no foundation," and he signed his name.(11) It was awesome.

A note from Sam Levinson in the makeup trailer during the filming of Season Two.

HB That's serious craft, and I don't think a lot of the beauty fans know about it. I've been so fascinated by the number of people who have been moved by the makeup on the show. It has been a window for me into this world that exists, primarily on social media, of people who are obsessed with makeup in a way that I don't think people are with clothes.

 My theory is that it often provides a sense of escapism for people. Without spending a ton of money, they're able to try something new and transform themselves into a more exciting version perhaps.

DD It's the whole picture that they're responding to, though: costumes, scene, writing, performance, makeup, hair, lighting, and the music! Glitter and rhinestones were not invented on the show, but it's so sickeningly exhausting to see those things predominantly occur on models coming down a runway. When we showcase colorful, bold, or glittery makeup in a more lived-in way, on cast members playing flawed, real characters, and without beauty lighting, it becomes this perfect concoction of inspirational, aspirational, and relatable. But the hook is the escapism bit, and I think your costumes are fantasy-meets-reality in the same way the makeup is.(12) Your costumes inspire so much that happens in my department, and I love working with you.

 I also think about how Sam doesn't feel he needs to explain or apologize for anything—there doesn't have to be a reason for any of it. We don't really have to explain ourselves beyond the question: is it the right mood?

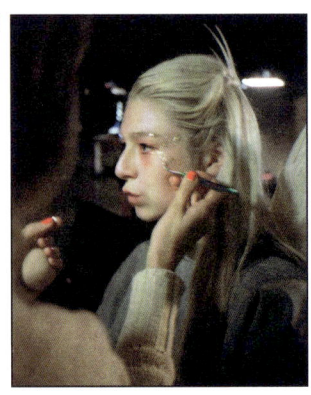

Finishing details on Hunter, Episode 106.

Right: Inspiration in the makeup trailer, Season One.

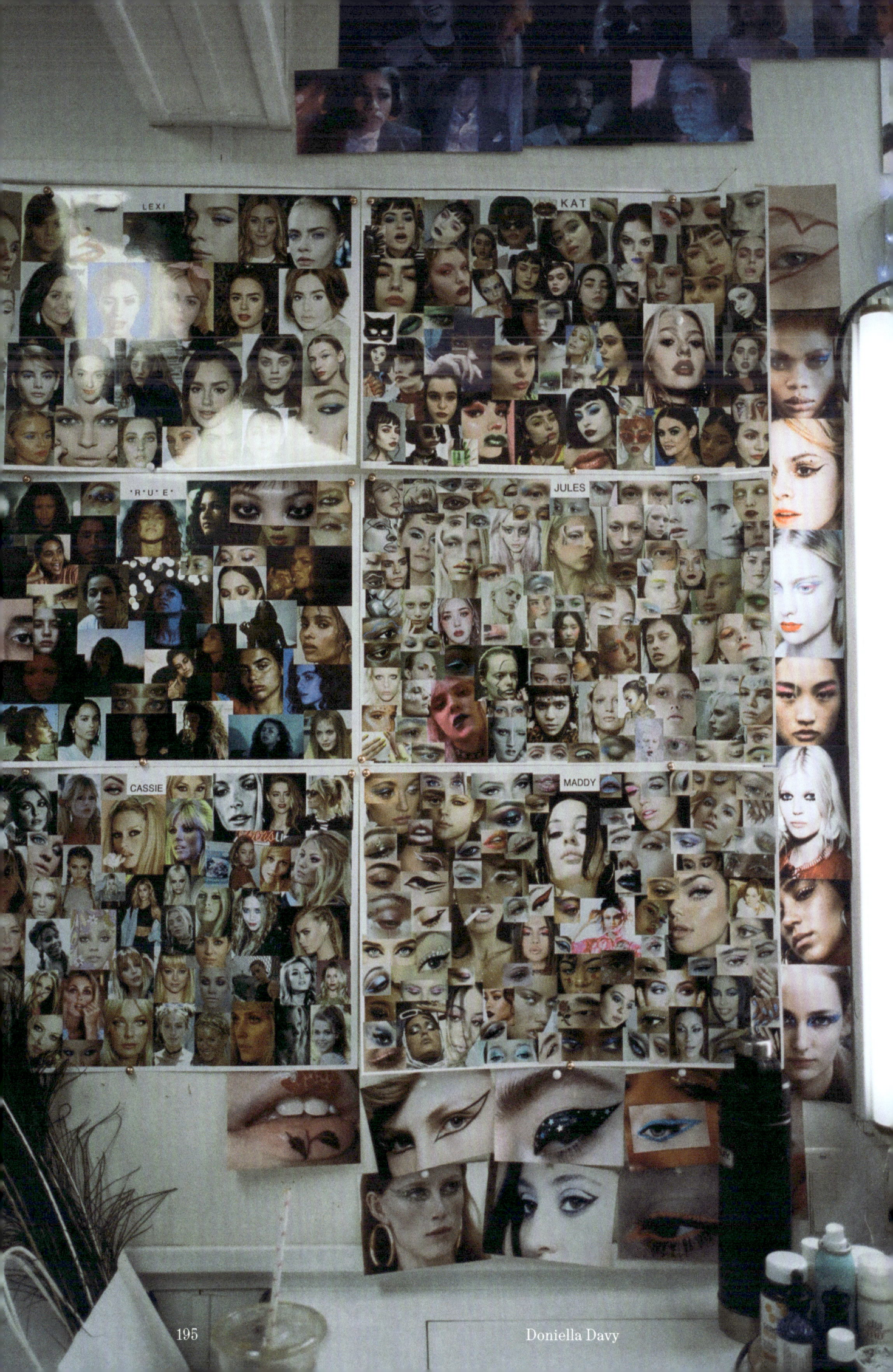

VI. CASSIE

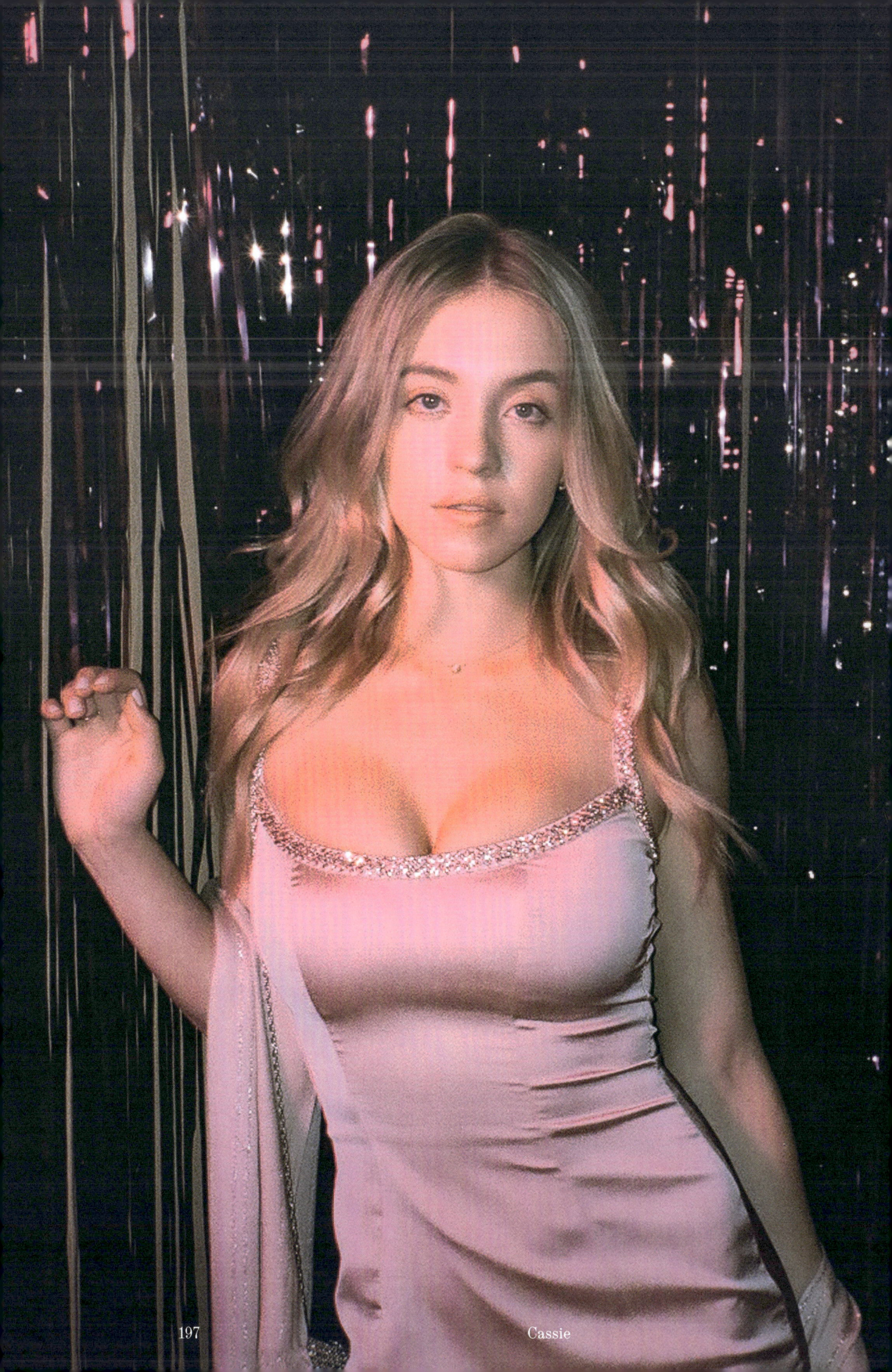

> "I think I'm going to do everything in my power for at least, like, the next three years not to fall in love."
> —Cassie Howard

Cassie just wants to be loved. After her father Gus' infidelity, her parents split, and he abandoned the family while struggling with drug addiction. Cassie was left longing for a dependable male figure in her life and for validation from men in general. Her self-esteem unconsciously became dependent on what boys think of her.

Cassie has always embraced all things girly, and she identifies with tropes traditionally assigned to cisgender women. In the vein of iconic blondes like Marilyn Monroe, Brigitte Bardot, and Claudia Schiffer, she is conscious of fashioning herself in a way that accentuates her curves (what she considers to be her best attributes). She often chooses colors like pink, baby blue, and other pastels to highlight her femininity. In Season One, she struggles with knowing herself and defining her personal style, looking for inspiration from generic mall culture and Instagram "It girls." In Season Two, Cassie's newfound obsession with Nate results in increasingly desperate attempts for his attention. She fixates on becoming the type of girl he desires and begins to model herself after what she knows he loves about Maddy, becoming more fashion-forward, bordering at times on the extreme.

The influence of family plays a substantial role in how Cassie defines her personal style as well. Her mother, Suze, tells her, "Woman to woman...you're perfect," reinforcing Cassie's confidence and the relationship she has with her body. Cassie considers her sister, Lexi, boring and conservative, the judgment often driving a wedge between the girls. Cassie's sex-positive sense of style is often criticized by Lexi and the boys in her life, reminding the audience that we still have a long way to go as a culture to stop shaming girls and women for the way they choose to dress.

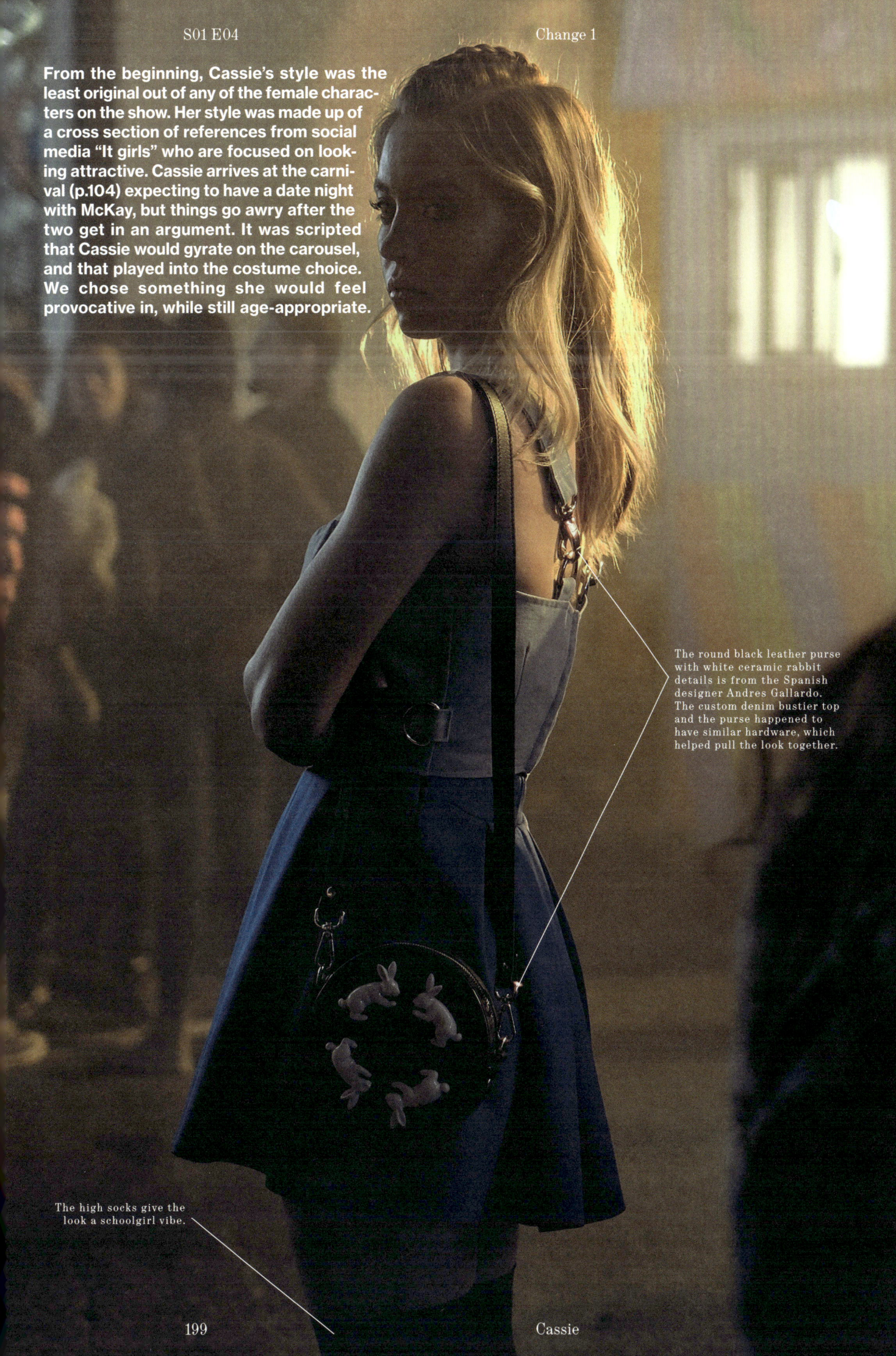

S01 E04 — Change 1

From the beginning, Cassie's style was the least original out of any of the female characters on the show. Her style was made up of a cross section of references from social media "It girls" who are focused on looking attractive. Cassie arrives at the carnival (p.104) expecting to have a date night with McKay, but things go awry after the two get in an argument. It was scripted that Cassie would gyrate on the carousel, and that played into the costume choice. We chose something she would feel provocative in, while still age-appropriate.

The round black leather purse with white ceramic rabbit details is from the Spanish designer Andres Gallardo. The custom denim bustier top and the purse happened to have similar hardware, which helped pull the look together.

The high socks give the look a schoolgirl vibe.

Cassie

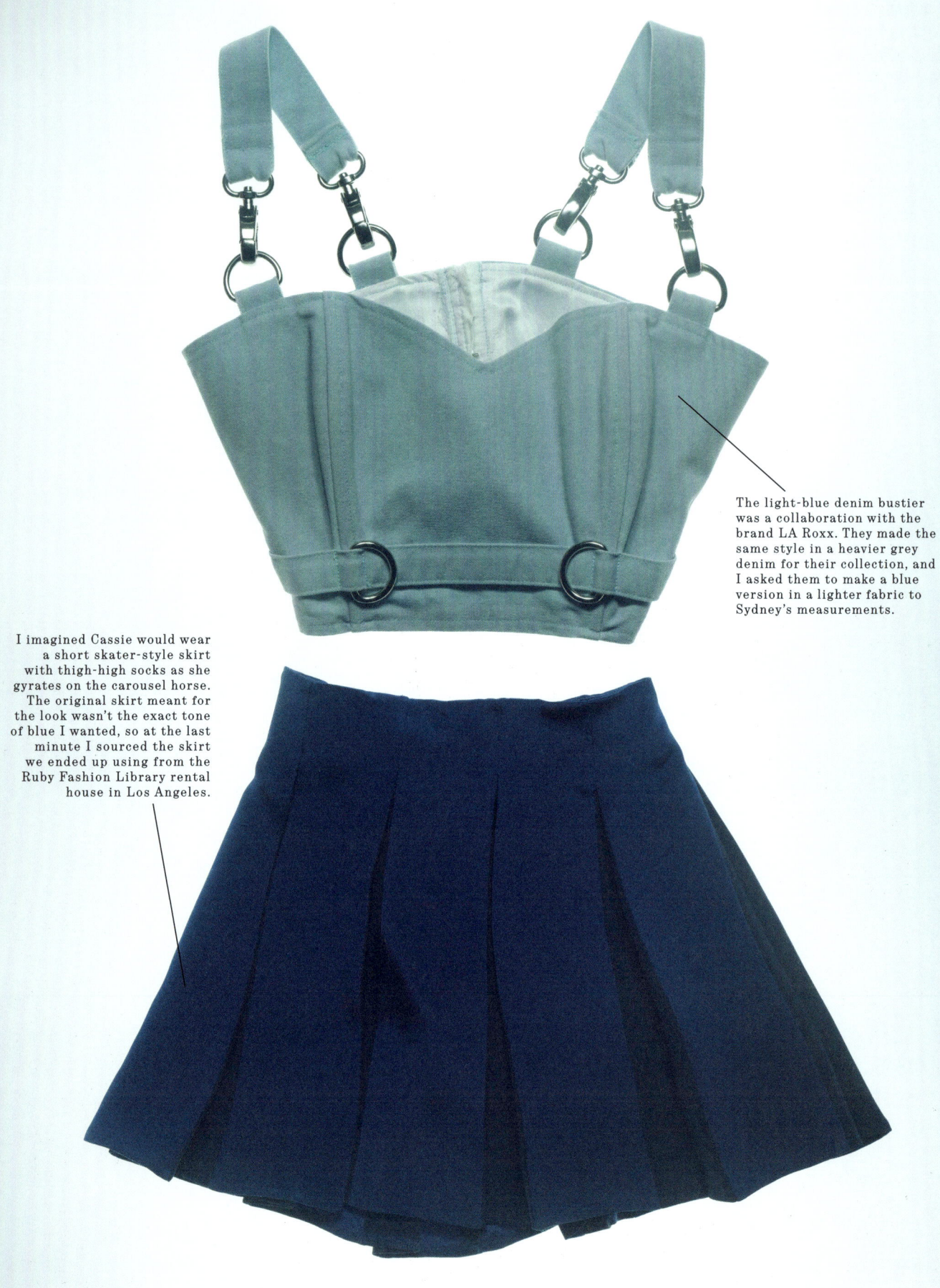

The light-blue denim bustier was a collaboration with the brand LA Roxx. They made the same style in a heavier grey denim for their collection, and I asked them to make a blue version in a lighter fabric to Sydney's measurements.

I imagined Cassie would wear a short skater-style skirt with thigh-high socks as she gyrates on the carousel horse. The original skirt meant for the look wasn't the exact tone of blue I wanted, so at the last minute I sourced the skirt we ended up using from the Ruby Fashion Library rental house in Los Angeles.

S01 E06 Change 2

Alabama Worley from the movie *True Romance* (1993) was the perfect, iconic Halloween costume for Cassie (p.166). It was a seminal film in my early cinematic education, and I wonder how many fans of *Euphoria* discovered it through the show. The costume was rather easy to recreate: a bra dyed to be the right shade of turquoise, vintage belt, bag, and earrings styled with dime-store sunglasses.

Some accessories were purchased online—for example, Amazon was the source for the the blue heart earrings, which I imagined Cassie might find and buy for her costume.

The cow-print mini skirt is a collaboration with Dolls Kill and Delia's, the original mail-order teen fashion brand made popular in the '90s. The cowboy boots she wears are a vintage blue pair from the brand Liberty.

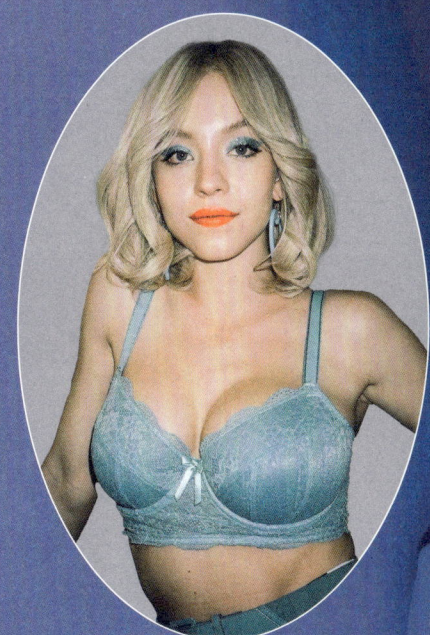

The coordinated eyeshadow, earrings, bra, and belt were true to the original inspiration—the look made famous by Patricia Arquette in *True Romance*.

Sam Levinson's visual reference for Cassie's fantasy ice skating look was Hedy Lamarr's peacock feather dress in the 1949 film *Samson and Delilah*. My job as the costume designer was to translate that inspiration into a memorable skating costume for Cassie.

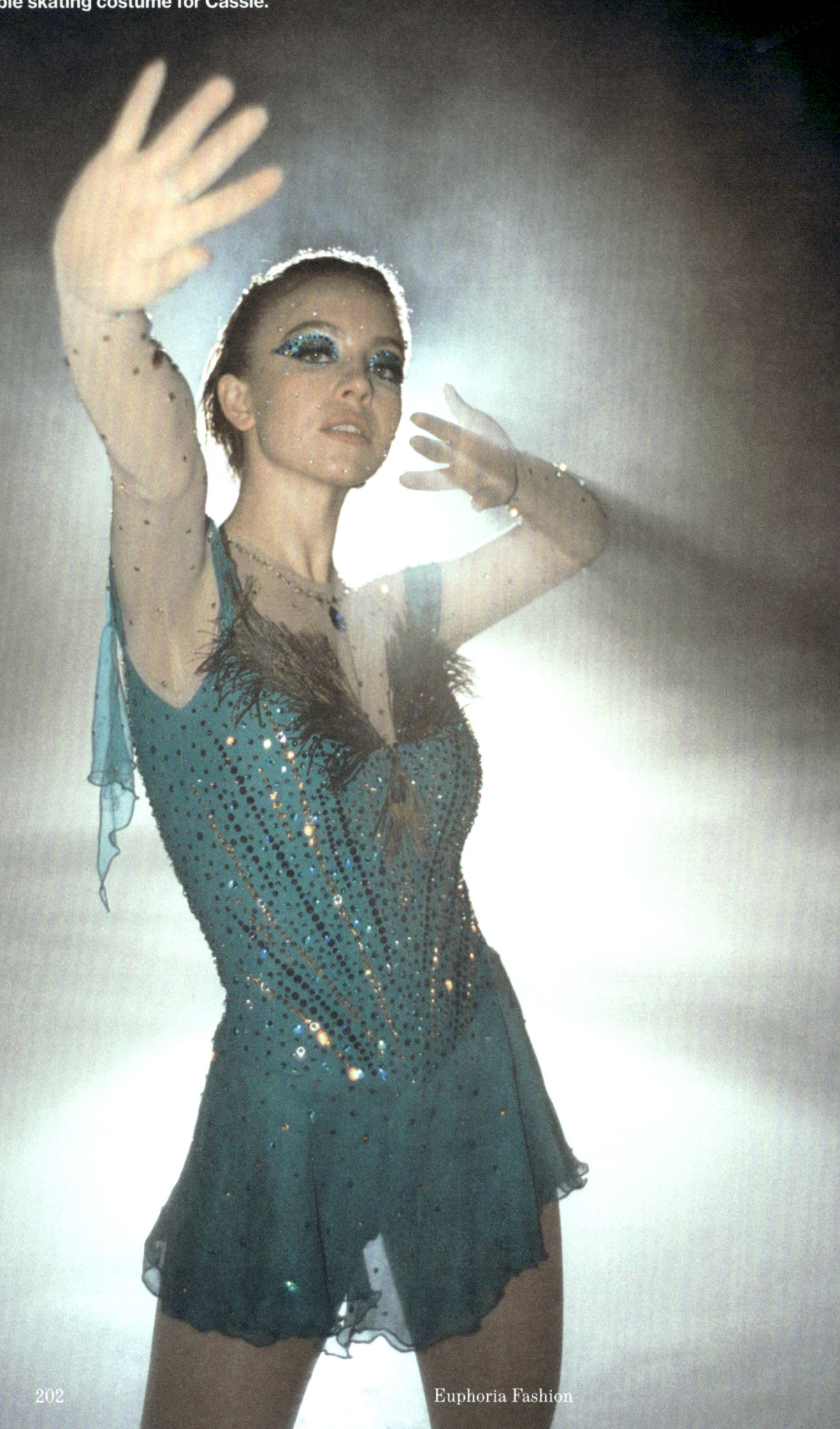

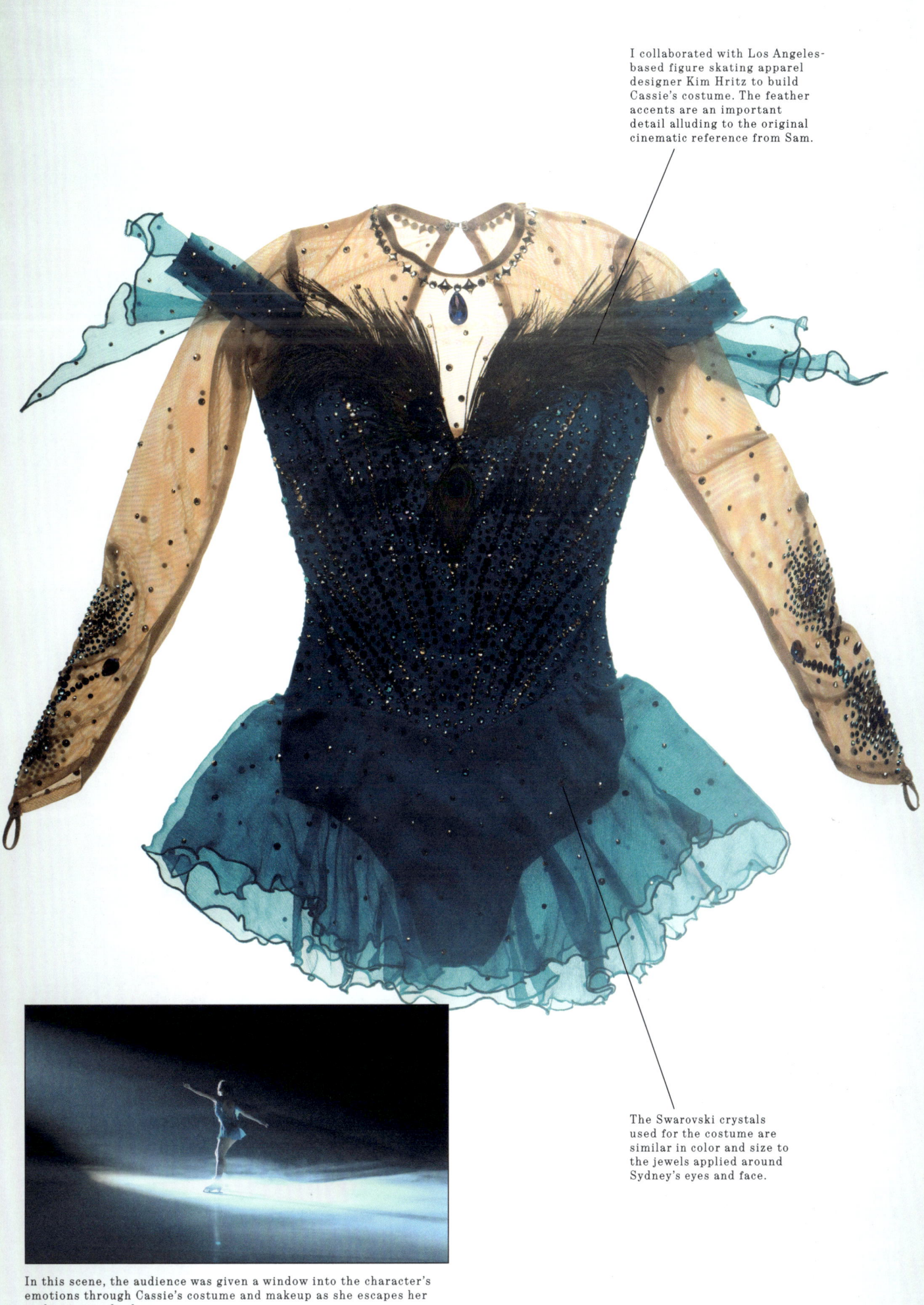

I collaborated with Los Angeles-based figure skating apparel designer Kim Hritz to build Cassie's costume. The feather accents are an important detail alluding to the original cinematic reference from Sam.

The Swarovski crystals used for the costume are similar in color and size to the jewels applied around Sydney's eyes and face.

In this scene, the audience was given a window into the character's emotions through Cassie's costume and makeup as she escapes her reality into a daydream.

Cassie

S02 E01 — Change 1

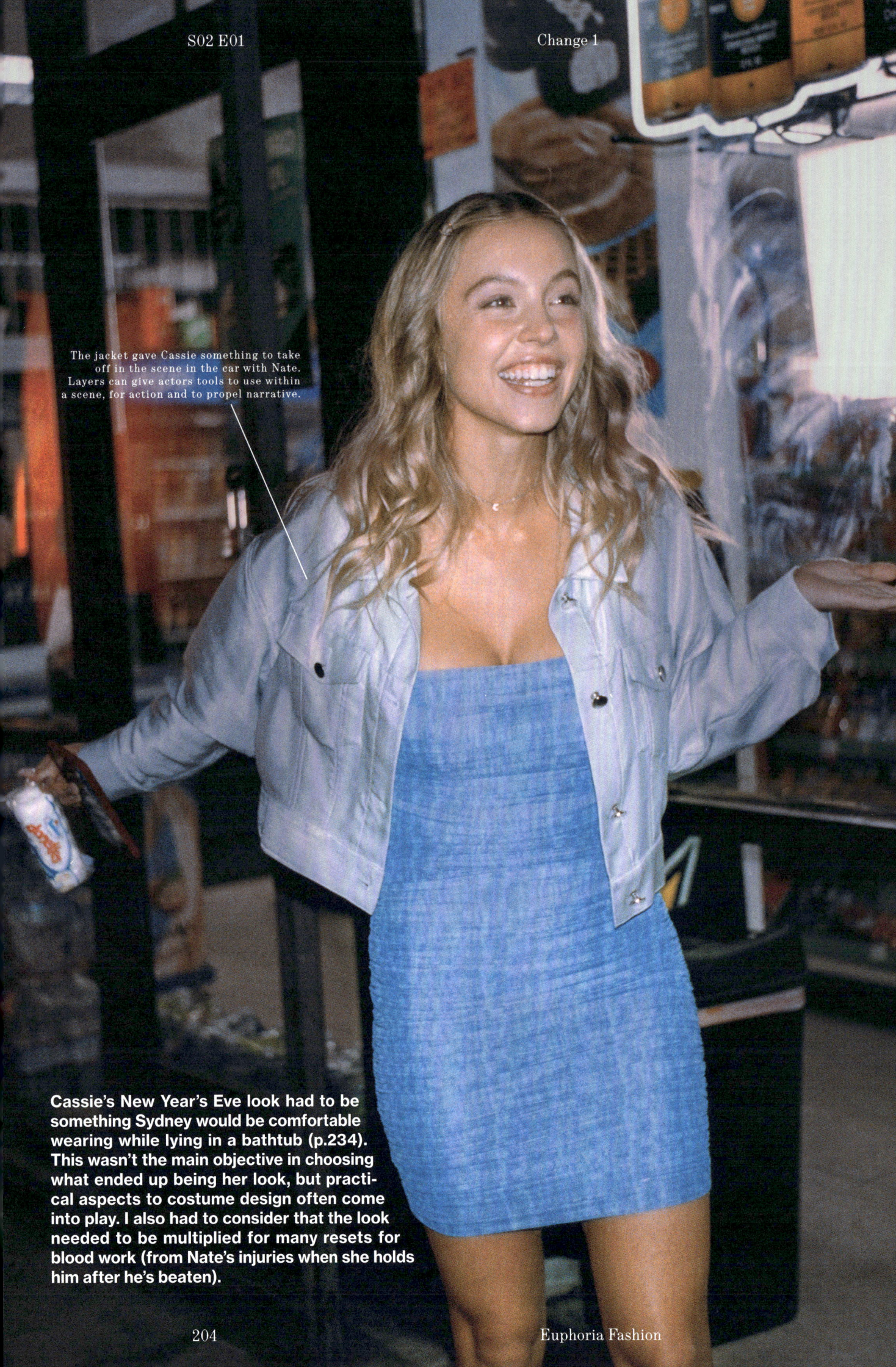

The jacket gave Cassie something to take off in the scene in the car with Nate. Layers can give actors tools to use within a scene, for action and to propel narrative.

Cassie's New Year's Eve look had to be something Sydney would be comfortable wearing while lying in a bathtub (p.234). This wasn't the main objective in choosing what ended up being her look, but practical aspects to costume design often come into play. I also had to consider that the look needed to be multiplied for many resets for blood work (from Nate's injuries when she holds him after he's beaten).

S02 E03 — Change 8

This was a progression of five looks, where Cassie was becoming more and more desperate for Nate to notice her at school. There's a lead-up to the final look, when her friends jokingly ask her if she's auditioning for *Oklahoma!* Figuring out how to go from zero to a hundred in five looks was a fun challenge.

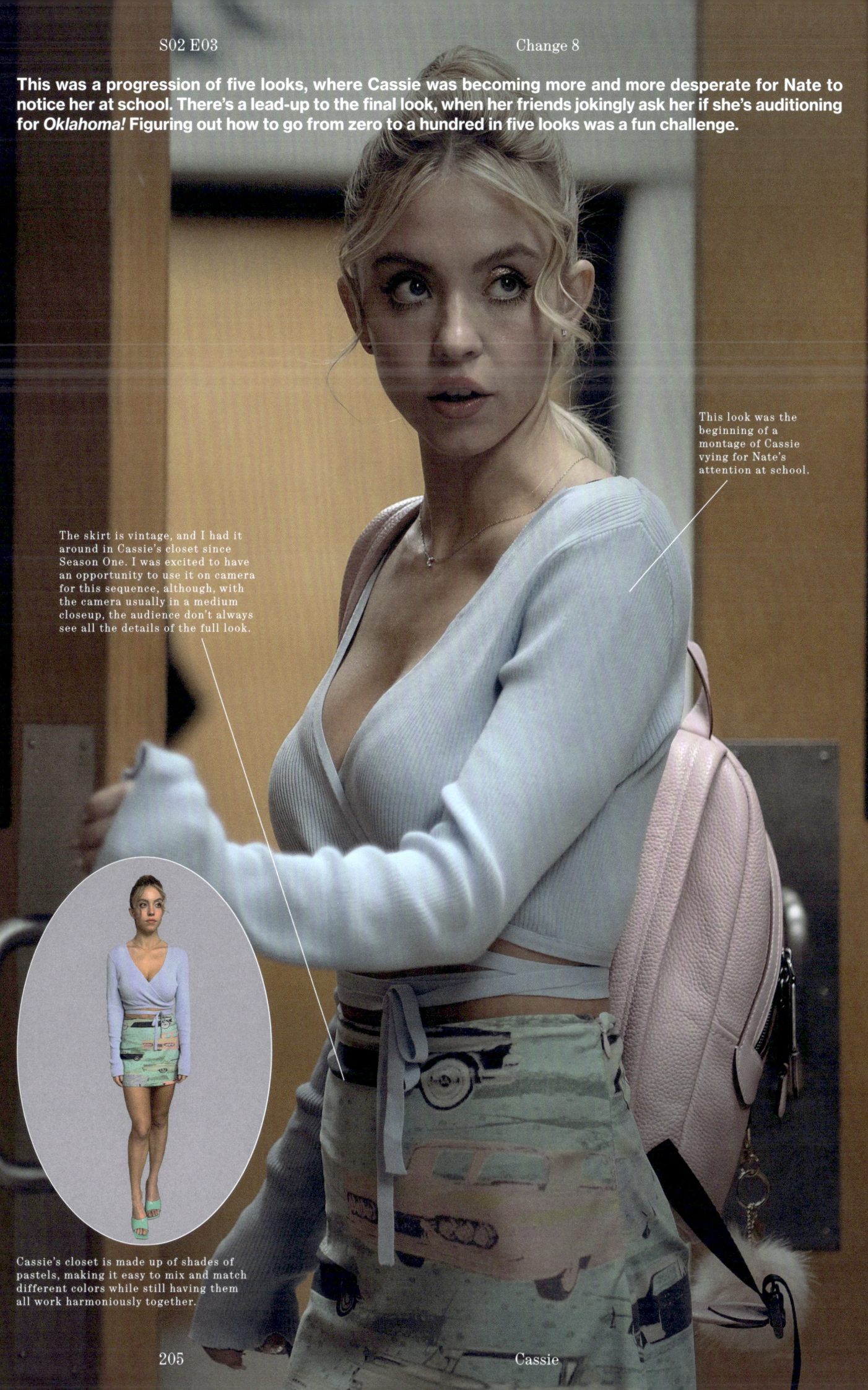

This look was the beginning of a montage of Cassie vying for Nate's attention at school.

The skirt is vintage, and I had it around in Cassie's closet since Season One. I was excited to have an opportunity to use it on camera for this sequence, although, with the camera usually in a medium closeup, the audience don't always see all the details of the full look.

Cassie's closet is made up of shades of pastels, making it easy to mix and match different colors while still having them all work harmoniously together.

Cassie

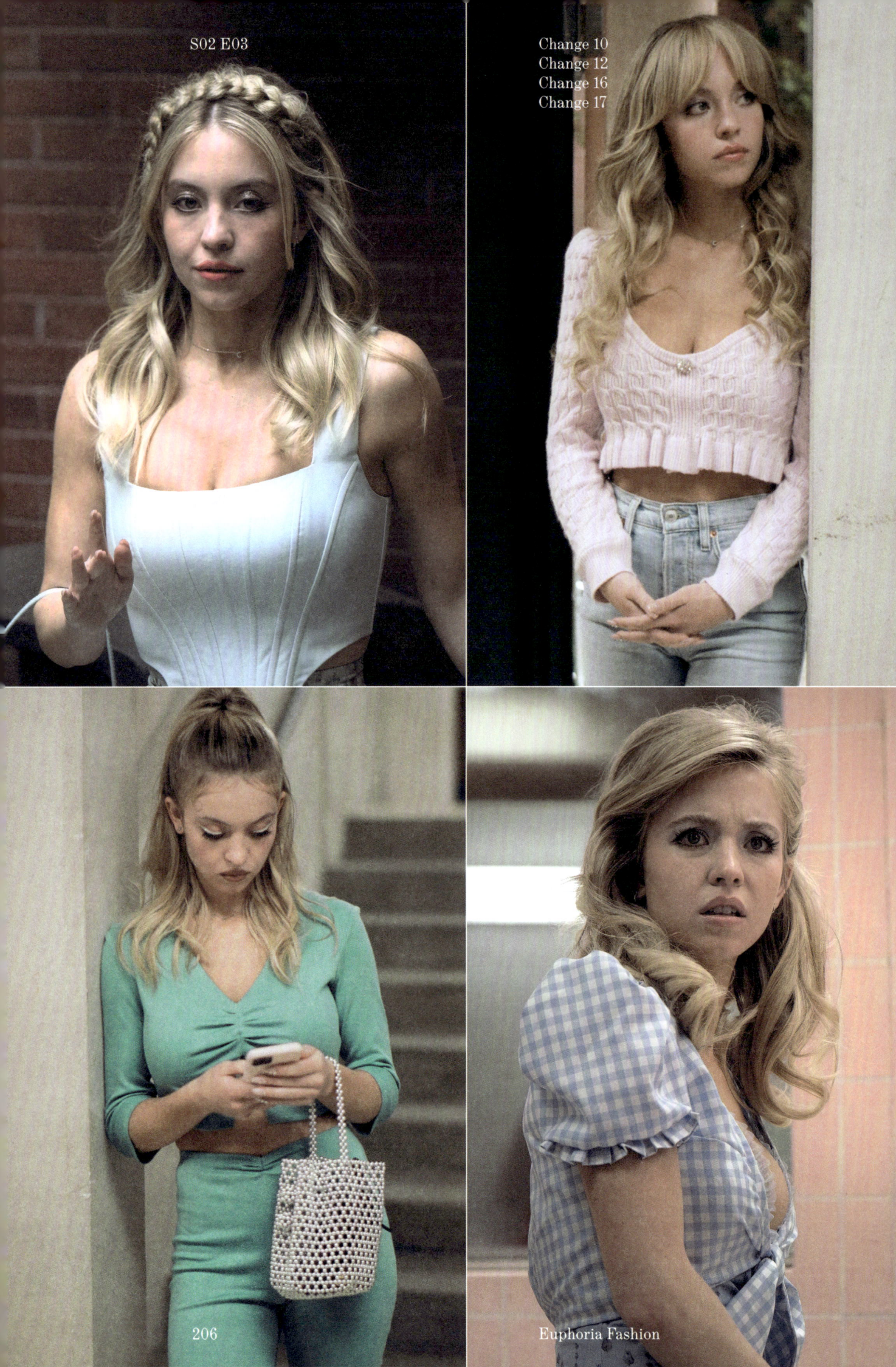

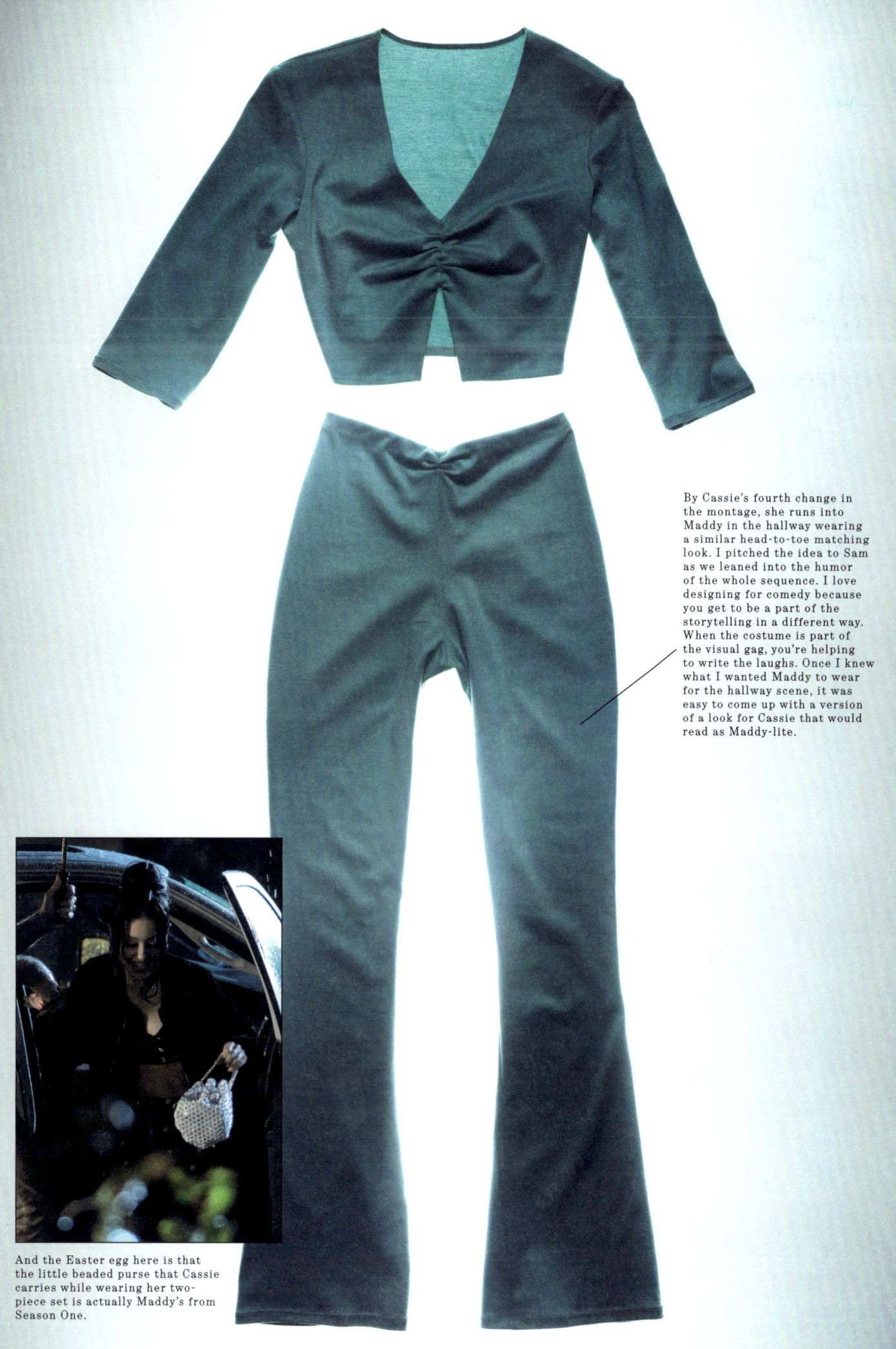

By Cassie's fourth change in the montage, she runs into Maddy in the hallway wearing a similar head-to-toe matching look. I pitched the idea to Sam as we leaned into the humor of the whole sequence. I love designing for comedy because you get to be a part of the storytelling in a different way. When the costume is part of the visual gag, you're helping to write the laughs. Once I knew what I wanted Maddy to wear for the hallway scene, it was easy to come up with a version of a look for Cassie that would read as Maddy-lite.

And the Easter egg here is that the little beaded purse that Cassie carries while wearing her two-piece set is actually Maddy's from Season One.

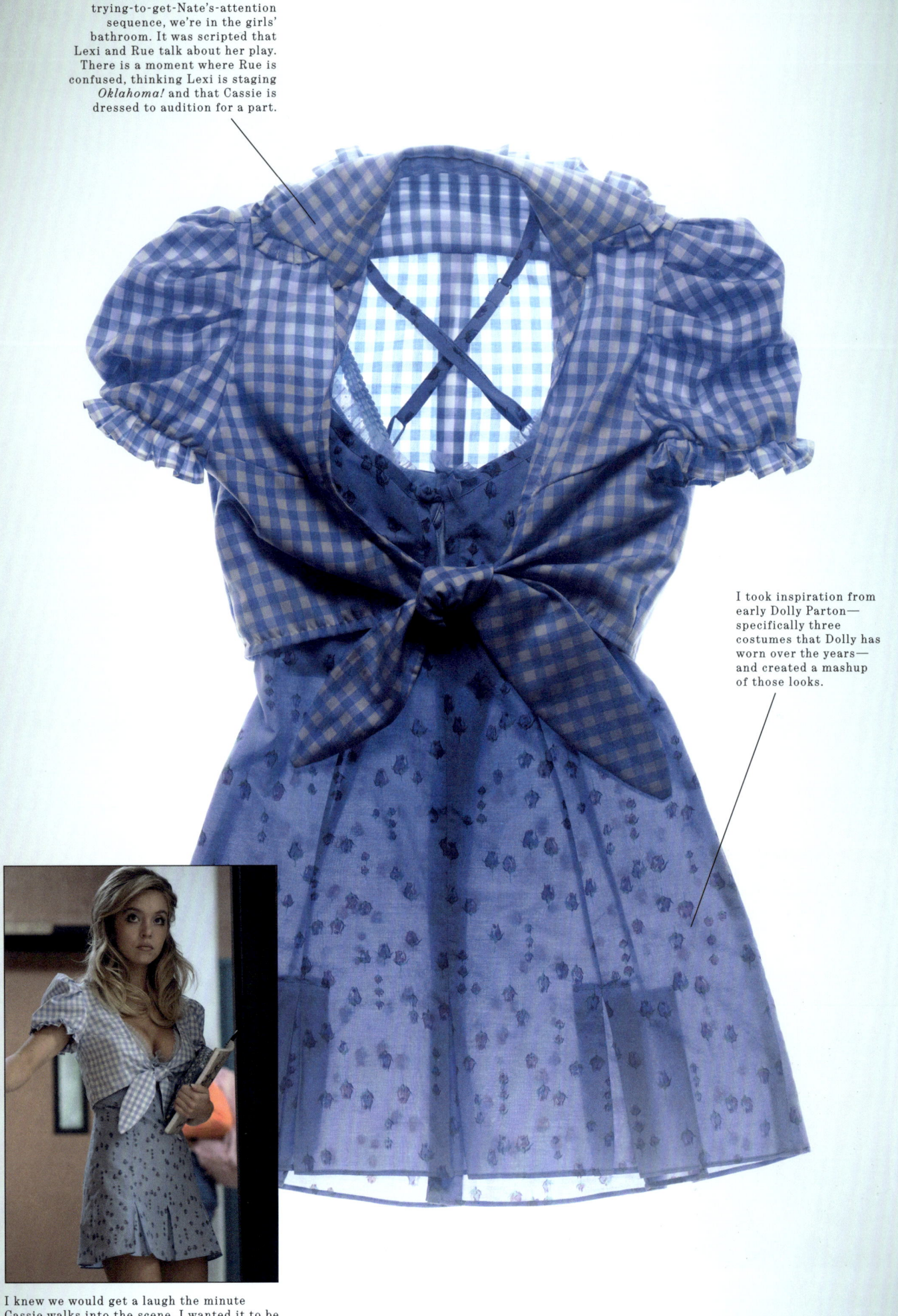

For the fifth look in Cassie's trying-to-get-Nate's-attention sequence, we're in the girls' bathroom. It was scripted that Lexi and Rue talk about her play. There is a moment where Rue is confused, thinking Lexi is staging *Oklahoma!* and that Cassie is dressed to audition for a part.

I took inspiration from early Dolly Parton—specifically three costumes that Dolly has worn over the years—and created a mashup of those looks.

I knew we would get a laugh the minute Cassie walks into the scene. I wanted it to be funny, but not for the audience to make fun of her. I still wanted her to look beautiful.

Euphoria Fashion

There were a few swimwear options for this scene, and Sydney chose this style after falling in love with it at a fitting. It's a showstopper as she walks down the stairs intoxicated, trying to impress Nate.

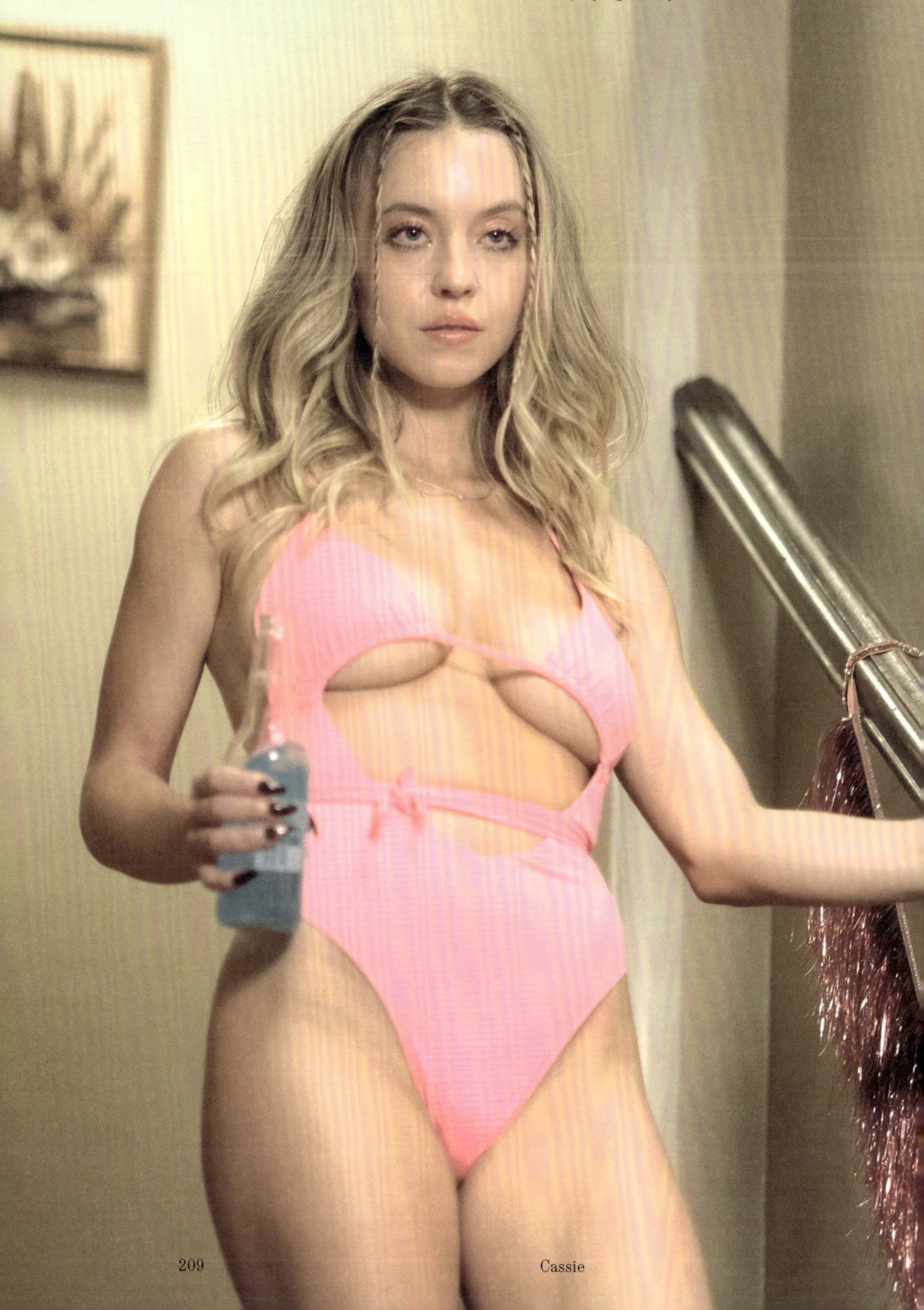

This strapless gingham bustier dress is from the Spring 2022 Moschino collection and one of the few runway looks I've used on the show. In this sequence, Nate has shopped for Cassie and is dressing her. There's a dream-like, fantasy quality to it, but it's unclear whose reality we're in.

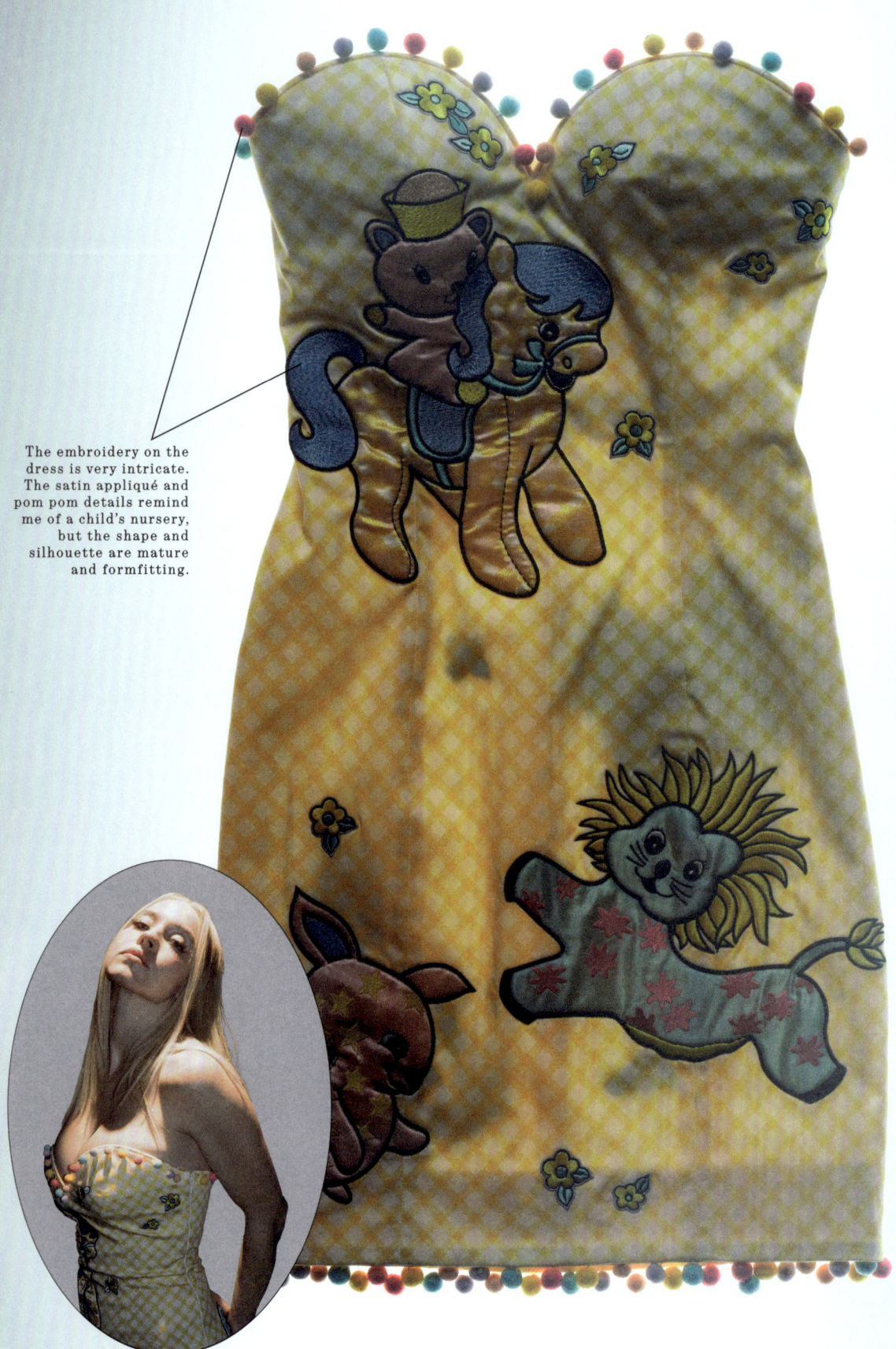

The embroidery on the dress is very intricate. The satin appliqué and pom pom details remind me of a child's nursery, but the shape and silhouette are mature and formfitting.

Jeremy Scott has described his Spring 2022 Moschino collection as "baby lady." I was intrigued by the idea that Cassie would look like a baby doll in a dress that Nate chose for her.

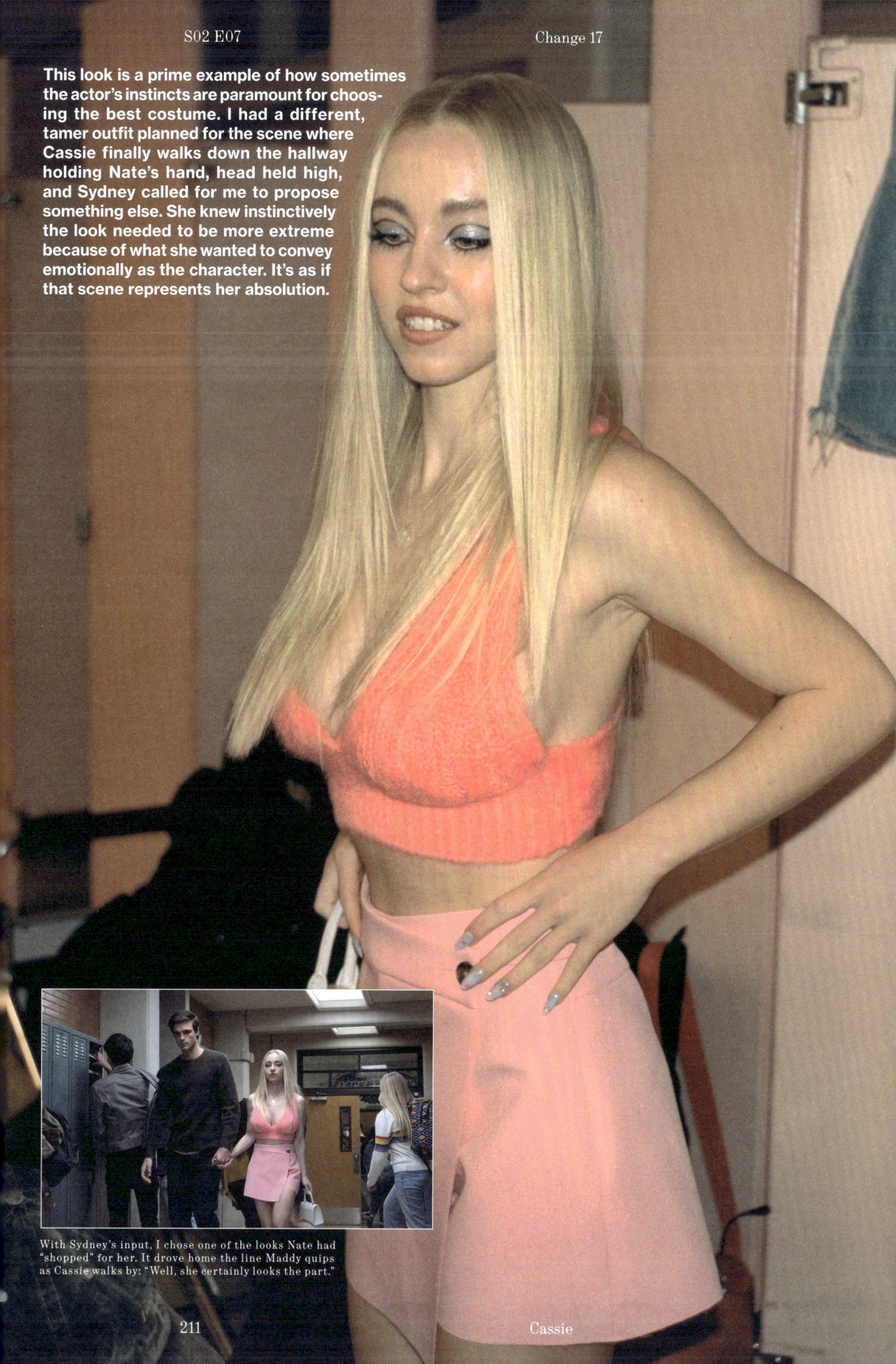

S02 E07 Change 17

This look is a prime example of how sometimes the actor's instincts are paramount for choosing the best costume. I had a different, tamer outfit planned for the scene where Cassie finally walks down the hallway holding Nate's hand, head held high, and Sydney called for me to propose something else. She knew instinctively the look needed to be more extreme because of what she wanted to convey emotionally as the character. It's as if that scene represents her absolution.

With Sydney's input, I chose one of the looks Nate had "shopped" for her. It drove home the line Maddy quips as Cassie walks by: "Well, she certainly looks the part."

Cassie

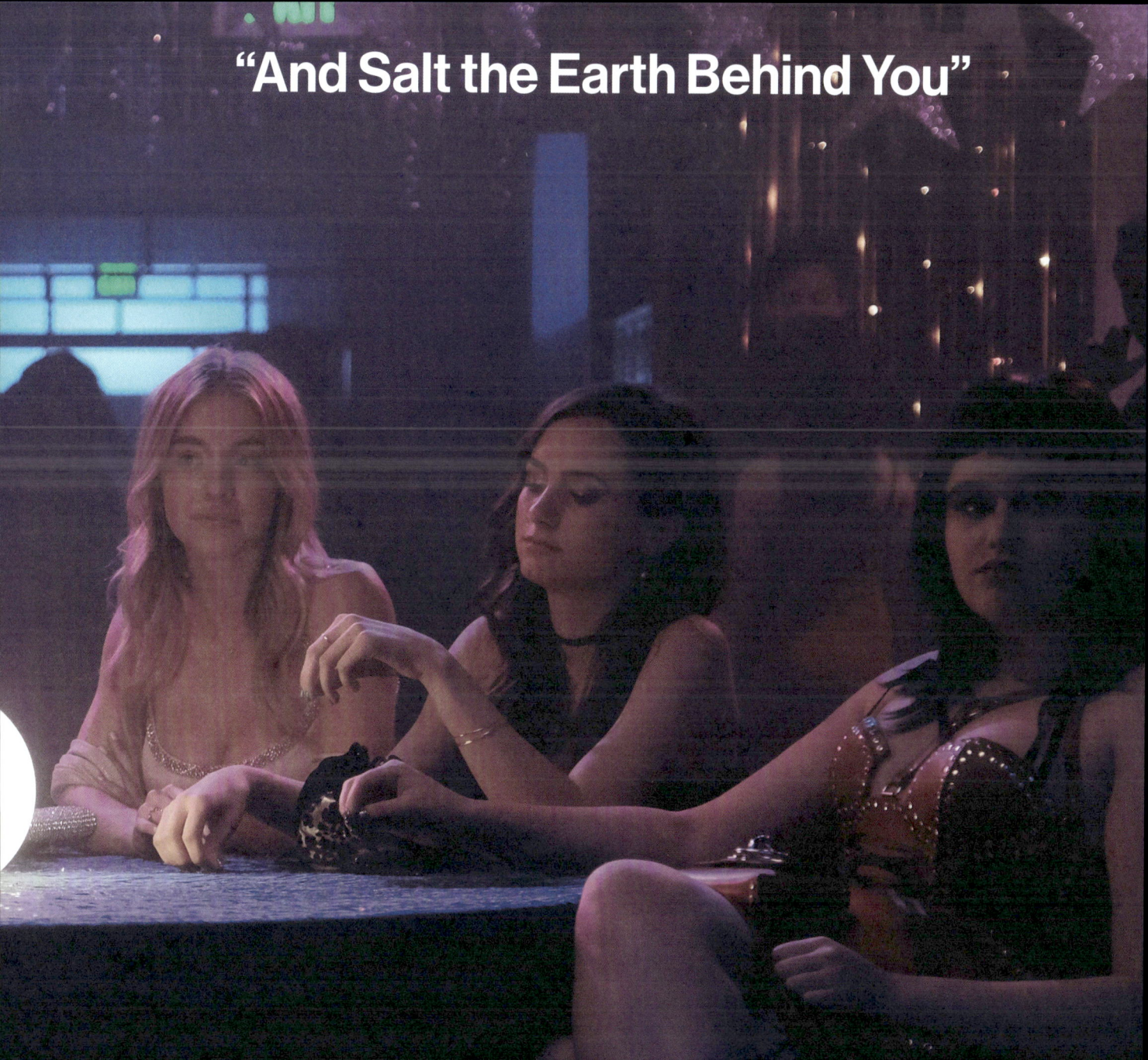
"And Salt the Earth Behind You"

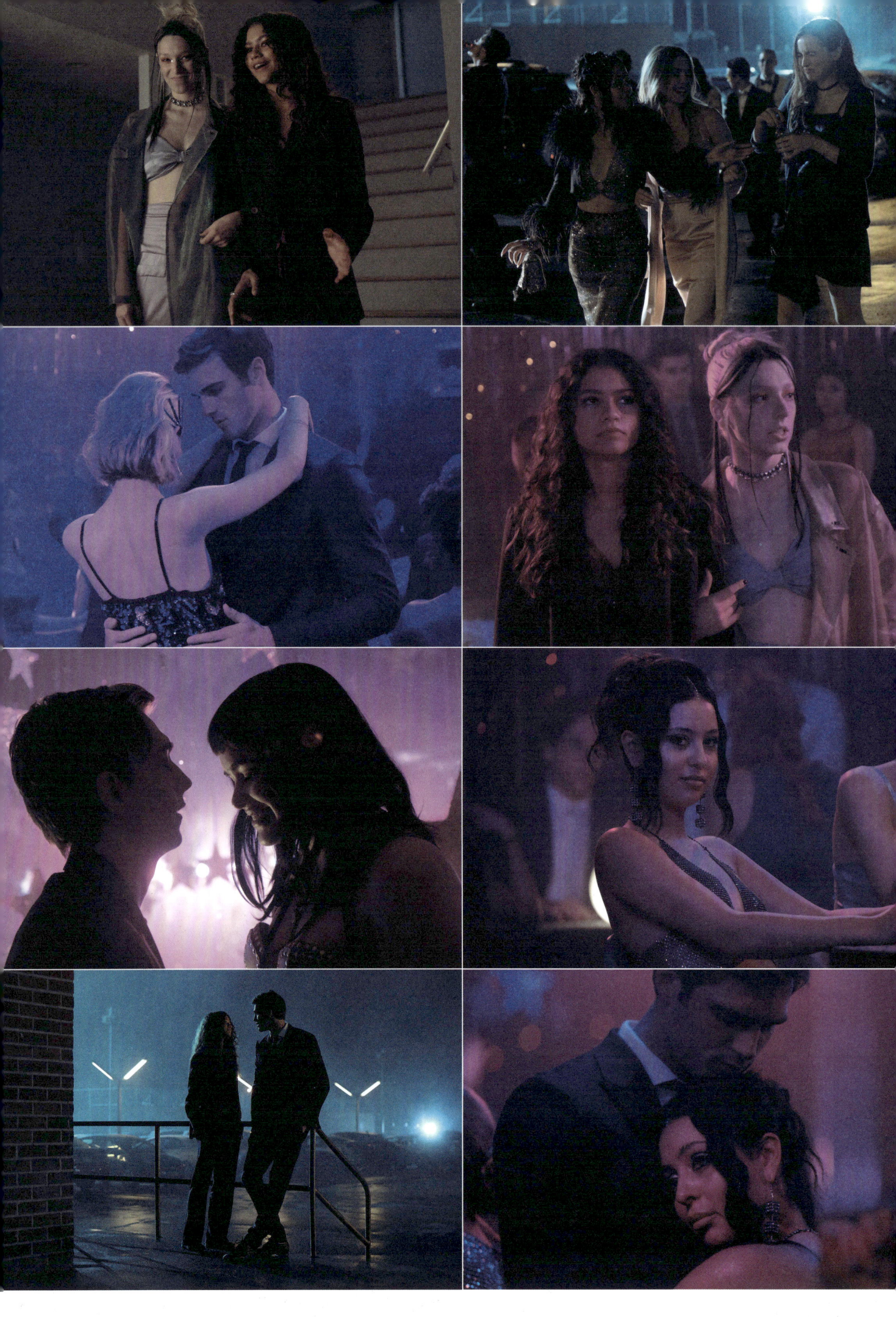

Euphoria Fashion

Jules applies makeup on Rue for the winter formal while recounting stories of her time in the city, telling Rue, "It was the first time I ever felt like I had a family that wasn't my dad, or you."

The two pose for pictures for their parents—Jules' dad and Rue's mom—who are waiting for them downstairs before they head to the dance.

Cassie, still reeling from her abortion, looks forlorn, and her mother reminds her to "keep your head up, baby." Lexi, descending the stairs in their house, is given her mother's approval—a stark reversal from their Halloween interaction. The sisters pick up Maddy from her house; she shimmers in black from head to toe (**p.116**). On their way in, Cassie tells them, "I feel really good about tonight… This is the first time since the beginning of high school that I haven't been in love with somebody." Maddy validates the feeling by replying, "Honestly, I love that for you."

Nate has invited a tall blonde to the winter formal. When she arrives at his house, his parents clearly approve. In the car, it's clear that the two have no chemistry. Meanwhile, the girls discuss a life beyond high school by reflecting on all that has happened in the past semester. Jules ends the conversation by saying, "I feel like high school's super fucking suffocating," before heading to the bathroom to take a selfie for Anna, the woman Jules met during her weekend with friends in the city.

When Nate baits Maddy by feeling up his date on the dance floor, Maddy finds an eligible suitor and brings him to the dance floor to respond to Nate's provocation. Rue heads to the bathroom to look for Jules, who has been texting with Anna. Jules asks Rue, "Why don't you kiss me," to which a bewildered Rue has no answer.

Kat spots Ethan across the dance floor and approaches him. She leads him to a quiet place and apologizes, admitting that when she saw him speaking with another girl at the carnival she "had this reaction, and [she] just hated [him]." Ethan allays her fears, and the two kiss.

Outside, Rue confronts Nate about Fezco's house raid and reveals her knowledge of his father's illicit, extramarital affairs that have ensnared Jules. He retorts by reminding Rue that Jules has a bigger life ahead of her and will leave her and forget who she is. Inside the dance, Nate asks Maddy to slow dance with him. Maddy tells him that he's "abusive and psychopathic" and that they shouldn't be together.

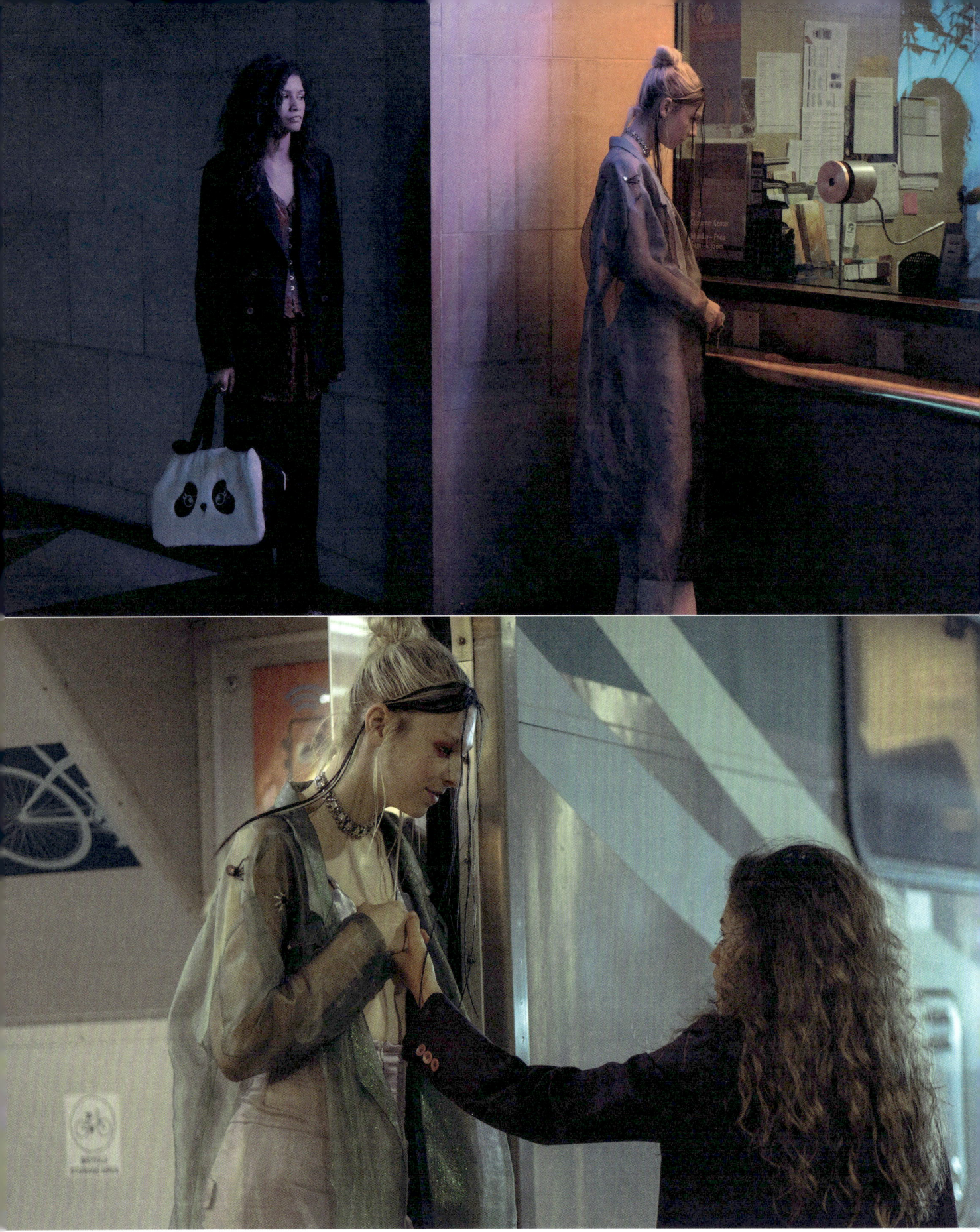

Outside the dance, Rue asks Jules if she is in love with Anna. Yes. And if Jules is in love with her. Yes. They make a plan to run away to the city. As the two approach the train platform, Rue begins to panic and finds excuses to stay behind. Jules gets on the train, pleading for Rue to join her. The train pulls away with Jules on board as Rue remains on the platform.

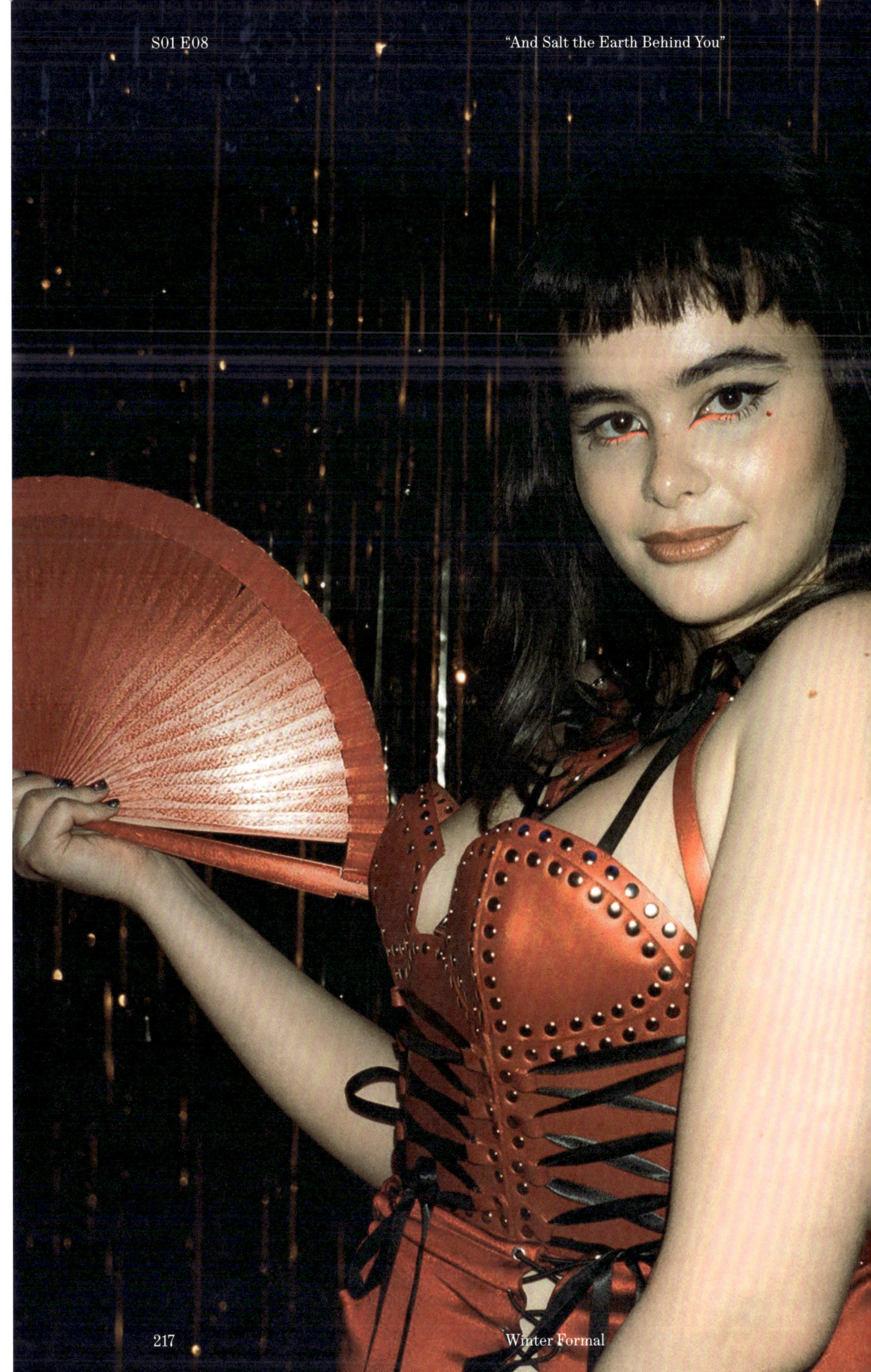

IT'S MY *EUPHORIA* PARTY, AND I'LL CRY IF I WANT TO

Mitchell Kuga

By almost any conceivable metric, the second season of *Euphoria* wasn't much of a party—unless your idea of a good time is experiencing heart palpitations on behalf of disaffected teenagers making terrible decisions. I watched most of the eight episodes with a clenched jaw, feeling that queasy sensation of being strapped into a roller coaster, waiting for the drop. Yet I couldn't look away. Even the actual parties depicted within the show, with their promise of frivolity via early aughts hip-hop and red Solo cups, offered little respite. One resulted in a closeup of Nate's bashed-in head, blood oozing like a broken bottle of Chanel's Rouge Noir polish,[01] another with clumps of Cassie's puke floating in a hot tub.[02] That sense of escalating doom was intentional. As writer/director Sam Levinson said in a behind-the-scenes interview, "If Season One was sort of a house party at 2 a.m., Season Two should feel like 5 a.m., way past the point at which everyone should have gone home."

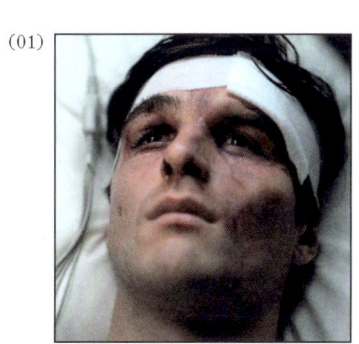

(01) Nate recovers from a New Year's Eve beating from Fezco, Episode 202.

(02) Cassie's guilt about her clandestine affair with Nate pushes her to get drunk at Maddy's birthday party and dissolve into a sobbing fit, Episode 204.

And yet that hasn't stopped *Euphoria* from having an outsized impact on nightlife, inspiring a spate of *Euphoria*-themed parties that have taken the show's characters, costuming, and aspirational mood lighting as their muse. On the surface, these events offer partygoers fodder for social media, an excuse to wear sexy outfits in front of metallic fringe photo backdrops while raging to club remixes of Labrinth's "Still Don't Know My Name," a key music cue from Season One—appropriate for a show that employs all of the dramatic strobe lights and unexpected musical transitions of your typical club, not to mention a gluttonous flair for making bad behavior look really good. But *Euphoria* also engages with nightlife in other ways: as a vehicle for questions about transgression, self-discovery, and what it means to emerge into the world again, making up for lost time.

Like a good dance floor, *Euphoria* has never shied away from reveling in the spectacle of maximalist theater, with the second season going so far as to culminate

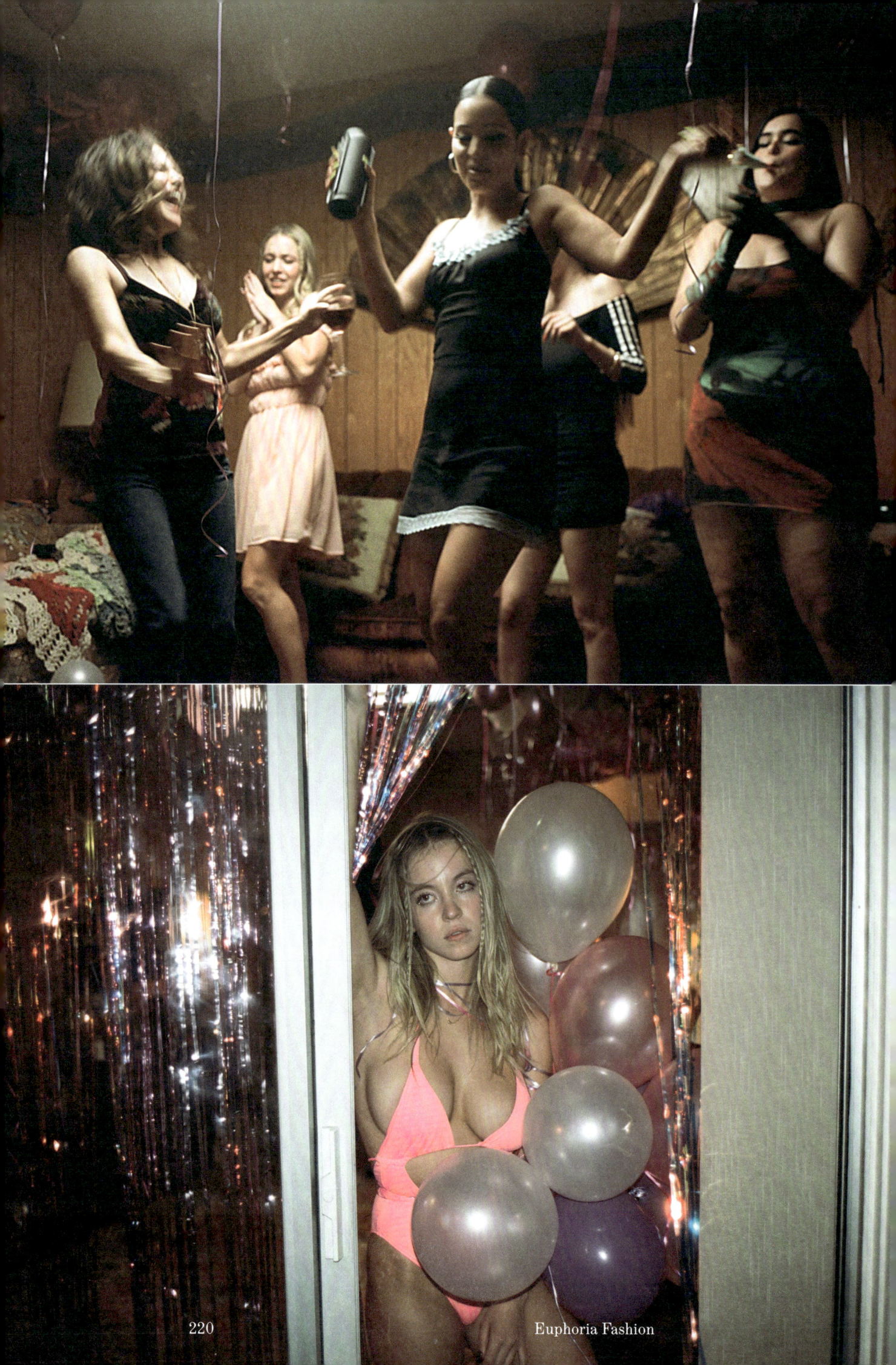

Euphoria Fashion

Lexi's ready for the spotlight and the stage, Episode 207.

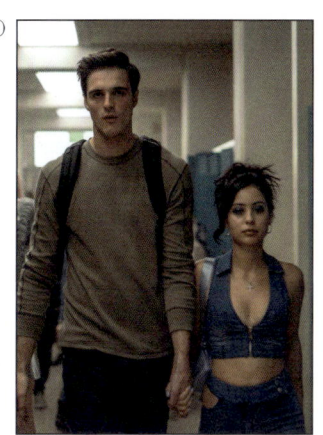

Maddy walks the halls of East Highland High with Nate in a look that inspired "Euphoria High," Episode 103.

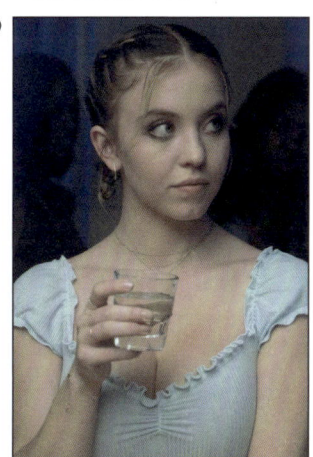

Favoring pastels, Cassie aspires to embody feminine lightness and ease as she accompanies McKay to a frat party in a cleavage-revealing pale blue top, Episode 103.

in a high school play about the show itself (**p.254**).(03) *Euphoria*'s visual identity has always existed in that liminal space, both in reality and fantastically beyond its bounds, and the show's costuming is no exception. Take the second season's breakout meme, in which students wearing frumpy school outfits supercut to outrageously skimpy ensembles once they remember they attend "Euphoria High." The punchline: Who really dresses like that? Much less in the light of day? Micro mini skirts. Peekaboo halters. Sparkling rhinestone eye makeup and shiny fetishwear. These were looks made for the night—for dimly lit spaces where transgressing sartorial norms isn't tolerated so much as encouraged. The fact that these nightlife looks were of a kind with so many of the ones paraded under the fluorescent-lit hallways of East Highland High School underscored one of the show's central features: its propensity for bringing dark subjects into the light.(04) If those subjects were *Euphoria*'s medicine, then fashion was the sugar helping it all go down, costuming being just one of many stylistic devices the show uses to remind us that we are living in, if not quite a nightclub, then a fantastical simulation of reality resembling nightlife's liberatory effects.

Who really dresses like that in the light of day? The fearless—and seemingly unsupervised—young women of *Euphoria*. On the dance floor, Jules, Maddy, Cassie, Lexie, Kat, and Rue have provided young people with a new set of nightlife avatars, ways of embodying heightened versions of themselves—like, on Halloween, when you're Catwoman, not just a sexually liberated drunk wearing cat ears. Collectively, they offer cover for exploration: are you an aspiring "It girl" à la Maddy? Or do you sway more toward the pensively deconstructed layering of Jules? Throughout the show, we glimpse fashion as pure id, signaling how each character sees themself at their most libidinal. Cassie's cleavage-baring tops(05) in various shades of bubblegum

pink and baby blue reveal her shaky identification with innocence, the damsel angling perennially towards the male gaze. Rue, on the other hand, is the embodiment of stoned insouciance, slouching around in whatever she found on her bedroom floor. The only thing she's trying to attract is her next high.(06)

Rue in easy layered shirts, seemingly plucked from her bedroom floor, Episode 103.

For a show about wayward teens, there actually aren't that many party scenes in *Euphoria*. In the second season, I counted two: a New Year's Eve bash (**p.232**) and Maddy's birthday (**p.122, 209**). But the show treats these house parties as critical backdrops for development—deranged meet-cutes where characters collide, spark, and occasionally incinerate. The New Year's party is where Rue stumbles into Elliot in the laundry room just as he's about to snort a line of God knows what, and the two begin their drug-fueled friendship.(07) Meanwhile, in the bathroom, Cassie and Nate hook up for the first time as Maddy threatens to tear down the locked door. Both encounters establish the two main plot points of the season.

Elliot and Rue bond over mutual recreational habits in the laundry room at the New Year's Eve party, Episode 201.

Elsewhere, more traditional nightlife spaces function as means of self-discovery, ways for queer characters to excavate parts of themselves they had long tried to bury. Take Cal, who speeds dangerously to a gay bar one night in a fit of drunken nostalgia.(08) The last time he was there was 25 years ago, with his best friend from high school. Cal imagines him on the dance floor while caressing another man. The scene resembles, on a smaller scale, Jules' experience at a nightclub at the end of Season One (**p.70, 156**). It's there, amidst strobing green lights, that she hallucinates an apology from Nate—the place where her lust for him curdles into unbridled rage.(09) In both spaces, time swells then compresses as reality melts into the slippery pool of the unconscious. Jules realizes something about her need to "conquer" femininity through her ability to attract men. Cal realizes something about the origins of his

Cal confronts his past during an unhinged night at a gay bar, Episode 203.

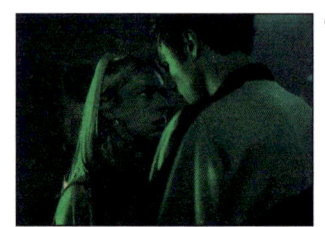

Jules spirals as her fantasy of Nate plays out on the dance floor, Episode 107.

long-suppressed desires. Both epiphanies are aided by drugs or alcohol, accompanied by the throbbing hum of a good sound system.

The first season of *Euphoria* came out in a vastly different world than the second, back when going to a party felt less complicated by the threat of viral infection. And though Season Two never explicitly addresses Covid, there are Easter eggs. Take Jules, shimmying on the dance floor on New Year's Eve as she tells Kat: "My goal tonight is to black out this entire, fucking stupid year."(10) Relatable. But in lieu of forgetting, *Euphoria*-themed parties have become a way for some partygoers to emerge into the world again—a tricky proposition given all we've lost and how much has changed.

Jules and Kat toast to an uncertain New Year, Episode 201.

"When the pandemic first hit, I was 19 years old—and now I'm 22," said YouTuber Lena Yeo, explaining the thinking behind her *Euphoria*-themed birthday party at a New York nightclub. Her avatar for the night was Maddy. "That girl just gives off bad bitch energy," she said, between dabs of concealer. "Also, she's an Aquarius like me, so we're soul sisters, basically." Due to Covid, Yeo hadn't been able to celebrate her last two birthdays, including the big 2-1, so the point was to make up for lost time. It was 5 a.m. after all, both in the twilight zone of *Euphoria* and in the real world. And what better way to account for the impending apocalypse than to rage with the urgency of the rising sun? Another day to go extra big. To go extra bold. To get euphoric.

VII. FEZCO

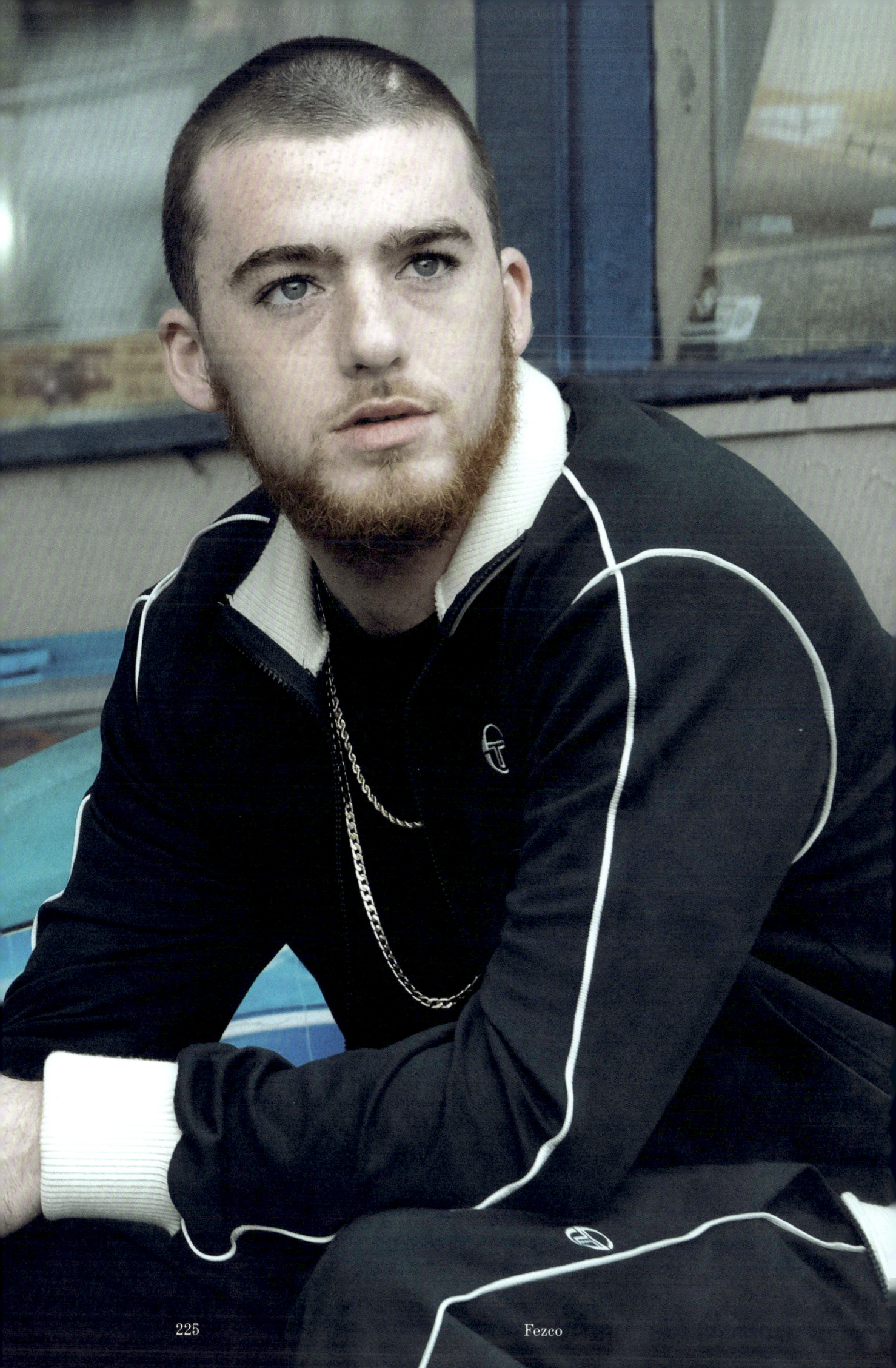
Fezco

"I don't know what type of fucked up shit you got going inside your head. I don't know how to help, but I could tell you one thing: this drug shit, it's not the answer." —Fezco

Fezco is a gangster with a heart of gold, and occasionally *Euphoria*'s unlikely moral compass. He holds his friends and family in high regard, going so far as to put his life on the line for them when necessary. His origin story at the top of Season Two reveals the early influence of Kitty, his "motherfucking G" of a grandma who raised him and taught him everything he knows about his chosen profession: East Highland's most charismatic drug dealer. When he's mocked for dropping out of school to be a gangster by Nate, who then makes threats toward Rue, Fezco draws a line, and a vendetta ensues.

Fezco is older than the high-school-aged characters on the show, and his style taps into a love for hip-hop nostalgia, like the Lo-Life crew of Brooklyn in the late '80s and early '90s whose motto, "love and loyalty," could double as a mantra for Fez. He has a uniform of sorts: polo collars, crewneck sweaters, jeans, and T-shirts, usually in bright colors (except for the rare occasion when he's in all black incognito mode, like the night he visits Mouse's drug source in the Season One finale). The style of his adopted baby brother, Ashtray, is cut from the same cloth, but Ash gravitates more toward sportswear and tracksuits. Brands define Fezco more than any other character on the show as they act as currency in the streets. Polo Ralph Lauren, Supreme, Palace, and Nike are in heavy rotation. The romanticized side of his outlaw persona is especially evident when he dresses up as Tony Montana in *Scarface* for Halloween (**p.164**). In Season Two, we see two extreme sides of Fezco: the violent defender of honor and the soft-hearted romantic that emerges as he and Lexi get to know each other better.

S01 E01 Change 1

I was inspired by Angus' personal style from our very first meeting. He experiments a lot with his own wardrobe and brings a real willingness to do the same with Fezco. Fezco is a familiar character – I often have people tell me they've known someone like him. He is a fan favorite for his kind heart and protective stance toward Rue and those he cares for.

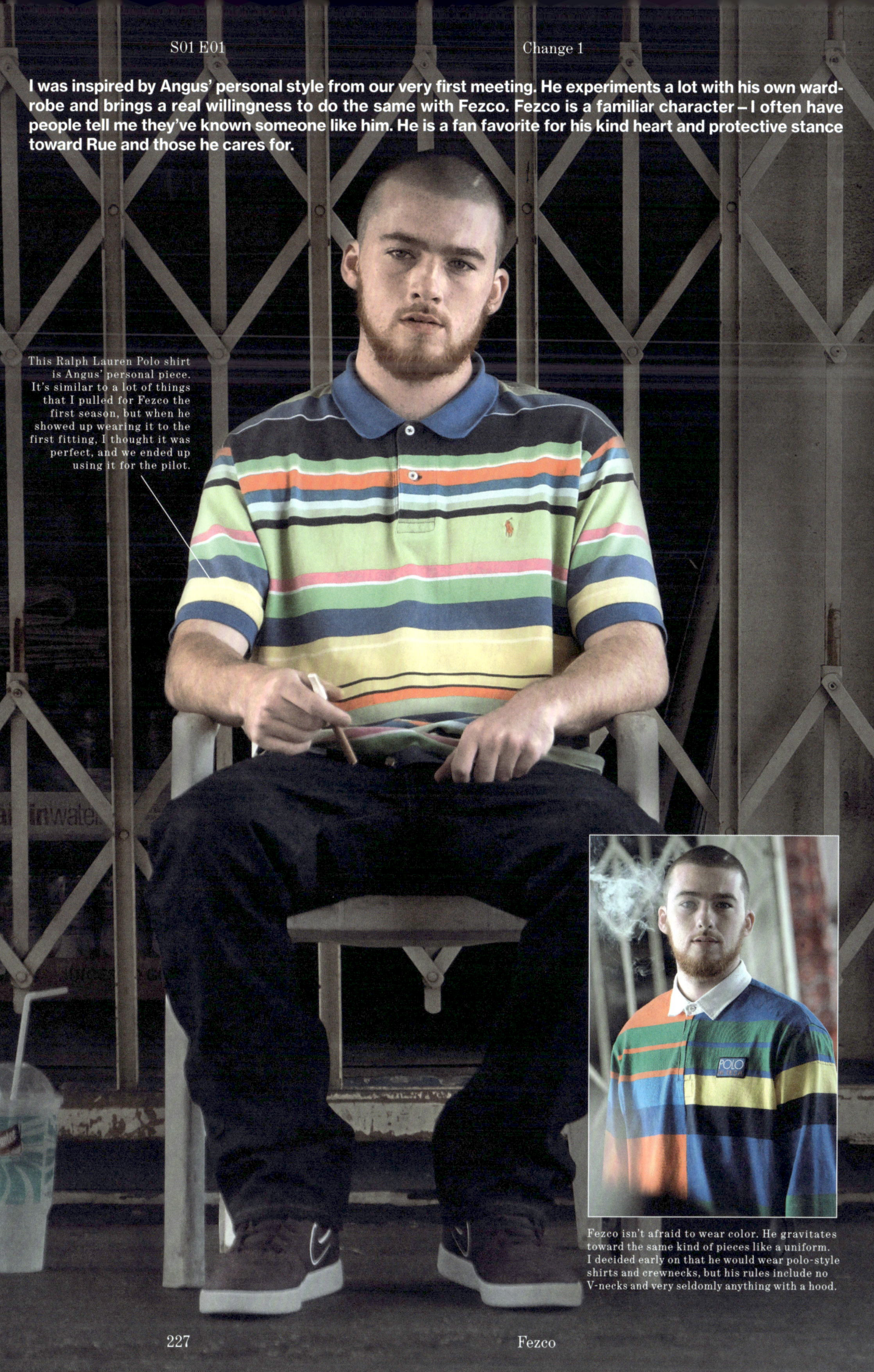

This Ralph Lauren Polo shirt is Angus' personal piece. It's similar to a lot of things that I pulled for Fezco the first season, but when he showed up wearing it to the first fitting, I thought it was perfect, and we ended up using it for the pilot.

Fezco isn't afraid to wear color. He gravitates toward the same kind of pieces like a uniform. I decided early on that he would wear polo-style shirts and crewnecks, but his rules include no V-necks and very seldomly anything with a hood.

Fezco

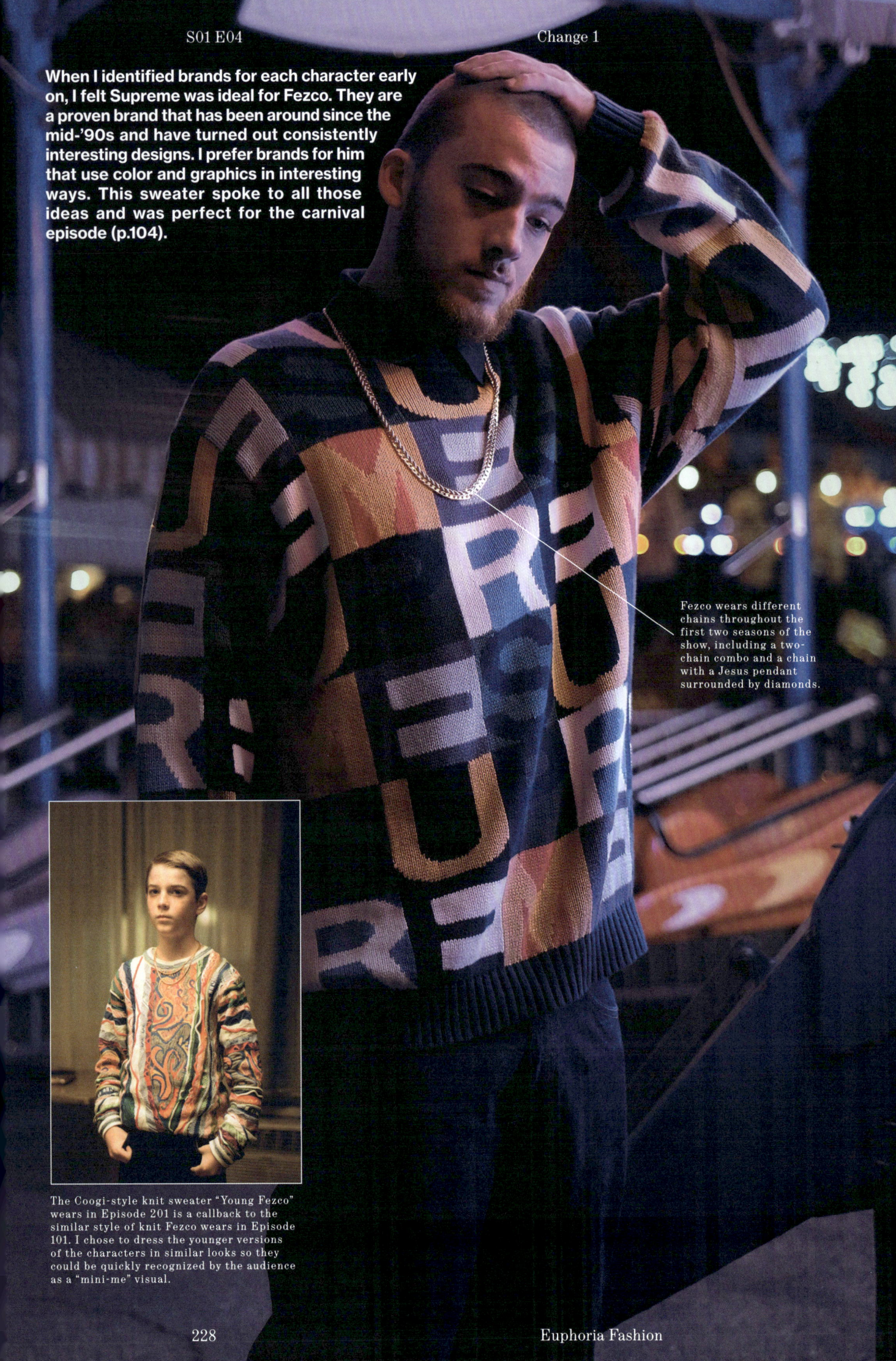

When I identified brands for each character early on, I felt Supreme was ideal for Fezco. They are a proven brand that has been around since the mid-'90s and have turned out consistently interesting designs. I prefer brands for him that use color and graphics in interesting ways. This sweater spoke to all those ideas and was perfect for the carnival episode (p.104).

Fezco wears different chains throughout the first two seasons of the show, including a two-chain combo and a chain with a Jesus pendant surrounded by diamonds.

The Coogi-style knit sweater "Young Fezco" wears in Episode 201 is a callback to the similar style of knit Fezco wears in Episode 101. I chose to dress the younger versions of the characters in similar looks so they could be quickly recognized by the audience as a "mini-me" visual.

S01 E06
S01 E07

Change 1
Change 2

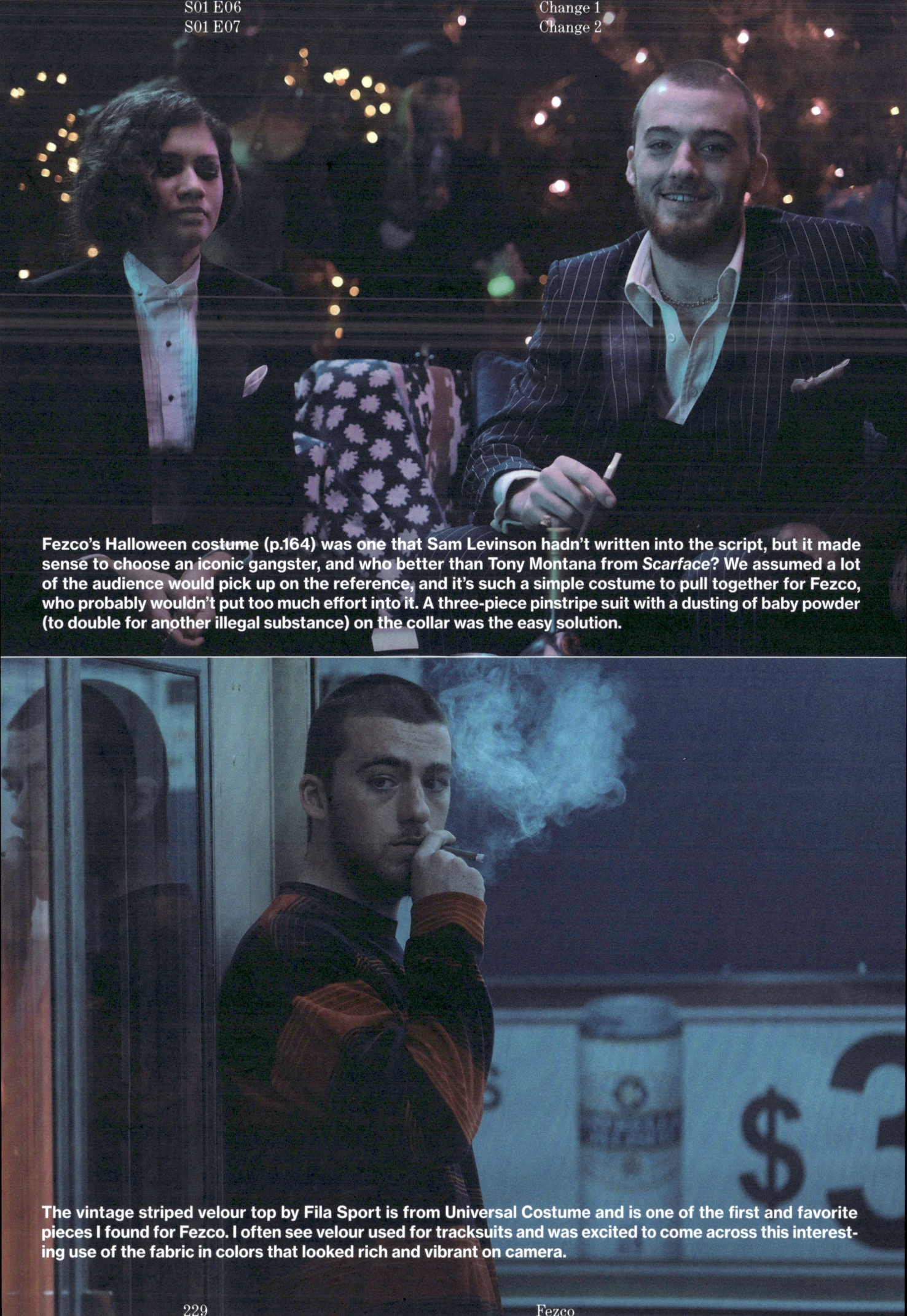

Fezco's Halloween costume (p.164) was one that Sam Levinson hadn't written into the script, but it made sense to choose an iconic gangster, and who better than Tony Montana from *Scarface*? We assumed a lot of the audience would pick up on the reference, and it's such a simple costume to pull together for Fezco, who probably wouldn't put too much effort into it. A three-piece pinstripe suit with a dusting of baby powder (to double for another illegal substance) on the collar was the easy solution.

The vintage striped velour top by Fila Sport is from Universal Costume and is one of the first and favorite pieces I found for Fezco. I often see velour used for tracksuits and was excited to come across this interesting use of the fabric in colors that looked rich and vibrant on camera.

Fezco

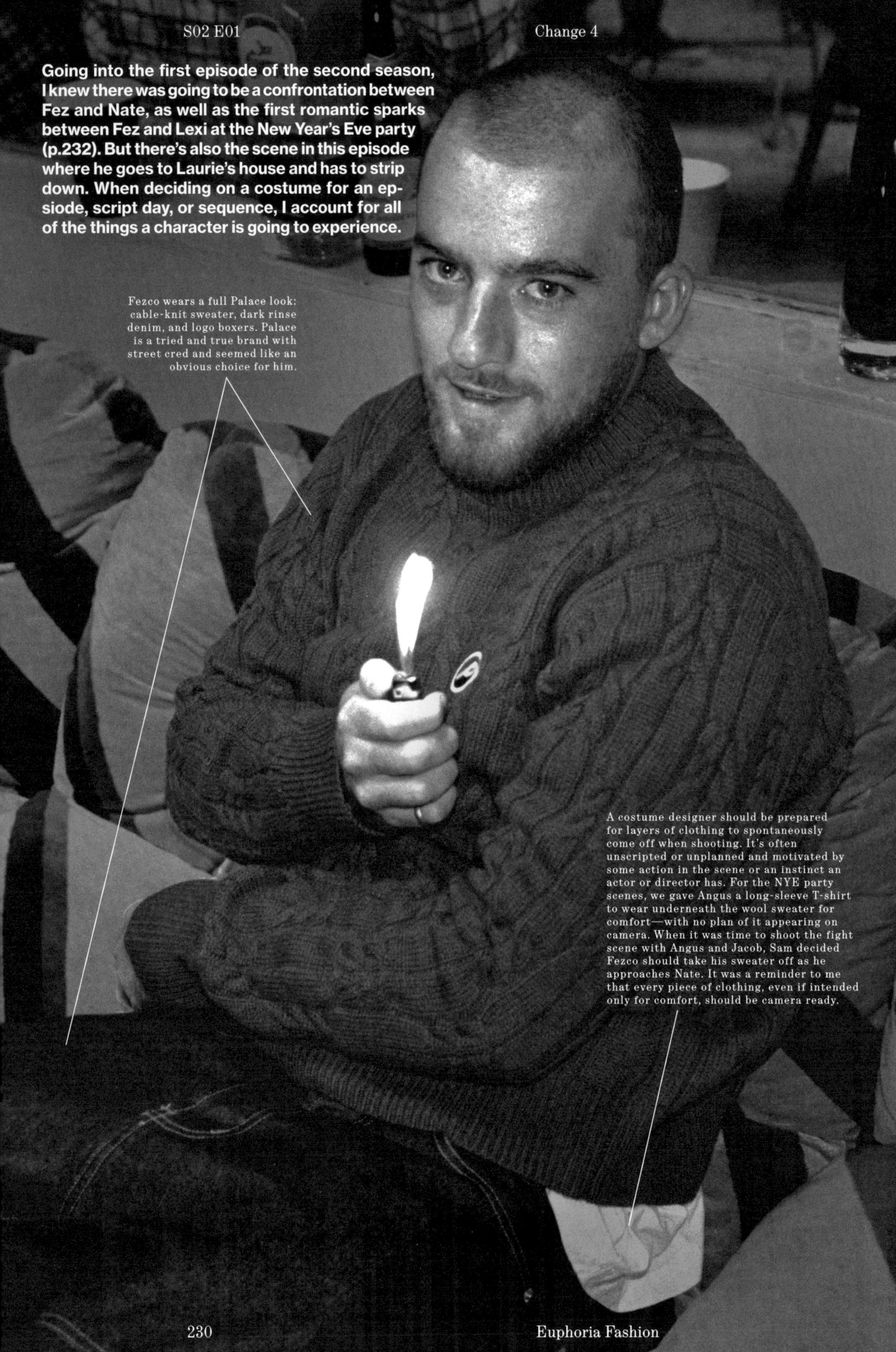

Going into the first episode of the second season, I knew there was going to be a confrontation between Fez and Nate, as well as the first romantic sparks between Fez and Lexi at the New Year's Eve party (p.232). But there's also the scene in this episode where he goes to Laurie's house and has to strip down. When deciding on a costume for an episode, script day, or sequence, I account for all of the things a character is going to experience.

Fezco wears a full Palace look: cable-knit sweater, dark rinse denim, and logo boxers. Palace is a tried and true brand with street cred and seemed like an obvious choice for him.

A costume designer should be prepared for layers of clothing to spontaneously come off when shooting. It's often unscripted or unplanned and motivated by some action in the scene or an instinct an actor or director has. For the NYE party scenes, we gave Angus a long-sleeve T-shirt to wear underneath the wool sweater for comfort—with no plan of it appearing on camera. When it was time to shoot the fight scene with Angus and Jacob, Sam decided Fezco should take his sweater off as he approaches Nate. It was a reminder to me that every piece of clothing, even if intended only for comfort, should be camera ready.

S02 E03 Change 2
S02 E08 Change 1

Fezco can be described as a disciple of Polo Ralph Lauren. I was inspired by the aesthetics of the Brooklyn crew called Lo Lifes, who created a lifestyle centered around their love of Polo in the late '80s and early '90s. Their motto, "love and loyalty," is one I imagine Fezco would subscribe to.

Fezco was dressing up to impress Lexi at her play (p.254), but I didn't want to put him in anything flashy — I just wanted him to look classic and handsome. There was some question around whether he should wear a tie. As an homage to one of the great directors I've had the pleasure of working with, David Lynch, I chose a white dress shirt buttoned to the top, sans tie. While shooting the scene where Fezco is getting ready, Sam decided he wanted Fezco to have the option to wear a tie, and the scene became improvised to include the action of Fezco questioning "tie or no tie?"

S02　　　　　　　　E01

"Trying to Get to Heaven Before They Close the Door"

New Year's Eve

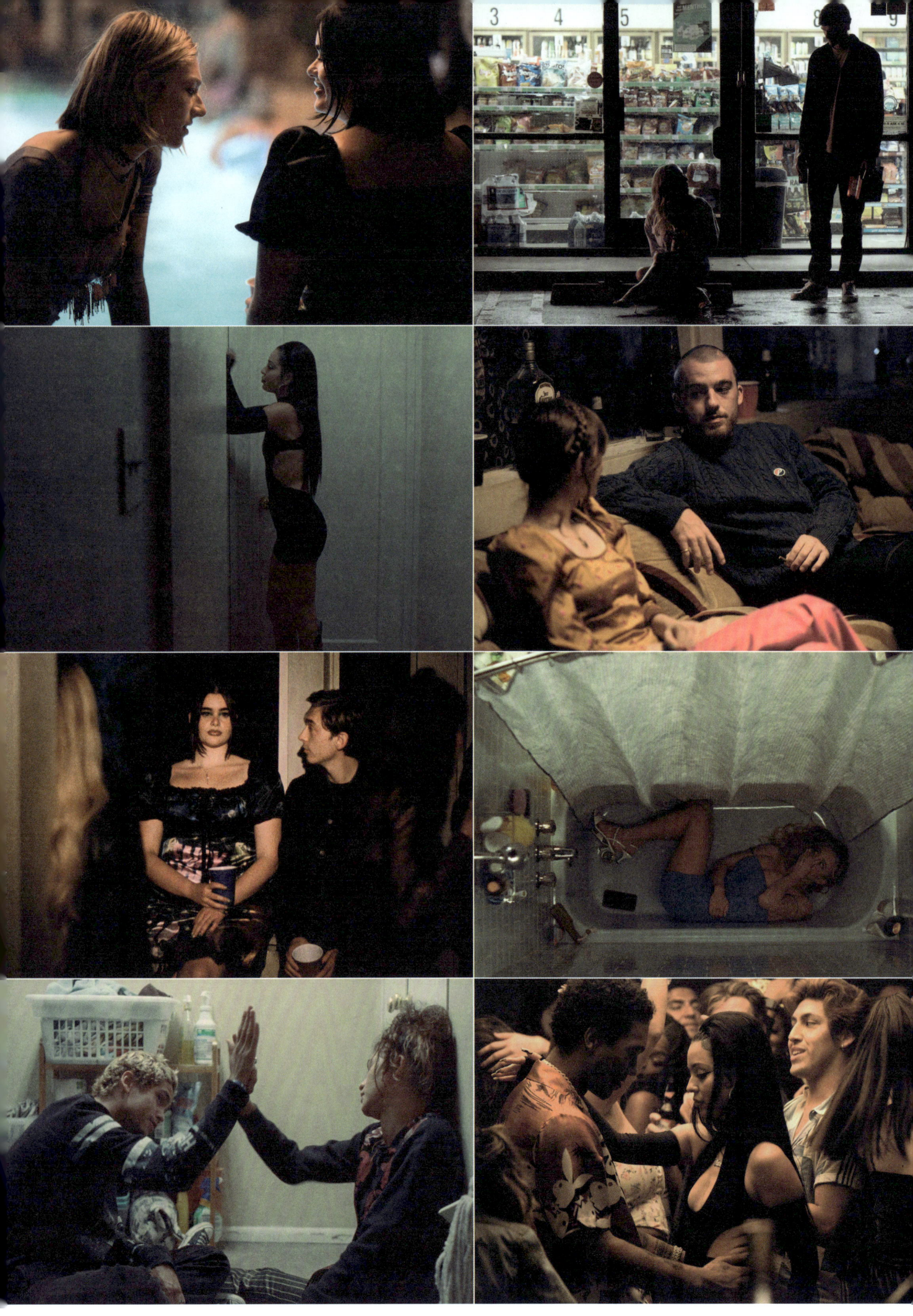

Euphoria Fashion

Jules, Kat, and Maddy arrive in a rush to a house party on New Year's Eve—and Maddy desperately needs to use the restroom. When a high Rue spots Jules across the room, she ducks away. On the way to the bathroom, Lexi asks Maddy if she's seen Cassie—they got in a fight on the way to the party, and Cassie got out of the car drunk in the middle of the road.

Nate spots Cassie sitting outside a convenience store and offers to give her a ride to the party. By the time they arrive, their flirtation has reached a boiling point. They head to the bathroom to hook up.

Maddy finally finds the bathroom and bangs on the locked door. When Nate responds, she realizes something is up and berates him for taking a "shit at a party." Cassie begins to cry, afraid of the consequences of their hookup, and Nate tries to calm her down. He eventually opens the door and tries to pull Maddy away, but she insists on going in, where Cassie is hiding in the bathtub behind the shower curtain.

Lexi gives up her search for Cassie and sits on the sofa next to Fezco, whose easy chatter turns flirtatious. Rue escapes the party and climbs into the back of a parked car. She finds an Altoids box with drugs and returns to the party to get high. She finds the laundry room, where Elliot, a stranger, is snorting powder. She joins him, and the two become fast friends.

Travis, another stranger, waits for Maddy outside the bathroom, and when she tries to leave he pulls her back in to smoke a blunt. Cassie remains hidden—and increasingly anxious—while the two flirt. Outside, Nate eyes the door.

Back in the laundry room, Rue almost overdoses. Elliot saves her by crushing up the Adderall stashed in her sock. Cassie escapes the bathroom and wanders into the party, where McKay pulls her aside to talk. She tells him she doesn't think she's a good person, and they break up. Jules, who's been searching for Rue, spots her smoking weed outside by the bonfire, and they awkwardly reunite. When Jules asks her when she relapsed, Rue says, "The night you left."

A minute before the clock strikes midnight, Fezco gets Lexi's number and then calls Ashtray to get the car ready. As he takes off his sweater, Lexi realizes what's about to happen. Rue returns to the party to apologize to Jules, saying she missed her and wants to be together. They kiss.

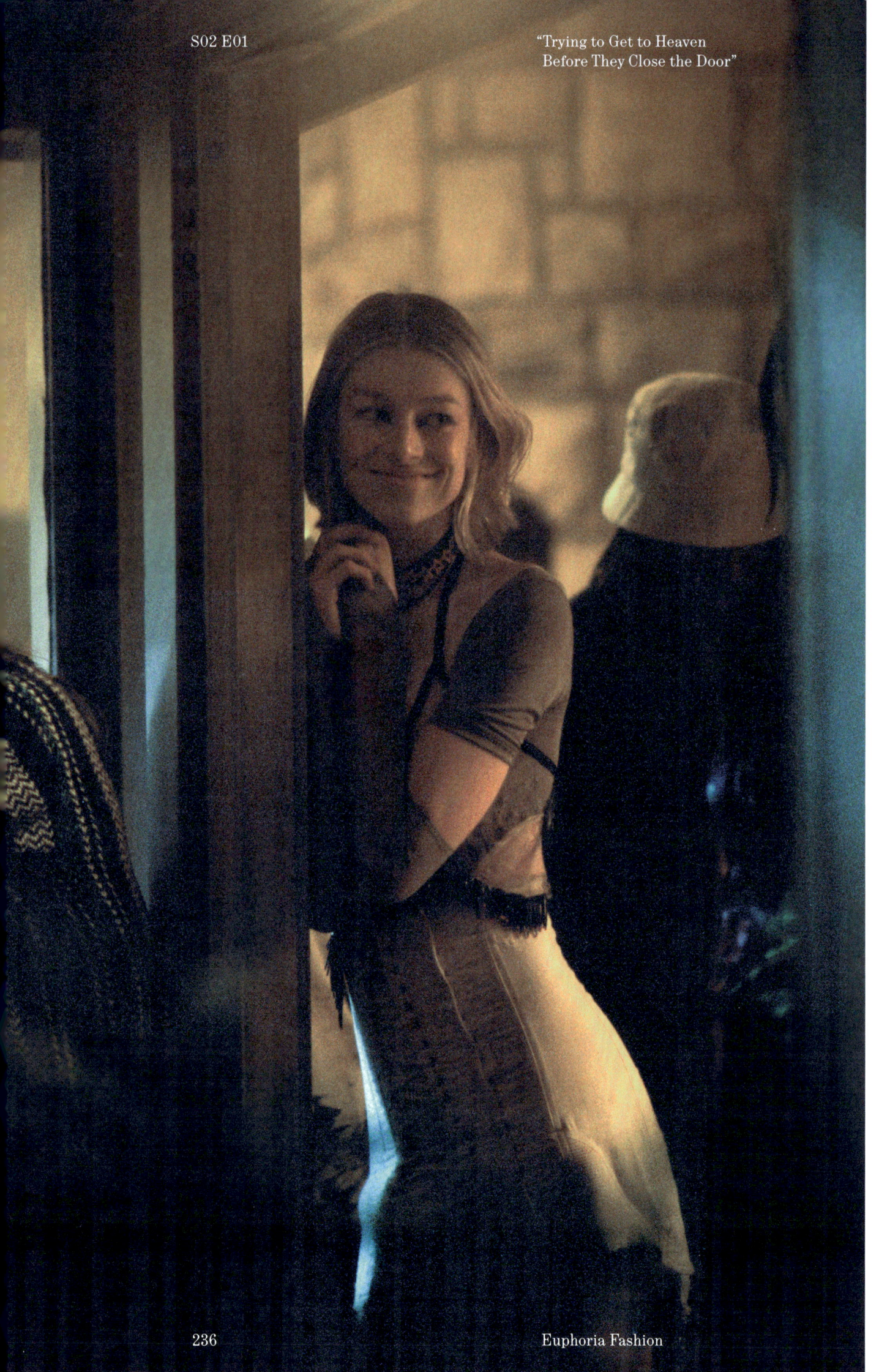

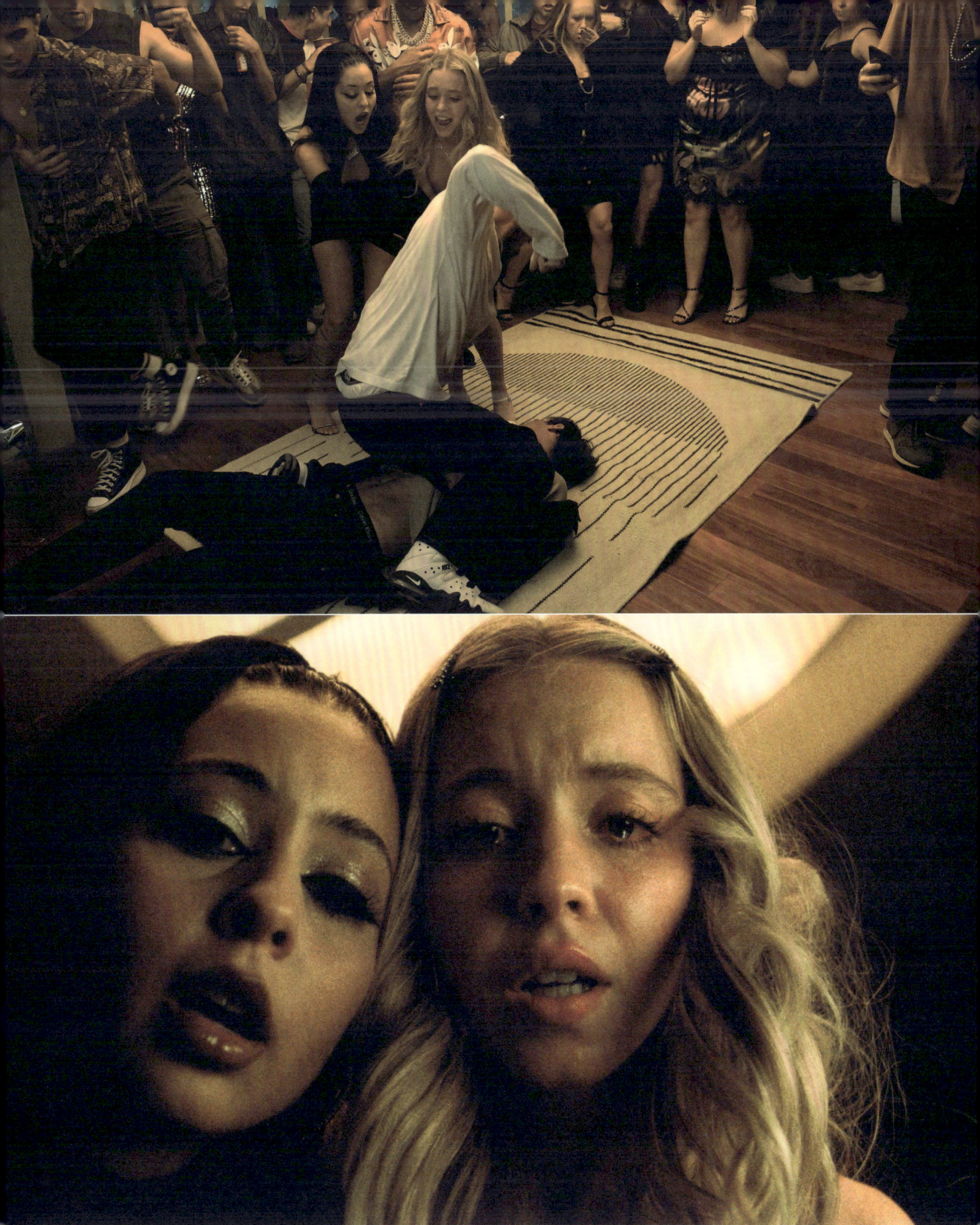

After the countdown, Fezco strikes up a conversation with Nate, who says, "Last time we talked, didn't you say you wanted to kill me?" Fezco responds, "It's a new year, playboy," tipping his glass for a toast with one hand while he smashes a bottle over Nate's head with the other. Before leaving the party, Fezco punches Nate on the ground until he is bloody and unconscious.

VIII. LEXI

"I feel like I've lived most of my life in my imagination, taking the smallest moments and dreaming them up into something bigger." —Lexi Howard

Lexi is thoughtful and caring, nurturing those around her and supporting her family and friends to a point where her own needs are often neglected. In her early development, as a reaction to the turmoil at home, she found cinema, poetry, and literature as means of escapism. An intellectual amongst her peers, she's not caught up in the superficial trappings of social media and fashion. Her approach to her personal style is more inspired by characters in her favorite books and films than the latest trends. Her cultural references transcend the Gen Z high school experience, like her studied choice of Halloween costume: Bob Ross, the educational landscape painter whose show aired on PBS from 1983–1994 (**p.164, 242**). While some girls use the holiday as an opportunity to dress up as a sexy, barely clothed character, Lexi chooses to dress as a somewhat obscure male television personality, complete with big hair and beard.

In her daily life, Lexi gravitates toward classic, timeless silhouettes in jewel tones and autumnal colors. Although she's a wallflower in earlier episodes, by Season Two she's ready to fully bloom, and her New Year's Eve party look in bright saffron and magenta is a visual signal of what's to come (**p.234, 244**). Though she is conservative by nature, we see her explore new, exciting aspects of her personality as she begins to unabashedly put herself first. When we reach the climax of Season Two, it's showtime for Lexi—no longer is she willing to wait in the wings. With the advent of her school play, *Our Life* (**p.254**), we see Lexi as a brazen young woman unafraid to speak brutal truths.

S02 E01 Change 1

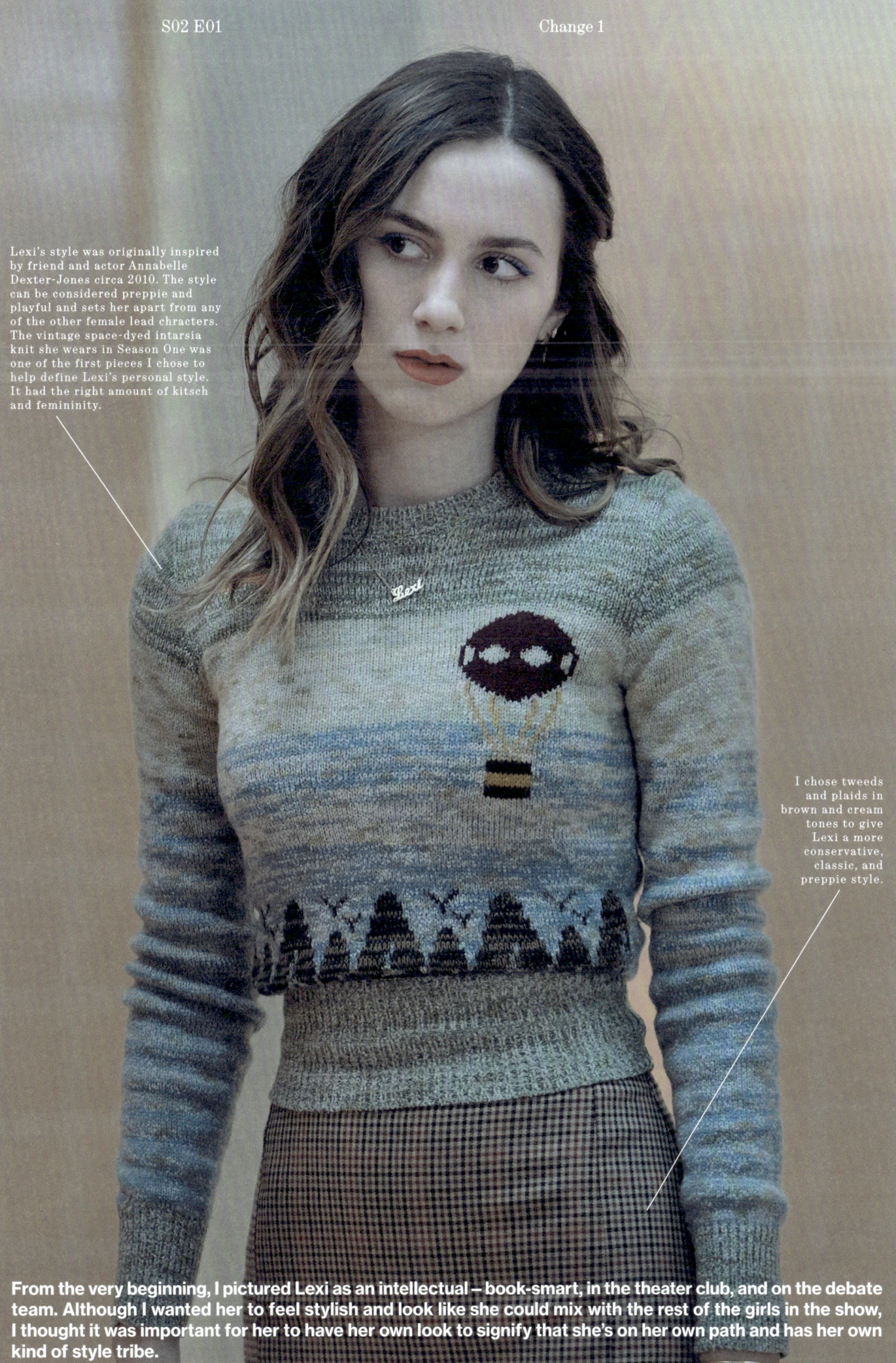

Lexi's style was originally inspired by friend and actor Annabelle Dexter-Jones circa 2010. The style can be considered preppie and playful and sets her apart from any of the other female lead chracters. The vintage space-dyed intarsia knit she wears in Season One was one of the first pieces I chose to help define Lexi's personal style. It had the right amount of kitsch and femininity.

I chose tweeds and plaids in brown and cream tones to give Lexi a more conservative, classic, and preppie style.

From the very beginning, I pictured Lexi as an intellectual – book-smart, in the theater club, and on the debate team. Although I wanted her to feel stylish and look like she could mix with the rest of the girls in the show, I thought it was important for her to have her own look to signify that she's on her own path and has her own kind of style tribe.

This is one of those Halloween costumes (p.164) that left some of the cast wondering if anyone would recognize who she's dressed up as. I'm guessing a lot of the audience came to know Bob Ross based on this costume in the show, but I grew up watching him on PBS. Sam Levinson, being of a similar age, understood him as a memorable icon of public television and that it would be a quick reference for an adult audience. Maude was totally game. The costume choice reinforces the fact that Lexi is doing her own thing. When she opens the door to the girls at the house and they ask who she's supposed to be, it's clear in her response that she's surprised they don't know.

In the beginning, we didn't know if she would have the full beard, but in choosing the pieces for this costume, it was just a question of what would be the quick read for "Bob" while still creating a silhouette that felt somewhat attractive for Lexi.

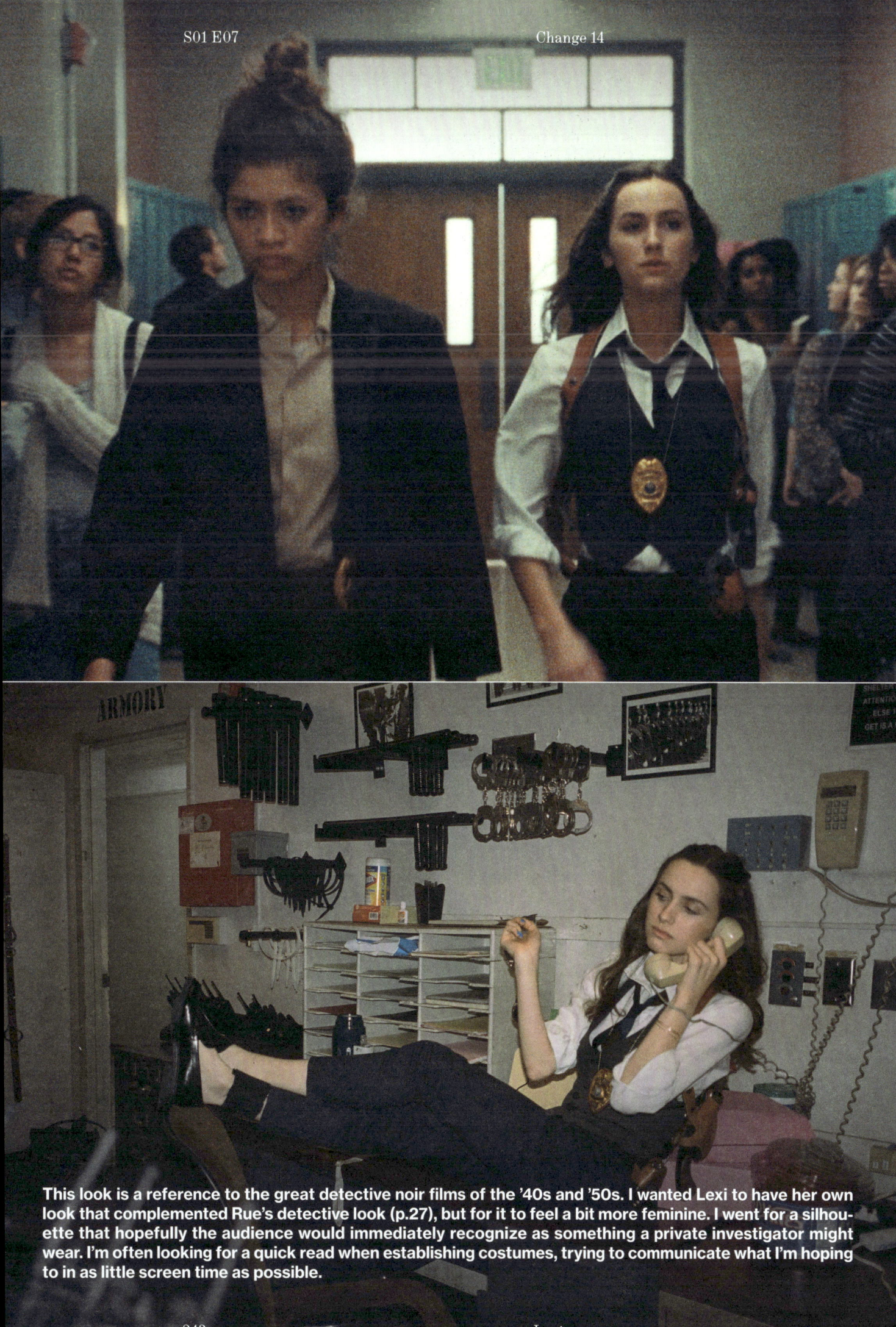

This look is a reference to the great detective noir films of the '40s and '50s. I wanted Lexi to have her own look that complemented Rue's detective look (p.27), but for it to feel a bit more feminine. I went for a silhouette that hopefully the audience would immediately recognize as something a private investigator might wear. I'm often looking for a quick read when establishing costumes, trying to communicate what I'm hoping to in as little screen time as possible.

Knowing that Lexi was going to have a more fulfilling character arc in the second season, it was important to give the audience an indicator that something surprising for her was coming. I started the season at the New Year's Eve party (p.232) by using bright fabrics and silhouettes that felt more exciting for Lexi than what we'd seen her in previously.

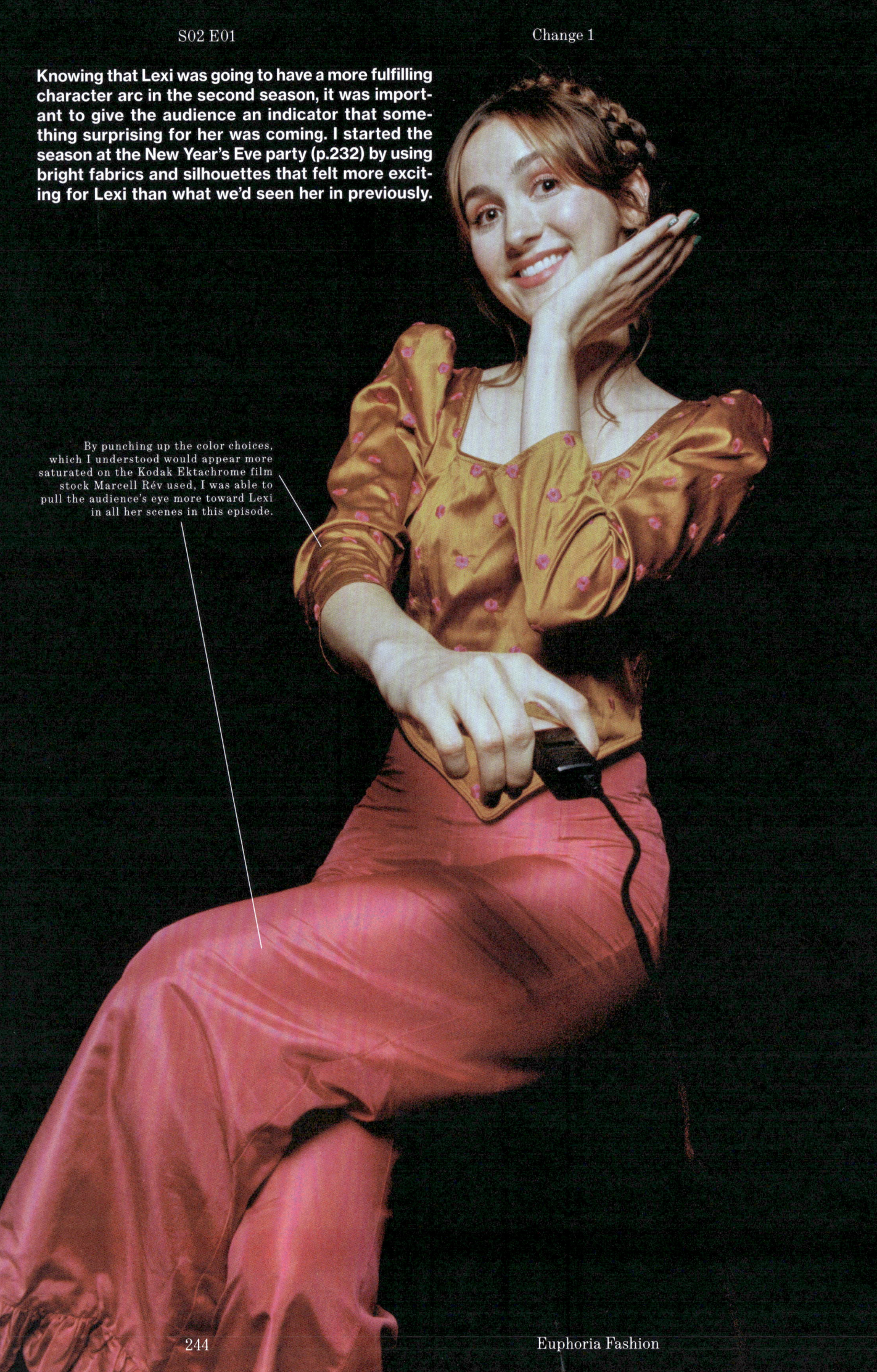

By punching up the color choices, which I understood would appear more saturated on the Kodak Ektachrome film stock Marcell Rév used, I was able to pull the audience's eye more toward Lexi in all her scenes in this episode.

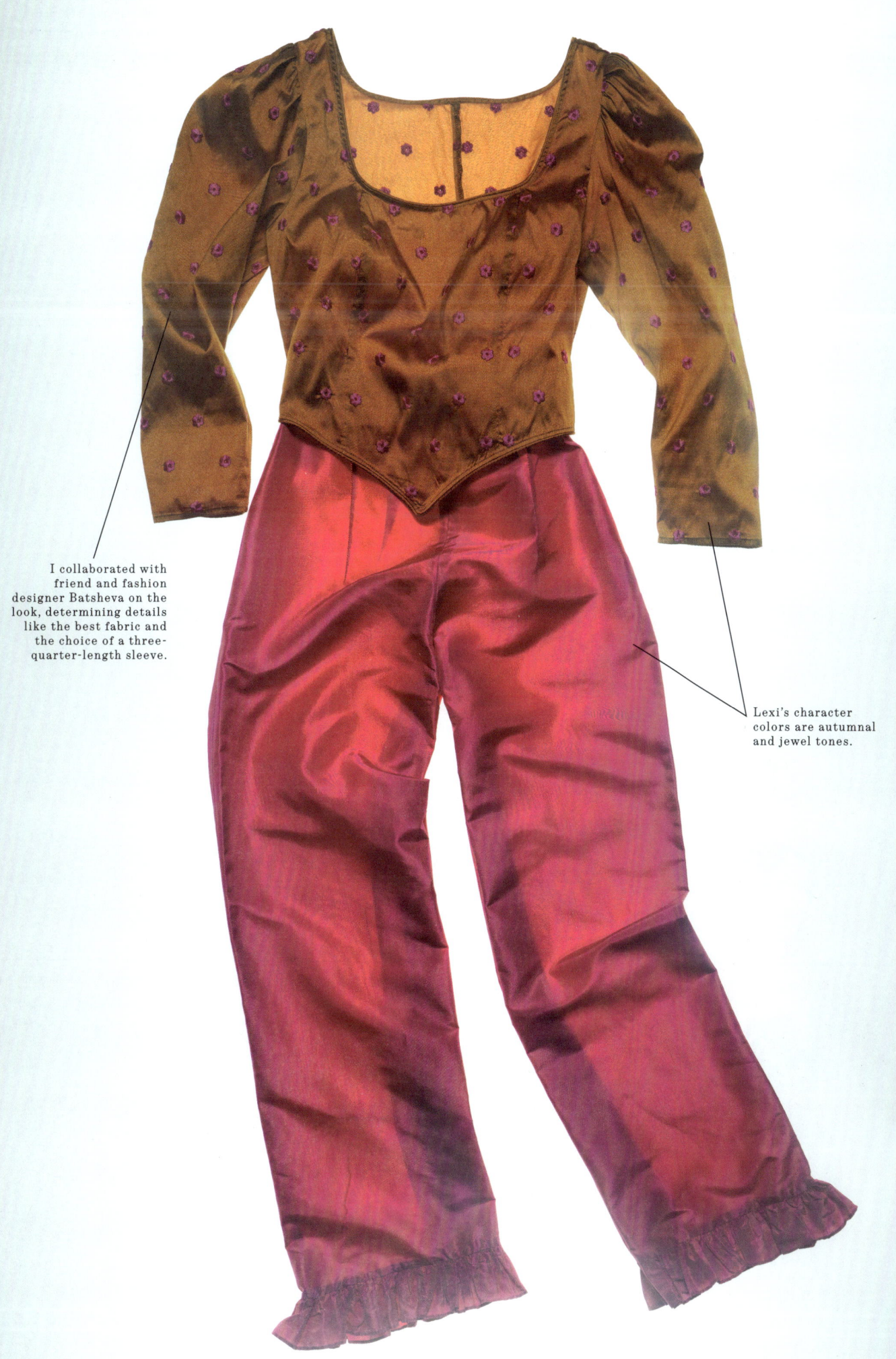

I collaborated with friend and fashion designer Batsheva on the look, determining details like the best fabric and the choice of a three-quarter-length sleeve.

Lexi's character colors are autumnal and jewel tones.

S02 E02 — Change 4

One of the challenges of costume designing *Euphoria* came when I was given change breakdowns for each character per episode, and I realized I had more exciting options in their closets than they had scripted changes. Some characters had more changes than others, as did Lexi for Season Two, which gave me a great opportunity to explore more of who she is and develop her personal style.

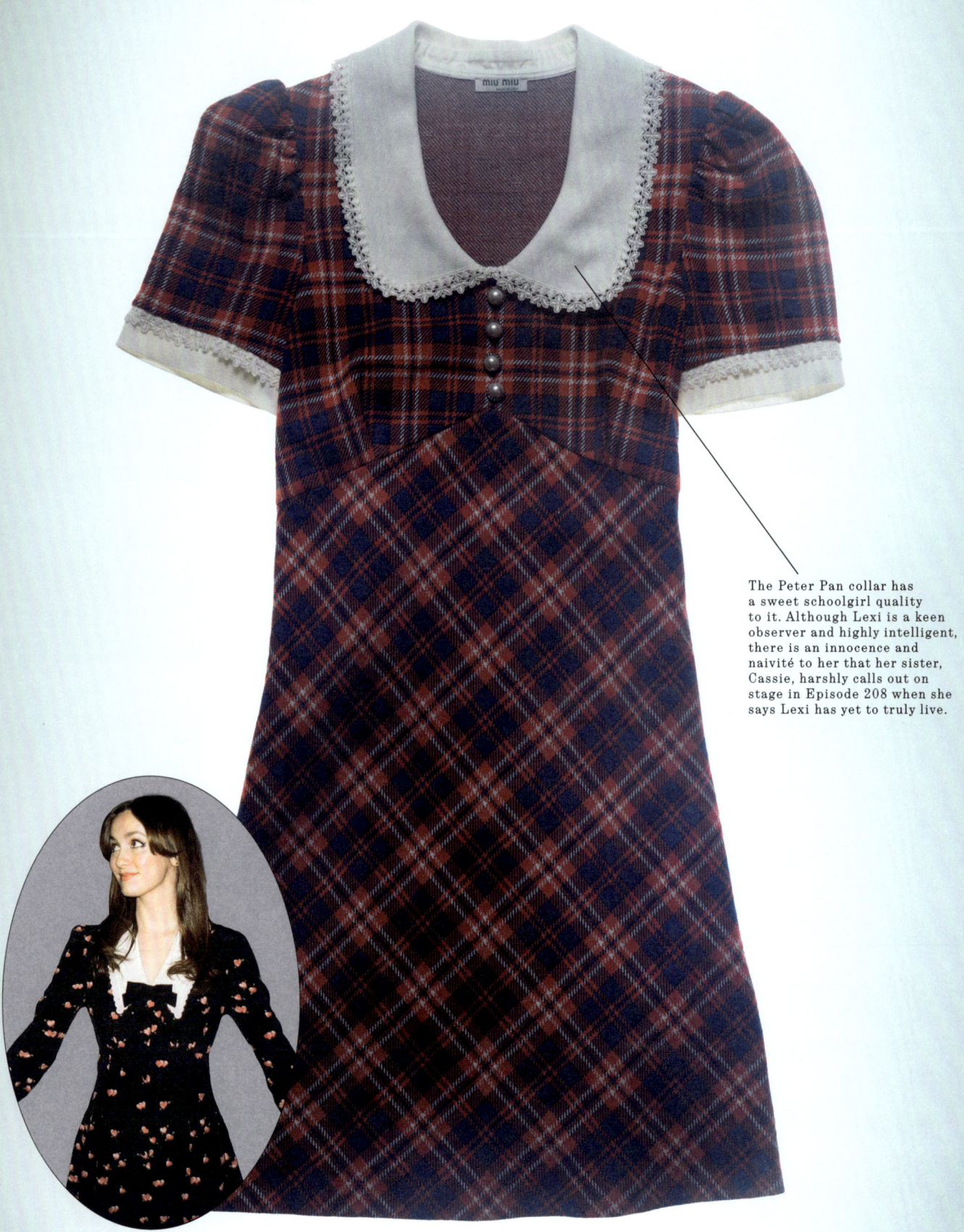

The Peter Pan collar has a sweet schoolgirl quality to it. Although Lexi is a keen observer and highly intelligent, there is an innocence and naïveté to her that her sister, Cassie, harshly calls out on stage in Episode 208 when she says Lexi has yet to truly live.

Featuring Lexi in Miu Miu looks for Season Two was abandoning one of the rules I had set up for Season One: that all the characters should be able to afford the clothes they wear. I decided to forgo reality for visual impact.

S02 E03 Change 1
 Change 2

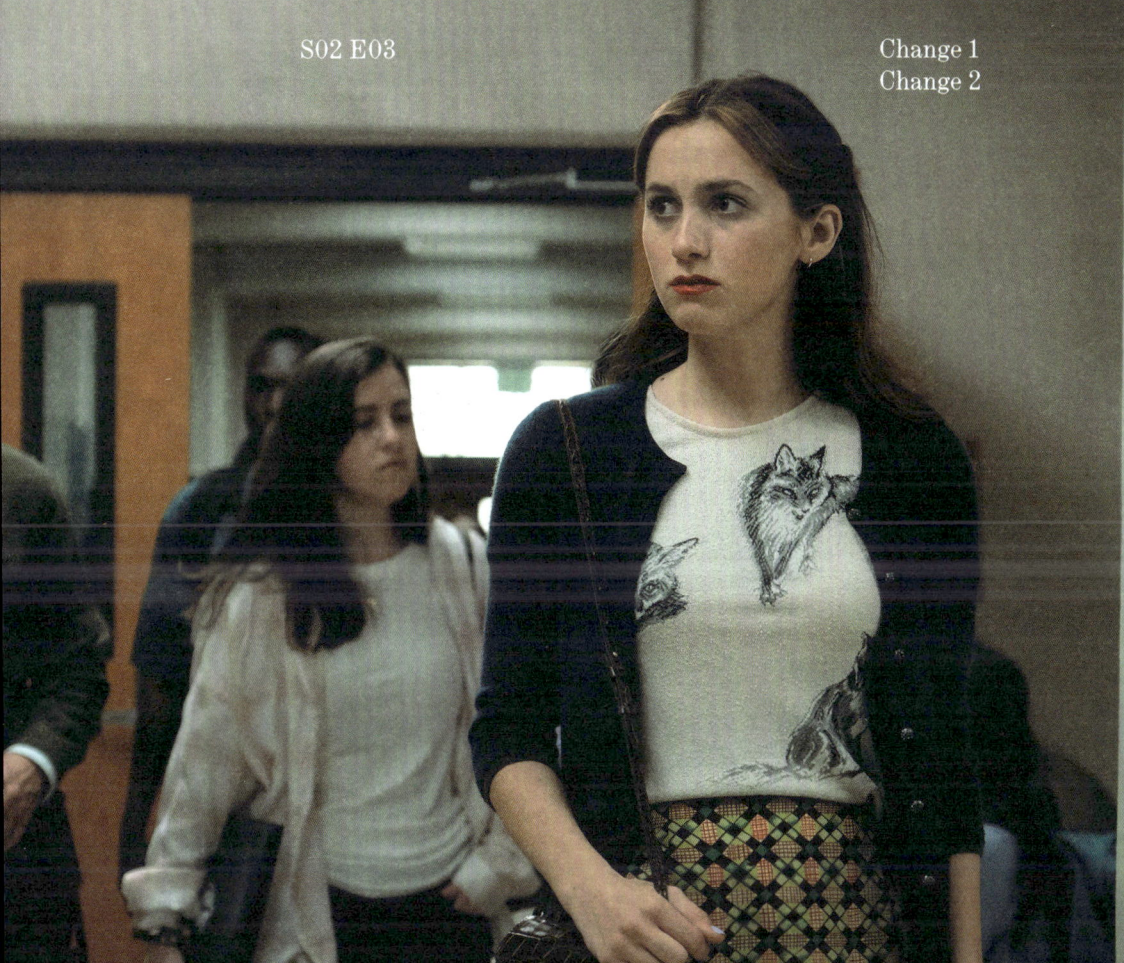

I love this outfit on Lexi: a Celine knit top with illustrations of foxes, vintage cashmere Ron Herman cardigan (which she also wore to the winter formal [p.212]), vintage skirt from Fox Costumes and Wardrobe, cork platform lace-up Miu Miu wedges, and By Far purse.

Cottagecore was a popular trend at the time of shooting, and out of all the characters on *Euphoria* Lexi was the only one whose style could borrow a bit from that aesthetic. We touched on it but tried not to rely too heavily on it for inspiration.

The blouse is Miu Miu — very sweet and in Lexi's wheelhouse with the Peter Pan collar. I love to pick wardrobe for characters in a way that people would dress themselves in real life. Some have a tendency to choose the same style of clothing over and over again — whether it's a favorite color or a detail like a collar. These choices make up personal style. The Peter Pan collar became one of Lexi's signature details in Season Two.

S02 E03 — Change 1

When deciding on Lexi's look for her visit to Fezco's convenience store, I wanted to keep with her book-smart vibe, but also show her body in a way that didn't look like she was hiding it. She has a bold lip here too, which also signifies that she's feeling confident and curious about Fezco. The top is a knit silk that clings to the body and reflects light, revealing her silhouette.

Sam wanted the students who play our main characters (Rue, Maddy, Lexi, Cassie, Kat) in the funeral scene in Lexi's play (p.254) to wear the exact same clothing as our main characters do in the flashback. Because Lexi plays herself in the staged play, it was important to pick a silhouette and a style of dress for her that felt like a throwback to what she would have worn to the real funeral for Rue's dad, while also feeling modern enough that it didn't look out of place on her in the present day. While the story weaves in and out of real life, memory, and fantasy, the costumes in the play offered an opportunity to explore what all these complex and overlapping ideas mean for Lexi and the audience.

HIGH CAMP AT "EUPHORIA HIGH"

José Criales-Unzueta

To talk about Camp is to betray it, Susan Sontag declared in her seminal essay "Notes on 'Camp.'" That was in 1964, and now, nearly five decades later, millennials and the core of Gen Z are engaged in an endless stream of conversations and (mis)definitions around the elusive sensibility of Camp, often equating it to kitsch or queer flamboyance. Most of these conversations happen URL (TikTok, Twitter), where fashion and costume serve as aesthetic codes and subcultural identifiers. With its rich variety of queer-coded characters, storylines, and cultural references, HBO's *Euphoria* has, perhaps inadvertently, found itself as a prominent exemplar of Camp in the mainstream. More than anything, it's in the costumes that the show strikes the Camp chord, where *Euphoria* has both transformed and become a mirror for youth culture.

With endless strains of hyper-micro microtrends, Gen Z finds the self through performing a subculture, through style as costume. *Euphoria*'s characters, too, craft their identities through play and performance of the self, via their clothing. The same way Cassie fashions herself as Maddy in order to channel her confidence (**p.207**), a teenager on TikTok looks to cottagecore or gorpcore as guideposts for attaining some semblance of self-actualization.

(01) A moment wreathed in pom poms and played for laughs as the friendship of "Marta" and "Hallie" takes on new dimensions, Episode 207.

Euphoria itself is not Camp—far from it—but many of its moving parts stem from Camp culture.[01] Camp is joyous and humorous, often ridiculous. *Euphoria* is not quite comedic, but it's queer-coded in its sensibility. There's a dichotomy that rests in a balance between the darkness and intensity of its subject matter and the playfulness of its characters. If Camp in Sontag's time was an underground queer code (i.e. if you know you know), what *Euphoria* underscores is that Camp today is not a sensibility, but an open-ended aesthetic tool for self-discovery.

While the tone of the show isn't capital-C Camp, this is precisely what the conversation around *Euphoria*

unlocks. As a new episode rolls out, a heated Twitter debate or a new TikTok trend emerges. The best example is Maddy, whose sartorial aesthetic(02) and one-liners have become instant icons of the URL canon. While viral moments, like her delivery of "Bitch, you better be joking," or "This bitch needs to be put down," are now integral parts of internet lingo, her aesthetic is the most notable example of *Euphoria*'s role as a subcultural barometer.

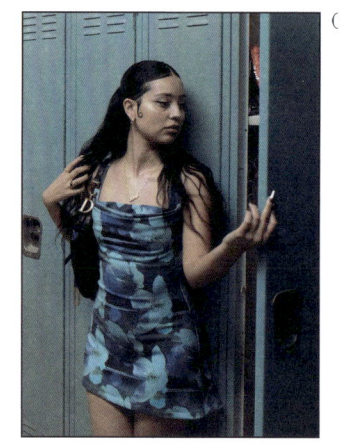

Maddy, ever the doyenne of "Euphoria High," even manages to match her dress to the East Highland lockers, Episode 203.

Last year, an image of Maddy in the hallways of the internet-dubbed "Euphoria High" started a viral online debate over what exactly students were doing there, all based on her ensemble (more "going out" than "ready for math class"). It quickly evolved into a viral fashion meme,(03) with people dressing up in their skimpiest Maddy-esque outfits on their way to "Euphoria High." Often, the meme was propelled by queer masc folks, and as they continued to dress up for "class," the conversation around identity and queerness on and off the show gained traction. It became clear that *Euphoria*'s unique aesthetic serves as a trigger for playful self exploration. The look itself is not the point, but the way it's used to build a character—to create a "self"—is.

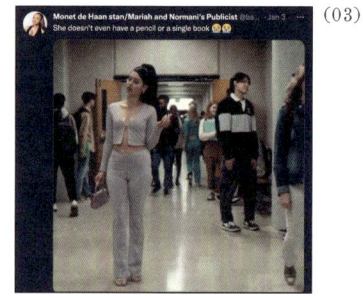

"She doesn't even have a pencil or a single book."

Take Cassie's fantasy-driven cosplay. She rises early each morning to maniacally perfect her costume (and role) for the day(04) with increasingly flamboyant looks. From her inadvertent "auditioning for *Oklahoma!*" moment (**p.208**) to dressing up as her best frenemy, Maddy (**p.207**), there's a consistent exploration of self and identity through her playful forays into costume-as-character. Cassie leans fully into artifice and into the Sontagian concept of *Being-as-Playing-a-Role*, which is not only the core of performance, but a queer act of play—and high Camp by definition. In the online conversation surrounding her character, viewers question both her actions and her motives. We have all fashioned ourselves as others in order to find confidence or truer senses of ourselves. The phrase "Dress for

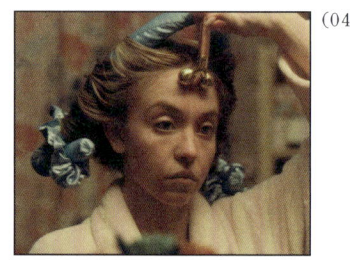

Cassie maniacally perfecting her daily look with a pre-dawn facial contouring session, Episode 203.

Behind the scenes with Rue and Jules as Jack Twist and Ennis Del Mar from *Brokeback Mountain*, Lover's Montage, Episode 204.

Nate quietly dying inside while watching a caricature of himself on stage in Lexi's play, Episode 207.

the life you want" is a cliché, but like all clichés it's rooted in a deeper truth.

Being-as-Playing-a-Role is an extension of life as performance. In the Lover's Montage (**p.52**), Rue and Jules embody cultural iconography from *Brokeback Mountain*[05] to René Magritte's *The Lovers II*. Later, at the end of the season, Lexi stages her play (**p.254**) by casting look-alikes as her friends. This is *Euphoria* at its campiest: holding a mirror to the characters through comedy. Ethan's performance as Nate, dancing to Bonnie Tyler's "Holding Out for a Hero," is a richly layered exploration of identity. He is performing both as Nate and as an uber-masculine version of himself, while Nate himself watches the homoerotic display, provoked to question his own identity.[06] How do you lean so far into masculinity that you end up in the queerness that it rejects? The answer is Camp (and Ethan's *Rocky Horror Picture Show* golden lamé briefs don't hurt).

Euphoria has managed to resonate with youth culture through its tendency to both reference and talk back to it. The show's subtle and overt queerness has resonated with an online conversation prevalent both IRL and URL: what happens to queerness when it transitions from underground subculture to the mainstream? Through the use of Camp in its fashion and costuming, the show has managed to provide a nuanced answer.

Queerness does not fade with mainstream acceptance; it transmutes. While Gen Z may not need Camp as an underground code, it still relies on it to craft identity. The more mainstream queerness becomes, the more overt Camp becomes to distance the self from the norm. Just as Kat chooses to wear harnesses and latex to perform her new self, or Cassie fashions herself as the person she wants to embody, Gen Z finds empowerment in overtly performing identity. As shown by *Euphoria* and its effect in pop culture, Camp is, and has been, the chosen vehicle to both find and express identity.

S02 E07
E08

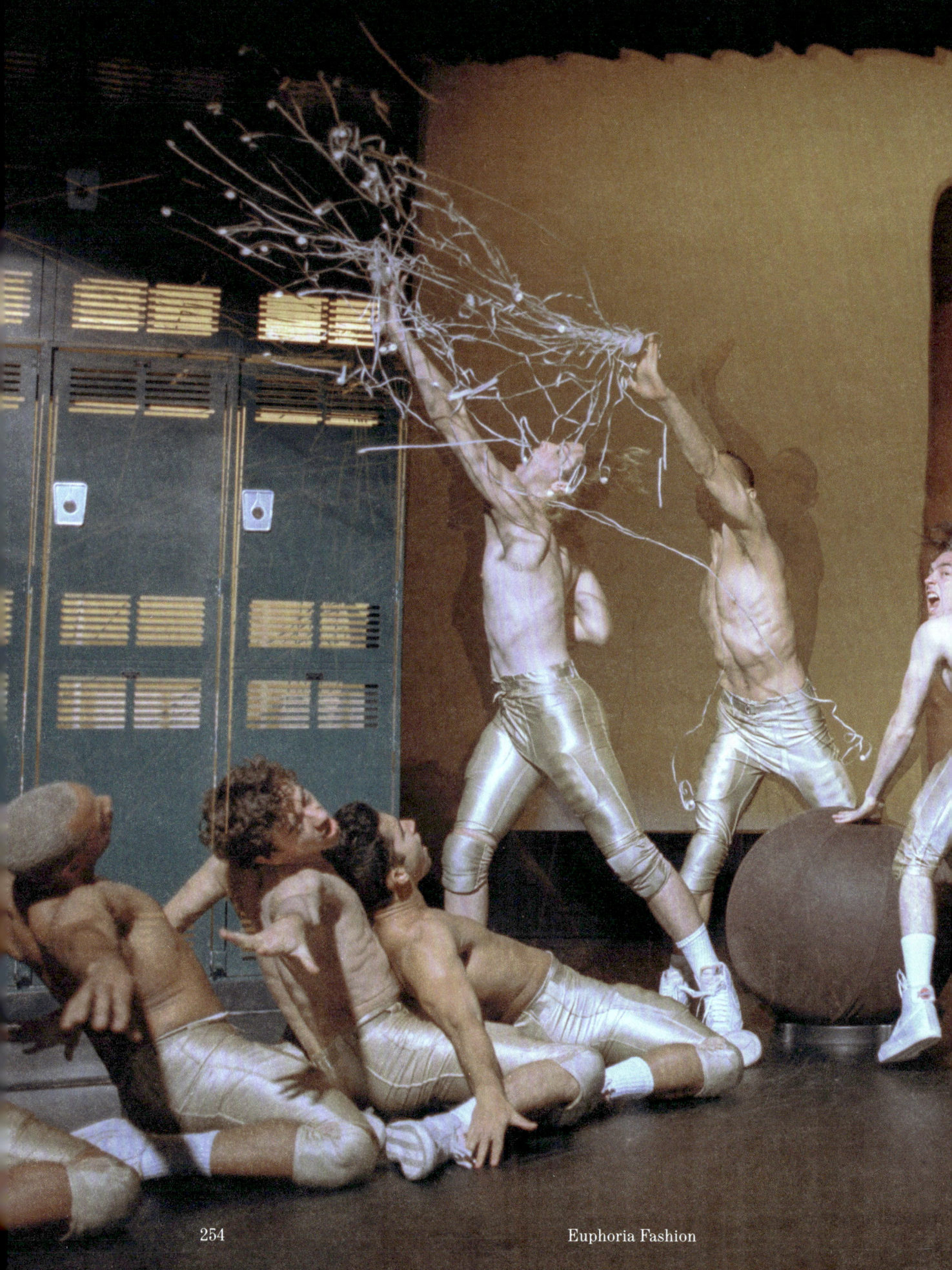

"The Theater and Its Double"
"All My Life, My Heart Has Yearned for a Thing I Cannot Name"

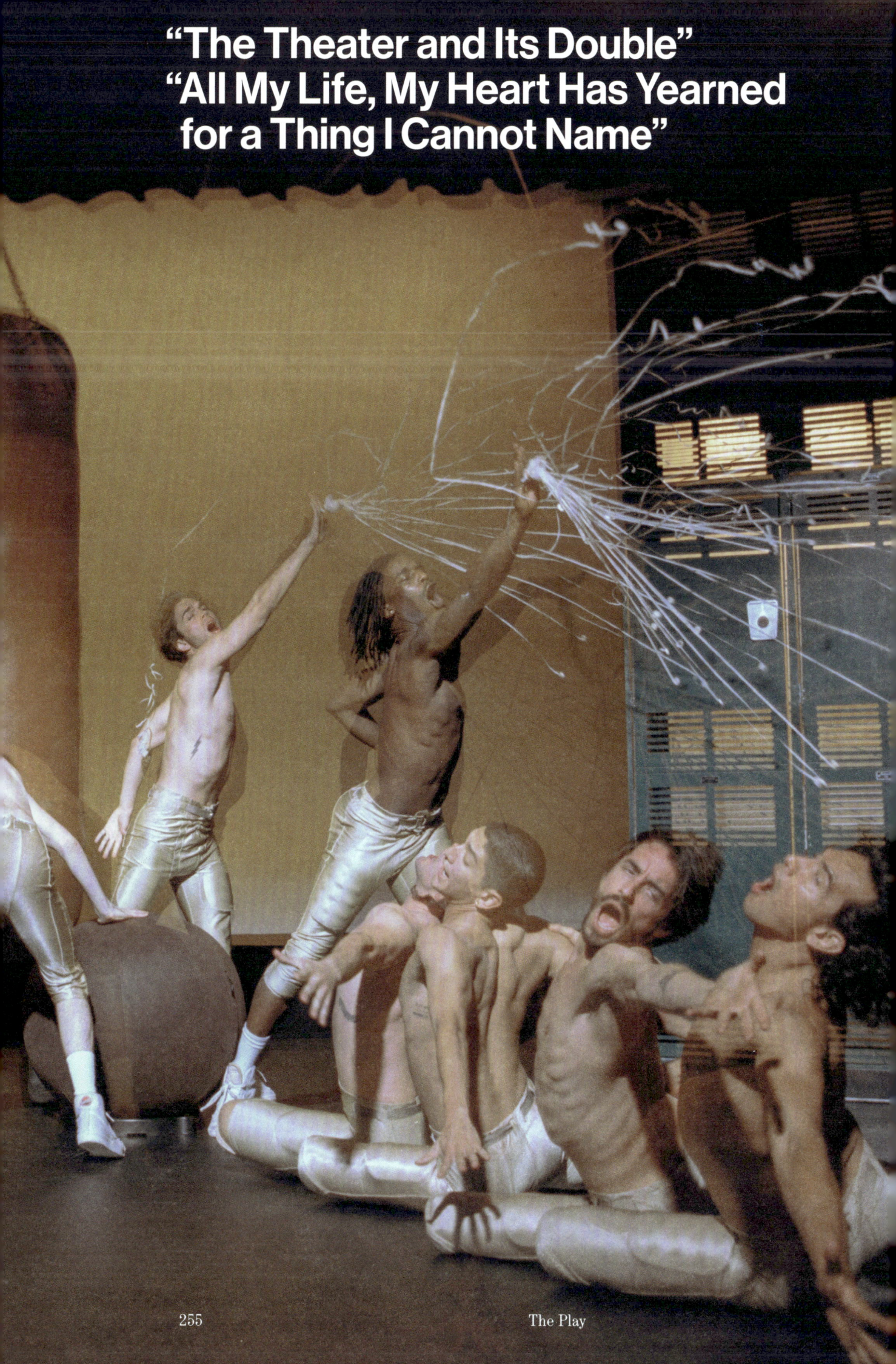

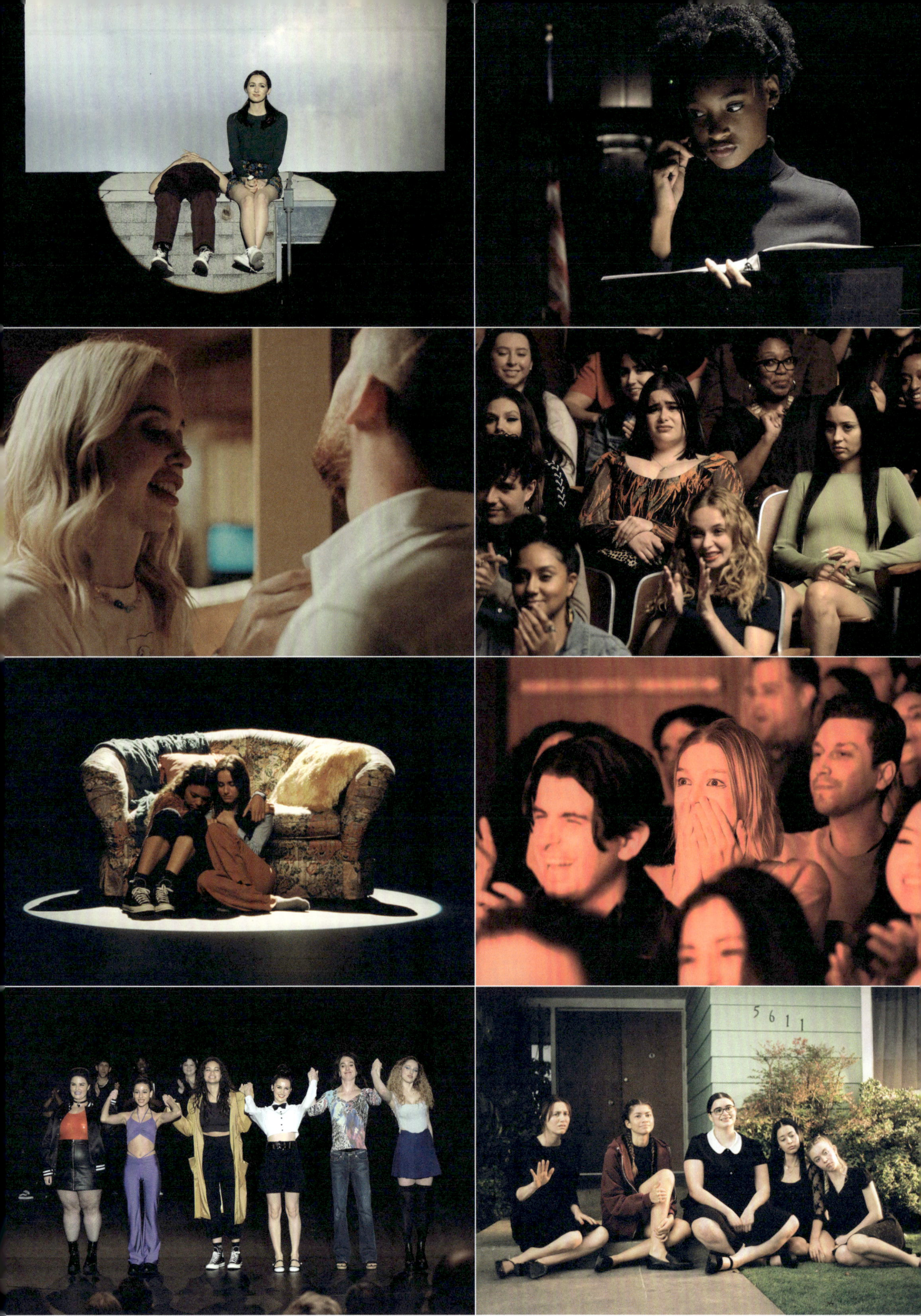

| S02 E07 | "The Theater and Its Double" |
| S02 E08 | "All My Life, My Heart Has Yearned for a Thing I Cannot Name" |

Finally, we get to see *Our Life*, the play Lexi has written and directed over the course of the season. *Our Life* follows the friendship of five girls who are avatars of Lexi's inner circle: Grace (Lexi), her sister Hallie (Cassie), her best friend Marta (Maddy), Marta's best friend Luna (Kat), and Grace's best friend Jade (Rue).

In the opening scene, a 13-year-old Grace tries to comfort Jade at her father's memorial. "I knew Jade had been doing drugs, but it wasn't until that day, at her dad's memorial, that I realized they were a greater comfort than I could ever be," Grace narrates to the full auditorium of East Highland High.

Rue takes in the play alone, stealing glances at Jules, who she hasn't spoken to since the intervention. There's only one open seat—the best seat in the house—which Lexi has saved for Fezco. Back at his place, Fezco is anxiously preparing to leave for the play. As Faye helps to press his shirt, Custer, Faye's drug dealer boyfriend, arrives unexpectedly, and Faye can tell something is off. Ashtray surreptitiously grabs a knife.

"Jake and Marta's relationship was our first impression of love," Grace tells the audience. Jake, the avatar for Nate, wraps Marta in a fur coat and says no one will ever love her as much as he does. In the next scene, an over-the-top musical number set to the 1984 song "Holding Out For a Hero," Jake leads a group of football players in a pumping, thrusting, locker-room workout. While the audience whoops in delight, Nate storms out with Cassie trailing after him. He shakes her off and tells her to pack her things and move out of his house, where she's been staying.

Cassie, alone now and with nothing to lose, returns to an auditorium still cheering for Jake's campy workout sequence. With a dead-eyed, unhinged look on her face, she walks down onto the stage, slow-clapping the whole way. Suze tries to intervene, but Cassie charges on, provoking a petrified Lexi by asking, "Is this the part of the play where I steal Jake from Marta?" From an audience unsure how to react to the interruption, Maddy jumps up and calls her a "two-faced cunt." As Suze talks Cassie down, the play picks back up with the carnival scene where Hallie gyrates on a carousel horse.

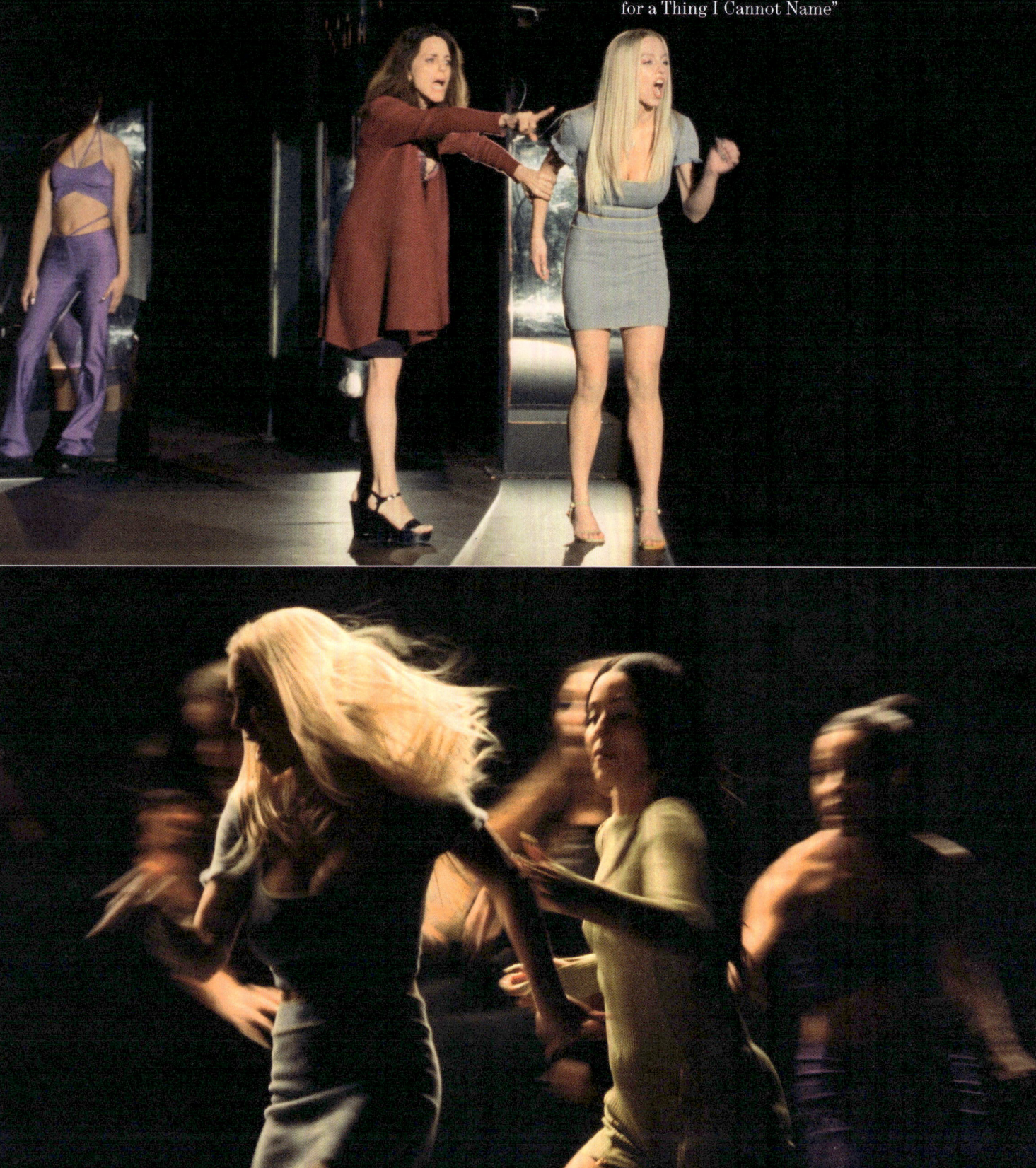

Cassie loses it and pulls the actor off the horse. Maddy turns to Kat and says, "Oh this bitch needs to be put down," and rushes the stage with Kat and BB behind her. Maddy grabs Cassie, slaps her, and chases her offstage.

Lexi, in tears backstage, debates what to do next. Bobbi, the stage manager, reminds her that "Art should be dangerous." The show must go on.

Fezco is about to leave his house when Custer reveals that the cops found Mouse's body. Suspecting that Custer might be bugged, Faye silently signals to Fezco to keep quiet. As Custer tries to implicate Fezco in the murder, Ashtray stabs him in the neck. Fezco's plans to attend Lexi's play are dashed. The ensuing police raid escalates the violence as Fezco tries to protect Ashtray from the cops.

S02 E07
S02 E08

"The Theater and Its Double"
"All My Life, My Heart Has Yearned
for a Thing I Cannot Name"

MEMES, MOODS, AND MIU MIU ERAS

Biz Sherbert

(01)

Wearing a recurring brand for the character throughout Season Two, Lexi appears in Miu Miu, Episode 203.

(02)

"The service dog at Euphoria High."

(03)

Cassie emerges from hiding from Maddy in the bathtub, Episode 201.

Every Sunday night during the rollout of *Euphoria*, Season Two, I lie in my bed and scroll through hot takes of the latest episode. The take-makers call to me like screen sirens, promising to reveal the hidden meaning behind Cassie's color palette, explaining why it matters that Nate's only wearing black and navy shirts this season, or asking me to really think about how the fuck Lexi Howard can afford to wear Miu Miu to high school.(01) I watch the TikToks, I read the Tweets, I tap through the Stories, and I arrive at next week's episode equipped with shiny, fragile insights around the symbolism of the costumes on screen. Some of this content stream is chopped and screwed from cast and crew interviews, but it all feels much more urgent and conspiratorial, and honestly on-brand for the Gen Z-ness of it all, when fun is fact-ified and delivered by a random on TikTok, their pupils reflecting the circular glow of a ring light.

The *Euphoria* costume memes hit even quicker, spawning across social media before the episode credits have time to roll.(02) Even if a meme isn't specifically about what the characters are wearing, it always is, in a way. A still of Cassie hiding from Maddy in a bathtub wouldn't be as funny without the contrast between the dingy shower curtain and Cassie's carefully selected blue ruched mini dress and white patent leather heels (**p.204**).(03) There's a forever-joke online that real-life teenagers at a real-life American high school would never wear what the make-believe teenagers at "Euphoria High" wear (if they did, they would be dress-coded into oblivion). But rating the overall success of a look on its site-specific wearability feels outdated when a look today is most successful when it can be described simply as a "mood." A mood is by definition incorporeal, meaning you can channel Cassie's full-blown school bathroom breakdown in a cornflower country music star dress (**p.208**),(04) when really you're just feeling a little unhinged and wearing a touch of blue eyeshadow.

Memes, Moods, and Miu Miu Eras

This idea, that *Euphoria* costumes are "unrealistic," comes up a lot. It's why the "Euphoria High" meme was so successful: if you watched the show and had ever set foot inside literally any high school, you felt like you were in on the joke. That's what fuels the online *Euphoria* takes too—feeling like you're in on something—if not a joke, then a reference, a meaning, a meaning within a meaning. For example, this year was a Miu Miu year— their pleated micro mini broke the internet as the skirt passed through an infinite loop of editorial sets and influencer shoots.(05) Season Two was also Lexi's Miu Miu year (or semester, at least), a detail noted online as soon as she appeared on screen wearing the brand. There's that same conspiratorial satisfaction in clocking Lexi's "Miu Miu era" and knowing what it means to be in one's Miu Miu era (and knowing what it means that Lexi's older sister, Cassie, is wearing Miu Miu's older sister, Prada), or in identifying that Kat's party dress was made by Mimi Wade (**p.182**), your personal favorite still-kind-of-underground designer for kind-of-weird "It girls." Knowing where the clothes come from makes the characters feel less realistic, reinforcing what we already know—that teenagers usually don't loiter in front of their lockers in designer clothes. But it also makes the characters feel more real, because you've seen these clothes somewhere in your own world, on your Instagram feed or on the cover of a magazine.

Despite our sleuthing, take-making, and scientific evaluation of looks on a sliding scale of slutty-realism, we expect the students of "Euphoria High" to dutifully slay—for every outfit to instantly achieve the iconic status of this year's Halloween costume. The bar here was, of course, set by Maddy's purple I.AM.GIA set from Season One (**p.114**), which seemed to change our collective brain chemistry, igniting a fire for Y2K fierceness in its most potent form.(06) *Euphoria* slays bring us closer to a mood—whether that's confidence, hopelessness, desperation, freedom, addiction, or that feeling

Cassie's *Oklahoma!* look plays into the comedy of the scene, Episode 203.

Miu Miu's pleated micro mini skirt on infinite loop in the media after it debuted on the Spring/Summer 2022 runway.

Maddy in her purple I.AM.GIA set from Season One, Episode 104.

you get when you're dressed like a hooker and nobody likes you. They introduce us to what's hot and ask us to think more deeply about why, and we keep watching to see how high that bar can be raised.

In the penultimate episode of Season Two, Cassie looks great, but she doesn't look right. She walks through school stuck to Nate, pretty in pink and just so, so wrong. Her getup is nauseatingly femme; her heart-shaped necklace sits lonely and obvious on her chest; her hair is too straight; her eyes are weighed down by the heavy glisten of her makeup (**p.211**).[07] Cassie doesn't say anything in this scene. She doesn't need to. She's a doll brought to life through the commitment of her daily full-body makeover routine and the dream of Nate's hand around hers, a male fantasy animated by female obsession. We know all of this not through dialogue, but through costuming.

(07) Cassie as a "doll brought to life" for Nate, Episode 207.

Unlike Cassie the fembot, quietly leaking sadness, Maddy is the life-of-the-party black widow in a cut-out mini dress and long gloves in the first episode of Season Two (**p.118**). It's a look that could kill, or at least act as armor as she beats both fists on a bathroom door (that Cassie's secretly locked behind). Like Cassie's hair in the final episode, Maddy's is pin straight, but it's scraped back with a plastic zig-zag headband—the kind you might find in the dollar store and wouldn't necessarily think to wear with your hottest going-out, post-breakup outfit. But Maddy would. Her necklace bears her own name in thick silver script,[08] while Cassie's necklace is engraved with the classically generic femme calling card, "Please Return to Tiffany & Co." Planted in the details of her look are pieces of who Maddy already knows she is, while the girl Cassie thinks she should be wavers in her fragile, clashing pinks. *Euphoria*'s costumes are embedded with clues that signify something deeper about who we are and how we feel, and social media gives us a stage to have a good time figuring them out.

(08) Maddy in her cut-out mini dress for New Year's Eve, Episode 201.

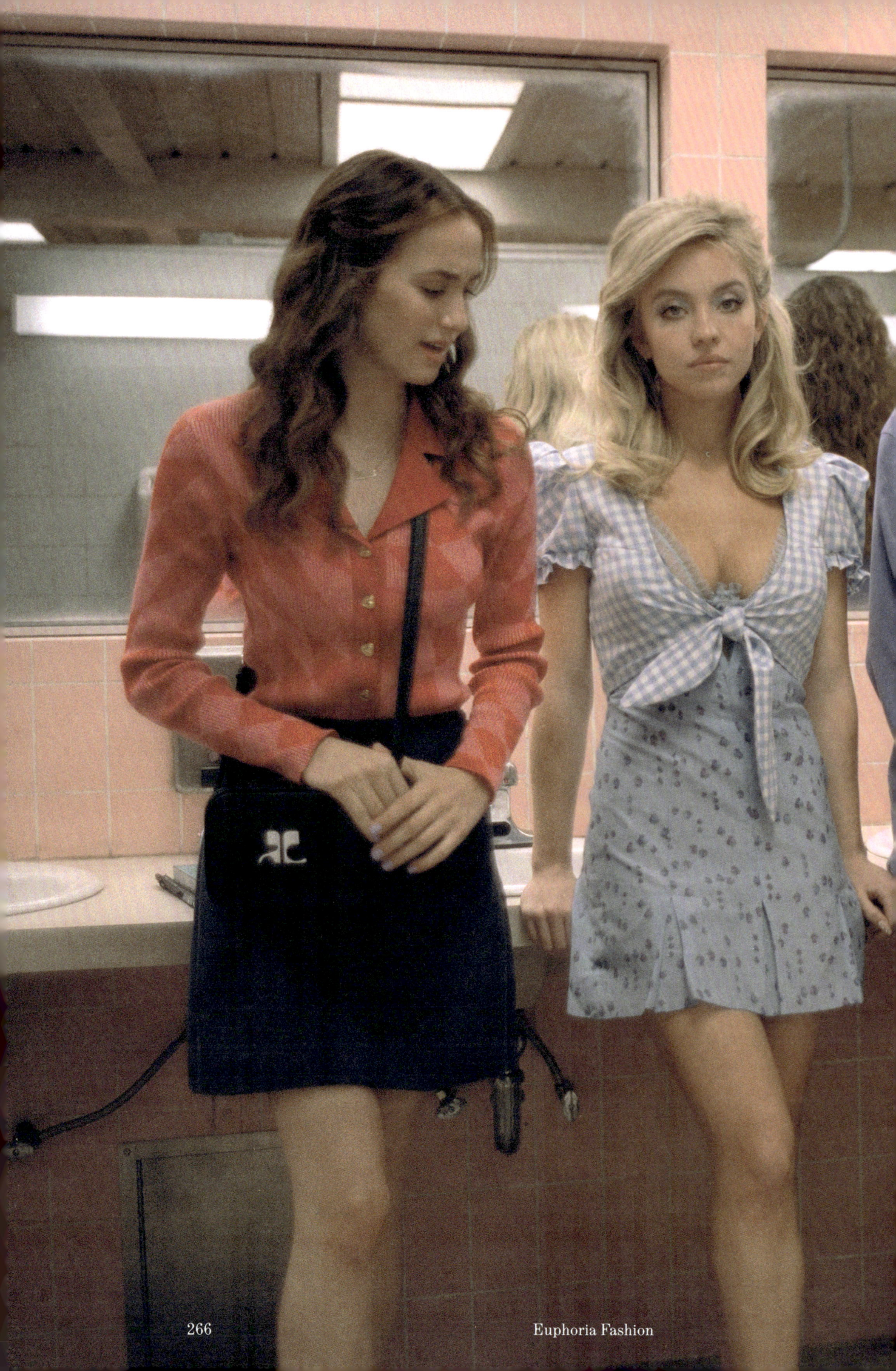

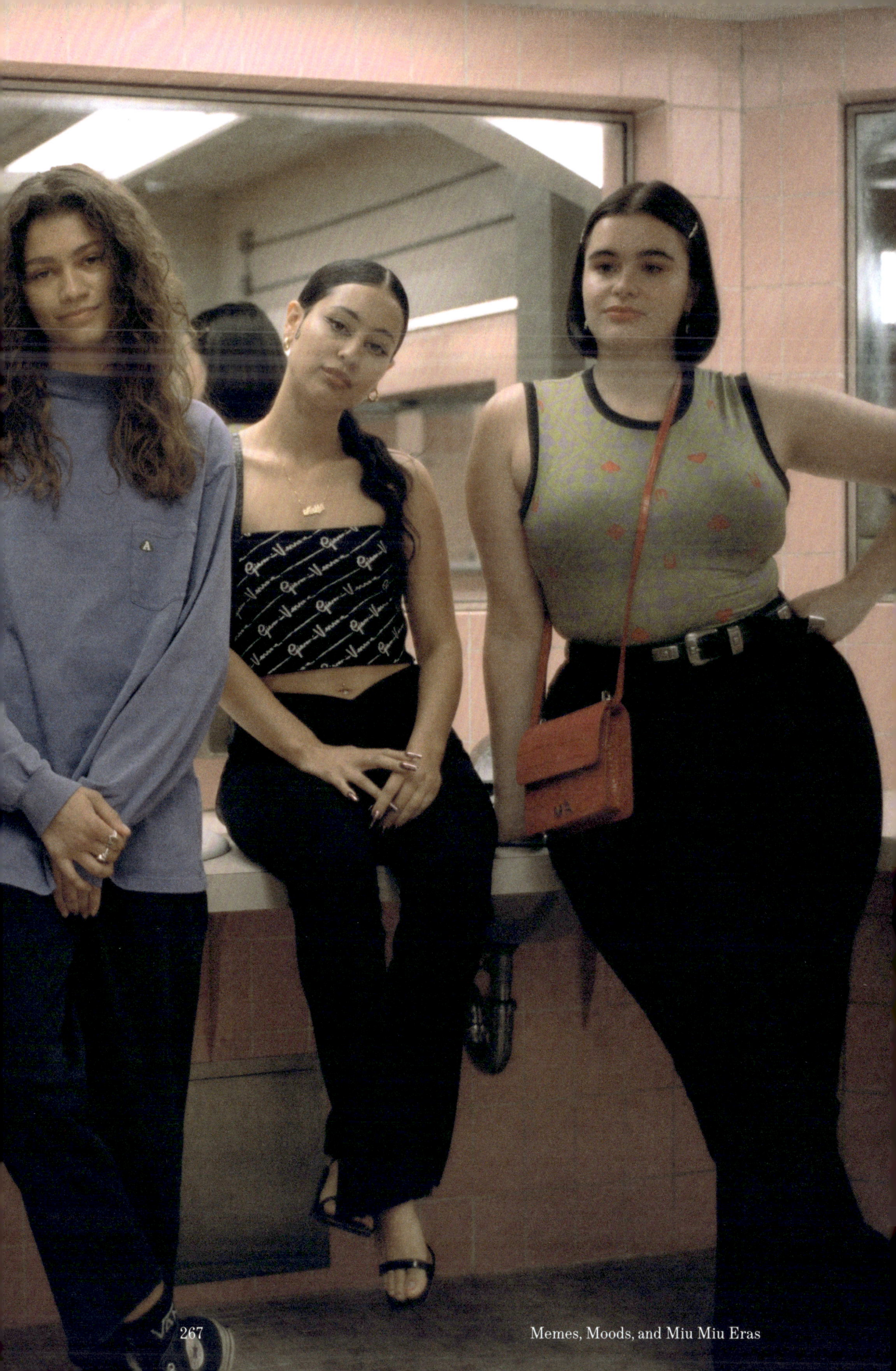

SUPPORTING CHARACTERS

GIA

Gia is one of the youngest characters, and her clothing choices reflect her childlike innocence. She is coming of age while witnessing the chaos of Rue's battle with addiction, and though Gia doesn't look up to her older sister as a role model, she often emulates Rue's sense of style and colors.

CAL

Cal suffers from a case of toxic masculinity in reaction to his decades-long repressed sexuality. When we meet him, he's a buttoned-up pillar of the community, but as his double life falls under threat of exposure, we see him and his appearance unravel.

ASHTRAY

Ashtray's age belies his street-smart savvy and swagger. Fezco's baby-faced younger "brother" prefers designer tracksuits and box-fresh sneakers from Gucci and Versace. He's a stone-cold shark: clever, cunning, and loyal to his family — perhaps to a fault.

SUZE

Suze is a single mom fiercely committed to raising her daughters, Cassie and Lexi. Her sense of fashion hasn't changed much since the early days of her relationship with her ex-husband, Gus, and she's rarely seen without a push-up bra and a glass of wine.

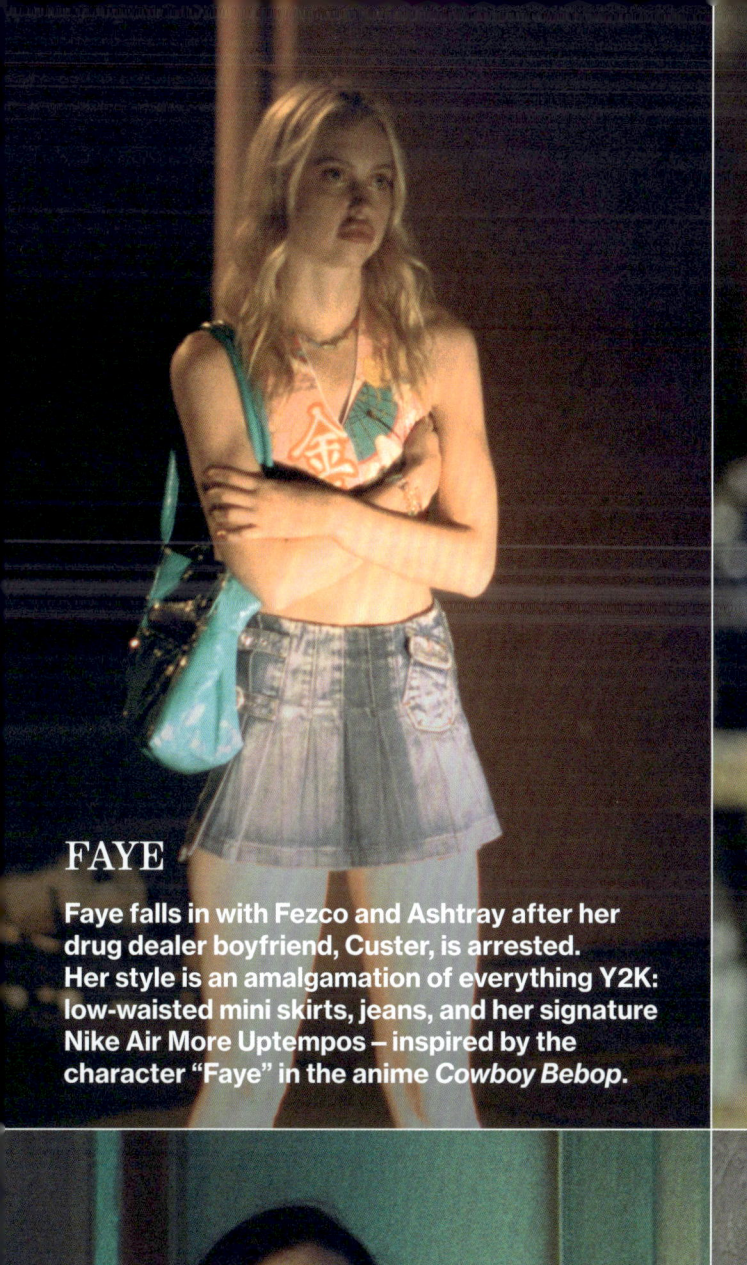

FAYE

Faye falls in with Fezco and Ashtray after her drug dealer boyfriend, Custer, is arrested. Her style is an amalgamation of everything Y2K: low-waisted mini skirts, jeans, and her signature Nike Air More Uptempos – inspired by the character "Faye" in the anime *Cowboy Bebop*.

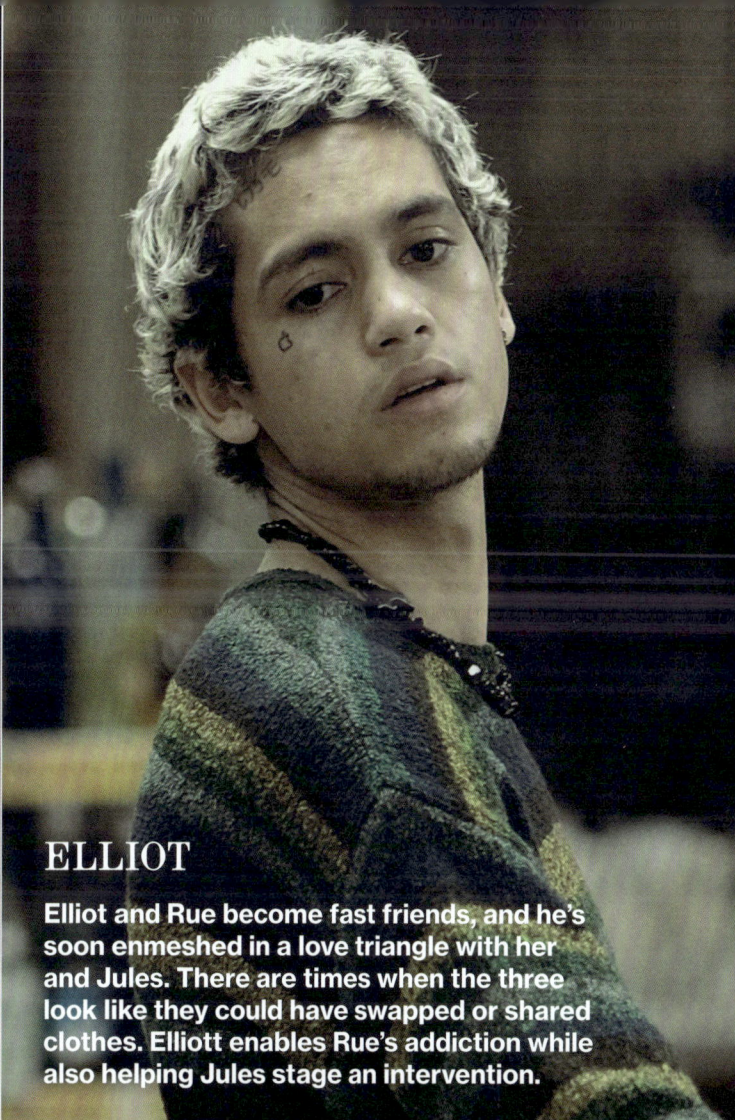

ELLIOT

Elliot and Rue become fast friends, and he's soon enmeshed in a love triangle with her and Jules. There are times when the three look like they could have swapped or shared clothes. Elliott enables Rue's addiction while also helping Jules stage an intervention.

LAURIE

Laurie, the unexpected drug kingpin, rarely leaves her house but favors vacation resort wear with a tropical theme to complement her animal menagerie. Her suggested agoraphobia is underlined by a T-shirt she wears that warns, "It's a Jungle Out There."

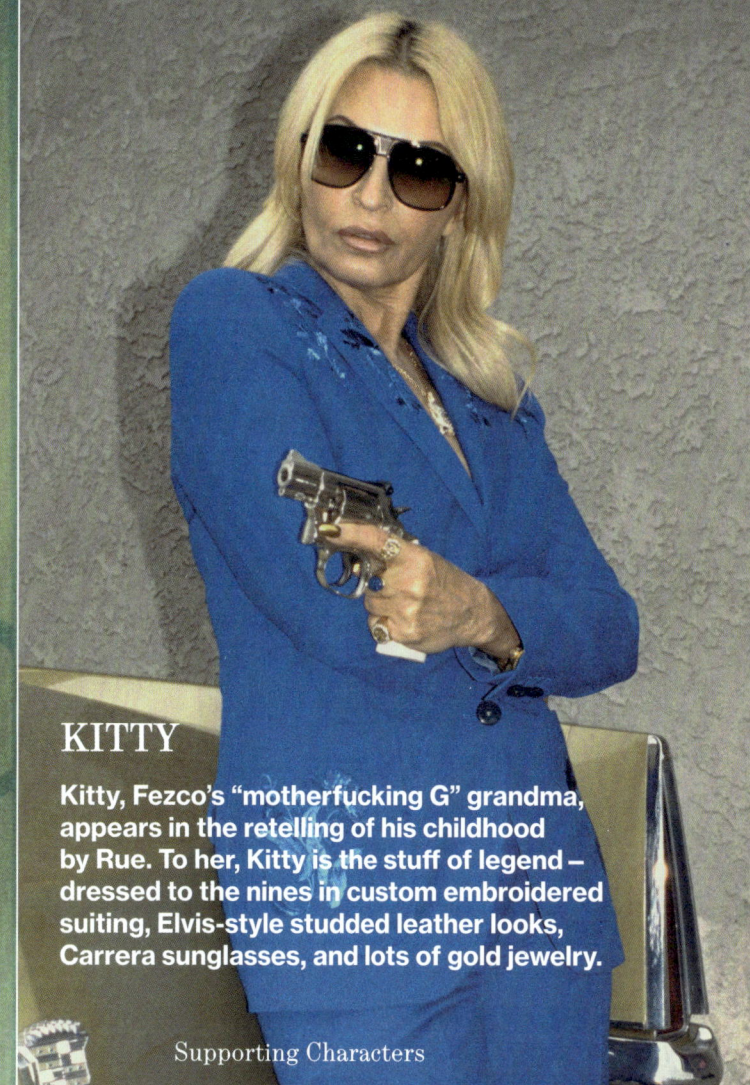

KITTY

Kitty, Fezco's "motherfucking G" grandma, appears in the retelling of his childhood by Rue. To her, Kitty is the stuff of legend – dressed to the nines in custom embroidered suiting, Elvis-style studded leather looks, Carrera sunglasses, and lots of gold jewelry.

FEATURED CAST

RUE BENNETT	Zendaya
JULES VAUGHN	Hunter Schafer
MADDY PEREZ	Alexa Demie
NATE JACOBS	Jacob Elordi
KAT HERNANDEZ	Barbie Ferreira
CASSIE HOWARD	Sydney Sweeney
FEZCO	Angus Cloud
LEXI HOWARD	Maude Apatow
CHRIS MCKAY	Algee Smith
GIA BENNETT	Storm Reid
CAL JACOBS	Eric Dane
ASHTRAY	Javon Walton
SUZE HOWARD	Alanna Ubach
FAYE	Chloe Cherry
ELLIOT	Dominic Fike
LAURIE	Martha Kelly
KITTY	Katherine Narducci
SAMANTHA	Minka Kelly

IMAGE CREDITS

All images courtesy of HBO unless otherwise noted.

14
Second row, left: Marcell Rév

43
Bettmann/Getty Images

44
Top: Bettmann/Getty Images.
Bottom: Dick Raphael/NBAE via Getty Images

45
Ebet Roberts/Getty Images

50
Bottom: Pictorial Press Ltd/Alamy Stock Photo

80
Marcell Rév

88
Middle: *Pokémon: The First Movie*, Kunihiko Yuyama (1998). ©Warner Bros/PictureLux/The Hollywood Archive/Alamy Stock Photo

91
PA Images/Alamy Stock Photo

92
Top: gallica.bnf.fr/Bibliothèque nationale de France. Bottom: PA Images/Alamy Stock Photo.

93
Top: Ted Tinling Archives, International Tennis Hall of Fame, Newport, RI.
Middle: Willi Smith Community Archive, Cooper Hewitt, Smithsonian Design Museum.
Bottom: Guy Marineau

97
Top: *Tank Girl*, Rachel Talalay (1995). ©United Artists/courtesy Everett Collection.
Bottom: *Girl, Interrupted*, James Mangold (1999). ©Columbia/courtesy Everett Collection

98
Eternal Sunshine of the Spotless Mind, Michael Gondry (2004). Courtesy of Universal Studios Licensing LLC

103
Frank Micelotta/Getty Images

117
Silo: Maude Apatow

121
Top: Marcell Rév

140
Photos courtesy of Coperni

143
Top: Roger Viollet/Getty Images.
Bottom: Paul van Riel/ANP/Redux

144
Top: Harry Benson. Bottom: Drew Carolan

147
WENN Rights Ltd/Alamy Stock Photo

168
Maude Apatow

170
Maude Apatow

173
Marcell Rév

195
Maude Apatow

197
Maude Apatow

217
Maude Apatow

239
Marcell Rév

242
Maude Apatow

243
Bottom: Maude Apatow

252
Middle: @baddiesonlyxoxo

263
Middle: @xxxngel

264
Middle: Melodie Jeng/Getty Images

Euphoria Fashion
The Art of Costume Design

A24 Films LLC
31 West 27th Street
New York, NY
a24films.com

Author
Heidi Bivens

Dedicated to Sam Levinson

Head of Publishing
Perrin Drumm

Publishing Operations Manager
Shayan Saalabi

Editor
LinYee Yuan

Copy Editor
Nathan Stobaugh

Proofreader
Zachariah DeGiulio

"Ode To" Writer
Jessica Glasscock

Research Assistant
Caitlin Quinlan

Lightbox Photographer
Nicholas Alan Cope

Unit Photographer
Eddy Chen

Colorist
Luke Barber-Smith

Book Design
Studio Elana Schlenker, Jordi Ng

Typography
EK Roumald by Erkin Karamemet
Neue Haas Grotesk

Paper
Fedrigoni Arena White Smooth 120gsm

Printer
Conti Tipocolor
Via Guido Guinizelli, 20
50041 Calenzano FI, Italy

Special Thanks
Alex Aranovich
Bianca Balconis
Michele Caruso
Costume Designers Guild 892
Kat Danabassis
Lola Elmo
The Film Path
Emily Giannusa
William Greenfield
Grant Illes
Brynn Jones
Andrew Kelley
Harrison Kreiss
Thessaly La Force
Ashley Levinson
Arielle Mauge
Stella McCartney
Amanda Merten
Moschino
Ravi Nandan
Devon Patterson
Arianne Phillips
Alli Reich
Marcell Rév
Ashley Reyes
Jeremy Scott
Shari Shankewitz
Kevin Turen
United Scenic Artists Local USA 829
Angelina Vitto
Martynka Wawrzyniak
Adam Weiss

©2022 the authors, editors, and owners of all respective content.

All rights reserved; no part of this publication may be reproduced, stored in a retrieval system, or transmitted in any form or by any means, electronic, mechanical, photocopying, recording, or otherwise, without prior written consent of the publisher.

Every effort has been made to identify copyright holders and obtain their permission for the use of copyrighted material. The publisher apologizes for any errors or omissions and would be grateful if notified at publishing@a24films.com of any corrections that should be incorporated in future reprints or editions of this book.

Official HBO Licensed Product ©2022
Home Box Office, Inc. All Rights Reserved.
HBO and related trademarks are the property of Home Box Office, Inc.

ISBN: 978-1-7372459-7-1